Paul Cézanne

# LETTERS

Paul

# LETTERS

*Revised and Augmented Edition*

Edited by JOHN REWALD

*Translated by* SEYMOUR HACKER

HACKER ART BOOKS
1984

*Paul Cézanne: Letters*
New, revised and augmented edition © 1984, John Rewald
Translation © 1984, Seymour Hacker
Published by Hacker Art Books, Inc.
New York, New York 1984

Libary of Congress Catalogue Card Number 81–81716
International Standard Book Number 0–87817–276–9

Printed in the United States of America

# Table of Contents

# List of Illustrations

# Preface

LESS THAN A YEAR after Cézanne's death, Emile Bernard published his recollections of the Master in the *Mercure de France*, together with the letters he had received from him. His article coincided with the opening of an important Cézanne retrospective at the *Salon d'Automne* that included more than fifty paintings and watercolors. This exhibition was to "reveal" Cézanne to Rainer Maria Rilke, who mentioned it in letter after letter to his wife, who was also a painter. After having read Bernard's article, Rilke—with a poet's heightened awareness—wrote: "A painter-writer, that is, a painter who was not really one, led Cézanne to express himself on pictorial subjects; however, as we read these few letters from the old man, we realize how rudimentary his diction was and how clumsy and infinitely repugnant he found verbal expression. He was able to express almost nothing. The sentences in which he attempts to do so meander on, become twisted, tie themselves into knots, and he ends up by abandoning them in a rage."*

Clearly, Cézanne did find it difficult to express himself in writing, and he was obviously not writing for publication. Forty-five years ago, when I edited the painter's *Correspondence* for the first time, I began with an admission that the publication had been undertaken only after considerable hesitation. Indeed, such an exposure of the painter's innermost thoughts was rather like an invasion of such a fiercely shy man, a man so jealous of his privacy. And it seems certain that the painter himself would never have agreed to the publication of his letters. He always made a clear distinction between the artist, the man who creates works that may impart "information," as he was to write, and the private person with his narrow but close circle of friends to whom he addressed his infrequent letters. As he wrote to Joachim Gasquet: "I like to think it's possible to paint well without drawing

---

* Rilke to Clara Rilke, Paris, 21 October 1907; cf. Rainer Maria Rilke, *Briefe aus den Jahren 1906 bis 1907*, Leipzig, 1930, p. 402.

attention to one's private life. Of course, an artist tries to improve himself as much as he can intellectually, but the man himself should still remain in the shadows."

However, the man remained too much in the shadow, and ever since Cézanne's vastly important role in modern art has gained its due recognition, we have also been trying to break down this barrier between the two distinct halves of his life he took such trouble to erect. As private person and as artist, he is a part of history, and a web of legend has been spun around him, one that has altered his words, deformed his thoughts, belittled his accomplishments and turned his personality into something archly picturesque. In his own lifetime, Cézanne had already discerned the first wavelets of this flood of anecdotes that was to engulf him. Better than anyone, he was food for legend, and no one was more at a loss vis-à-vis his detractors. Believing as he did that he need only win acceptance for his art in order to put an end to all such idiotic stories, Cézanne never attempted to contradict them; he merely tried to avoid intruders and to work even harder.

Now that Cézanne's work has long gained recognition, it is fitting that we allow the artist to speak for himself, so that we can replace the many untruths and distortions about him with his own words, however clumsily they may be expressed. It is for that purpose that this publication was undertaken, in the conviction that his letters could not be a disservice to a man who had already been so badly served by legend. On the contrary, the letters bring us closer to him as a human being and strengthen the deep and respectful feelings his work inspires.

Every chord of an immensely rich, albeit unequal, temperament is sounded in this correspondence. Although Cézanne could be frivolous and carefree in the letters of his younger years, he reveals himself as simple, grateful, friendly and affectionate in his many missives to Zola; he shows respect when he writes to Pissarro, insolence when addressing the director of the Ecole des Beaux-Arts; he is violent in his letters to Oller and cordial when he communicates with Achille Empéraire or Numa Coste; respectful but firm with his family, full of self-confidence when writing to his mother; he is polite and almost humble in his letters to Victor Chocquet, Roger Marx or Egisto Fabbri, highly indulgent and full of fellow feeling when writing to Charles Camoin (and sometimes to Emile Bernard as well); timid, shy, sad and bitter in a letter to

Gasquet; paternal and affectionate when addressing his only child. Throughout his correspondence, however—with the exception of a few early examples—he writes what is on his mind: the letters seem to have been composed during those rare moments when his brushes had been laid aside, but all reveal that he never stopped his tireless pursuit of his pictorial experiments.

Cézanne's immense suffering was caused not so much by his feeling that he was misunderstood—convinced as he was that he was slowly achieving the goal he had set for himself—as it was by his feeling that he had failed to express his sensations, for that embodiment always seemed to him to fall short in some way. For a long time, Zola was the only person to guess at his pain and to sense the hidden tragedy of this personality so rich in gifts and so poor in peace, just as he was the only person whose friendship and patience were great enough to enable him to retain Cézanne's trust for over thirty years. Thus, the letters to Zola, which make up more than a third of this volume, are the most suitable monument to Zola's friendship for the painter, whose sincere feelings of affection are reflected in his own long and moving letters. He, and all those to whom Cézanne wrote, often acted as moral supports for the solitary soul, and he in turn reveals himself to them as he is, contradictory but never banal, insecure but always filled with his faith in art, violent and tormented but able to speak about his troubled efforts, his goals, his theories, with a moving grandeur and unusual lucidity that, in the final analysis, outweigh the problems that had so struck Rilke.

Whereas the first edition of this book, which appeared in 1937, contained 207 letters, drafts or fragments of letters, this new edition contains 233; the letters to Joachim Gasquet in particular are now reproduced *in extenso* as are those to Louis Aurenche. At the same time, the notes and commentary have been considerably expanded and quotations of passages of letters from Zola to Cézanne and Baille—which fill in the gaps created by the absence of letters to Zola between 1858 and 1862—are more lengthy and more numerous. Other documents, such as letters to Cézanne or in which he is mentioned, have been inserted in their proper place to fill out the documentation of this collection which, admittedly, has been forced to deal with the happenstance through which some letters were preserved while many others disappeared.

Most of those who generously assisted me in preparing the first edition of Cézanne's *Correspondence* are now gone. Among them, I owe a particular gratitude to the artist's son and to Zola's daughter, Madame Denise Le Blond-Zola, as well as to Marcel Arnauld, Edouard Aude, P. B. Barth, Gaston Bernheim de Villers, Georges Besson, Charles Camoin, A. Chardeau, Paule Conil, Madame J. Delaistre, née Guillemet, Maurice Denis, Félix Fenéon, Paul Gachet, Jules Joëts, Louis Le Bail, Maurice Le Blond, Lukas Lichtenhan, Pierre Loeb, Countess Ludolf, née Fabbri, Madame Lutzviller, née Gabet, Léo Marchutz, Lucien and Ludovic-Rodo Pissarro, M. Raimbault, Claude Roger-Marx, Emile Solari, Lionello Venturi, Ambroise Vollard and Madame Zak.

I am also most grateful to my friends Adrien Chappuis, René Huyghe, Gerstle Mack and Fritz Novotny for the assistance they have provided, as well as to the Homehouse Trustees of the Courtauld Institute of Art, London, for permission to consult the letters from Cézanne to Emile Bernard.

*       *       *

It might be useful to mention here that some quests have, unfortunately, failed and that many of Cézanne's letters must be considered as forever lost. Thus, it has been impossible to find any of them among the papers of Baptiste Baille, Cézanne's boyhood friend, or among the papers of the painters Armand Guillaumin, Auguste Renoir and Claude Monet. It has not been possible to examine the originals of the letters to Gustave Geffroy which he quoted in his book on Claude Monet. Charles Camoin no longer had all the letters addressed to him, and of Cézanne's lengthy correspondence with Justin Gabet only a single letter remains extant. Zola too must have received many more letters than he kept. Cézanne's parents, sister and wife, did not preserve his letters, and his son had only those dating from the painter's final weeks.

Almost all of the letters have been copied from the original manuscripts.

The concern to make this volume as complete as possible has led me to include all of Cézanne's letters I have been able to discover, without exception. Thus, the group of early letters—owing to the number that have been preserved—perhaps occupies an unduly large space, since many of them are of minor interest. However, there was no question of

making choices. By presenting the entire extant correspondence as fate has preserved it, it is left to the reader to delve as he will.

Cézanne's letters, as well as the related documents reproduced herein, have appeared in various publications, which are listed in chronological order:

E. Bernard: "Souvenirs sur Paul Cézanne et lettres inédites," *Mercure de France*, 1 and 15 October 1907.

E. Zola: *Correspondance—Lettres de jeunesse*, Paris, 1907. Nouvelle édition avec commentaires et notes de M. Le Blond, Paris, Éditions François Bernouard, 1928.

A. Vollard: *Cézanne*, Paris, édit. Vollard, 1914.

Duret, Werth, Jourdain, Mirbeau: *Cézanne*, Paris, édit. Bernheim-Jeune, 1914.

C. Coquiot: *Paul Cézanne*, Paris, Ollendorf, 1919.

J. Gasquet: *Paul Cézanne*, Paris, édit. Bernheim-Jeune, 1921.

G. Rivière: *Le Maître Paul Cézanne*, Paris, Floury, 1923.

G. Geffroy: *Claude Monet, sa vie, son œuvre*, Paris, Crès, 1924.

M. Provence: "Cézanne chrétien," *Revue des Lettres*, December 1924.

L. Larguier: *Le Dimanche avec Paul Cézanne*, Paris, l'Édition, 1925.

J. Royère: "Louis Leydet," *L'Amour de l'Art*, November 1925.

M. Provence: "Cézanne et ses amis, Numa Coste," *Mercure de France*, 1 April 1926.

M. O. Maus: *Trente années de lutte pour l'art*, Brussels, édit. L'Oiseau Bleu, 1926.

D. Le Blond-Zola: *Émile Zola, raconté par sa fille*, Paris, Fasquelle, 1931.

A. Germain: *In Memoriam E. P. Fabbri*, Florence, 1934.

J. Joëts: "Les Impressionnistes et Chocquet," *L'Amour de l'Art*, April 1935.

G. Mack: *Paul Cézanne*, New York, Knopf, 1935.

J. Rewald: *Cézanne et Zola*, Paris, Sedrowski, 1936. Nouvelle édition: *Cézanne, sa vie, son œuvre, son amitié pour Zola*, Paris, Albin Michel, 1939.

*Catalogue de l'Exposition* Cézanne à l'Orangerie, Paris, 1936, 2ᵉ édition.

L. Venturi: *Cézanne, son art, son œuvre*, Paris, édit. Rosenberg, 1936.

J. Rewald et L. Marschutz: "Cézanne et la Provence," numéro spécial du *Point*, August 1936.

A. Barr: "Cézanne d'après les lettres de Marion à Morstatt," *Gazette des Beaux-Arts*, January 1937.

M. Raimbault: "Une lettre de Cézanne à Joseph Huot," *Provincia*, Bull. de la Soc. de Statist. et d'Archéol. de Marseille, vol. 2, 1937.

L. Venturi: *Les Archives de l'impressionnisme*, edit. Durand-Ruel, Paris, 1939.

L. Venturi: "Giunte a Cézanne," *Commentari* (Florence), January–March 1951.

V. Nicollas: *Achille Emperaire*, Aix-en-Provence, 1953.

J. de Beucken: *Un portrait de Cézanne*, Paris, Gallimard, 1955.

P. Gachet: *Lettres impressionnistes au Dr Gachet et à Murer*, Paris, Bernard Grasset, 1957.

M. Denis: *Journal (1884–1904)*, Paris, La Colombe, 1957. *Künstler-Autographen von 1850–1950*, Katalog n° 89, Gutekunst und Klipstein, Bern, 14 May 1958.

J. Rewald: *Cézanne, Geffroy et Gasquet—suivi de Souvenirs sur Cézanne de L. Aurenche et de lettres inédites*, Paris, Quatre Chemins, 1959.

J. Rewald: "Une lettre inédite de Paul Cézanne," *Mélanges Kahnweiler*, Verlag Gerd Hatje, Stuttgart, 1966.

Catalogue, *Vente d'Autographes et documents divers*, Hôtel Drouot, Paris, June 19, 1970.

Catalogue, *Sale of Autographs*, Sotheby's, London, November 20, 1973.

The unpublished letter to Saint-Martin of August 15, 1864, as well as other documents were kindly brought to my attention by Theodore Reff.

I am indebted to Henri Dorra for the communication of two unpublished letters from Zola to Cézanne, of May 13, 1880, and May 20, 1883, respectively. These documents are reproduced here with the generous permission of the Fondation Custodia, Institut Néerlandais, Paris.

Letters that I have been unable to compare with the originals have been reproduced as they appear in the above publications.

J.R.

*Early Letters*
[1858–1870]

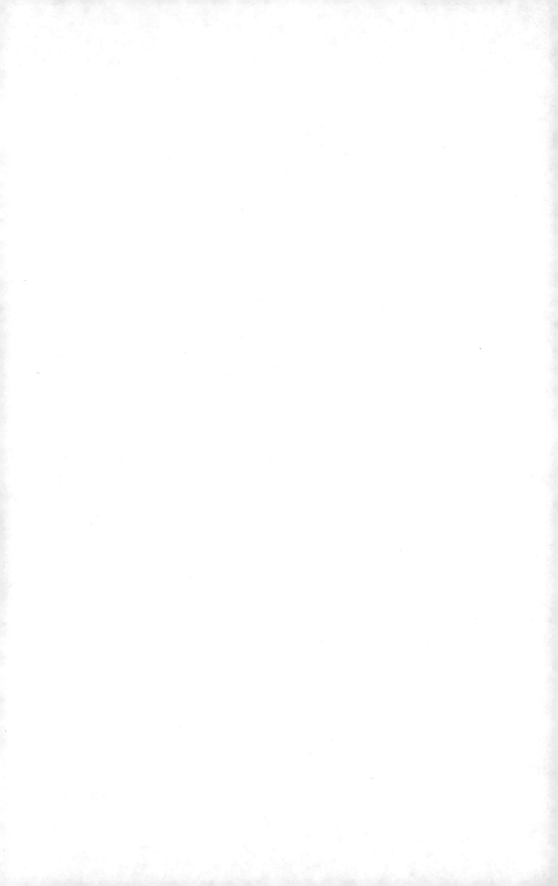

# Early Letters
## [1858–1870]

BORN IN AIX-EN-PROVENCE on 19 January 1839, the son of a wealthy banker, Paul Cézanne first attended Aix's Collège Bourbon in 1852, where he became friends with Emile Zola. The latter, born in Paris and a year younger than he, was raised in Aix. The two classmates were close friends until 1858, when Zola returned to Paris with his mother, the young widow of an Italian engineer. There, he continued his studies, returning to Aix every summer. After his departure, a continued correspondence sprang up between Cézanne and himself, as well as with Baptiste Baille, who was the third member of this group of "inseparable" friends.

## [1858]

TO EMILE ZOLA

Aix, 9 April 1858

Greetings, my dear Zola,

> Enfin je prends la plume
> Et selon ma coutume[1]
> Je dirai tout d'abord
> Pour nouvelle locale
> Qu'une forte rafale
> Par son ardent effort
> Fait tomber sur la ville
> Une eau qui rend fertile
> De l'Arc[2] le riant bord.
> Ainsi que la montagne

Notre verte campagne
Se ressent du printemps,
Le platane bourgeonne,
De feuilles se couronne
L'aubépin vert aux bouquets blancs.

---

At last I take up my pen and as is my wont[1] I'll begin with the local news, which is that a heavy storm is drenching the town with might and main and bringing rain to make the pleasant banks of the Arc[2] fertile. And, along with the mountains, our verdant countryside is feeling the effects of spring, the plane trees are in bud and leaves are beginning to crown the green hawthorns with their white garlands.

---

I've just seen Baille,[3] this evening I'm going to his place in the country (I mean Baille the elder), so I'm writing you.

Le temps est brumeux
Sombre et pluvieux,
Et le soleil pâle
Ne fait plux aux cieux
Briller à nos yeux
Ses feux de rubis et d'opale.

---

The weather is misty and dark with rain, and the feeble sun in the sky no longer sheds its ruby and opal fires to dazzle our eyes.

---

Since you left Aix, my friend, I've been overcome with gloomy grief; believe me, I'm telling the truth. I don't feel my old self, I'm heavy, stupid and slow. And Baille tells me that in a couple of weeks he will have the pleasure of transmitting to the hands of your eminent greatness a sheet of paper on which he will impart to you variously his sorrows and his pains at being separated from you. Truly, I would love to see you, and look forward to seeing you, I and Baille (of course), at vacation time, and then we shall carry out, we shall accomplish all the plans we have made, but in the meantime, I bewail your absence.

Adieu, mon cher Émile:
Non, sur le flot mobile
Aussi gaiement je file
Que jadis autrefois,

Quand nos bras agiles
Comme des reptiles
Sur les flots dociles
Nageaient à la fois.

Adieu, belles journées
Du vin assaisonnées!
Pêches fortunées
De poissons monstrueux!
Lorsque dans ma pêche,

A la rivière fraîche
Ma ligne revêche
N'attrapait rien d'affreux.

---

Farewell, my dear Emile: No, I no longer speed over the running stream as gaily as I did in those bygone days when our arms, agile as any snake, propelled us side by side along the peaceful flood. Farewell, fine days of spiced wines! Days of successful casting for enormously large fish! Those days when my recalcitrant line cast into the cool river never caught anything horrid.

---

Do you remember on the bank of the verdant Arc the pine that bent its long-haired head over the gulf yawning at its feet? That pine tree that shielded our bodies with its foliage from the heat of the sun, Ah! may the gods protect it from the fearful attack of the woodman's axe!

We count on your coming to Aix during the vacation, and then, by god, then . . . hooray for pleasure! We have planned hunting expeditions as monstrous and unruly as our fishing expeditions used to be.

Soon, my friend, we will be beginning to go after fish again, if the weather holds; today is magnificent, for it's the 13th and I'm still writing this letter.

Phoebus traversing his brilliant path
Sheds floods of his light over all Aix.

POÈME INÉDIT

C'était au fond d'un bois
Quand j'entendis sa voix brillante

Chanter et répéter troiˊfois
Une chansonnette charmante
Sur l'air du mirliton, etc.

J'aperçus une pucelle
Ayant un beau mirliton
En la contemplant si belle
Je sentis un doux frisson
Pour un mirliton, etc.

Ses grâces sont merveilleuses
Et son port majestueux,
Sur ses lèvres amoureuses
Erre un sourire gracieux
Gentil mirliton, etc.

Je résous de l'entreprendre,
J'avance résolument:
Et je tiens ce discours tendre
A cet objet charmant:
Gentil mirliton, etc.

Ne serais-tu pas venue,
Inexprimable beauté,
Des régions de la nue,
Faire ma félicité?
Joli mirliton, etc.

Cette taille de déesse,
Ces yeux, ce front, tout enfin
De tes attraits la finesse
En toi tout semble divin.
Joli mirliton, etc.

Ta démarche aussi légère
Que le vol du papillon
Devance aisément, ma chère,
Le souffle de l'aquilon,
Joli mirliton, etc.

L'impériale couronne
N'irait pas mal à ton front.
Ton mollet, je le soupçonne
Doit être d'un tour bien rond.
Joli mirliton, etc.

Grâce à cette flatterie,
Elle tombe en pâmoison,
Tandis qu'elle est engourdie,
J'explore son mirliton.
O doux mirliton, etc.

Puis revenant à la vie
Sous mes vigoreux efforts,
Elle se trouve ébahie
De me sentir sur son corps.
O doux mirliton, etc.

Elle rougit et soupire
Lève des yeux langoureux
Qui semblaient vouloir me dire
"Je me complais à ces jeux."
Gentil mirliton, etc.

Au bout de la jouissance
Loin de dire: "C'est assez."
Sentant que je recommence
Elle me dit: "Enfoncez."
Gentil mirliton, etc.

Je retirerai ma sapière,
Après dix ou douze coups—
Mais trémoussant du derrière:
"Pourquoi vous arrêtez-vous?"
Dit ce mirliton, etc.

---

## UNPUBLISHED POEM

It was from the depths of a wood that I heard her warm voice singing and repeating thrice a charming little song to the notes of a wood flute, etc.

I spied a maid with a fine wood flute, and seeing her so lovely I felt a sweet shiver for a wood flute, etc.

She had marvelous graces and a majestic carriage, and on her lips made for love a graceful smile played, sweet wood flute, etc.

I resolved to accost her and moved towards her with determination: and the following are the words I exchanged with that charming creature: sweet wood flute, etc.

Have you not descended from the lofty clouds to create my felicity, my indescribable beauty? Sweet wood flute, etc.

Your goddess's waist, your eyes, your brow, all your features and finesses make you seem divine, lovely wood flute, etc.

Your step, light as a butterfly's flight, easily outdistances the breath of the north wind, my dear, my lovely wood flute, etc.

A royal crown would suit your brow, and I suspect that your thigh must be a fine round form, lovely wood flute, etc.

Because of my flattery, she fell into a swoon, and while she was thus unconscious, I explored her wood flute, ah, lovely wood flute, etc.

Regaining her senses under my vigorous efforts, she was astounded to find me upon her, oh sweet wood flute, etc.

She blushed and sighed and raised her languid eyes, which seemed to be telling me "I like this game," kind wood flute, etc.

And at the peak of her pleasure, far from saying "That's enough," she sensed that I was ready to begin all over again and she said "Plunge on," gentle wood flute, etc.

I withdrew my tool after ten or twelve strokes—but wriggling her behind: "Why are you stopping?" said the wood flute, etc.

---

> Aix, April 14th
> Paul Cézanne
> *Salve, carissime Zola.*

P.S. When you write to me, you'll tell me if the weather is good up there. Until very soon. I won't be so lazy in future. Note 1. Bernabo, Léon with the bamboo and Alexandre are, I'm told, at school, at the Lycée (I don't know what kind of thing it is) Sainte-Barbe in Paris. As for the other above-mentioned individuals, I'll find out and give you the address in a future letter. (This one is riddled with nonsense.) If you see the Bernabos, say hello to them.

Note 2. I got your letter containing the affectionate *mirlitons* that we have had the honor to sing with Boyer,[4] basso, and Baille, light tenor.

TO EMILE ZOLA

Aix, 3 May 1858

Cher ami que Paris retient bien loin de moi,
D'un ténébreux rébus devine le mystère.
Est-il bon? Je ne sais; mais je sais, par ma foi,
Que je l'ai composé dans le but de le faire
Bon, mais non pas mauvais. Si tu peux deviner
Le sens de ce rébus que je te fais donner
Par la poste, morbleu! je saurai bien prétendre
Qu'il est bon et fort bon, et je ne veux entendre
Là-dessus point du tout de contradiction.
Comme j'en suis l'auteur, c'est toute la raison.

———————

Dear friend, whom Paris keeps far from me, try to plumb the mystery of this shadowy rebus. Is it good? I don't know, but what I do know is that I fabricated it with the intention of making it good and not bad. If you can guess the meaning of this rebus I'm sending you through the post, by golly, I'll know that it's a very good one, and I shall brook no contradiction on that score. Since I'm its author, that's reason enough.

———————

Are you all right? I'm very busy, by golly, very. Which explains the absence of the poem you requested. Believe me, I'm very contrite that I can't reply with the spirit, warmth and energy of your letters. I like the principal's "savage mug"! (The one in your letter, I mean, not to confuse things.) If you guess my great rebus, you'll write to tell me what I meant. Do one for me if *tempus habes*.

I passed your letter on to Baille. Also Marguery's.[5] Marguery is still just as dull.

Now the air has suddenly turned cold. Farewell to swimming.

Adieu nos belles nages
Sur les riantes plages
Du fleuve impétueux

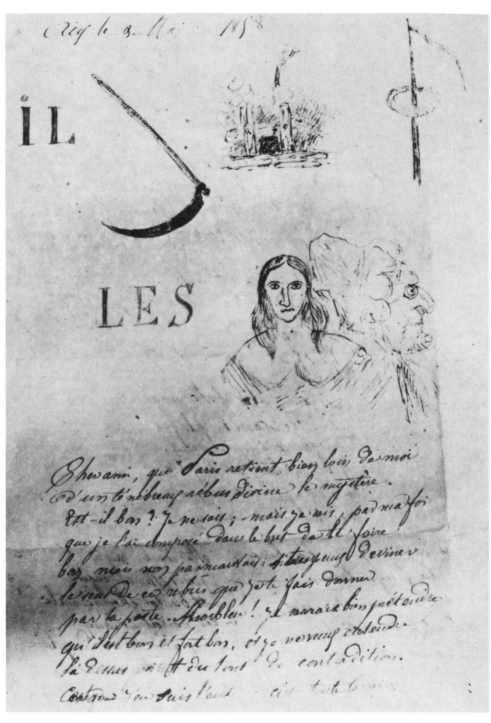

Drawing on a letter to Emile Zola. May, 1838.

Qui roulait sur la grève
Une onde, dont mon rêve
Ne souhaita rien mieux.

Une eau rouge et bourbeuse
Sur la fange terreuse
Entraîne maintenant
Plantes déracinées,
Branches abandonnées
Au gré de son courant.

Elle tombe, la grêle!
Puis elle se dégèle

Bientôt elle se mêle
A ces noirâtres eaux.
De grands torrents de pluie
Que la terre essuie
Forment de grands ruisseaux.

Ce sont des rimes sans raison.

Mon cher, tu sais, ou bien tu ne sais pas,
Que d'un amour subit j'ai ressenti la flamme
Tu sais de qui je chéris les appas,
C'est d'une gentille femme.
Brun est son teint, gracieux est son port,
Bien mignon est son pied, la peau de sa main fine
Blanche est sans doute,[6] enfin, dans mon transport
J'augure, en inspectant cette taille divine,
Que de ses beaux tétons l'albâtre est élastique,
Bien tournés par l'amour. Le vent en soulevant
Sa robe d'une gaze en couleurs magnifiques
Laisse d'un rond mollet deviner le charmant
Contour . . .

---

Farewell to our lovely swims on the smiling banks of the impetuous flood that casts upon the strand a wavelet that makes all my dreams come true.

A ruddy and muddy water now muckily bears along the uprooted plants and abandoned branches willy-nilly on its current.

Hailstones fall! And then they thaw and soon they will mingle with these dark waters. Torrents of rain sweep the earth and form wide running brooks.

These rhymes have no reason.

My friend, you do know—or perhaps you don't—that I have felt the burning touch of a sudden love, you know the sweet thing whose charms I cherish, her complexion is dark, her carriage graceful, her feet tiny and her delicate hands—without a doubt white-skinned,[6] and lastly, in my transport I could imagine as I inspected her divine form that the alabaster of her lovely bosom was elastic and well shaped by love. As it lifted her magnificent dress of tinted gauze, the wind revealed a hint of the charming shape of her rounded calf . . .

———————

I'm sitting across from Boyer at the moment, upstairs at home. I'm writing in his presence and I shall command him to write a few lines in this letter.

> *Que ta santé soit parfaite,*
> *En amour sois toujours heureux,*
> *Rien n'est si beau qu'être amoureux,*
> *C'est tout ce que je te souhaite.*

———————

May your health be perfect, may you always be happy in love, nothing is finer than being in love and those are all my wishes on your behalf.

———————

*I warn you that when you in turn come to see Cézanne you will find on the walls of his room a huge collection of maxims from Horace, V. Hugo, etc.*

*Boyer, Gustave*[7]

My dear fellow, I'm studying for the *bachot*. Ah, if I were passed, if you were passed, if Baille were passed, if we were passed. At least Baille will make it, but I: sunk, submerged, smashed, petrified, extinguished, wiped out, that's what I will be.[8]

My dear fellow, today is May 5th and it's raining heavily. The cataracts of the sky have been unloosed.

L'éclair a sillonné la nue
Et la foudrrre en grrrondant rrroule dans l'étendue.

———————

Lightning has sliced through the clouds
And the thunderrr grrrrowls and rrrrrumbles in the vastness.

———————

There is over two feet of water in the streets. God, irritated by the crimes of the human race, has obviouly determined to wash away their many iniquities by this new flood. This frightful weather has lasted for two [days]: my thermometer shows 5 degrees above zero, and my barometer indicates heavy rain, storm, hurricane for today and the rest of the period. All the town's inhabitants have fallen victims to a deep despondency. Consternation can be read on every face. Everyone's expression is taut, their eyes haggard, their miens fearful, they hold their arms close to their sides as though they were afraid of being jostled in a crowd. Everyone walks around muttering prayers; on every street corner, despite the beating rain, groups of young maidens can be seen who, careless of their crinolines, recite litanies to the heavens until they're blue in the face. The town echoes with their unspeakable uproar. It has made me dizzy. I hear nothing but *ora pro nobis* on every side. As for me, I've added to the impudent ditties and awful hallelujahs a few pious *pater nosters* or even some *mea culpa, mea culpa* repeated to the third, fourth, fifth power of *mea culpas*! thinking thus to avert the attention of the august Trio that reigns on high from all our past impieties.

But I perceive that a change, forevermore sincere, has just calmed the Gods' wrath. The clouds are lifting. A radiant rainbow glitters in the heavenly vault. Farewell, farewell.

P. Cézanne

TO EMILE ZOLA

Aix, 29 . . . 1858

My dear chap,

Your letter not only gave me pleasure, but just getting it made me happy. I am prey to a kind of inner sorrow, and, God knows, I dream

of nothing but that woman I spoke to you about. I don't know who she is: on the way to the monotonous school, I see her going by in the street from time to time. I'm at the sigh–heaving stage, but sighs that have no outward manifestation, they are mental sighs, whether *mentals* or *mentaux* I don't know.

The bit of poetry you sent me raised my spirits. I was very pleased to see that you remember the pine tree that shades the riverbank near Palette.[9] How I should like—what a rotten fate keeps us apart—how I should like to see you getting here. If I didn't restrain myself, I would let off a whole string of "damns," of "goddamns" of "what a bitch" to the sky; but what's the use of getting angry, that doesn't make it any better, and so I put up with it.—Yes, as you say in another no less poetic passage (but I prefer the bit on swimming), you are happy, yes you [are] happy, but I, the unfortunate, must wither away in silence, for my love (for it *is* love that I feel) cannot find an outlet.—A kind of boredom hangs over me and I forget my unhappiness only at moments: when I've had something to drink. I always liked wine and I like it even more now. I get drunk, I'll get even drunker, unless by some unexpected good fortune—oh well! I might succeed, for God's sake! But no, I despair, I despair, so I'm going to get loaded.

My dear friend, I reveal to you a picture representing:

<div style="text-align:center">

Cicero

striking down Catiline

after having uncovered the conspiracy

of that dishonorable citizen.[10]

</div>

> Admire, cher ami, la force du langage
> Dont Cicéron frappa ce méchant personnage,
> Admire Cicéron dont les yeux enflammés
> Lancent de ces regards de haine envenimés,
> Qui renversent Statius cet ourdisseur de trames
> Et frappent de stupeur ses complices infâmes.
> Contemple, cher ami, vois bien Catilina
> Qui tombe sur le sol, en s'écriant "Ah! Ah!"
> Vois le sanglant poignard dont cet incendiaire
> Portait à son côté la lame sanguinaire.
> Vois tous les spectateurs, émus, terrifiés
> D'avoir été bien près d'être sacrifiés!

Vois-tu cet étendard, dont la pourpre romaine
Autrefois écrasa Carthage l'Africaine?
Quoique je sois l'auteur de ce fameux tableau
Je frissonne en voyant un spectacle si beau.
A chaque mot qui sort (j'ai horreur, je frissonne)
De Cicéron parlant tout mon sang en bouillonne,
Et je prévois déjà, je [*suis*] bien convaincu
Qu'à cet aspect frappant, tu seras tout ému.
Impossible autrement! Non jamais, autre chose
Dans l'Empire romain ne fut plus grandiose.
Vois-tu des cuirassiers les panaches flottants
Ballottés dans les airs par le souffle des vents?
Vois aussi, vois aussi, cet appareil de piques
Qu'a fait poster par là l'autre des Philippiques.
C'est te donner, je crois, un spectacle nouveau
Que t'exposer aussi l'aspect de l'écriteau:
"*Senatius, Curia.*" Ingénieuse idée
Pour la première fois par Cézanne abordée!

O sublime spectacle aux yeux très surprenant
Et qui plonge dans un profond étonnement.

---

Admire, my dear friend, the forceful speech with which Cicero brought low that wicked character; admire Cicero, whose fiery gaze darts a look of such venemous loathing as he overthrows Statius, that fomenter of intrigues, and strikes dumb his infamous accomplices. Contemplate, dear friend, and gaze upon Catiline as he falls to the ground crying out "Ah, ah!" See the bloody dagger whose gore-stained blade this firebrand carried at his side. Behold the spectators, awestruck and terrified at having been on the verge of being sacrificed! Do you see that standard, whose Roman purple once crushed the African Carthage? Although I am the begetter of this great picture, I tremble as I look upon such a magnificent spectacle. And my blood churns with each word (I recoil, I tremble) of Cicero as he speaks, and I anticipate with certainty that you too will be deeply moved at this striking spectacle. How can it be otherwise! No, nothing in all the Roman Empire was ever more grandiose. Do you note the cuirassiers with their floating plumes that toss in the air as the wind blows? Behold too that array of pikes summoned forth by the author of the Philippics. This new realization will give you greater insight into the meaning of the phrase

*Senatius, Curia.* An ingenious idea that is here given expression for the first time ever by Cezanne!

Oh, sublime sight, to amaze the eyes and arouse profound astonishment.

———————

However, it's enough to have pointed out to you the incomparable beauties contained in this admirable watercolor.

The weather is clearing, I'm not sure if it will last. The one sure thing is that I can't wait to go:

> En plongeur intrépide
> Sillonner le liquide
> de l'Arc
> Et dans cet eau limpide
> Attraper les poissons que m'offre le hasard.

> Amen! amen! ces vers sont stupides.
> Ils ne sont pas pleins de goût
> Mais ils sont stupides
> Et ne valent rien du tout.
> Adieu, Zola, adieu.

———————

Like an intrepid diver to cleave the waters of the Arc, and to catch in that limpid stream the fish fate sends.

Amen! amen! these verses are silly. They are tasteless and stupid and worthless. Farewell, Zola, farewell.

———————

You can see that, compared with my brush, my pen can utter nothing worthwhile, and today it would be futile for me even to attempt to

> Te chanter quelque nymphe de bois
> Je ne me trouve pas une assez belle voix
> Et les beautés des campagnes agrestes
> Sifflent de mes chansons les tours trop peu modestes.

———————

Sing you some wood-nymph, I find my voice is lacking, and the beauties of the rural countryside mock my immodest strophes.

———————

So I'll end this, since I'm piling silliness on top of stupidity.

Tel on voit vers les cieux un tas d'absurdités
S'élever avec les stupidités.
C'est assez.

---

So one sees pile up to the sky a heap of absurdities on stupidities.
Enough.

---

P. Cézanne

ZOLA TO CEZANNE

[Zola, who turned eighteen in April 1858, was attending the Lycée Saint-Louis in Paris. Although born in that city, he had spent his youth in Aix and was apparently treated with a certain condescension by his fellow students in Paris. He was already planning a literary career and felt that he was destined for poetry.]

*Paris, 14 June 1858.*

*[. . .] Paris is big, full of things to do, monuments, charming women. Aix is small, dull, petty, full of women [. . .] (God preserve me from the evil tongues of the women of Aix.) And yet I still prefer Aix to Paris.*

*Is it the pines moving in the wind, is it the arid gullies, the rocks piled up like Pelion on Ossa, is it the picturesque nature of Provence that attracts me to it? I don't know; yet my poet's dream tells me that a steep cliff is better than a freshly whitewashed house, the wave's roar better than that of a big city, virgin nature better than one tormented and affected. Or is it rather the friends I have left behind by the banks of the Arc that draw me to the land of bouillabaisse and aioli? Of course, that must be it.*

*I see so many young people here attempting to be clever, thinking themselves above other people, finding merit only in themselves and granting to others nothing but a large share of stupidity, and I yearn to see those whose true wit I know and who, before they cast stones at other people wonder whether they might not deserve to have some thrown at them. Well! I'm very serious today. You must forgive me for the dull thoughts I have just expressed: but, you see,*

*when one begins to look at the world a bit more closely, one notices how muddled it all is and one cannot help but wax philosophical. To hell with logic, hurrah for happiness! How are you coming with your conquest? Have you spoken to her?*

*Ah, you rogue, I think you're quite capable of doing so. Young man, you are bound to perdition, you are going to commit follies, but I'll soon show up to prevent that. I don't want anyone to spoil my Cézanne for me.*

*Have you been swimming? Are you having the time of your life? Are you painting? Are you playing the cornet? You are writing poetry? In other words, what are you doing? And your bachot? Is it going well? You're going to dumbfound all the teachers. Ah, dammit, we'll have a wonderful time. I have wild ideas. You'll see, it's enormous [. . .]*

*Now, if you have time, send me a nice bit of poetry. That distracts me while giving me pleasure. As for me, I have been dead to poetry for a while.*

TO EMILE ZOLA

[Aix] 9 July 1858

*Carissime Zola, Salve.*
*Accepi tuam litteram, inqua milis dicebas*
*te cupere ut tibi rimas mitterem ad bout-rimas*
*faciendas, gaude; ecce enim pulcherrimas rimas.*
*Lege igitur, lege, et miraberis!*

| révolte | Zola | métaphore | brun |
| récolte | voilà | phosphore | rhum |

| vert | bachique | bœuf | aveugle |
| découvert | chique | veuf | beugle |

| chimie | uni | borne |
| infamie | bruni | corne |

Dear Zola, hail! Accept your letter, wherein, as you have often said you wished, there are most beautiful rhymes. Read on and marvel!

| revolt | Zola | metaphor | brown |
| harvest | behold! | phosphorous | rum |

| green | bacchic | beef | blindman |
| discovered | phoney | widower | bellow |

| chemistry | united | boundary |
| infamy | bronzed | horn |

And you have permission to employ the above rhymes, first by putting them in the plural, should your serene majesty see fit; secondly, you can rearrange them in any order you like; but, thirdly, I insist on Alexandrines and, finally, fourthly, I want—no, not want—I beg you to turn the whole thing into a poem, including the Zola.

Here are a few small verses of my own that I find admirable because they are mine—the real reason being that I am their author.

PETITS VERS

Je vois Leydet
Sur un bidet
Poignant son âne
Et triomphant
Il va chantant
Sous un platane.

L'âne affamé
Tout enflammé
Tend vers la feuille
Joyeux et fol
Un très long col
Qui bien la cueille.

Boyer chasseur
Plein de valeur
Met dans sa poche
Un noir cul-blanc
Qui plein de sang
Verra la broche.

Zola nageur
Fend sans frayeur
L'onde limpide.
Son bras nerveux
S'étend joyeux
Sur le doux fluide.

---

## LITTLE VERSES

I see Leydet[11] on a bidet spurring his ass as he rides along singing triumphantly under a plane tree.

The famished ass, totally inflamed, extends its immensely long neck to the merry untamed leaves as if to pluck them.

Boyer, the hunter, filled with bravery, slips into his pocket a white-tailed blackbird that will soon, still warm, experience the spit.

Zola the swimmer cleaves the limpid stream fearlessly, his eager arm joyfully extended through the gentle liquid.

---

It's very foggy today. Oh, I've just composed a couplet, as follows:

De la dive bouteille
Célébrons la douceur,
Sa bonté sans pareille
Fait du bien à mon cœur.

---

Let us celebrate the mellowness of the bottle whose unequaled goodness lifts my heart.

---

To be sung to the tune of:

D'une mère chérie
Célébrons la douceur,
etc.

---

Let us celebrate the gentleness of a beloved mother, etc.

---

My friend, I do believe you must be really sweating when you tell me in your letter

Que ton front tout baigné d'une chaude sueur
Était environné de la docte vapeur,
Qu'exhale jusque'à moi l'horrible géométrie!
(Ne prends pas au sérieux cette dure infamie)
    Si je qualifie
    Ainsi la Géométrie!
C'est qu'en l'étudiant je me sens tout le corps
Se fondre en eau, sous mes trop impuissants efforts.

---

That your brow all bath'd with a warm dew was enhaloed with that aura of wisdom that exhales horrid geometry to my very nostrils! (Don't take this cruel insult seriously) Should I qualify geometry thus, it is because studying it makes me feel that my entire body is turning to liquid because of the undue strain of my effort.

---

My dear fellow, when you have sent me your set rhymes,

Car dans les bouts rimés je te trouve adorable,
Et dans les autres vers vraiment incomparable,

---

For in this rhyming game I find you adorable and in other verses downright incomparable,

---

I shall get busy searching out other, richer and more outlandish rhymes; I'm preparing them, I'm developing them, I'm distilling them in my alembic brain. They will be new rhymes—ahem!—rhymes such as are rarely seen, by heaven— in short, perfect rhymes.

My dear fellow, after having begun this letter on 9 July, it is only right that I finish it today, the 14th, but alas! in my arid spirit I cannot find even the tiniest idea, and yet with you there are so many subjects to be covered—hunting, fishing, swimming, there are some varied subjects for you, and love (Unutterable, let us not go into that corrupting subject):

Notre âme encore candide,
Marchant d'un pas timide,
N'a pas encore heurté
Au bord du précipice
Où si souvent l'on glisse,

En cette époque corruptrice.
Je n'ai pas encore porté
A mes lèvres innocentes,
Le bol de la volupté
Où les âmes aimantes
Boivent à satiété.

---

Our still candid soul, walking with timid step, has not as yet encountered the edge of the abyss into which one so often slips in these corrupt times. I've not yet raised to my innocent lips the cup of pleasure from which amorous souls drink their fill.

---

Here's a mystical tirade, ahem, you know, it seems I can see you reading these soporific verses, I can see you (although it's a bit far) shaking your head and saying: "Poetry doesn't seem to thunder around him . . ."[12]

*Letter finished evening of the 15th*

## CHANSON EN TON HONNEUR!

(Je chante ici comme si nous étions ensemble adonnés
à toutes les joies de la vie humaine,
c'est pour ainsi dire une élégie,
c'est vaporeux, tu vas voir.)

Le soir, assis au flanc de la montagne,
Mes yeux au loin erraient sur la campagne:
Je me disais, quand donc une compagne,
De tant de mal qui m'accable aujourd'hui
Viendra, grands Dieux, soulager ma misère?
Oui, avec elle, elle me paraîtrait légère,
Si gentillette ainsi qu'une bergère,
Aux doux appas, au menton rond et frais
Aux bras rebondis, aux mollets très bien faits,
    A la pimpante crinoline,
    A la forme divine,
    A la bouche purpurine,
digue, dinguedi, dindigue, dindon,
    O, ô le joli menton.

---

### SONG IN YOUR HONOR!

(I sing herein as though both of us were reveling in all the joys of life, it's an elegy, so to speak, it's fairly flimsy stuff, as you'll see)

In the evening, seated on the mountainside, my eyes wandering over the distant landscape, I said to myself: When will some companion come to comfort me, O Lord, in all the misery I feel today, in my sorrow? Yes, with her, my misery would seem as nothing, and she would be sweet as a shepherdess, with soft charms and a round, fresh chin, with plump rounded arms and well-formed calfs, wearing a dainty crinoline, of divine shape, and with a scarlet mouth, dig-a-dig-a-doo, O, o, her lovely chin.

---

So I'll end, since I sense I'm not really in the mood, alas!

> Hélas! Muses, pleurez, car votre nourrisson
> Ne peut pas même faire une courte chanson.

> O du bachot, examen très terrible!
> Des examinateurs, ô faces trop horribles!
> Si je passais, ô plaisir indicible.

---

Alas, Muses, weep, for your nursling cannot even manage one short song. Oh, the *bachot*, arch-awful exam, and examiners, with arch-horrid faces! Were I to pass it—oh pleasure indescribable!

---

Good God, I don't know what I'd do. Farewell, my dear Zola, I babble on, as always.

Paul Cézanne

I've had an idea for a five-act tragedy that we (you and I) will entitle *Henry the Eighth of England*. We'll do it together during vacation.

TO EMILE ZOLA

[Aix] 26 July 1858

*Mein lieber Freund,*

Cézanne is writing, Baille is dictating. Muses, descend from Helios into our veins to celebrate my baccalaureal triumph! (Baille is speaking and my turn will not come until next week.)

[In Baille's handwriting]

*Such outlandish originality reflects our moods. We were going to send you a batch of puzzles to figure out: but fate decided otherwise. I arrived to visit our mutual poetic, fantastic, bacchic, erotic, antique, physical, geometrical friend; he had already written 26 July 1858 and was waiting to be inspired. I obliged: I put the salutation in German: he was to write at my dictation and sow profusely, along with his rhetorical figures, the flowers of my own geometry (permit me that transposition—You might have thought that we were going to send you triangles and such-like). But, my dear fellow, the love that led to Troy's downfall is still causing havoc: I have serious suspicions that he is in love. (He doesn't want to admit it.)*

[In Cézanne's hand]

My dear friend, Baille is the one whose daring hand (oh vain thought) has just written those perfidious lines, he never thinks up any other kind. You know him well enough, you know the follies he committed before he passed the horrible examination, and now see what he has become! What ridiculous and formless notions spring from his evil, mocking brain! You know, Baille is a bachelor of science, and on the 14th he will sit for the exam for bachelor of letters—I'm taking it the 4th of August; may the all-powerful Gods keep me from breaking my nose in my alas forthcoming fall. Great Gods, I grind away at my books, I rack my brains over this abominable work.

> Je frémis, quand je vois toute la géographie,
> L'histoire, et le latin, le grec, la géométrie
> Conspirer contre moi: je les vois menaçants
> Ces examinateurs dont les regards perçants
> Jusqu'au fond de mon cœur portent un profond trouble.
> Ma crainte, à chaque instant, terriblement redouble!
> Et je me dis: Seigneur, de tous ces ennemis,
> Pour ma perte certaine impudemment unis,
> Dispersez, confondez la troupe épouvantable.—
> La prière, il est vrai, n'est pas trop charitable.—
> Exaucez-moi pourtant, de grâce, mon Seigneur,
> Je suis de vos autels un pieux serviteur . . .
>
> D'un encens quotidien j'honore vos images.
> Ah! terrassez, Seigneur, ces méchants personnages.

Les voyez-vous déjà prompts à se rassembler,
Ils se frottent les mains, prêts à nous tous couler?
Les voyez-vous, Seigneur, dans leur cruelle joie
Compter déjà des yeux quelle sera leur proie?
Voyez, voyez, Seigneur, comment sur leurs bureaux
Ils groupent avec soin les fatals numéros!
Non, non, ne souffrez pas que victime innocente
Je tombe sous les coups de leur rage croissante.
Envoyez votre Esprit-Saint sanctificateur!
Qu'il répande bientôt sur votre serviteur
De son profond savoir l'éclatante lumière.
Et si vous m'exaucez, à mon heure dernière
Vous m'entendrez encore beugler des oremus
Dont vous, Saintes et Saints, serez tous morfondus.
De grâce, veuillez bien, veuillez, Seigneur, m'entendre

Daignez, aussi, Seigneur, ne pas vous faire attendre
(Dans l'envoi de vos grâces, sous-entendu)
Puissent mes vœux monter jusqu'au céleste Eden:
    *In saecula, saeculorum, amen!*

---

I tremble when I look upon all the geography, history, Latin, Greek, geometry that conspire against me. I see them threatening me, those examiners, whose piercing glances send deep trouble into the depths of my soul. At every instant, my fear redoubles! And I tell myself: Lord, disperse and confound this fearsome troop of innumerable foes who conspire against me to ensure my certain failure. True, this is not a charitable prayer. Yet spare me, Lord, by thy Grace. For I am a pious attendant at your altars.

Daily I honor your images with incense. Ah, Oh Lord, lay low those wicked ones. See them already preparing to assemble, rubbing their hands and ready to sink us all! See them, Lord, in their cruel glee, as they dart glances at those who will be their prey! See, see, Lord, how carefully they arrange the fatal questions on their desks! No, no, do not suffer me, an innocent victim, to fall beneath the blows of their growing wrath. Send your sanctifying Holy Spirit! Let it shed anon o'er your servant here the dazzling light of its profound knowledge. And if you grant me salvation at my final hour, yet shall you hear me murmuring prayers that will send shivers through the Saints. Hear me, oh Lord, hear my prayer. And deign too, Lord, not to tarry overlong (in

the bestowing of thy aforementioned favors) and may my prayers mount to thy celestial Eden. World without end, Amen. *In saecula saeculorum, Amen!*

———————

Isn't that a preposterous digression! What do you have to say about it? Isn't it formless? Ah, had I but time, you'd swallow plenty more. And by the way, a bit later I'll be sending you your set rhymes. Address some kind of prayer to the All-Highest-Highest so that the Faculty will grant me the degree I so hope for.

*My turn to continue.*[13] *I'm not going to force verses on you: I've almost nothing to say other than that we are all waiting for you: Cézanne and me, me and Cézanne. We're slaving away in the meantime. So come: only I won't be going hunting with you: let's understand that: I won't hunt, but I'll go with you—So anyhow! We can still have some good times: I'll bring the bottle: even though it is the heaviest! You've already been bored enough by this letter: it's certainly boring enough: I don't mean that we wrote it with that intention.*

*Give our respects to your mother (I say "our" for good reason: The Trinity is only one single person).*

*We send a hearty handshake: this letter is from two characters.*

*Bacézannile.*

In this letter you see the work of two characters.

My friend, when you come, I will let my beard and mustache grow: I await you *ad hoc.* Tell me, have you a beard and mustache? Farewell, my friend, I don't know how I can be so silly . . .

[Zola spent his summer vacation with his friends at Aix. After his return to Paris, Cézanne finally, on 12 November, passed his *bacca- lauréat* examination in literature with "passing" marks. A letter dated 14 November informing Zola of this event appears to have been lost.]

TO EMILE ZOLA

[Aix] Wednesday, 23 November 1858

Work, my dear fellow, *nom labor improbus omnia vincit.*[14]

Pardon, my friend, pardon me! Yes, I'm guilty. But there is forgive- ness for all sins. Our letters have crossed, you'll tell me when you write

again—but you don't need that to get you going—if you haven't received a letter dated from my room: rhyming with 14 November?*

I'm waiting until the end of the month for you to send me another letter furnishing me with the title for a *very* long poem I have in mind and that I mention in my letter of 14 November, as you shall see if you receive it, if not, I'm at a loss to understand its nonarrival, however, since nothing is impossible, I have hastened to write to you. I passed the *bachot*, but you should know that from that same letter of the 14th, providing it got to you.

> Sacré nom, sacré nom de 600 000 bombes!
> Je ne peux pas rimer.—Je tombe et tu succombes
> Aux 600 000 éclats des 600 000 bombes.
>
> C'est trop d'esprit en un seul coup, oui.
>
> Je le sens (*bis*) je dois jeune en mourir,
> Car comment tant d'esprit en moi pourrait tenir?
> Je ne suis pas assez vaste, et ne puis suffire
> A contenir l'esprit, aussi, jeune j'expire.

---

Curses on the 600,000 binges! I can't create a rhyme. I fall and you succumb to 600,000 explosions of 600,000 bomb-outs.

Yes, that's too much wit at one blow.

I feel it (*bis*) I shall die young because of it, for how can such wit be kept inside me? I'm not big enough, I can't cope with containing so much wisdom, and thus, young, I shall expire.

I've written to Baille[15] to tell him, and to announce to him that I am, irrevocably and definitively, a bachelor. Aha! Ahem!

> Oui, mon cher, oui mon cher, une très vaste joie,
> A ce titre nouveau, dans mon cœur se déploie,
>
> Du latin et du grec je ne suis plus la proie!
> O très fortuné jour, ô jour très fortuné,
> Où ce titre pompeux put m'être décerné;
> Oui, je suis bachelier, c'est une grande chose,

---

* *i.e., chambre: novembre*

Qui, dans l'individu fait bachelier, suppose
Du grec et du latin une fameuse dose!

---

Yes, my dear friend, yes, a very immense joy pervades my heart at this
new title, I'm no longer prey to Latin and Greek! Oh happy day, oh so
happy day, on which this distinguished title was conferred upon me;
yes, I'm a bachelor, it's a great thing, one that presumes that a person
who has been made a bachelor possesses a great store of Greek and
Latin.

---

The content of Latin verses set for rhetoric and translated into French
by ourself, a poet.

## SONGE D'ANNIBAL
### ANNIBALIS SOMNIUM

Au sortir d'un festin, le héros de Carthage,
Dans lequel on avait fait trop fréquent usage
Du rhum et du cognac, trébuchait, chancelait.
Oui, déjà le fameux vainqueur de Cannes allait
S'endormir sous la table: ô étonnant miracle!
Des débris du repas effrayante débâcle!
Car d'un grand coup de poing qu'appliqua le héros
Sur la nappe, le vin s'épandit à grands flots.
Les assiettes, les plats et les saladiers vides
Roulèrent tristement dans des ruisseaux limpides
De punch encore tout chaud, regrettable dégât!
Se pouvait-il, messieurs, qu'Annibal gaspillât,
Infandum, Infandum, le rhum de sa patrie!
Du vieux troupier français, ô liqueur si chérie!
Se pouvait-il, Zola, commettre telle horreur,
Sans que Jupin vengeât cette affreuse noirceur?
Se put-il qu'Annibal perdit si bien la tête
Pour qu'il pût t'oublier d'une façon complète,
O rhum?—Éloignons-nous d'un si triste tableau!
O punch tu méritais un tout autre tombeau!
Que ne t'a-t-il donné, ce vainqueur si farouche,
Un passe-port réglé pour entrer dans sa bouche,
Et descendre tout droit au fond de l'estomac?
Il te laissa gisant sur le sol, ô Cognac!

—Mais par quatre laquais, irrévocable honte,
Est bientôt enlevé le vainqueur de Sagonthe
Et posé sur un lit; Morphée et ses pavots
Sur ses yeux alourdis font tomber le repos,

Il bâille, étend les bras, s'endort du côté gauche;
Notre héros pionçait après cette débauche,
Quand des songes légers le formidable essaim
S'abattit tout à coup auprès du traversin.
Annibal dormait donc.—Le plus vieux de la troupe
S'habille en Amilcar, il en avait la coupe.—
Les cheveux hérissés, le nez proéminent,
Une moustache épaisse extraordinairement;
Ajoutez à sa joue une balafre énorme
Donnant à son visage une binette informe,
Et vous aurez, messieurs, le portrait d'Amilcar.
Quatre grands chevaux blancs attelés à son char
Le traînaient: il arrive et saisit Annibal par l'oreille
Et bien fort le secoue: Annibal se réveille,
Et déjà le courroux . . . Mais il se radoucit
En voyant Amilcar qu'affreusement blêmit
La colère contrainte: "Indigne fils, indigne!
Vois-tu dans quel état le jus pur de la vigne
T'a jeté, toi, mon fils—Rougis, corbleu, rougis,
Jusqu'au blanc de l'œil. Tu traînes sans souci,
Au lieu de guerroyer, une honteuse vie.
Au lieu de protéger les murs de ta patrie,
Au lieu de repousser l'implacable romain,
Au lieu de préparer, toi vainqueur au Tésin,
A Trasimène, à Cannes, un combat où la Ville
Qui fut des Amilcars toujours le plus hostile
Et le plus acharné de tous les ennemis,
Vit tous ces citoyens par Carthage soumis,
O fils dégénéré, tu fais ici la noce!
Hélas! ton pourpoint neuf est tout taché de sauce,
Du bon vin de Madère et du rhum! C'est affreux!
Va, suis plutôt, mon fils, l'exemple des aïeux.
Loin de toi, ce cognac et ces femmes lascives
Qui tiennent sous le joug nos âmes trop captives!

Abjure les liqueurs. C'est très pernicieux
Et ne bois que de l'eau, tu t'en trouveras mieux."
A ces mots Annibal appuyant sur son lit
Sa tête, de nouveau profondément dormit.

As-tu trouvé jamais style plus admirable?
Si tu n'es pas content, tu n'es pas raisonnable.
<div align="right">P. Cézanne.</div>

_____

## HANNIBAL'S DREAM
### *Annibalis Somnium*

The Carthaginian hero, upon leaving a feast at which too-frequent recourse had been had to rum and cognac, stumbled and staggered. Yes, the famous conqueror of Cannes was about—oh miracle!—to pass out beneath a table. The remains of the feast presented a fearsome spectacle! For upon the hero's having smitten the table with a great blow of his fist, the wine had spilled in floods. Plates, platters and empty salad bowls rolled sadly about in the limpid streams of still-steaming punch, a regrettable waste! Was it possible that Hannibal should thus squander, *Infandum, Infandum,* the rum of his homeland! Oh, liquor dear to any old French trooper! Say, Zola, could he commit such an outrage without Jupiter taking revenge for such an affront? Could Hannibal have so lost his head that he forgot you completely, oh Rum? But let us withdraw from such a sorry spectacle! Oh punch, you were deserving of quite another resting place! Why could that rabid conqueror not have allowed thee a valid passport to enter his mouth and descend directly to the depths of his belly? Oh, Cognac, he left you there, supine on the floor.

—However, oh shame irrevocable, the conqueror of Saguntum is soon raised up by four lackeys and laid upon a couch. Morpheus with his poppies sheds sleep upon his heavy eyes; he yawns and stretches his arms and falls asleep on his left side; Our hero was thus snoozing after this debauch when mighty swarms of fitful dreams suddenly alit upon his pillow. But Hannibal slept on. The eldest of the troop, disguised as Hamilcar, looked the part to perfection: his hair stood on end, his nose jutted out, he had an extraordinarily thick mustache added to a huge scar on his cheek that gave his face a shapeless look, in short, gentlemen, you have the very picture of Hamilcar. Four large white steeds hitched to his chariot drew it along. Upon arriving he seizes Hannibal by the ear and gives him a good shake: Hannibal awakens in a rage . . .

But he calms down when he sees Hamilcar, who has turned pale with stifled wrath: "Unworthy son, unworthy one! See the state to which the pure juice of the vine has reduced you, my son. Blush, by Jove, blush to the whites of your eyes. Instead of doing battle, you loll aimlessly about, leading a shameful life. Instead of guarding the ramparts of your homeland, instead of repelling the implacable Roman, instead of preparing—you, the conqueror of Ticinum, of Traseminus, of Cannes, a battle in which that city that was always most hostile to the Hamilcars and the most implacable of their enemies would see its citizens bend the knee to Carthage . . . instead of which, oh degenerate son, you roister here! Alas, your new doublet is spotted with sauce, with fine madeira wine and with rum! It's awful! Come, my son, follow the example of your ancestors. Abandon this cognac and those lascivious women who keep our all-too susceptible souls beneath their yoke! Abjure spirits. They are most pernicious. Drink nothing but water, you'll feel better for it."

At these words, Hannibal, resting his head upon his couch, fell back again into a deep sleep.

Have you ever encountered a more admirable style? If you aren't pleased with it, you're being unreasonable.

<div align="right">P. Cézanne</div>

———————————

[After having passed his baccalauréat examination, Cézanne was obliged by his father to take up the study of law at the Faculté d'Aix, where he enrolled the same year.]

TO EMILE ZOLA

<div align="right">Aix, 7 December 1858</div>

My friend,

You didn't tell me your illness was serious, so very serious.—You should have let me know; instead Monsieur Leclerc told me about it; but since you're well now, greetings.

After having hesitated for some time—for I must admit to you that this *pitot* didn't suit me at first—I have finally decided to accept it with as little woe as possible. So I've begun work; but, by Jove, I do not

know my mythology; however, I will settle down to learn the exploits of Master Hercules and convert them into great deeds of *pitot*, as best I can. I am announcing to you that my work—if it deserves to be called work instead of mess—will be long elaborated, digested and improved by me, for I have little time to devote to the adventurous tale of the Herculean *Pitot*.

> Hélas, j'ai pris du Droit la route tortueuse.
> —J'ai pris, n'est pas le mot, de prendre on m'a forcé!
> Le Droit, l'horrible Droit d'ambages enlacé
> Rendra pendant trois ans mon existence affreuse!
>
> Muses de l'Hélicon, du Pinde, du Parnasse
> Venez, je vous en prie, adoucir ma disgrâce.
> Avec pitié de moi, d'un malheureux mortel
> Arraché malgré lui d'auprès de votre autel.
> Du Mathématicien[16] les arides problèmes,
> Son front pâli, ridé, ses lèvres aussi blêmes
> Que le blême linceul d'un revenant terreux,
> Je le sais, ô neuf sœurs, vous paraissent affreux!
> Mais celui qui du Droit embrasse la carrière
> De vous et d'Apollon perd la confiance entière.
>
> Sur moi ne jetez pas un œil trop dédaigneux
> Car je fus moins coupable, hélas, que malheureux.
> Accourez, à ma voix, secourez ma disgrâce
> Et dans l'éternité, je vous en rendrai grâces.

---

Alas, I've entered upon the tortuous path of the Law.—Entered isn't the word, I've been forced onto it! The Law, the horrid law, with its twisted circumlocutions, will make my life frightful for three years!

Muses of Helicon, Pindar and Parnassus, come, I beg you, to assuage my disgrace. Have pity on me, an unhappy mortal, torn from your altar despite himself—I know that the arid problems of the Mathematician,[16] with his pale, creased forehead and pallid lips, white as the shroud of some grimy ghost, appear frightful to you, Oh Nine Sisters! But he who embraces the career of the Law totally loses your confidence and that of Apollo as well. Do not look down upon me with too disdainful gaze, for I was, alas, less guilty than unfortunate. Heed my

plea, pardon my disgrace, and I shall pay homage to you throughout eternity.

_____

Upon hearing—no, reading—such insipid lines, you might say that the Muse of Poetry has removed herself from my presence. Alas, that's what this miserable Law does.

> O Droit, qui t'enfanta, quelle cervelle informe
> Créa, pour mon malheur, le Digeste difforme?
> Et ce code incongru, que n'est-il demeuré
> Durant un siècle encore dans la France ignoré?
> Quelle étrange fureur, quelle bêtise et quelle
> Folie avait troublé ta tremblante cervelle,
> O piètre Justinien des Pandectes fauteur,
> Et du *Corpus juris* impudent rédacteur?
> N'était-ce pas assez qu'Horace et que Virgile,
> Que Tacite et Lucain, d'un texte difficile
> Vinssent, durant huit ans, nous présenter l'horreur,
> Sans t'ajouter à eux, causes de mon malheur!
> S'il existe un enfer, et qu'une place y reste
> Dieu du ciel, plongez-y le Gérant du Digeste!

_____

Oh Law, who bore thee? What twisted brain created for my discomfort the misshapen *Digest*? And that incongruous Code, why has it not remained unknown for yet another century in France? What strange fury, stupidity and folly disturbed thy quaking brain, O wretched Justinian, abettor of the Pandects, impudent editor of the *Corpus Juris*? Wasn't it enough that Horace and Virgil, Tacitus and Lucan, forced us foe eight years to look upon their tortuous texts, without your adding yourself to my unhappiness! If there be a hell, and if there is still room in it, cast, Oh God in Heaven, into it the Director of the Digest.

_____

Find out about the Académie competition, because I still intend to cleave to our decision to enter at whatever cost, providing, of course, that it costs nothing.[17]

> Tu sais que de Boileau l'omoplate cassée,
> Fut trouvée l'an dernier dans un profond fossé,
> Et que creusant plus bas des maçons y trouvèrent

Tous ses os racornis, qu'à Paris ils portèrent.
Là, dans un muséum, ce roi des animaux
Fut classé dans le rang des vieux rhinocéros.
Puis on grava ces mots, au pied de sa carcasse:
"Ci-repose Boileau, le recteur du Parnasse."

Ce récit que voilà, tout plein de vérité
Te fait voir le sort qu'il avait mérité,
Pour avoir trop loué dans sa verve indiscrète
Le quatorzième Louis, de nos rois le plus bête.
Puis cent francs l'on donna pour les récompenser,
Aux ardents travailleurs, qui, pour cette trouvaille,
Portent, avec ces mots, une belle médaille:
"Ils ont trouvé Boileau dans un profond fossé."

Hercule, un certain jour, dormait profondément
Dans un bois, car le frais était bon, car vraiment
S'il ne s'était tenu sous un charmant bocage
Et s'il avait été exposé à la rage
Du soleil, qui dardait des rayons chaleureux,
Peut-être aurait-il pris un mal de tête affreux;
Donc il dormait très fort. Une jeune dryade
Passant tout près de lui . . .

---

You know that last year Boileau's broken collarbone was found lying
in a deep ditch, and that upon digging deeper the masons found the rest
of his shriveled bones, which they bore off to Paris. There, in a mu-
seum, this Lord of the Beasts was displayed in the row of old rhinoceri,
and the following words were thereupon engraved at the foot of his
carcass: "Here lies Boileau, Rector of Parnassus."

This totally true tale shows you his well-deserved fate for having in
his indiscreet ardor overpraised the Fourteenth Louis, the stupidest of
all our Kings. The devoted workmen were then given 100 francs in
recompense, and for their discovery they now sport a fine medal en-
graved with the words: "They found Boileau lying in a deep ditch."

Hercules lay asleep one day in an airy grove, for in truth had he not
taken refuge in a charming copse instead of allowing himself to be
exposed to the wrath of the sun, which was emitting burning rays, he

might have got a frightful headache. So he was deep in sleep. A young dryad passing by . . .

———————

But I see that I was on the point of uttering some stupidity, so I'll shut up. Permit me to end this letter as stupidly as I began it.

I wish you a thousand and one good things, pleasures, delights. Farewell, my dear friend, greetings to Monsieur Aubert,[18] to your parents. Farewell, I salute you.

  Your friend,

<div align="right">P. Cézanne</div>

P.S. I just received your letter, which gave me much pleasure; however, in future I must beg you to use a bit thinner paper, since you have drained more blood from my pocketbook than is good for it. Good God, the monsters who run the post office made me pay 8 sous! I would have had enough to send you two additional letters. So use thinner paper. Farewell, my friend.

[Poem by Cézanne on the back of an undated youthful drawing now in the Museum at Basle.]

### POÈME

Ma gracieuse Marie
Je vous aime et je vous prie
De garder les mots d'écrit
Que vous envoient vos amis.

Sur vos belles lèvres roses
Ce bonbon glissera bien,
Il passe sur bien des choses
Sans en gâter le carmin.

Ce joli bonbon rose
Si gentiment tourné
Dans une bouche rose
Serait heureux d'entrer.

———————

POEM

My gracious Marie, I love you and I beg you to keep the notes that your friends send you.

This bonbon will glide smoothly through your lovely pink lips, it passes through many things without spoiling their carmine color.

This pretty pink bonbon so sweetly popped into a pink mouth will be happy to enter therein.

------------

# [NOTES 1858]

1. This phrase would appear to indicate that the April 9th letter is not the first written by Cézanne to Zola. However, no earlier letters are extant.

2. The Arc is a stream that runs through a wide valley near Aix, where the three friends liked to swim. Cézanne often painted the view of this valley, which is crossed by a railway viaduct and dominated by Mont Sainte-Victoire.

3. Baptiste Baille (1841–1918), a boyhood friend of Cézanne and Zola, became a professor at the Ecole Polytechnique and assistant to the Mayor of the XIth *arrondissement* in Paris. He had two younger brothers, one of whom, Isidore, sometimes accompanied the three friends on their outings.

4. Gustave Boyer, a boyhood friend of Cézanne and Zola. See Boyer's postscript to the following letter. Cézanne painted several portraits of him. He later became a notary in Eyguières.

5. Marguery, Louis-Pascal-Antoine (1841–1881), boyhood friend of Cézanne and Zola, wanted to be a writer. He published several sketches and later became a lawyer attached to the court in Aix.

6. For she was wearing gloves (Cézanne's note).

7. Added in Gustave Boyer's handwriting.

8. Cézanne's forebodings were not totally unjustified. In fact, he failed his first examination and did not pass it until a few months later. Baille, on the other hand, passed and enrolled at the Faculté des Sciences Naturelles in Marseilles.

9. Palette, a village on the Arc near the road to Nice, between Aix and the village of Le Tholonet.

10. The poem is accompanied by a watercolor drawing.

11. Leydet, Victor (1845–1908), boyhood friend of Cézanne and Zola, future senator from the *département* of the Bouches-du-Rhône. His son, a painter, saw Cézanne frequently towards the end of the painter's life.

12. See Zola's letter to Cézanne with regard to the latter's poems, written from Paris on 1 August 1860.

13. Added in Baille's handwriting.

14. Hard work leads to victory.

15. Baille was attending the university in Marseilles.

16. Reference to Baille.

17. Cézanne probably planned to enter a competition to attend the Académie des Beaux-Arts in Paris.

18. Monsieur Aubert was Zola's grandfather; his grandmother died in Aix in November 1857, before his family moved to Paris.

# [1859]

ZOLA TO BAILLE

*Paris, 14 January 1859*

*Cézanne, who is not as lazy as you—I should say as diligent—has written me a good long letter.*[1] *I've never seen him wax so poetical, nor be so much in love; to the extent that, far from dissuading him from this platonic love affair, I advised him to persevere. He told me that at Christmas time you had tried to persuade him to be more realistic in love. Once, I thought as you do, but now I believe that it's a course unworthy of our youth, unworthy of the friendship we have for him. I wrote him a lengthy reply,*[2] *advising him to be always in love and advancing arguments founded on reasons I cannot go into here. If by chance you have been advocating realism, if the advice you have given Cézanne was not dictated by your friendship for him, if you too despaired of love, I must ask you to read my reply to Cézanne when you can, and I hope that that perusal will rejuvenate your heart, drowned as it is in algebra and mechanics. I am even going to transcribe for you a few lines I plan to send Cézanne soon.*[3] *I am speaking to him, but it applies to you too; here they are:*

*"In one of your last letters, I find this sentence: 'Michelet's love—pure, noble—may exist, but you must admit that it's very rare.'*[4] *Not as rare as you might think, and this is a point I forgot to mention in my last letter. There was a time when I too said the same thing, a time when I scoffed as soon as purity and fidelity were mentioned, and those days are not so long ago. But upon reflection, I believe I have discovered that our century is not as materialistic as it tries to appear. We act like schoolboys playing hookey and arguing amongst themselves about who has been the naughtiest; we tell each other about our good luck as egotistically as we can, and we paint ourselves as black as we can. We pretend to mock holy things; but if we play around with the altar vases, if we strive to show everyone how worthless we are, I think it's more out of self-love than because of any innate wickedness. Young people in particular exhibit this kind of self-love, and since love is, if I may venture to say so, one of the most beautiful qualities of youth, they are fervent in maintaining that they do not love, that they wallow in vice. You have gone through that, and you ought to know. Anyone who would*

admit to having a platonic love affair in school—something holy and poetic, that is—would be treated as crazy, wouldn't he? [. . .] Just as, with regard to religion, a young man never admits that he prays, a young man in love never admits he loves. However nature never abdicates its rights; in the days of chivalry it was the fashion to avow one's love, and so one did; now the fashion has changed, but man remains man and he can't do without loving.

"I'm willing to bet that love can be found deep down in the hearts of those who try to pass as the greatest scoundrels: it is inevitable and everyone experiences it. Now, it's true that there are lovers who are poets to varying degrees, with varying degrees of inspiration. Everyone loves after his own fashion, and it would be absurd for you, who love flowers and moonbeams, to say that one cannot love without writing verses and without strolling in the moonlight. A rustic swain can love his shepherdess: love is an exalted thing, even a sublime one, but it enters every soul, even the least cultivated [. . .] To get back to the point, it is pride, therefore, and stupid pride at that, that is at issue, in my opinion; it's society, men as a group, and not man as an individual. Man cannot forgo loving, if only a flower or an animal; so why shouldn't he love women? I don't know that the cause I am pleading here is a thorny one; we are children of our time and care has been taken to imbue us with the fixed notions on this subject. We have been told so many amiable jokes about women and love that we no longer believe in all that. But if you think carefully, if you really examine your heart, you will be forced to agree—for you are not made any differently from other men—that it is false to state that love is dead and that our era is totally materialistic. A great and worthy task, a task that Michelet undertook, a task that I sometimes dare envisage, is to reconcile man to woman. Perhaps finally then his eyes will be opened; life is so short, and that would be a way to make it more beautiful; the world is advancing, and that would be a way of getting there more quickly. Don't think I'm waxing poetic or exaggerating. Michelet makes a goddess of woman and man her humble worshipper. Great evils call for great remedies, if we carried out the half of what he asks, the world would go on perfectly, in my opinion."

TO EMILE ZOLA

[The drawing at the top of this letter is entitled "Death reigns in this place!" and the ensuing dialogue refers to it.]

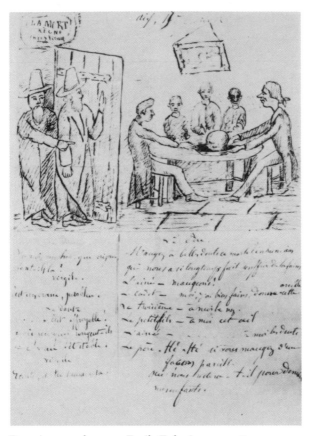

Drawing on a letter to Emile Zola, January, 1859,
inscribed "La Morte regne en ces lieux."

<div align="right">Aix, 17 January 1859</div>

Dante: Tell me, my friend, what are they gnawing on?
Virgil: Good heavens, it's a skull.
Dante: My God, that's horrible!
    But why are they chewing on that detestable brain?
Virgil: Listen, and you will know.
The Father: Take a good bite of this inhuman mortal
    Who made us suffer hunger for so long.
The Elder: Let's eat!
The Younger: I'm really hungry, pass me that ear!
The Third: I get the nose!
The Grandson: And I that eye!
The Elder: I get the teeth!
The Father: Ha-ha, if you eat like that
    What will be left for tomorrow, my children?

J'ai résolu, mon cher, d'épouvanter ton cœur
D'y jeter une énorme, une atroce frayeur
Par l'aspect monstrueux de cet horrible drame
Bien fait pour émouvoir la plus dure des âmes.

J'ai pensé que ton cœur sensible à ces maux-là
S'écrierait: quel tableau merveilleux que voilà!
J'ai pensé, qu'un grand cri d'horreur, de ta poitrine
Sortirait, en voyant ce que seul imagine
L'enfer, où le pécheur, mort dans l'impunité,
Souffre terriblement durant l'éternité.

Mais j'observe, mon cher, que depuis quinze jours
Notre correspondance a relâché son cours;
Serait-ce par hasard l'ennui qui te consume,
Ou bien ton cerveau pris par quelque fâcheux rhume
Te retient, malgré toi, dans ton lit, et la toux
Te chagrinerit-elle? Hélas, ce n'est pas doux
Mais pourtant mieux vaut ça que d'autres maux encore.
Peut-être est-ce l'amour qui lentement dévore
Ton cœur? Oui? Non? Ma foi, je n'en sais rien
Mais si c'était l'amour, je dirais, ça va bien.
Car l'amour, je crois fort qu'il n'a tué personne;
Peut-être que parfois tout de même il nous donne
Quelque peu de tourment, quelque peu de chagrin,
Mais vient-il aujourd'hui, il disparaît demain.
Si, par malheur, malheur serait, il faut le dire,
Si quelque maladie horrible te déchire;
Pourtant je ne crois pas que les Dieux malveillants
T'aient donné, sacrebleu, quelque affreux mal de dents,

Ou bien quelque autre chose horriblement bien bête
A souffrir, par exemple, un vaste mal de tête
Qui du chef jusqu'aux pieds promenant son tourment
Te fasse envers le ciel jurer atrocement.
Cela serait stupide; être malade est chose,
Quelque mal que ce soit, extrêmement morose;
Car l'on perd l'appétit, et l'on ne mange pas;
En vain devant nos yeux passeraient mille plats
Très doux, très attrayants; notre estomac repousse

Le plus doux, le meilleur des fricots, la plus douce
Des sauces:
        le bon vin—car je l'aime—il est vrai
Que chez Baille il nous a sur le coco frappé,
Mais je l'excuse: adonc le vin est bonne chose
Des maux les plus divers il peut guérir la cause
Bois-en donc, cher ami, bois-en, car il est bon
Et de ton mal bientôt viendra la guérison
Car le vin est bien bon: *bis, ter.*

Aurais-tu, par hasard, mangé trop de bonbons
Le jour de l'an? Pourquoi non? car trop forte dose
T'aurait pu condamner à rester bouche close,
En te donnant, hélas, une indigestion,
Mais c'est assez, ma foi, se livrer sans vergogne
A la bêtise: car le temps, sans cesse rogne
Notre vie, et nos jours déclinent. Le tombeau,
Ce vorace et terrible abîme insatiable
Est là toujours béant—Dépucelé, puceau
Quand viendra notre jour, vertueux ou coupable
Nous paierons le tribut au sort inévitable.

---

My friend, my fixed intention was to make your heart quake, to fill it
with an immense and atrocious horror at the monstrous vision of this
horrible tragedy, so well designed to move the hardest of hearts.

I thought that your heart, touched at witnessing such evils, might
cry out: What a marvelous picture that is! I thought that a great cry of
horror would leap from your breast upon seeing what can only be
conceived by Hell, where the sinner, expired unrepentant, suffers ter-
ribly through all eternity.

However, my friend, I observe that our correspondence has fallen
off for two weeks now; is it by chance boredom that gnaws at you, or
has your brain been suffering from some pesky cold that has confined
you unwilling to your bed, are you being plagued with a cough? Alas,
that's not pleasant, but it's better than some other evils. Perhaps love is
nibbling slowly at your heart? Yes? No? Well, I've no idea, but if it
were love, I would say that was all right, for love, I firmly believe,
never killed anyone; sometimes of course, it may cause us a bit of
torment, a bit of sorrow, but here today, gone tomorrow. If by some
mischance, and mischance it would be, some awful disease is destroy-

ing you, tell me. Yet I don't believe the malevolent Gods would have inflicted you with an awful toothache, or something equally and horribly boring such as a huge headache that hurts from head to toe and makes you swear awful oaths to the heavens. That would be stupid too; being sick is a very depressing thing, no matter what the illness, for one loses one's appetite and doesn't eat; in vain, a thousand luscious and delectable dishes can be set before out eyes, but our stomach will reject even the softest and finest viands, the most refined sauces: and good wine too, of which I'm fond—true, at Baille's, it knocked us on the noggin, but I forgive the wine since it is a good thing that can heal the causes of a great variety of illnesses. So drink, my dear friend, drink up, it's good, and your illness will soon be cured. Wine is really good, twice, thrice.

Or did you perchance eat too many sweets on New Year's Day? Why not? An undue quantity could have condemned you to silence by giving you—alas—an attack of indigestion. But enough of such shameless indulgence in silliness, for time pares ceaselessly away at our lives and our days decline. The tomb, that voracious, terrible, insatiable abyss, always yawns before us—be we virgins or not, when our time comes, virtuous or sinful, we shall pay tribute to that inexorable fate.

---

Now, it's several days since I wrote the foregoing; I said to myself, I don't know anything good to tell him, so I'll wait a while before sending him my letter, but now I am worried because I receive no news at all from you. Good God in heaven, I've made up so many hypotheses, even utterly ridiculous ones, with regard to this keeping of silence. Perhaps, I thought, it's because he's busy with some *immensissime* work, perhaps he's elucubrating some vast poem, perhaps he's preparing some truly unsolvable riddle for me, perhaps he's even become an editor for some seedy newspaper; but all such suppositions have not enabled me to really know *quod agis, quod vivis, quod cantas, quomodo te ipsum portas*, etc., I could go on boring you and you could, in your vexation, cry out with Cicero:

*Quosque tandem, Cezasine, abuteris patientia nostra?* To which I would reply that if you don't want to be pestered, you must write to me at once, if there's no serious impediment. *Salut omnibus parentibus tuis, salut tibi quoque, salve, salve,*

Paulus Cezasinus.

TO EMILE ZOLA

[Aix] 20 June 1859

Dear Zola,

Yes, my friend, it's true, what I told you in my last letter. I was trying to fool myself, by the Pope's tithe and his cardinals, but I was very much in love with a certain Justine, who is truly *very fine;** but since I am not privileged to be *of a great beautiful,** she always looked the other way. When I would give her the eye, she would lower hers and blush. Now I've begun to realize that whenever we found ourselves in the same street, she made what you might call a half turn and disappeared without looking back. *Quanto a della donna*: I'm not happy, and yet I still run the risk of meeting her three or four times a day. And what's more, my friend: one fine day, a young man stops me, a young man who is a first-year student like myself, a young man who is actually Seymard, whom you know.[5] "My friend," says he to me, taking my hand and then hanging on my arm as we continue to walk towards the Rue d'Italie, "I'm going," he continued, "to show you a sweet little thing I'm in love with and who is in love with me." I must admit to you that a cloud immediately seemed to pass before my eyes, I actually had a presentiment that I was not meant to succeed, and I wasn't mistaken, for as the clock struck noon, Justine emerged from her dressmaker's shop and, by God, no sooner had I glimpsed her than Seymard nudges me, saying, "There she is." At that point I no longer saw anything, I felt dizzy, but Seymard dragged me along with him, and I brushed against the girl's skirt . . .

Since then, I seem to run into her every day, with Seymard in frequent pursuit . . . Ah, what dreams I cherished, what mad dreams, but that's how it is: I told myself that if she didn't hate me we would go off to Paris together, and there I would be an artist and we would be together. I told myself: that way we'll be happy, I dreamed of pictures, of a fifth-floor studio, you with me, how we would have laughed then! I didn't ask to be rich, you know how I am, with a few hundred francs, I thought that we could live happily, but I swear that was a great

---

* In English in the original.

dream, and now I, who am so lazy, am happy only when I'm drinking. I can hardly go on, I'm like an inert body, good for nothing.

I must say, old fellow, your cigars are excellent, I'm smoking one as I write; they taste like caramel or barley sugar. Ah, but wait a minute, there she is, 'tis she, how she glides, how she floats, yes, it's my girl, how she laughs at me, she flies upwards in the clouds of smoke, see, she mounts and descends, she frolics, she revolves, but she mocks me. O Justine, at least tell me that you don't hate me; she laughs. Cruel girl, you enjoy making me suffer. Justine, hear me . . . but she disappears, she floats up and up, and finally she vanishes. The cigar falls from my lips, and at that point I fall asleep: For a while, I thought I was going crazy, but thanks to your cigar my mind is now settling down, ten more days and I won't think of her at all, or at least I'll only see her on the horizon of the past, like a shadow in a dream.

Ah yes, it would give me an ineffable pleasure to shake your hand . . . You know, your mother told me that you would be coming to Aix around the end of July. Believe me, had I been a good jumper, I would have hit the ceiling I gave such a leap. Indeed, for a moment I did think I was going mad, it was dark, evening had fallen, and I thought that I was going to go mad, but you see it was nothing. Only that I had drunk too much, then I saw phantoms before my eyes that floated just at the end of my nose, and danced and laughed and leaped wildly about.

Farewell, my dear friend, farewell.

<div align="right">P. Cézanne</div>

[On the reverse of the last page is a drawing of a swimming party.]

TO EMILE ZOLA

<div align="right">Undated<br>[Aix, early July 1859]</div>

My dear Zola,

Tu me diras peut-être: Ah! mon pauvre Cézanne,
Quel démon féminin a démonté ton crâne?
Toi que j'ai vu jadis marcher d'un pas égal,

Ne faisant rien de bien, ne disant rien de mal?
Dans quel chaos confus de rêves bizarres,
Comme en un Océan aujourd'hui tu t'égares?
Aurais-tu vu danser par hasard la Polka
Par quelque jeune nymphe, artiste à l'Opéra?
N'aurais-tu pas écrit, endormi sous la nappe
Après t'être enivré comme un diacre du pape,
Ou bien, mon cher, rempli d'un amour rococo,
Le vermouth t'aurait-il frappé sur le coco?
—Ni l'amour, ni le vin n'ont touché ma sorbonne
Et je n'ai jamais cru que l'eau seule fût bonne;
Ce seul raisonnement doit te prouver, mon cher,
Que, bien qu'un peu rêveur, je vois pourtant très clair.

N'aurais-tu jamais vu dans des heures rêveuses
Comme dans un brouillard des formes gracieuses,
Indécises beautés dont les ardents appas,
Rêvés durant la nuit, le jour ne se voient pas?
Comme on voit le matin la vaporeuse brume,
Quand le soleil levant de mille feux allume
Les verdoyants coteaux où bruissent les forêts,
Les flots étincelants des plus riches reflets
De l'azur; puis survient une brise légère
Qui chasse en tournoyant la brume passagère,
C'est ainsi qu'à mes yeux se présentent parfois
Des êtres ravissants, aux angéliques voix,
Durant la nuit. Mon cher, on dirait que l'aurore
D'un éclat frais et pur à l'envi les colore,
Ils semblent me sourire et je leur tends la main.
Mais j'ai beau m'approcher, ils s'envolent soudain,
Ils montent dans le ciel, portés par le zéphyre
Jetant un regard tendre et qui semble me dire
Adieu! près d'eux encor je tente d'approcher,
Mais c'est en vain, en vain que je veux les toucher,
Ils ne sont plus—déjà la gaze transparente
Ne peint plus de leurs corps la forme ravissante.

Mon rêve évanoui, vient la réalité
Qui me trouve gisant, le cœur tout attristé,
Et je vois devant moi se dresser un fantôme
Horrible, monstrueux, c'est le DROIT qu'on le nomme.

_____

Perhaps you will say: Ah, my poor Cézanne, what she-devil has un-
done your brain? You who I used to see walk upright, doing no good,
speaking no evil? In what confused chaos of bizarre dreams are you
wandering lost today, as on the vast Ocean? Have you by chance
glimpsed some youthful nymph dancing the polka at the Opera?
Wouldn't you have written about it, passed out beneath the tablecloth
after having got as drunk as one of the Pope's deacons, or, my friend,
filled as you are with a rococo love, has vermouth given you a rap on
the noggin?

   Neither love nor wine has pierced my skull, and I never believed that
water was the only good thing. This logic should prove to you, my
friend, that although a little vague, I can still see very clearly. Haven't
you ever seen—in daydreams—as if through a mist, graceful forms
and impalpable beauties whose ardent charms, dreamed of by night,
are no longer visible by day? Just as in the morning one sees the va-
porous mist when the rising sun lights with its thousand fires the
verdant hillsides with their murmuring forests the sparkling waves of
its deepest azure reflections . . . and then a light breeze comes that wafts
away the passing mist; in the same way, before my eyes, in the night I
sometimes see ravishing creatures with angelic voices. My friend, it is
as though dawn with its fresh pure glow tints them splendidly, and
they seem to smile at me as I stretch my hand out toward them. Yet try
as I will to approach them, they suddenly fly away, rising into the sky,
borne on the breeze, casting back a tender glance that seems to say
Farewell! Again I try to draw near to them, but in vain . . . vainly I try
to touch them, they are no more. The transparent gauze no longer
limns the ravishing outlines of their bodies.

   My dream vanished, reality finds me lying sad at heart, and I see
rising before me a horrible, monstrous phantom called LAW.

---

   I think I did more than daydream, I actually fell asleep, and I must
have bored you stiff with my platitudinousness, but I did dream that I
was holding in my arms my doxy, my sweet jade, my darling, my
saucy wench, that I was fondling her buttocks and other parts as well . . .

> O crasse lycéenne! ignoblissimes croûtes![6]
> O vous qui barbotez dedans les vieilles routes
> Que dédaignent tous ceux dont la moindre chaleur
> Fait naître quelque élan sublime dans leur cœur;

Quelle insane manie à critiquer vous pousse
Celui-là qui se rit de si faible secousse

Myrmidons lycéens! admirateurs forcés
De ces tristes vers plats que Virgile a laissés:
Vrai troupeau de pourceaux qui marchez sous l'égide
D'un pédant tout pourri qui bêtement vous guide,
Vous forçant d'admirer sans trop savoir pourquoi
Des vers que vous trouvez beaux sur sa seule foi;
Quand au milieu de vous surgit comme une lave
Un poète sans frein, qui brise toute entrave,
Comme autour d'aiglon l'on entend criailler
Mille chétifs oiseaux; bons rien qu'à fouailler,
O mesquins détracteurs, prêtres de la chicane
Vous vomissez sur lui votre bave profane.
Je vous entends déjà, vrais concerts de crapauds,
Vous égosiller tous chantant sur un ton faux,
Non, on n'a jamais vu dans le monde grenouilles
Qui comme vous, messieurs, plus sottement bredouillent.
Mais remplissez les airs de vos sottes clameurs,
Les vers de mon ami demeureront vainqueurs!
Ils résisteront rous à votre vilenie,
Car ils sont tous marqués au vrai coin du génie.

---

Oh crass collegian! oh most ignoble crammers![6] Oh you who scrounge along ancient paths disdained by all whose souls at the least warmth are inspired with some sublime impulse . . . what insane yen impels you to criticize him who laughs at your feeble attacks, schoolboy Myrmidons! forced admirers of those sorry and flat verses Virgil has left us: a real herd of swine, you advance under the aegis of a totally rotten pedant who leads you blindly, forcing you to admire without knowing why verses you deem beautiful on his word alone; while in your midst, like lava, an unfettered poet freed from every shackle bursts, as around an eagle can be heard the peeping of a thousand puny birds; good for nought but horseplay, oh wicked detractors, priests of chicanery, you vomit your profane slobber upon him. I can hear you now, like a chorus of frogs, croaking away off key, no—there have never been frogs like you in this world, gentlemen, none that jabbered so stupidly as you. So fill the air with your idiot clamor, my friend's poems will

still win out! They will stand up against all your vileness, for they are all stamped with the true seal of genius.

---

Baille told me that your fellow scholars dared—quite ridiculously, in my opinion—to criticize your play dedicated to the Empress. That made my blood boil, and, albeit somewhat belatedly, I am nonetheless issuing this address whose terms are not too weak to describe such literary penguins, such misconceived abortions, such asthmatic supercilious mockers of your sincere rhymes. If you feel like it, pass my compliment on to them, add that, if they have anything to say, I'm here and prepared to meet them, anytime, and to box the first one that comes within reach of my fist.

*This morning, 9 July, at 8 a.m.*

I saw Monsieur Leclerc who told me that the youngest M. daughter, and once the prettiest, was covered with chancres from top to toe, and on the verge of breathing her last on her hospital cot. Her mother, who also was over-sexed, laments her late faults, finally, the elder of the two girls, she who was once the ugliest and who still is, is sporting a bandage because she has been so horny.*

Your friend, who drinks a vermouth to your health, Paul Cézanne, Farewell to all your relatives and also to Houchard.

TO EMILE ZOLA

Undated

[Aix, late July 1859]

Baille ne t'écrit pas, il craint qu'à son esprit
Tu restes, cher Zola, sur le coup interdit.
De peur conséquemment que tu ne le comprennes
Aujourd'hui pour t'écrire il me livre les rênes,
Donc je suis dans sa chambre et c'est sur son bureau
Que je t'écris ces vers, enfants de mon cerveau.
Je ne crois pas, mon cher, qu'aucun les revendique
Car ils sont vraiment plats d'une façon unique.

---

* Pun on *bander* (to have an erection) and bandage.

Cependant ci–dessous je m'en vais t'exposer
Des vers que nous avons eu soin de composer
A ton honneur: "Le suif" est le titre de l'ode
Qui de l'art poétique a méprisé le code.

### ODE

O suif dont le bienfait vraiment incomparable
Mérite qu'on lui rende un honneur remarquable
O toi qui de la nuit éclaircis la noirceur
        Honneur.

Non, non, rien n'est plus beau qu'une belle chandelle
Et rien n'éclaire mieux qu'une chandelle belle,
Qu'on te chante en tout temps et dans tout l'univers
        En vers.

C'est pourquoi j'entreprends d'une ardeur pleine de zèle
De célébre ici la chandelle immortelle.
Pour t'immortaliser je ne vois pas de mots
        Trop beaux.

Ta gloire est très brillante, et brillants les services
Que tu rends à ceux-là qui se graissent les cuisses.
Oui, ta gloire inspira ces sublimes versets
        Bien faits.

Mais ce serait surtout à l'armée autrichienne
De prendre la parole et de chanter la tienne.

---

Baille doesn't write you, he fears that his wit is impenetrable to you, my dear Zola. Consequently, lest you fail to understand him, he has today handed me the reins and I am writing. So here I am in his room and it is at his desk that I pen these verses, my brainchildren. Not that I think that anybody will claim them, my friend, for they are truly uniquely uninspired. However, without further ado I am going to expose to you some verses we have taken pains to compose in your honor: the ode is entitled "Tallow," and holds the art of poesy in contempt.

## ODE

O tallow, whose truly incomparable benefactions deserve outstanding honor, O thou that lightens the darkness of the night, all honor to you.

No, no, nothing is more beautiful than a fine candle, and nothing lights better. May you be hymned constantly and throughout the universe, in verse.

That is why with zealous ardor I undertake to celebrate herein the immortal taper . . . to immortalize you I cannot conceive any words too fine.

Your glory is brilliant, and brilliant too are the services you render to those who grease their thighs. Yes, your glory inspired these sublime lines, so well conceived. But it is above all up to the Austrian army to raise its voice and sing your charms.

---

*My dear fellow, come, come!*[7]

*Cézanne had the gall to go off to [word undecipherable]. He wants to stay there for a week. He left this letter on my desk, and I'm sending it on to you. Come, come! The parties are incredible, you can't imagine them.*

*Farewell, and until soon. Write us about your passing,*[8] *your departure, your arrival.*

*Baille.*

TO EMILE ZOLA

Aix, 30 November 1859

I

Mon cher,
     si je suis tardif
A te donner en rime en if
Le résultat définitif
Sur l'examen rébarbatif
Dont le souci m'était très vif[9]

---

My friend,

If I'm late in sending rhymes ending in "if" it's because the final

result of the awesome examination was giving me considerable con-
cern.[9]

_____

It's because (I'm not in very good form) on Friday my exam was put
off until Monday the 28th, but I did pass,

> Chose facile à croire
> Avec deux rouges et une noire.
> Aussitôt j'ai voulu rassurer tes esprits
> Dans le doute flottant sur mon sort indécis.

### II

> *La Provence* bientôt verra dans ses colonnes
> Du flasque Marguery l'insipide roman:
> A ce nouveau malheur, Provence, tu frissonnes,
> Et le froid de la mort a glacé tout ton sang.[10]

### III

PERSONNAGES:
Esprits inspirateurs de Gaut;[11] Gaut lui-même rédigeant le
sublime *Mémorial*.

UN ESPRIT:
Grand Maître, avez-vous lu le roman feuilleton
Que *la Provence* vient de mettre en livraison?

GAUT:
C'est du dernier mauvais.

UN SECOND ESPRIT:
J'en dis de même, Maître,
*La Provence* jamais au jour n'a fait paraître
Rien de plus saugrenu.

GAUT:
Quel est le polisson
Assez présomptueux pour braver mon renom
Et venir après moi, moi flambeau de la Presse,
D'un roman si mesquin étaler la détresse?

UN ESPRIT:
Son nom jusqu'à ce jour plongé dans le brouillard
Veut se produire enfin . . .

UN ESPRIT AUTRE:
Juste ciel, quel écart!

GAUT:
Et que pense-t-il faire, aurait-il donc l'audace
De vouloir ici-bas marcher sur notre trace,
Oserit-il prétendre atteindre la hauteur
Au-dessus du vulgaire où je règne en vainqueur?

UN ESPRIT:
Non, Maître, non jamais, car sa plume débile
Ne connaît nullement comme un roman se file
Comment, par une intrigue embrouillée, aux lecteurs
Qui vous lisent, on fait arriver les vapeurs.

UN AUTRE ESPRIT:
Il ignore surtout cet art si difficile,
Cet art, où plus que vous aucun autre est habile,
Cet art si précieux et pénible d'autant,
Cet art ambitionné, dont Dieu vous fit présent,
Cet art, enfin cet art, que tout le monde admire,
Et que pour l'exprimer nul mot n'y peut suffire.

GAUT:
C'est bien, je te comprends, c'est la Verbologie,
Du gréco-latin sort son étymologie
En effet sous l'azur des cieux aux mille feux,
Quel est le gunogène assez audacieux
Pour proclamer avoir inventé quelque chose
De plus beau que les noms employés dans ma prose.
Mes carmines français sont très supérieurs
A tout ce qu'ont produit un tas de rimailleurs
Et mes romans surtout, ce champ où je domine,
Et comme le soleil, se levant, illumine
Les excelses hauteurs des virides forêts
Comme un prisme brillant au monde j'apparais.

UN ESPRIT:
Domine souverain, Esprit incomparable
Louange soit rendue à votre estimable
Vertu.

UN CHOEUR D'ESPRITS:
Toi seul, toi seul, Grand Gaut innovateur
Sublime dans les cieux plans avec grandeur
      Les plus brillants sidères
      Au feu de tes paupières
      Courbant leur front confus,
      Ébloui de ta gloire,
      Sans tenter la victoire
      Croisant les bras moulus
      Et remuant la tête
      Ludovico s'arrête
      Et dit: "je n'écris plus!"
Gloire à toi, gloire à toi, Gaut philonovostyle,
Pout t'égaler, grand Gaut, ce sera difficile.

---

Easy to believe, with two reds and a black, and I immediately wanted to ease your mind, which had been in the dark as to my undecided fate.

## II
Soon, the columns of *La Provence* will be carrying flabby Marguery's insipid novel: Provence, you shudder at this new disaster and the chill of the grave freezes your blood.[10]

## III
## CHARACTERS
The creatures of Gaut's inspiration; Gaut himself editing the sublime *Memorial*.[11]

## A CREATURE
Great Master, have you read the serial novel that *La Provence* has just begun to publish?

## GAUT
It's the absolute worst.

## SECOND CREATURE

That's what I say, Master; *La Provence* has never published anything more ridicuous.

## GAUT

Who is the rogue so presumptuous as to flout my fame and attempt to take my place—me, the Press's brightest light—fomenting distress with so wicked a novel?

## A CREATURE

He is trying to make his name, hitherto veiled in mist, known . . .

## ANOTHER CREATURE

Just Heavens, what a falling off!

## GAUT

And what does he mean to do—has he then the audacity to walk in our footsteps here below, and does he aspire to the heights on which I reign, a conqueror, above the vulgar horde?

## A CREATURE

No, Master, never, for his feeble pen knows nothing of how a novel goes or of how its intricate plot makes your readers faint.

## ANOTHER CREATURE

Above all, he doesn't know anything about that arch-difficult art, at which no one is more practiced than yourself, that art that is so precious and so difficult at one and the same time, that ambitious art with which God has endowed you, that art—finally—that the whole world admires and that no words can express.

## GAUT

Fine, I know what you mean: *Verbology*, derived etymologically from Greco-Latin roots. What *gunogene* has dared beneath the glittering blue sky to claim to have invented anything more beautiful than the words I employ in my own prose? My French *carminae* are vastly superior to anything a whole host of rhymesters could produce and above all my novels, that field in which I am unparalleled and as the rising sun lights up the highest of the viridian glades, so, like a glittering prism, I appear to the world.

### A CREATURE
Sovereign domine, incomparable Mind, praised be your virtues.

### CHORUS OF CREATURES
You alone, you alone, Great Gaut the Innovator, Sublime in the heavens, soar there in all grandeur, the most brilliant siderea bend their embarrassed foreheads before the fire from your eyes, dazzled by thy glory. Foregoing victory, folding his sinewy arms and shaking his head, Ludovico stops short and says "I shall write no more." Glory to thee, glory to thee, Philonovostyle Gaut, Great Gaut, it would be hard to equal thee.

-------

### EXPLANATORY DICTIONARY
### OF THE GAUTIAN TONGUE

Verbology: the sublime art invented by Gaut; it consists in creating new words from Greek and Latin.

Gunogene: from the Greek Γυνή (woman) and the Latin *gignere* (to engender). The *gunogene* is thus someone born of woman, that is, man.

Carminae: from the Latin *carmina* (green)

Excelsiors: from *excelsus* (lifted up)

Viridian: from Latin *virides* (verdant)

Domine: *dominus* (master)

Siderea: *sidera* (stars)

Philonovostyle: from φιλος (friend) *novus*-new-and *style*: partisan of the new style.

My friend, now that I've bored you sufficiently, allow me to bring my stupid epistle to an end, farewell *carissime* Zola *salve*. Greetings to your parents, to everyone, from your friend.

P. Cézanne.

As soon as something new happens, I'll write you about it. Up until now, the usual unbroken calm continues to fold its cheerless wings over our dull town.

Ludovico is still a writer with a great deal of fire, verve and imagination.

Farewell my friend, farewell.

Undated
[Aix, 29 December 1859]

Dear Friend,

      cher ami, quand des vers l'on veut faire
La rime au bout du vers est chose nécessaire;
Dans cette lettre donc s'il vient mal à propos
Pour compléter mon vers se glisser quelques mots,
Ne va pas t'offusquer d'une rime stérile
Qui ne se cogne là que pour se rendre utile;
Te voilà prévenu: je commence et je dis
Aujourd'hui 29 décembre, je t'écris.
Mais mon cher, aujourd'hui fortement je m'admire
Car je dis aisément tout ce que je veux dire;
Pourtant il ne faut pas se réjouir trop tôt,
La rime, malgré moi, peut me faire défaut.
De Baille, notre ami, j'ai reçu la visite
Et pour t'en informer je te l'écris bien vite.

Mais le ton que je prends me semble être trop bas;
Sur les hauteurs du Pinde il faut porter mes pas:
Car je ressens du ciel l'influence secrète;
Je vais donc déployer mes ailes de poète
Et m'élevant bientôt d'un vol impétucux,
Je m'en irai toucher à la voûte des cieux.
Mais de peur que l'éclat de ma voix t'éblouisse,
Je mettrai dans ma bouche un morceau de réglisse,
Lequel interceptant le canal de la voix
N'étourdira plus par des cris trop chinois.

## UNE TERRIBLE HISTOIRE

C'était durant la nuit.—Notez bien que la nuit
Est noire, quand au ciel aucun astre ne luit.
Il faisait donc très nuit, et nuit même très noire,
Lorsque dut se passer cette lugubre histoire.
C'est un drame inconnu, monstrueux, inouï,
Et tel qu'aucun gens n'en a jamais ouï.

Satan, bien entendu, doit y jouer un rôle,
La chose est incroyable, et pourtant ma parole
Que l'on a toujours crue, est là pour constater
La vérité du fait que je vais te conter.
Écoute bien: C'était minuit, heure à laquelle
Tout couple dans son lit travaille sans chandelle,
Mais non pas sans chaleur. Il faisait chaud. C'était
Par une nuit d'été; dans le ciel s'étendait
Du nord jusqu'au midi, présageant un orage,
Et comme un blanc suaire, un immense nuage.
La lune par instants, déchirant ce linceul,
Éclairait le chemin, où, perdu, j'errais seul—
Quelques gouttes tombant à de courts intervalles
Tachaient le sol. Des terribles rafales
Précurseur ordinaire, un vent impétueux
Soufflant du sud au nord s'éleva furieux;
Le simoun qu'en Afrique on voit épouvantable
Enterrer les cités sous de vagues de sable,
Des arbres qui poussaient leurs rameaux vers les cieux
Courba spontanément le front audacieux.
Au calme succéda la voix de la tempête.
Le sifflement des vents que la forêt répète
Terrifiait mon cœur. L'éclair, avec grand bruit,
Terrible, sillonnait les voiles de la nuit:
Vivement éclairés par sa lueur blafarde
Je voyais les lutins, les gnomes, Dieu m'en garde,
Qui volaient, ricanant, sur les arbres bruissants.
Satan les commandait; je le vis, tous mes sens
Se glacèrent d'effroi: son ardente prunelle
Brillait d'un rouge vif; parfois une étincelle
S'en détachait, jetant un effrayant reflet;
La ronde des démons près de lui circulait . . .

Je tombai; tout mon corps, glacé, presque sans vie,
Trembla sous le contact d'une main ennemie.
Une froide sueur inondait tout mon corps,
Pour me lever et fuir faisant de vains efforts
Je voyais de Satan la bande diabolique
Qui s'approchait, dansant sa danse fantastique,
Les lutins redoutés, les vampires hideux,

Pour s'approcher de moi se culbutaient entre eux,
Ils lançaient vers le ciel leurs yeux pleins de menaces
Rivalisant entre eux à faire des grimaces . . .
"Terre, ensevelis-moi! Rochers, broyez mon corps!"

Je voulus m'écrier: "O demeure des morts,
Recevez-moi vivant!" Mais la troupe infernale
Resserrait de plus près son affreuse spirale:
Les goules, les démons, grinçaient déjà des dents,
A leur festin horrible, ils préludaient.—Contents,
Ils jettent des regards brillants de convoitise.
C'en était fait de moi . . . quand, ô douce surprise!
Tout à coup au lointain retentit le galop
Des chevaux hennissants qui volaient au grand trot.
Faible d'abord, le bruit de leur course rapide
Se rapproche de moi; le cocher intrépide
Fouettait son attelage, excitant de sa voix
Le quadrige fougueux qui traversait les bois.
A ce bruit, des démons les troupes morfondues
Se dissipent, ainsi qu'au zéphyr les nues.
Moi, je me réjouis, puis, plutôt mort que vif
Je hèle le cocher: l'équipage attentif
S'arrêta sur-le-champ. Aussitôt du calèche
Sortit en minaudant une voix douce et fraîche:
"Montez," elle me dit, "Montez." Je fais un bond:
La portière se ferme, et je me trouve front

A front d'une femme . . . Oh, je jure sur mon âme
Que je n'avais jamais vu de si belle femme.
Cheveux blonds, yeux brillants d'un feu fascinateur,
Qui, dans moins d'un instant, subjuguèrent mon cœur.
Je me jette à ses pieds; pied mignon, admirable,
Jambe ronde; enhardi, d'une lèvre coupable,
Je dépose un baiser sur son sein palpitant;
Mais le froid de la mort me saisit à l'instant,
La femme dans mes bras, la femme au teint de rose
Disparaît tout à coup et se métamorphose
En un pâle cadavre aux contours anguleux:
Ses os s'entrechoquaient, ses yeux éteints sont creux . . .

Il m'étreignait, horreur! . . . Un choc épouvantable
Me réveille, et je vois que le convoi s'entable . . .
. . . le convoi déraillant, je vais, je ne sais où,
Mais très probablement je me romprai le cou.

### CHARADE

Mon premier fin matois à la mine trompeuse
Destructeur redouté de la classe rongeuse,
Plein de ruse, a toujours sur les meilleurs fricots
Avec force impudeur, prélevé des impôts.
Mon second au collège avec de la saucisse
De nos ventres à jeun faisait tout le délice,
Mon troisième est donné dans l'indigestion
Et pour bien digérer. L'anglaise nation
Après un bon souper, chaque soir s'en régale;
Mon entier est nommé vertu théologale. [12]

---

dear friend, when it's verse you wish to write, the end of each line must have a rhyme; thus in this letter, if it seems unfitting when a few extra words are slipped in to fill out my verse, don't get in a huff over a bad rhyme, they're only there for that purpose; so you've been warned, and I'll begin by saying that I'm writing to you today, 29th December. However, my friend, today I am admiring myself enormously, for I am saying freely everything I want to say; however, let's not rejoice too soon, for the rhyme may escape me despite myself. I had a visit from our friend Baille, and am writing to you at once to tell you about it.

However, the tone I've taken seems too modest; I must turn my steps towards Pindar's heights; for I feel the secret afflatus from on high. So I shall spread my poet's wings and, rising swiftly in impetuous flight, attain heaven's vault. But lest you be dazzled by the brilliance of my voice, I'll stick a piece of licorice into my mouth and, by blocking the vocal passages, will not deafen you with overly Chinese cries.

### A TERRIBLE STORY

It was night—bear in mind that the night is dark when no star glimmers in the sky. It was, thus, night indeed and a black night too, when this lugubrious tale took place. It is a tragedy so monstrous and unknown and unheard-of that no one has ever heard of it before.

Of course, Satan had a part in it, it's unbelievable . . . but yet my word, which has always been accepted, is given as to the truth of what I am about to relate. Hear me well: it was midnight, the hour at which every couple is at work in bed, without light, but not without heat. It was warm. It was a summer night, and in the sky, from north to south a vast cloud was stretched like a shroud, presaging a storm. At moments, the moon tore through this winding-sheet, lighting up the path along which I wandered alone and lost—a few drops fell from time to time and spattered upon the ground. With its usual preliminary and fearsome gusts, a wind from south to north began to rise, with a fury; the *simoon*, which in Africa buries whole cities beneath waves of sand, and the trees thrusting their branches to the sky bent their bold heads. The whistling of the wind echoed by the forest struck terror into my heart. With a terrible sound, the lightning tore through night's veils: lit brilliantly by that pallid glow I could see—God save me—elves and gnomes flying about and mocking in the rustling trees. Satan was in command of them; I saw him, all my senses froze with fear: his burning eyes glittered red, and sometimes a spark darted from them, casting a fearful reflection; the dance of the demons around him continued . . . I fell to the ground; my entire body was chill and nearly lifeless, and trembled at the contact of an enemy hand. A cold sweat bathed me, and as I made vain attempts to rise and flee, I saw Satan's diabolical band drawing nearer, dancing its fantastic dance, frightful elves, hideous vampires, all tumbling helter-skelter to get closer to me, lifting their menacing eyes to heaven and outdoing each other in making faces at me . . . "Earth, swallow me up, rocks, crush me!" I tried to cry out. "Oh, realm of death receive me, alive as I am!" But the infernal band tightened its dreadful circle about me: ghouls and demons were already grinding their teeth in anticipation of their horrible feast. Contentedly, they cast glowing greedy glances at me, and it was all up with me . . . when, oh sweet surprise! from the distance there came the sudden sound of neighing horses galloping at full speed. First faint, the sound of their swift approach drew nearer; the brave driver whipped his team and urged them on with shouts as the fiery foursome traversed the woods. At this sound, the demons in that quavering band fled, as clouds flee before the wind. And as for me, I rejoiced, and then, more dead than alive, I hailed the driver: the obedient team stopped on the spot. At once, from inside the coach, a sweet, fresh voice spoke caressingly: "Get in," it said. I leaped inside: the door closed, and I found myself face to face with a woman . . . Oh, upon my soul I swear that I

never saw such a beauty. Blond hair, eyes glowing with a captivating fire, she won my heart in a trice. I threw myself at her feet—tiny, adorable foot—lovely leg; encouraged, I kissed her palpitating bosom; at that instant, the chill of death seized me, and the woman in my arms who had been so pink and rosy suddenly disappeared and turned into a pale cadaver with angular body and rattling bones and dull, empty eyes . . . Oh horrors! It was embracing me . . . A frightful shock awakened me and I saw that the coach was vanishing . . . swaying madly, it was taking me I knew not where, but very likely to break my neck.

### RIDDLE

My first is a crafty thing with a deceitful air, a redoubtable destroyer of gnawers, full of tricks and always taking with great impudence the best share of any choice morsel.

My second is something that used to delight our famished bellies at school, along with sausages.

My third is taken both for indigestion and to help proper digestion. The English nation enjoys it each evening after a good supper.

All together, I am a theological virtue. [12]

Your friend, who wishes you *bonnam valetudinem*.

Paul Cézanne.

My friend, I've not been able nor has Baille to figure out your puzzle, which really is a hard one, tell me the word in your next letter.

As for *my* riddle, I don't think I'll need to explain.

Greetings to your parents.

P. Cézanne.

### [NOTES 1859]

1. This letter appears to have been lost.
2. This letter also appears to have been lost.
3. This letter has not been preserved either.
4. Cézanne's letter from which this quotation is drawn concerning Michelet's *L'Amour*, published in 1858, has not survived.
5. A bit younger than Cézanne, Paul Seymard, also a law student and a future judge, died in Aix in 1939 at nearly 100 years of age without being able to recall his amorous rivalry with the painter.

6. These epithets refer to Zola's schoolmates, who apparently did not appreciate his poetry.

7. Passage added in the handwriting of Baptiste Baille.

8. Undoubtedly a reference to the *baccalauréat* examination for which Zola sat in 1859, passing the written portion but failing the oral because of his lack of proficiency in German, history and literature. During his vacation in Aix, Zola studied to sit for it again in Marseilles, where he failed both the written and the oral sections.

9. This refers to a law examination.

10. In November 1859, Marguery became one of the editors of *La Provence*, where he wrote under the pseudonym "Ludovico." Zola, in two letters to Baille, wrote that Marguery proved the opposite of what he set out to prove, made love ridiculous and flirtation triumphant, etc.

11. Gaut, Jean-Baptiste (1819–1891), Provençal poet and publicist, editor of the weekly newspaper *Le Mémorial d'Aix*, and curator of the Bibliothèque Méjanes.

12. Solution: *chat-riz-thé = charité*.

# [1859–1860]

[Cézanne's letters to Zola from the end of 1859 until 1862 seem to be lost. Portions of Zola's letters to Cézanne and Baille that refer to or quote from Cézanne's letters are the only reflection we have of his correspondence during these three years. The following extracts, culled from Zola's correspondence, refer solely to Cézanne.]

## ZOLA TO BAILLE

*[Paris] 29 December 1859*

*. . . You promised to come to Paris next year, and I'm counting on you; I'll see you at least twice a week, and that will give me some amusement at least. If that rogue Cézanne would come too, we could take a small room together and lead a* real *vie de bohèmes. At least we'll have lived our youth, rather than just stagnating. Tell him [Cézanne] that I'll answer him one of these days.*

## ZOLA TO CEZANNE

*Paris, 30 December 1859*

*My dear friend,*
*I want to answer your letter, and I don't know what to say to you [. . .]*
*What are you two up to? I'm bored here, and sometimes I think of you there, having fun. But on reflection, I think that it must be the same everywhere, and that gaiety is a very rare thing nowadays. And then, I feel as sorry for you as I do for myself, and I petition heaven for some gentle creature, namely, a loving woman. You have no idea the things that have been going through my head for some time now. You won't laugh at me, so I shall tell you about it. You know of course that in* L'Amour *Michelet begins his book only after the marriage has taken place and so he deals only with married couples, not lovers. Well, I, wretch that I am, plan to describe dawning love and carry it up to marriage.*

*You can't imagine the difficulty of what I want to accomplish. Three hundred pages to be filled, with hardly any plot; more a kind of poem in which I must invent everything, in which everything must be directed toward one single end: loving! And furthermore, as I say, so far I've only been in love in my dreams, and no one has ever loved me, even in a dream! But no matter . . . since I feel myself capable of great love, I shall consult my own heart, I'll create some fine ideal for myself, and* perhaps *I shall succeed. In any event, if I write this book I won't begin it until good weather; if I think it worth publishing I'll tell you— you would perhaps do it better than I can if you were to write it, you whose heart is younger, more loving than mine . . .*

*Forgive me if my thoughts are a bit confused. We won't talk politics; you don't read the newspapers (something I indulge in) and so you won't understand what I'm trying to say. I'll merely tell you that the pope is very troubled at the moment, and I beg you to glance at* Le Siècle *once in a while, for these are strange times. What can I say to end this missive on a happy note? Should I be inspiring you with courage to attack the ramparts?[1] Or perhaps I should speak of painting and drawing? Damn the ramparts, damn painting! The first is under the gun, the other under paternal veto. When you set out to storm the wall, your timidity tells you: "No further!" And when you take up your brushes, your father tells you: "My boy, you must think of the future. You can die on genius, but with money you can eat!" Alas, alas, my poor Cézanne, life is a ball that doesn't always roll the way you want it to go.*

*Since you've translated the second* Eclogue *of Virgil, why don't you send it to me? Thank God I'm not a young girl and won't be shocked.*

ZOLA TO CEZANNE

*Paris, 5 January 1860*

*My dear Cézanne,*

*I received your letter . . .*

*You asked me to tell you about my mistresses, my love affairs are all dreams. My wild adventures are lighting my fire in the morning, smoking my pipe and thinking of what I've done and what I'm going to do. You see that they're not very expensive and that I shan't lose my health over them. I haven't seen Villevieille yet;[2] I'll do the framing errand at the first opportunity . . .*

*You say you've read my article. I fear that it hasn't been understood any better than* Mon follet *has . . .*

*As you are aware, I am hardly one of fortune's favorites, and for some time now it pains me to look at myself, a grown boy of twenty, still dependent on my family. So I've decided to do something, to earn my daily bread. I think that in two weeks I shall begin work at the Docks Administration.*[3] *You who know me and how much I love my freedom, you'll understand that I have had to force myself to this resolve. But I would feel that I was behaving badly were I not to do it. I will still have a lot of free time that I can devote to occupations that please me. I am far from giving up literature—one gives up one's dreams with difficulty—and I am going to try to pursue as short a time as possible this occupation that will undoubtedly weigh heavily on me. However, I shall always be the same, I shall always be the poet with the restless mind, the Zola who is your friend.*

ZOLA TO CEZANNE

*Paris, 9 February 1860*

*My dear friend,*

*I've been sad, very sad, for several days and I'm writing you to take my mind off it.*

*I'm beaten down [. . .] I think of the future and I see it black, so black that I shrink back in horror. No money, no profession, nothing but disappointment. No one to depend on, no woman, no friend close by. Everywhere, indifference or scorn. That is what I see when I lift my eyes to the horizon, that is what makes me so unhappy [. . .]*

*And yet sometimes I am in good spirits, when I think of you and Baille. I feel myself fortunate to have discovered in the throng two hearts that could understand mine. I tell myself that whatever our situations we will always have the same feelings, and that comforts me. I see myself surrounded by such insignificant, dull creatures that my knowing you gives me pleasure, you who are not of our century, you who would invent love if it hadn't been done so long ago, albeit still unrevised and unperfected. I feel almost a kind of glory at having understood you, at having been able to discern your true value. So away with the wicked and the jealous: since the majority of mankind is stupid, the mockers will not be on our side, but what matter! if you take as much pleasure in shaking my hand as I do in shaking yours.*

ZOLA TO BAILLE

*Paris, 20 February 1860*

*. . . When we met at the threshold of life and when, thrown together by some unknown force, we took each other's hands, swearing never to part, neither of us inquired into the wealth or background of his new friend. What we were seeking was the wealth of the heart, of the mind, it was above all that future that our youth made us see so shining bright . . .*

*I await Cézanne and I hope to recover something of my former gaiety once he's here.*[4]

ZOLA TO CEZANNE

*Paris, 3 March 1860*

My dear Paul,

I don't know why, but I have uneasy forebodings about your trip, I mean about the more or less imminent dates of your arrival. To have you here with me, to be able to gossip together as we used to, pipe between our teeth and glass in hand, seems to me such a marvelous thing, so impossible, that there are times when I wonder if I'm not deluding myself and if that lovely dream can indeed become reality . . .

I don't know from what direction the tempest will come, but I feel as though some storm were brewing over me.

You fought for two years to reach this point; it seems to me that after so much effort, your victory can't be complete without a few further struggles. So you have Sire Gibert, who tries to discover your intentions, who advises you to stay in Aix; a teacher who obviously doesn't like to see any pupil get away from him. On the other hand, your father speaks of making inquiries, of consulting this Gibert,[5] a consultation that will inevitably result in your trip being put off until August. All that gives me the shivers, I quail at the thought of receiving a letter from you in which, with many regrets, you inform me the date has been changed. I have grown so used to looking forward to the last week of March as the end of my boredom that it would be very painful for me, having managed to store up just enough patience for that length of time, to find myself alone when the day comes [. . .]

*You ask me an odd question. Of course one can work here, as anywhere, given the willpower. Furthermore, Paris offers you an advantage you can't find anywhere else, that of museums in which you can study from the Masters from 11 to 4. Here is how you can schedule your time: from 6 to 11, you'll go to a studio for life painting; you'll have lunch and then, from noon to 4 you will copy, either at the Louvre or at the Luxembourg,*[6] *whatever masterpiece you choose. That will make 9 hours of work; I think that's enough and that with such a regimen you can't help but accomplish something. You will note that we shall have the entire evening free and that we can use it as we see fit, and without prejudicing our studies in any way. And then on Sunday, we'll take off and go somewhere outside of Paris; there are charming places, and if you care to, you can jot down on a bit of canvas the trees under which we will have had lunch. I have charming dreams every day that I want to turn into realities when you get here: poetic work, the kind we love. I'm lazy at the daily grind, at jobs that only occupy the body and that stifle the mind. But art, which occupies the soul, fills me with rapture and it's often when I'm nonchalantly lying down that I'm working the hardest. There are masses of people who don't understand that, and I'm not the one to try to enlighten them. Anyway, we aren't children now, we have to think of the future. Let's work, work: it's the only way to succeed.*

*As for the matter of money, it's true that 125 francs a month won't allow for any great luxuries. I'm going to figure out your budget. A room at 20 francs a month; lunch at 18 sous and dinner at 22 sous, which makes 2 francs a day or 60 francs a month; adding the 20 francs for the room, that's 80 francs a month. Then you'll have your studio to pay for; the Suisse,*[7] *one of the least expensive, is 10 francs I believe; I'm figuring an additional 10 francs for canvases, brushes, paints, which makes 100 francs. So you will have 25 francs left for your laundry, light, the thousand little things that come up, your tobacco, your amusements; you see that you'll have just enough to get by, and I can assure you that I'm not exaggerating, but rather understating. But that will be a very good school for you; you'll learn the value of money and the way in which a resourceful man should manage. I repeat, not to discourage you, that you* can *get along. I advise you pass the above calculation on to your father; perhaps the sorry reality of the figures will persuade him to open his purse a bit wider. On the other hand, you can manage to make a bit on your own here. Studies done in the studios, and especially copies done at the Louvre,*[8] *sell very well; and even if you only do one a month, that will be a nice extra for frivolities. The thing is to find a dealer, which is just a question of looking. So take the plunge and come, with bread and wine assured, one can devote oneself to the arts without risk.*

*[. . .] In any event, I trust you will write me on the eve of your departure telling me the day and time you arrive. I'll meet you at the station and lead you off to lunch in my learned company. I'll write you in the meantime. Baille wrote me. If you see him before leaving, make him promise to join us in September.*

ZOLA TO BAILLE

*Paris, 17 March 1860*

*[. . .] If weary of my solitude, I call upon the Muse, that gentle comforter doesn't answer me. [. . .] The Muse has abandoned me for a while, and I am versifying all on my own, and I tear up in disgust all the verses I write. [. . .]*

*Although the past months, so full of trouble and disillusionment, have been painful for me, they weren't able to snuff out all poetry inside me. I can still feel it somewhere inside; all it will take for it to flower anew is a fine day, a happy event. I am counting a lot on Cézanne's arrival.*

*I recently had a letter from Cézanne in which he tells me that his younger sister is ill and that he doesn't expect to arrive in Paris until around the beginning of next month. So you'll still be able to see him during the Easter vacation. Drink one last drink, smoke a good pipe, and swear to him that you will come to join us next September. We shall then be able to form a pleiade, a constellation of rare stars, pale ones, true, but brilliant because united. As our old chum says,[9] there will be no dreams or philosophy to compare with ours . . .*

ZOLA TO CÉZANNE

*Paris, 25 March 1860*

*My dear friend,*

*We often speak of poetry in our letters, but the words sculpture and painting come up rarely, not to say never. That is a serious omission, almost a crime; and I am going to try to correct it today.*

[There follow lengthy discussions of a fountain by Jean Goujon and a sentimental painting by Ary Scheffer that aroused Zola's enthusiasm to such an extent that he even inveighed against realism, without however naming its principal representative, Courbet, who was at that time still quite controversial.]

*[. . .] What do they really mean by the word realist? They brag that they paint only subjects devoid of poetry! But everything has its poetry, manure as well as flowers. It is because they are claiming to slavishly imitate nature? But then, since they inveigh against poetry to such a degree, they must mean that nature is prosaic. And that is a lie. I say this for your benefit, my friend, the great painter of the future. I tell you that art is a whole, that spiritualist, realist, are nothing but words, that poetry is a great thing and that there is no salvation outside of poetry.*

*I had a dream the other day—I had written a fine book, a sublime book that you had illustrated with beautiful, sublime engravings. Both our names were shining there in gold letters on the first page, together, and in that bond of genius, entered inseparably into posterity. It's still nothing but a dream, unfortunately.*

*Moral and conclusion of these four pages: You must make your father happy by studying law as assiduously as you can. But you must also work hard and firmly at drawing—*unguibus et rostro[10]*—in order to become another Jean Goujon, an Ary Scheffer—not to become a realist—so as to be able to illustrate a certain volume that is fermenting in my brain[11] [. . .]*

*As for the excuses you advance, either about sending engravings or about the so-called boredom your letters cause me, permit me to say that that is the height of bad taste. You don't really mean the things you say, and that's some consolation. I complain of only one thing, and that is that your letters are not longer, more detailed. I look forward to them with impatience, they make me happy for a day. And you know it; so no more excuses. I'd rather stop smoking or drinking than forgo our correspondence.*

*Then you write that you are sad. I tell you that I am very very sad. It's the temper of the times, like wind blowing over our heads, no one is to blame, not even ourselves; the fault lies with the times in which we live. Then you go on saying that although I have understood you, you don't understand yourself. I don't know what you mean by the word* understand. *This is how it is for me: I discerned in you a great goodness of heart, a great imagination, the two foremost qualities before which I bow. And that's enough; from then on, I understood you, I judged you. Whatever your failings, whatever your waverings, you will always be the same for me. Only stone doesn't change, and never alters its nature of stone. But man is an entire world; anyone who set out to analyze the feelings of one man during a single day would perish in the attempt. Man is incomprehensible as soon as one tries to know him down to his most frivolous*

*thoughts. But as for me, what do I care for your apparent contradictions. I've judged you good and a poet, and I shall go on repeating: "I have understood you."*

*But begone, sorrow! Let's finish with a laugh. In August, we'll drink, we'll smoke, we'll sing*[12] *[. . .]*

ZOLA TO CEZANNE

*Paris, 16 April 1860*

*[. . .] My new life is fairly monotonous. At nine o'clock I go to the office, I write up customs declarations until four, I copy correspondence, etc., etc.; or, more likely, I read my paper, I yawn, I pace back and forth, etc., etc. Sad indeed. However, as soon as I'm out, I shake myself like a wet bird, I light a pipeful of tobacco, I breathe, I live. I mull over long poems and tragedies in my head, long novels; I wait for summer to unleash my energies. Good God, I want to publish a book of poems and dedicate it to you*[13] *[. . .]*

*I got your letter. You are right not to complain overmuch about your fate. For after all, as you say, with two loves in one's heart, one for women and the other for the beautiful, one would be very wrong to despair [. . .]*

*You send me a few verses that breathe a sombre sorrow. The quickness of life, the brevity of youth, and death there, on the horizon: that is enough to make us quake, if we really thought about it for a few minutes. But isn't it sadder if in the swift course of a lifetime, youth, that springtime of life, is completely absent, if at twenty we haven't yet experienced happiness, if we see age striding toward us and we don't even have memories of fine summer days to brighten those harsh winter days. And that's what lies in store for me.*

*You go on to say that sometimes you lack the courage to write to me. Don't be so selfish: your joys belong to me as do your sorrows. When you're cheerful, make me cheerful; when you're sad, you may darken my sky with impunity. A tear is sometimes sweeter than a smile. So write me your thoughts day by day; as soon as a new sensation arises in your soul, put it down on paper. Then, when you have four pages, send them off to me.*

*Another sentence in your letter pained me. It's this one: "the painting I like, although I am unable to bring it off, etc., etc." You, not succeed! I think you're wrong about yourself, as I've already told you: in the artist there are two men,*

*the poet and the laborer. A person is born a poet, he becomes a laborer. And you, who have the spark, who possess that something that can't be acquired, you are complaining; when all you have to do to succeed is to move your fingers, to work at it. I can't abandon this subject without adding two words. Recently, I warned you about realism; today, I want to point out another pitfall, business. The realists are still creating art—in their way—they are working conscientiously. But the businessmen, the ones who paint in the morning to earn the evening meal, they eke out a miserable existence. I have a reason for saying this to you; you are going to work with X . . . , you will copy his pictures, you may even admire him.*[14] *I am fearful on your behalf of this path on which you are setting out, the more so because the person you may be going to emulate has great qualities which he puts to pitiful use, but which nonetheless make his pictures look better than they are. It's pretty, it's fresh, it's well-painted; but all that is only a trick of the trade and you'd be wrong to dwell on it. Art is a more sublime thing than that; art doesn't dwell on the folds in fabric, on a maiden's pink skin. Look at Rembrandt: with one ray of light, all his characters, even the ugliest, become poetic. Thus, I repeat, X . . . is a good master to teach you the technique; but I doubt that you can learn anything else from his pictures. Since you're rich, you probably dream of engaging in art and not in business. [. . .]*

*So be wary of an exaggerated admiration for your compatriot; put your dreams, those beautiful golden dreams, onto your canvases and try to pass onto them that ideal love you possess. Above all, and here is the abyss, do not admire a picture because it was done quickly; in a word, and in conclusion, do not admire or imitate a commercial painter. I shall return to this subject. Perhaps I have flouted some of your notions. Tell me so frankly, so that you don't harbor any hidden rancor towards me [. . .]*

ZOLA TO CEZANNE

*Paris, 26 April 1860, 7 a.m.*

*[. . .] When I look at a picture, I who barely know how to tell white from black, it's obvious that I am in no position to judge the work of the brush. I confine myself to saying whether the subject pleases me, whether the overall effect makes me dream of some good and great thing, whether the love of the beautiful breathes in the composition. In a word, without concerning myself with technique, I talk about art, about the thought behind the work. And I think*

*I am acting wisely; I find nothing more pitiable than the exclamations of so-called art lovers who, having picked up a few technical terms in the studios, repeat them with aplomb like parrots. You, on the other hand, you who have understood how hard it is to lay colors onto a canvas in realizing one's imaginings, I can understand that in looking at a picture you pay a great deal of attention to technique, that you are carried away by this or that brush stroke, by a color, etc., etc. That's natural; you have the idea, the spark, you search for the form you don't have, and you admire it in good faith wherever you find it. But beware: that form isn't everything, and whatever your excuse, you must put the idea ahead of it. Let me explain: a picture for you must not be only colors mixed and spread onto a canvas; you mustn't constantly be searching out the mechanical process by which the effect has been achieved, what color has been used; you must see the whole, ask yourself whether the work is truly what it ought to be, whether the artist is truly an artist. There is such little difference, in the eyes of the vulgar, between a daub and a masterpiece. Both of them consist of white, red, etc., of brush strokes, canvas, a frame. The difference is only to be found in that nameless something, that is revealed only by thought and taste [. . .]*

*For that matter, I'm not speaking for you; if you really have it, as I firmly believe, you don't need to bother with the rather puerile distinctions I've just made. Each genius is born with his own thought and his original form; those are things that can't be separated without leading to total nullity [. . .] But it's that devil of a painter, who, although he has no ideas, usually has form on his side; he's the one whose pictures are a real trap [. . .] One must admit that it's pretty, and if one goes no further, there one is, admiring an unworthy work, perhaps imitating it. I realize that only imbeciles are snared thus; but will you hold it against me if I am frightened, even if wrongly, and if I tell you as a friend: "Beware! Think of art, of the highest art; do not consider form alone, because form alone is commercial painting; consider the idea, dream lovely dreams; the form will come with work and all you do will be lovely, will be great." That is what I've always told you, that is what I will go on telling you [. . .]*

*P.S. I've just received your letter. It has given rise to a really pleasant hope. Your father is becoming more human; be firm without being disrespectful. Remember that it's your future that's being decided and that all your happiness depends on it. What you say about painting becomes useless as soon as you yourself recognize X's defects.*

*I'll answer your letter soon.*

ZOLA TO BAILLE

*Paris, 2 May 1860*

*Cézanne speaks of you. He confesses his error*[15] *and assures me that he is going to change his ways. Since he brought up the subject, I intend to tell him what I think about the way he acted;*[16] *I wouldn't have started it, but I think that now there's no need to wait until August to try to smooth things out between you.*

ZOLA TO CEZANNE

*Paris, 5 May 1860*

*[. . .] You mention Baille in both your letters. For a long time I've wanted to speak to you about this good fellow. It's that he isn't like us, his mind doesn't work the same way; he has many qualities that we don't, and many faults as well. I'm not going to try to describe his character to you, to tell you the ways in which he is wrong or right; I wouldn't describe him as wise either, no more than I would call him crazy; all that's only relative and depends on the point of view from which you look at life. And what difference does it make to us, his friends; isn't it enough that we think him a good fellow, above the crowd, or at least more apt to understand our hearts and our minds? [. . .] I had the feeling that the bond between you and Baille was weakening, that a link in our chain was going to break. And, trembling, I beg you to think of our joyful outings, at the oath we took, our glasses raised, to march through life arm in arm along the same path; remember that Baille is my friend, he's your friend, and if his nature is not completely in accord with ours, he is no less devoted to us, fond of us, and that lastly he understands me, he understands you, he is worthy of all our trust, of your friendship. If you have something against him, tell me, and I'll try to give his side, or rather, tell him yourself what bothers you about him—nothing is to be feared so much as the things that are not brought out into the open between friends.*

*Remember our swimming parties, that happy time when one fine evening, without a care for the future, we made up the drama of the famous* <u>Pitot;</u> *and of that great day there on the bank of the river, the sun radiantly sinking, the countryside that perhaps we did not admire much then but which, in memory now appears to us so calm, so lovely. Someone said—Dante, I think—that*

*nothing is more painful than a happy memory in unhappy times. Painful, yes, but also how bittersweet; you weep and laugh at the same time. What unhappy creatures we are! at twenty, we are already regretting the past; [. . .] we thoughtlessly waste our lives, always hoping to bring back the past, or loudly importuning the future, never knowing how to enjoy the present. I told you this in my last letter—sometimes a memory, like a flash of lightning, passes through my mind; a word you once spoke, one of our parties, a mountain, a path, a shrub, I repine, and I despair [. . .]*

*In both your letters you mention our reunion like some distant hope. "When I've finished my law studies, perhaps," you say, "I may be free to do what I please; perhaps then I may be able to rejoin you." God willing, that isn't a passing fancy; that your father is opening his eyes to your true interests. Perhaps he looks upon me as a fool, a madman, even a bad friend for backing you up in your dream, in your love for the ideal. Perhaps, if he were to read my letters, he would judge me harshly; but even were I to lose his esteem, I would still speak frankly to him just as I do to you: "I've thought about the future for a long while, and about the happiness of your son, and for a thousand reasons that would take too long to explain to you, I believe that you ought to allow him to follow his bent." My dear fellow, it's a matter of a little effort, a bit of work. What the devil, are we totally lacking in courage? After night comes the dawn; let's try to get through this night as well as we can, and when day breaks you will be able to say: "I've slept long enough, father, I feel strong and brave. For pity's sake, don't shut me up in an office, set me free, I'm stifling, be kind, father."*

*[. . .] I'm planning to come to shake your hand as I did last year. Of course, I'd prefer it if it were you who were coming here, and for a host of reasons; but since I still have doubts as to your father's goodwill, I'm getting ready to pack my bags.*

ZOLA TO BAILLE

*[Paris] at the Docks,
14 May [1860], 3 o'clock*

*Serious things first. I've written to Cézanne as I told you I would about the coolness with which he treated you. I can't do better than to copy out for you word for word his reply to me on the subject; here it is:*

*"According to your last letter, you seem to fear that our friendship for Baille
is weakening. Not at all! Heaven knows he's a fine fellow; but you know that
with my character the way it is, I am not always too sure of what I'm doing, and
so if I've committed some faults in his regard I hope he will forgive me for them;
but otherwise, you know that we get along very well together, but I accept what
you tell me, for you are right . . . So we are still good friends."*

*You see, my dear Baille, I was right in thinking that it was nothing but a
wisp of cloud that would disappear at the first breeze; I told you that the poor old
chap doesn't always know what he's doing, as he rather complacently admits
himself; and that when he upsets you, you mustn't ascribe it to his real feelings,
but to the evil spirit that clouds his mind. He has a heart of gold, I repeat, a
friend able to understand us, as mad as we, as much of a dreamer [. . .]*

*[. . .] In August, I want to show you the number of letters from Cézanne and
make you blush when you compare them to the number of yours.*

ZOLA  TO  BAILLE

*Paris, 2 June 1860*

*[. . .] One day I shall tell you all, my best friend, to you and Cézanne, but
both of you may rest assured that I'm not the featherbrain you think me, that I
make decisions only after long reflection, that I am caught up in the real world
all day long and that I only dream to relax. Thus, I won't hide it from you, the
only reason I want a job is so that I can dream at leisure. Sooner or later, I come
back to poetry; what I want is to be able to devote myself to it without being a
burden on anyone [. . .]*

*You mention the false glory of poets; you call them madmen, you claim that
you will not be as stupid as they, going off to die in an attic for the sake of a round
of applause. I've already told you in one of my letters something that should
have hindered you from reiterating that blasphemy. Do you really believe that
the poet works only for glory? . . . No, he takes up his lyre in solitude, he loses
sight of this world and lives only in the world of spirit. That's his life, why mock
him, why accuse him of madness: he will tell you that you don't comprehend,
that you aren't a poet, and that he'll be right. I want to live happy: that is your
old refrain. Ah! my Lord, everyone wants to live happy; you have your*

*happiness, the poet has his: each walks where God bids him, the coward is the one who complains of the thorns and refuses to go forward.*

*Of course, our different ways of looking at things will not weaken our friendship.*[17] *You know me and you know that I am anything but a conceited ass. I know what I want [. . .]*

*Old Cézanne tells me in each of his letters to say hello to you. He asks very often for your address in order to write to you. I'm surprised he doesn't know it, and that proves not only that he doesn't write to you, but that you are as silent as he. Well, since it's a request that shows his good feeling, I'll satisfy it. So there is another little misunderstanding that has become part of the past.*

*[. . ] In the meanwhile, take it easy, as Cézanne says [. . .]*

ZOLA TO CEZANNE

*Paris, 13 June 1860*

My dear Paul,

*On a lovely morning the other day I wandered far from Paris, in the fields, for three or four miles [. . .] The fact is that after having tramped along for a good two hours, I suddenly found myself ravenous. I looked around; trees everywhere, wheat fields, hedges, etc. I found myself in a part of the country that was totally unfamiliar to me. Finally, I spied a steeple looming above an old oak tree; a steeple presumes a village, a village an inn. I walked towards the welcome church, and it wasn't long before I was sitting down to a frugal lunch in an ordinary café. In that café—and this is the point I was getting at, the rest is only prefatory—I noticed as I came in some paintings that struck me. They were large panels such as you want to paint in your place,*[18] *on canvas, depicting village celebrations; but with a chic, with such a sure hand, with such a perfect understanding of the illusion of distance, that I was awestruck. I have never seen anything like them in any café, even a Parisian one. I was told that the artist who had produced these minor masterpieces was twenty-three years old. Indeed, if you come to Paris, we will go to Vitry—which is the name of that happy village—and I'm certain you will admire as I did.*

*I see Chaillan quite often. Yesterday, we spent the evening together; this afternoon I'm supposed to meet him at the Louvre. He told me he had written to you the day before yesterday, I believe, so I won't go into his work. Combes is*

*here, he is going to tell you about that. The other artists I see are Truphème Junior, Villevieille, Chautard; as for Emperaire, I haven't been able to meet him yet.* [19]

*[. . .] We are waiting to begin the superb picture I told you about* [20] *until I have moved into a room I've just rented.* [21] *It's on the seventh floor; the highest building in the quarter; a vast terrace, a view of all Paris [. . .] Baille, who will probably be coming to Paris in September, will undoubtedly join me; I wish I could say as much for you. Chaillan will tell you all the felicities the art students enjoy here [. . .] You don't speak any more about your law courses. What about them? Are you still on the outs with the law? The poor helpless law, how you treat it! I've noticed that we always need some trouble or a love affair, without which we find life incomplete. For that matter, the idea of love implies hate to a certain extent, and vice-versa. You love pretty women, therefore you detest ugly ones; you hate the city, therefore you love the countryside. Of course, that can't be pursued too far! [. . .] The real wise man would be the one who knew only love, in whose soul hatred would have no place. But we aren't perfect—thank God! that would be too boring—and since you are like everyone else, your love is for painting and your hatred for the law. There is, as Astier would say, your Q.E.D.*

*You write that you sometimes reread my old letters. That is a pleasure that I often allow myself. I've kept all of yours; they are my memories of youth [. . .]*

*One last question: "How are you sporting your beard?"*

ZOLA TO CEZANNE

*Paris, 25 June 1860*

*My dear friend,*

*You seem discouraged in your last letter; you even speak of throwing up your brushes. You bemoan the solitude around you; you're bored. Isn't that the awful malaise we all have, this terrible boredom, isn't it the curse of our century? And isn't discouragement one of the results of this spleen that chokes us? As you say, if I were with you, I would try to console you, to encourage you. I'd tell you that we are no longer children, that the future awaits us and that it's cowardly to recoil before the task we have set for ourselves; that the great wisdom lies in accepting life as it is; in adorning it with dreams, but to realize that they* are

*dreams. God help me if I am your evil genius, if I should make you unhappy by vaunting art and dream. And yet I don't believe it; the evil one cannot hide in our friendship and lead us both to ruin. So take courage; pick up your brushes again, let your imagination wander as it will. I have faith in you; for that matter, if I am impelling you to evil, may it be upon my head. Above all, courage, and bear in mind before setting out along this path the thorns you may encounter. Be a man, leave off dreaming for a moment and act [. . .]*

*Let me speak a bit about myself [. . .] If I am proud . . . I have no pride with you, my friends; I admit my weakness and my only good quality consists in loving you. Like the shipwrecked man clinging to his floating plank, I cleave to you, my dear Paul. You understood me, I felt a harmony in your character; I had found a friend, and I thanked heaven for it. I was afraid of losing you on several occasions; now, that seems impossible. We know each other too well ever to separate [. . .]*

*I spent yesterday with Chaillan. As you said, he is a chap with a certain poetic depth; he lacks only direction [. . .] He is working* unguibus et rostro, *hoping with all his heart to have you as a companion.*

*I still plan to come to see you soon. I need to talk to you; letters are all very well, but one doesn't say all one wants. I'm tired of Paris; I go out very little and, if it were possible, I would move somewhere near you. My future is still the same: very dark and so covered with clouds that my eye seeks in vain to make it out. I truly don't know where I am going: may God guide me. Write me often, it consoles me. I know how much you hate crowds, so tell me only about yourself; and above all never be afraid of boring me. Courage. Until soon.*

ZOLA TO CEZANNE

*[Paris] July 1860*

My dear Paul,

*Allow me to express myself one last time frankly and clearly: everything seems to be going so badly with our affairs that I'm incredibly worried. Is painting for you only a caprice that happened to catch hold of you one fine day when you were bored? Is it no more than a hobby, a subject of conversation, a pretext to neglect the law? If such be the case, then I can understand your behavior: you are right not to push things to extremes and not to create new family problems for yourself. But if painting is your vocation—and that is how*

*I have always perceived it—if you feel yourself capable of doing well after you work hard at it, then you are a puzzle to me, a sphinx, I don't know what kind of impossible and shadowy creature. It's either one of two things: you don't want to and thus you are admirably achieving your goal; or you do want to, and hence I no longer understand anything. Your letters either give me great hopes or they deprive me of any hope at all; take the last one, in which you seem almost to be bidding farewell to your dreams which you could so easily transform into reality. That letter contains this sentence that I have tried in vain to understand: "I am talking without saying anything, since my conduct contradicts my words." I've constructed various hypotheses as to the meaning of those words, none of which has satisfied me. What is that behavior of yours? that of a lazy man, obviously, but what's so surprising about that? you are being forced to do a job that disgusts you. You want to ask your father to allow you to go to Paris to become an artist; I see no contradiction between that request and your actions; you neglect the law, you go to the museum, painting is the only work acceptable to you; that, I think, shows an admirable harmony between your desires and your actions. Do you want me to tell you?—above all, don't get angry—you lack character; you have a horror of pushing things through, in thought as well as in deeds; your great principle is to let things happen, and to give yourself up to time and chance. I don't say that you are totally wrong; each of us sees in his own way or at least believes he does. Only that line of behavior is one you have already followed in love; you said you were waiting for time and an occasion; you know better than I, neither appeared [. . .] I felt it my duty to repeat to you one last time here what I have already told you so often: my position as a friend excuses my frankness. From many aspects, our characters are alike; but, by God's rood, if I were in your place I would speak up, risk all for all, not float vaguely between two such different futures, the studio and the Bar. I feel for you, for you must suffer from this uncertainty, and that would be for me another motive for rending the veil; one thing or the other, be really a lawyer, or else be really an artist; but don't go on being a nameless creature, wearing paint-stained legal robes. You are somewhat careless—may I say without angering you— and doubtless my letters are left lying around and your parents read them. I don't think I'm giving you bad advice; I believe I am speaking as a friend and logically. But not everyone perhaps sees things as do I, and if what I suggest above is true, I must not be in your family's best graces. They doubtless regard me as a* liaison dangereuse, *as the stone cast in your path to trip you up. All that upsets me considerably, but, as I've already told you, I have been judged*

*badly so often that another false opinion added to the rest doesn't surprise me. Remain my friend, that's all I want.*

*Another passage in your letter upsets me. You tell me you sometimes throw your brushes into the air when your form does not follow your thought. Why such discouragement, such impatience? I would understand them after years of study, after thousands of futile efforts. Recognizing your nullity, your hopelessness, you'd be doing well to throw down your palette, canvas and brushes. But you—who have up to now had only the itch to work, you who have not yet undertaken your task seriously and regularly, you have no right to consider yourself incapable. So have courage; all you've done up to now is nothing. Take courage and remember that in order to reach your goal you need years of study and perseverance. Am I not in the same case as you? Isn't form just as rebellious under my fingers? We have the concept; so let us advance freely and bravely along our path, and may God guide us! Actually, I like your lack of self-confidence. Look at Chaillan, he finds everything he does is excellent; because he doesn't have anything better in his head, an ideal to attain. So he will never progress, for he believes he's already there, because he is satisfied with himself.*

*You ask me for details about my material life. I have left the Docks; was I right or wrong to do so? a relative question [. . .] I can only say: I couldn't stay any longer, and so I left. As for what I'm thinking of doing, I'll tell you later when I've done it. For the moment, my life is this: we've started on the painting of Amphyon in my tiny room on the seventh floor, a paradise with a terrace from which we discover all Paris. [. . .] Chaillan comes at one o'clock. [. . .] In the morning, I always write a bit; in the evenings, after the sitting, I read a few verses of Lamartine, or Musset, or V. Hugo [. . .] I don't work enough, and I reproach myself. If you come to Paris, we'll try to plan our day so that we can toil away as much as possible, not, however, forgetting the pipe, the glass and the song.*

*Amphyon, under Chaillan's brush, looks rather like an ill-tempered monkey. All in all, I despair more than ever of this fellow as an artist [. . .]*

*I've just received a letter from Baille. I don't understand anything anymore; here's a sentence I read in this epistle: "It's almost certain that Cézanne will be going to Paris: what joy!" Is he repeating something you said, did you really give him this hope when he came to Aix recently? Or has he dreamed it, is he taking your wish for the reality? I tell you again, I don't understand anything any more. I urge you to tell me frankly in your very next letter; for three months*

*I've been telling myself successively, according to the letters I receive, "He's coming, he won't come." For God's sake, try not to imitate a weathercock. . .*

*My trip is still set for September 15th.*[22]

*[. . .] When is your exam? Did you pass? Will you pass?*

ZOLA TO BAILLE

*Paris, 25 July 1860*

*[. . .] Cast a glance at those I love [. . .] Paul, whose nature is so good, so open, whose soul is so loving, so tenderly poetic; you, energetic, stubborn [. . .]*

*In my last letter [. . .] I asked you several things. News from Aix, which Cézanne persists in not telling me [. . .]*

ZOLA TO BAILLE

*[Paris] July 1860*

*[. . .] As for the future, I don't know; if I take up a literary career once and for all, I want to be true to my motto: All or nothing!*

*[. . .] A charming phrase from one of Cézanne's letters: "I'm the foster child of illusions."*

ZOLA TO CEZANNE

*Paris, 1 August 1860*

*My dear Paul,*

*In rereading your letters of last year, I came upon the little poem HERCU-LES, between vice and virtue a poor lost child that you've probably forgotten and that had disappeared from my memory as well.*[23] *Anyhow, reading it pleased me very much; some passages, a few isolated lines, pleased me infi- nitely. You yourself, I'm sure, were you to read them, would be astonished, you would wonder whether it was indeed you who had written that [. . .]*

*[. . .] Those forgotten verses seemed better to me than they once did, and with my forehead in hand, I began to think. What does he lack, I wondered, this good fellow Cézanne, in order to be a great poet? Purity. He has the idea; his form is*

*febrile, original, but what spoils it, what spoils everything, are the Provençal-isms, the barbarisms, etc. Yes, my friend, more of a poet than I. My verse is perhaps purer than yours, but there is no doubt that yours is more poetic, more true; you write with your heart and I with my mind; you firmly believe what you set down, with me often it's only a game, a brilliant invention. And don't think that I'm joking here; above all don't think that I'm flattering you or myself; I have studied and I'm giving you the result, nothing more. The poet has many ways to express himself: pen, brush, scissors, instrument. You have chosen the brush, and you've done well: one must follow his own bent. So I have no intention of advising you to take up the pen now and, abandoning color, work on style; to do something well, one must do only one thing. Yet allow me to shed a tear over the writer that is dying in you; I repeat, the earth is good, fertile; a bit of cultivating and the harvest would be a splendid one. It's not that you are unaware of this purity of which I speak; you know more about it, perhaps, than I. It's that, carried away by your nature, singing for the sake of singing, careless, you employ the most bizarre expressions, the drollest Pro-vençal turns of phrase. Far be it from me to reproach you with it, above all in our letters, where, on the contrary, I like that. You are writing for me, and I thank you for it; but the crowd, my friend, is much more demanding;*[24] *it's not enough to say something; one must say it well. Now, if some idiot, some numbskull were writing to me, what difference would it make to me if his form was as ragged as his thoughts. But you, my dreamer, my poet, I sigh when I see your thoughts, those lovely princesses, so poorly clad. They are odd, these beautiful ladies, odd as young gypsy girls with their strange look, their feet muddy, their heads crowned with flowers. Oh, for the great poet that is fading give me a great painter, or I shall never forgive you. You who have led my doddering steps toward Parnassus, you who have suddenly abandoned me, make me forget the budding Lamartine by becoming the Raphael of the future. I am not quite sure what I'm saying. I wanted to remind you in two lines of your old poem and to ask you for a new one, purer, better crafted. I wanted to tell you that I'm not content with the few verses that you send me in each letter; to advise you not to abandon the pen entirely, and, when you're in the mood, to speak to me of some beautiful sylph [. . .]*

*I received your letter this morning. Allow me to give you my opinion on the subjects you have been discussing, you and Baille. I join you in saying that the artist must not rework his work. Let me explain: if a poet, in rereading his work as a whole, alters a verse here and there, if he alters the form without changing*

the idea, I see nothing wrong with that, I even hold it to be a necessity. But if afterwards, after weeks, months, years have gone by, he refashions his work, tearing down parts, rebuilding others, that I regard as a stupidity and a waste of time. Aside from destroying a monument that in a way bears the seal of its time, he can never transform a mediocre but original piece into anything but a twisted, cold thing [. . .] So I am totally in accord with you: work conscientiously, do the best you can, file it down here and there to make the parts fit better and present a suitable whole, and then abandon your work to its good or bad fortune, being careful to put the date of its composition at the bottom. It will always be wiser to leave bad what is bad and to attempt to do better on another subject. Like yourself, I am speaking here for the artist in general: poet, painter, sculptor, musician [. . .]

As for the great question we need not mention, I can only repeat myself, give you the advice I have already offered. As long as two lawyers have not pleaded their case, the case is still at the same point; the argument is the torch that sets everything off. So if you remain silent, how can you hope to go forward and reach any conclusion? It's materially impossible. And remember that it isn't the one who shouts the loudest who is right; speak softly and wisely, but by the devil's horns, feet, tail and navel, speak, say something!!! [. . .]

ZOLA TO BAILLE

*Paris, 21 September 1860*

Tell my old chum Cézanne that I'm depressed and can't reply to his last epistle . . . It's almost useless for him to write to me until the question of his trip is settled.

ZOLA TO CEZANNE AND BAILLE

*Paris, 2 October 1860*

[. . .] I recall one of Cézanne's profound sayings. When he had money, he usually hurried to spend it before bedtime. When I asked him about this prodigality: "Good God," he said, "if I should die tonight, would you want my parents to inherit?" [. . .]

*You assure me that Cézanne will be coming here in March.*[25] *I'm talking to Baille now, not to Paul, having promised myself not to mention this to him again. I hope you're right [. . .]*

ZOLA TO CÉZANNE AND BAILLE

*Paris, 24 October 1860*

*[. . .] Cézanne having written to me, I owe him a reply. The description of your model cheered me considerably. Chaillan maintains that here the models are tolerable, albeit not in their first bloom. One draws them in the daytime and caresses them at night (and the word caress is somewhat weak). So much for the diurnal pose, so much for the nocturnal one; furthermore, I am assured that they are vastly accommodating, especially during the nighttime. As for the fig-leaf, it is unknown in the studios; one undresses there quite naturally and the love of Art veils anything in the nudity that might be overstimulating. Come, and you'll see.*

# [NOTES 1859–1860]

1. Perhaps a reference to a law exam Cézanne was to sit for.
2. Joseph-François Villevieille (1829–1915), a painter from Aix, and a pupil of Granet, occasionally gave advice to Cézanne, who was ten years his junior; he sometimes also allowed him to work in his studio.
3. Zola was to abandon this position in May, unable to bear the life of an office worker.
4. At the time, Cézanne intended to abandon his law studies and come to Paris to devote himself to painting. Although his father strongly opposed this plan, the young artist had nevertheless hinted to Zola the possibility of his arriving in Paris by the beginning of April.
5. Gibert, professor of drawing at the Ecole d'Art in Aix, had been consulted by Cézanne's father, and, unwilling to lose a pupil, he had advised against Paul's departure. The trip to Paris was therefore definitely postponed until Cézanne had finished his law studies. See Zola's letter to Cézanne of 3 March 1860.
6. At the Musée de Luxembourg, which no longer exists, the works of contemporary artists who were not admitted to the Louvre until years after their deaths were exhibited (unless they were transferred to provincial museums).

7. The so-called Académie Suisse was a free school on the Quai des Orfèvres run by a former model named Suisse. Artists could work there from live models at a minimal price and without having their work corrected or supervised. This "Académie" did not cater solely to beginners; many painters attended it to take advantage of a cheap opportunity to paint or draw from nude models.

8. According to the Louvre archives, Cézanne did not apply for a student card entitling him to free entry until the beginning of 1868. It is possible that the artist had delayed making this application because he was not working with any recognized teacher. In his request, Cézanne stated that he was the pupil of a certain Chesneau. The card, number 278, was issued to him on 13 February 1868.

9. This "old man" is Paul Cézanne.

10. With tooth and nail (or claw).

11. Cézanne never illustrated any text by Zola.

12. Although Zola did not previously mention that Cézanne's trip had been delayed, the reference to the month of August clearly indicates that his friend's arrival in Paris, which he had expected in April, had been postponed until later. However, the painter was obviously so depressed that Zola preferred not to discuss this trip, the more so as their projected meeting in August concerned Zola's summer vacation, which he planned to spend in Aix. The last sentences of this letter are therefore designed to console Cézanne.

13. Zola published no volume of poetry, but his first novel, *La Confession de Claude*, which appeared in 1865, was dedicated: "To my friends P. Cézanne and J-B Baille." A year later, Zola collected his early art criticism, signed "Claude," in a slim pamphlet dedicated to Cézanne; see, below, his letter of dedication dated 20 May 1866.

14. The Aix painter referred to here cannot be identified. Perhaps it is J.-F. Villevieille, in whose studio Cézanne is supposed to have worked.

15. Baille, who was studying at Marseilles, complained at having been very coldly received by Cézanne during a visit to the Jas de Bouffan, a property purchased by the artist's father in 1859.

16. When Zola planned to be in Aix.

17. In spite of these affirmations of friendship, Zola was soon to reproach Baille with being too logical, objecting that the expression "position in life" appeared too frequently in his letters, that they sounded as though they were written by a well-to-do grocery owner and that they annoyed him. In his despair, Zola was finally to exclaim: "Take your path; I don't know what God has in store for me, but I shall die happy so long as I die free." In order to avoid any unduly personal argument, Zola finally ended up not discussing literary questions with Baille at all.

18. Since Cézanne's father had acquired the Jas de Bouffan property on the outskirts of Aix in 1859, the painter had thought of decorating the walls of the large salon, which the family did not use at first, with murals. Among other things, he was to paint four panels representing the seasons, ironically signed

"Ingres," and, in the place of honor, a portrait of his father reading a news-paper.

19. Chaillan, Combes, Truphème, Villevieille, Chautard and Emperaire were Aix friends who had almost all attended, with Cézanne, the evening drawing courses taught by Gibert at the Ecole d'Art. Cézanne worked there from 1858 to 1862. He, as well as Zola, had a fairly poor opinion of the talents of his fellow townsmen, with the exception of Emperaire. Joseph Chautard, Villevieille's close friend, was later to supervise Cézanne's work in Paris (see Cézanne's letter to Numa Coste and Villevieille of 5 Janury 1863).

20. Chaillan planned to paint Zola as Amphyon, wearing a toga and hold-ing a lyre, his eyes raised heavenward.

21. Zola was to move into this new room on 8 July.

22. Zola's trip to Aix was first postponed from August to mid-September, but in the end it did not occur, probably owing to lack of money.

23. This poem, which seems to have been of a more serious tenor than the others Cézanne had sent to Zola, appears to be lost.

24. This strange epistle was doubtless inspired by Zola's desire to prove to Cézanne that he was a born artist, come what might. However, it is true that the painter cared very little for the "demands of the public" and that he never took his poetic productions too seriously. On the other hand, it was clearly easier for Zola to analyse his friend's literary talent than it was for him to appreciate his pictorial efforts.

25. March 1861.

# [1861]

ZOLA TO CEZANNE

*Paris, 5 February 1861*

*[. . .] The easiest thing for me is to answer your letter. Alas, no, I am no longer roaming the countryside, I no longer wander the rocky paths of Le Tholonet,[1] and, above all, I no longer head, bottle in rucksack, for Baille's country place, that memorable grange of vinous memory; other days, other customs, as popular wisdom puts it. I have become so sedentary that the slightest stroll exhausts me [. . .]*

Photograph of Emile Zola, ca. 1865.

*So we are saying that you're going to paint in the middle of winter sitting on the frozen ground without a thought for the cold. This news I found charming; I say charming not because I take pleasure in seeing you run the risk of catching a terrific cold and one or more chillblains, but because from such devotion I can deduce your love for the arts and the determination you put into your work. Ah, my poor old friend, how far I am from emulating you [. . .] I am coming out of a hard school, that of true love; so that I couldn't concentrate on any subject whatever, so exhausted is my mind. I'll have a lot to tell you about it when you arrive. Such things can't be spelled out in letters; the event is nothing in itself, only the details are important. I even doubt my capacity to communicate to you face to face all the painful or joyous feelings I have experienced. The result is that I now have experience on my side, and that knowing the way I can now guide my friends along it sure-footed. Another result is that I have gained new perspectives on love and that they will be of great service to me in the work I plan to write.*

*[. . .] I see only one thing distinctly: that you must come soon and that that will assuage my cares.*

ZOLA TO BAILLE

*Paris, 22 April 1861*

My dear friend,

Thanks for your letter; it is exasperating, but useful and necessary. The sorry impression I got from it was somewhat diminished by my vague knowledge of the suspicions that were floating about with regard to myself. I felt like an adversary, almost an enemy, in Paul's family; our different ways of seeing, of understanding life, gave me a hint of the small sympathy Monsieur Cézanne must feel towards me. What can I say? everything you tell me I knew already, but I didn't dare admit it to myself. Above all, I didn't believe that anyone could accuse me of such infamy and see in my brotherly friendship only some base motive. I am being frank, I must admit that an accusation coming from such a source rather surprised than saddened me [. . .]

[. . .] As Paul's friend, I would wish to be, if not loved by his family, at least respected; if a stranger, someone I happened to run into and will never see again, should listen to such calumnies about me and believe them, I'd let him do so

*without even trying to dissuade him. But here, it's a different matter; wishing above all to remain a brother to Paul, I am obliged to have frequent dealings with his father, to undergo the scrutiny of a man who despises me and whose dislike I cannot return; on the other hand, I don't at any price want to bring trouble to that family; so long as Monsieur Cézanne thinks me a vile intriguer and so long as he sees his son associating with me, he will be irritated with that son. I don't want it to be like that and I cannot keep silent. If Paul himself doesn't decide to open his father's eyes, I'll have to consider doing it myself. My utter detachment would be out of place here; I must not allow any doubt to fester in the mind of my old friend's father [. . .]*

*There is another detail that I can guess at and that you are concealing from me, doubtless out of affection. You include us both in the reprobation of the Cézanne family; and something tells me that I am the more accused of the two, perhaps even the only one. If such is the case—and I don't think I'm mistaken—I thank you for having taken half of this heavy burden upon yourself and for having thereby tried to alleviate the sad impression of your letter. A thousand details and deductions have brought me to this notion; first, my lack of money, second my almost-acknowledged status as a writer, my stay in Paris, etc. [. . .]*

*The question appears to me thus: Monsieur Cézanne has seen his son thwart the plans he had made for him. The future banker has turned out to be a painter, and feeling the eagle's wings on his back he wants to leave the nest. Completely taken aback by this alteration and this desire for freedom, Monsieur Cézanne, unable to believe that anyone might prefer painting to banking and the open air to his dusty office, has been cudgeling his brains to discover the key to the puzzle. He is unable to understand that all this has happened by the will of God, for God, having made him a banker, has made his son a painter. But having pondered the matter, he has finally decided that it is because of me; that I am the one who has made Paul what he is today, that I'm the one who deprived the bank of his fondest hope. Words about evil companions were doubtless uttered, and behold, Emile Zola, man of letters, is now an intriguer, a false friend, and who knows what else besides. It's even sadder than it is silly [. . .]*

*Fortunately, Paul has doubtless kept my letters; in reading them, it will be clear what my advice has been and whether I've ever led him into wicked ways. Quite the opposite, I often showed him all the drawbacks of his coming to Paris and urged him above all to work things out with his father. . . For that matter, there's no need for me to justify myself here [. . .] I wanted him to be with me, but never in expressing that wish did I advise him to rebel. [. . .]*

*Without trying to, I aroused his love for the arts, but I probably did no more than nourish seeds that already existed, a process that any other outside influence might have effected. I examine myself, and I find no guilt. My conduct has always been frank and blameless. I have loved Paul like a brother, always wishing his happiness, unselfishly, shoring up his courage when I saw that it was wavering, always speaking to him of the beautiful, the just and the good, always trying to raise his spirits and above all to make a man of him. [. . .]*

*True, I barely mentioned money in those letters; I didn't point out to him such and such a way one could earn fabulous sums. True, my letters spoke to him only of my friendship, my dreams, and I don't know how many lofty feelings, a currency not traded in any market in this world [. . .]*

*I joke, but I don't feel like it. In any event, my plan is as follows. After having come to an agreement with Paul, I plan to see Monsieur Cézanne alone and to give him a frank explanation. I have no fears as to my moderation and the calm terms in which I will speak. Here, I can be ironical about my affection [. . .] But face to face with our friend's father, I shall be only what I ought to be—strictly logical and with a frankness based upon the facts [. . .]*

*I tell you all this, and yet I'm still none too sure what I will do. I'm waiting for Cézanne and I want to see him before I decide anything. Sooner or later, his father will be forced to grant me his esteem [. . .]*

*I break off this hasty and unworthy analysis to shout "I've seen Paul!!!" I've seen Paul—do you understand what that means; do you understand all the melody of those three words? He arrived this morning, Sunday, and called me several times from the stairs. I was half asleep; I opened the door trembling with joy and we embraced furiously. He then reassured me as to his father's antipathy towards me; he maintained that you had exaggerated somewhat, doubtless out of zeal. Finally, he announced that his father was asking for me, I must go to see him today or tomorrow. We then went off to lunch together, smoked countless pipes, visited countless parks, and I parted from him. As long as his father is here, we can see each other only rarely, but in a month we firmly plan to share lodgings.*

ZOLA TO BAILLE

*Paris, 1 May 1861*

*[. . .] Last Sunday I went to the painting exhibit with Paul.[2] Although I love the arts, I can hardly bring myself to discuss this latest manifestation by our artists. You don't know their names, the differences in school that separate*

*them, their earlier works, and the briefest of reports would therefore be devoid of interest for you. Wait till you're in Paris and come under the spell of some teacher or other, and then we will admire together, if your god is mine, or we'll argue if we end up in opposite camps. I see Paul very often. He's working very hard, which sometimes keeps us apart; but I can't complain of this reason not to see me. We haven't yet had any outings, or rather, those we have attempted are not worth noting. Tomorrow, Sunday, we were supposed to go out to Neuilly to spend the day by the Seine, swimming, drinking, smoking, etc., etc. But now the weather is darkening, the wind is blowing, it's cold. Farewell to our fine day; I'm not sure how we shall spend it. Paul is going to paint my portrait.*

TO JOSEPH HUOT[3]

Paris, 4 June 1861

Dear Huot,

Ah, good Joseph, good grief! I'm forgetting you . . . and friends, and the cottage[4] and your brother and the good wine of Provence; what you get here is awful, you know. I don't want to go into an elegy in these few lines, but yet, *in all frankness*, I'm not very lighthearted. I scrape along in my petty existence, left and right; Suisse keeps me busy from six a.m. to 11.[5] I eat well enough for 15 sous per meal; it's not a lot, but what do you expect? In any case, I'm not dying of hunger.

When I left Aix behind me, I thought I'd also leave the boredom that harrassed me. All I changed was my address, the boredom followed me. I left behind my parents, my friends, some of my habits, and that's it. And yet I wander around aimlessly almost all day. I have seen, needless to say, the Louvre and the Luxembourg and Versailles. You know the nonsense those *admirable monuments* inspire, it's all *stunning, astonishing, overwhelming*. Don't think I'm turning Parisian . . .

I've been back to visit the Salon. For someone young at heart, for a child awakening to art, one who says what he thinks, it's my opinion that the best things are to be found there because there you have every taste, every genre, coming together and confronting one another. I could give some lovely descriptions here and put you to sleep. Be grateful to me for what I'm sparing you.

J'ai vu d'Yvon la bataille éclatante;
Pils dont le chic crayon d'une scène émouvante
Trace le souvenir dans son tableau vivant,
Et les portraits de ceux qui nous mènent en laisse;
Grands, petits, moyens, courts, beaux ou de pire espèce
Ici c'est un ruisseau; là, le soleil brûlant,
Le lever de Phébus, le coucher de la lune;
Un jour étincelant, une profonde brune,
Le climat de Russie ou le ciel africain;
Ici, d'un Turc brutal la figure abrutie,
Là, par contre, je vois un sourire enfantin:
Sur des coussins de pourpre une fille jolie
Étale de ses seins l'éclat et la fraîcheur.
De frais petits amours voltigent dans l'espace;
Coquette au frais minois se mire dans la glace.
Gérôme avec Hamon, Glaise avec Cabanel,
Müller, Courbet, Gubin, se disputent l'honneur
De la victoire . . .

---

I saw the brilliant battle of Yvon; Pils, whose chic pencil limns the memory of an emotional scene in his vivid painting, and the portraits of those who lead us on leash; the great, the small, the middle-sized, the short, the handsome or less favored. Here there's a brook; there, the blazing sun, the ascent of Phoebus, the setting moon; sparkling daylight, deep brown, Russian clime or African sky; here's a brutal Turk with a bestial expression and there, on the other hand, one sees a childish smile; a pretty girl reclining on purple cushions displays the radiance and freshness of her breasts. Naked little cupids soar through space; a fresh-faced flirt admires herself in the mirror. Gérôme alongside Hamon, Glaise with Cabanel, Muller, Courbet, Gubin, all vie for the honor of triumph . . .

---

(Here, I've run out of rhymes, so it's just as well I leave off . . . it would be presumptuous of me to attempt to impart to you any notion, even a slight one, of the chic of this exhibition.) There are also some magnificent Meissoniers. I've seen nearly everything and I plan to go back again. That, at least, I allow myself to enjoy.

Since my regrets would be useless, I won't tell you that I regret your not being with me to see all that together, but, God knows, that's the truth.

Monsieur Villevieille, with whom I work daily, sends you a thousand good wishes, as well as friend Bourck whom I see from time to time. Chaillan[6] greets you very cordially. Greetings to Salari, Félicien, Rambert, Lelé, Fortis. A thousand good times to all. I'd never finish this if I tried to list them all; tell me if you can how fate is treating all our friends. A thousand regards to your parents; for yourself, courage, good vermouth, not too much boredom, and farewell.

Farewell, my dear friend Huot.

<div align="right">Paul Cézanne</div>

P.S. You also have Combes's greeting, with whom I have just had supper. Villevieille has just sketched out a monster painting, 14 feet high, with figures six feet tall and more.

The great G. Doré has a prodigious painting in the Salon. Farewell again, until we have the pleasure of sharing a glorious bottle.

<div align="right">P. Cézanne,<br>39 Rue d'Enfer.</div>

<div align="center">ZOLA TO BAILLE</div>

<div align="right">*Paris, 10 June 1861*</div>

*[. . .] I rarely see Cézanne.[7] Alas, it's no longer like it was in Aix when we were eighteen, when we were free and without a care for the morrow. Life's demands, different work now separate us. In the morning, Paul goes to Suisse's, I remain writing in my room. At 11, we have lunch, each on his own. Sometimes at noon I go to his place, and then he works on my portrait. He goes off to draw for the rest of the day at Villevieille's; he has supper and goes to bed early, and that's it. Is this what I had hoped? Paul is still the excellent whimsical lad I knew in school. As proof that he is losing none of his originality, I need tell you only that barely had he arrived here than he was talking about returning to Aix; to have struggled for his trip for three years and not to care a straw about it! With a character like that, in the face of such unexpected and unreasonable changes of behavior, I must admit that I hold my tongue and rein in my logic. Proving something to Cézanne is like trying to persuade the towers of Notre Dame to dance a quadrille. He may perhaps say yes, but he won't budge an inch. And be*

*aware that age has increased his stubbornness [. . .] He is all of a piece, stiff and*
*hard to reach; nothing makes him bend, nothing can make him give in. He*
*doesn't even want to argue about what he thinks; he abhors argument, first*
*because talk is tiresome and secondly because if his adversary were right, he*
*would have to change his mind. And there he is, thrown into life, bringing to it*
*certain notions and unwilling to change unless he himself sees fit; and yet he is,*
*after all, the best fellow in the world, always repeating what you say—the*
*result of his horror of argument [. . .] Should he chance to happen to voice a*
*contrary opinion and if you argue with him, he flies into a fury without*
*thinking, yells that you understand nothing at all about the matter and abruptly*
*changes the subject. Try to argue—what am I saying? even converse!—with*
*such a fellow and you won't gain an inch of ground and will be forced to resign*
*yourself merely to having been allowed to observe a very special personality. I'd*
*hoped that age might have changed him somewhat. But I find him just as I left*
*him. My course of conduct is therefore quite simple: never shackle his fantasy;*
*give him only very veiled advice; rely on his good nature for the continuation of*
*our friendship; never force his hand to shake mine; in short, completely efface*
*myself, always welcoming him with a smile, seek him out without pressing*
*him, and go along with whatever he seeks as the greater or lesser degree of*
*intimacy he wants us to enjoy. My language may surprise you, yet it's logical.*
*Paul will always be for me a good heart, a friend who can understand and*
*appreciate me. Only, since each to his own nature, I must be wise and go along*
*with his moods if I don't want to lose his friendship. To preserve yours, I might*
*be able to rely on logic; with him, it would mean losing everything. You mustn't*
*think that any cloud has come between us; we're still very close, and everything*
*I've just told you arises unfortunately out of the chance circumstances that keep*
*us apart more than I might like*[8] *[. . .]*

ZOLA TO BAILLE

*Paris, 18 July 1861*

*[. . .] For some time now, I have seen Cézanne only rarely. He's working*
*with Villevieille, visits Marcoussis, etc. Yet there has been no break between*
*us. I still believe I will soon arrive at an understanding, and that I will certainly*
*maintain it when you arrive [. . .]*

*I'm counting a great deal on you. It seems to me that your arrival here will be a moral and physical improvement for me [. . .]*

ZOLA TO BAILLE

*Undated*
[*Probably Paris, August 1861*]

*[. . .] my last letter in which I spoke to you about Cézanne. I had tried to judge him, and despite my good faith I was sorry for having come to a conclusion which, after all, is not a true one. No sooner had he returned from Marcoussis, Paul came to see me, more affectionate than ever; since then, we've been spending six hours a day together; we meet in his small room; there, he works on my portrait, during which time I read or we chat together, then, when we've worked ourselves out, we usually go off to smoke a pipe in the Luxembourg. Our conversations range over almost everything, especially painting; our memories also make up a large part of it; as for the future, we mention it only briefly, in passing, either to wish for our total reunion or to wonder about the awful question of achieving success. Sometimes Cézanne holds forth on thrift and ends up by forcing me to go out to have a beer with him. On other occasions, he spends hours on end singing a refrain, inane both verbally and musically, at which times I loudly declare that I prefer the lectures on economy. We're seldom disturbed; a few intruders drop in from time to time to insert themselves between us; Paul determinedly returns to his painting, I pose like an Egyptian sphinx, and the intruder, taken aback by so much work, sits down for a moment, doesn't dare to move, and goes off with a muttered farewell, softly shutting the door behind him. I wanted to give you further details. Cézanne has frequent fits of depression; despite his somewhat feigned contempt for fame, I can see that he longs to achieve it. When the weather is bad, he talks about going back to Aix, no less, and of becoming a clerk in some office. Then I have to launch into a long speech to prove to him the stupidity of such a return; he is easily persuaded and goes back to work. However, this idea nags at him; twice already he has been on the point of leaving; I'm afraid that he may escape me from one moment to the next. If you write to him, try to mention our forthcoming reunion to him, and do it in the most seductive tones; it's the only way to keep him. We haven't yet had*

*an outing owing to lack of funds; he's not rich and I'm even less so. One of these days, however, we hope to take off and go away somewhere to dream. To sum it all up, I'll just say that, in spite of its monotony, the life we're leading is not totally boring; work keeps us from yawning; and then, we have our shared memories to cast a golden glow of sunlight over the whole. Come, and we'll be even less bored.*

*I take up this letter again to tell you more about something I mentioned earlier that happened yesterday, Sunday. I had gone to Paul's, who announced very coolly that he was in the process of packing his trunk to leave the next day. In the meantime, we went out to a café. I didn't preach to him at all; I was so surprised and so convinced that my reasoning would be useless that I didn't put forth the slightest objection. However, I was searching for some ploy to keep him here; at last I thought I had hit upon one and I asked him to paint my portrait. He fell in with this idea with alacrity and thus at least for this time there was no longer any question of his leaving. Then this damned portrait which I thought would keep him in Paris, yesterday almost brought him to the point of leaving it. After having made two starts on it, still unhappy with himself, Paul was nevertheless determined to finish it, and he asked me to sit one last time yesterday morning. Yesterday, therefore, I went to his place; when I came in, I saw the trunk open, the drawers half empty; Paul, with a somber expression, was tossing things pellmell into the trunk. Then he calmly announced, "I'm leaving tomorrow." "And what about my portrait?" I asked. "Your portrait," he replied, "I've just wiped it out. I tried to touch it up this morning, and since it was getting worse and worse, I rubbed it all out and I'm leaving." Once again, I refrained from making any remark. We went to have lunch together, and I didn't leave him until evening. During the day, his feelings became more reasonable, and finally, when we parted, he promised me he would stay. However, this is only poor patchwork: if he doesn't leave this week, it'll be the next; you can expect to see him leave at any time. I even think he may be doing the right thing. Paul may possess the genius of a great painter, he'll never have the genius to become one. The slightest obstacle sends him into despair. I repeat, let him leave if he wants to avoid a lot of unhappiness.*

*My poor friends, you show me very little courage; one succumbs at the outset, the other curses the career he has been led into. You can't imagine how much your weakness in the struggle affects me; I think of our youth, at that cherished link between us; I tell myself that your success ought to lead to mine; and when I see you doubt your own intelligence and judge yourselves incapable, I wonder if*

*it isn't just a question of pride in my still having confidence in my own and in trying to do what you all despair of doing [. . .]*

*It's for you, above all, that I say all this. Paul, good natured and plentifully gifted, nevertheless cannot stand any chiding, however gentle. I let him do as he pleases, trusting to heaven. But you, who will doubtless listen to me, I shall still shout to you: have courage!*

*[. . .] I'd probably come down to the Midi if Paul doesn't leave until September, but he'll never hold out until then. It will mean fifteen more days of separation between us. When you see Paul, give him a severe talking to.*

*P.S. Evidently, Paul is going to stay in Paris until the end of September; but is that his final decision; yet I still hope that he won't change it.*

## [NOTES 1861]

1. A village a few kilometers east of Aix. Le Tholonet served as a model for the village of the Artauds in Zola's novel *La Faute de l'Abbé Mouret*. The Gorge des Infernets, the site of the dam designed by François Zola, opens out at Le Tholonet.

2. The Salon was held every two years at this time. See Cézanne's letter to Huot, below.

3. J. Huot (1840–1898), a friend of Cézanne in his youth, attended the Ecole des Beaux-Arts in Paris in 1864, and from 1887 chief architect for the City of Marseilles. Cézanne mentions him in his letter to Zola dated 14 September 1878.

4. A country house where J. Huot's brothers and friends met.

5. Cézanne had thus followed Zola's advice to study at the Académie Suisse, where he was soon to meet Pissarro, Guillaumin, Oller and several other painters.

6. Chaillan, Jean-Baptiste-Mathieu, an apparently untalented painter, whom Cézanne met in 1858 at the Ecole de Dessin in Aix. In Paris he was briefly a member of Zola's circle. Zola mentions him in many of his early letters.

7. It would appear from this that Cézanne did not move in with Zola after his father's departure.

8. Zola mentions two letters to Baille to which Cézanne had added a few lines; these appear to be lost.

# [1862]

[Returning to Aix in the autumn of 1861 greatly disillusioned by his first visit to Paris, Cézanne entered the parental bank, where, however, his stay was to be fairly brief. The correspondence between the two friends languished for a time. Cézanne finally broke the silence with a letter—now lost—to which Zola replied on 20 January 1862. None of the letters Cézanne wrote to Zola during the year 1862 appears to have been preserved.]

*Paris, 20 January 1862*

My dear Paul,

*It's a long time since I've written you, I'm not too sure why. Paris did nothing for our friendship; perhaps it needs the sunshine of Provence to flourish freely. The chill on our relationship was probably cast by some unfortunate misunderstanding, or some ill-tempered remark taken too much to heart. I don't know why and I don't want to know; stirring up mud only dirties the hands. In any case, I still feel you are my friend; I know that you think me incapable of any kind of base act and that you still have the same high regard for me as you did in the past. If it were otherwise, you would do well to explain yourself and tell me frankly whatever it is you have against me. However, it's not my intention to write you a letter of explanation. I merely want to reply to your letter as your friend and to chat a bit with you, as though your trip to Paris had never been.*

*You urge me to work, and you do it so insistently that anyone would think I found work repugnant. I'd like to try to convince you of the following: that my fervent desire, my daily thought, is to find a position; that only the impossibility of finding anything is keeping me stuck at home [. . .]*

*Baille was not joking when he told you that I would be taking up, probably quite soon, a job as an employee in the Hachette firm [. . .]*[1]

*I see Baille regularly every Sunday and Wednesday.*[2] *We don't laugh very*

*much; it's freezing cold, and the pleasures of Paris, if such exist, cost enormous amounts of money. We are reduced to talking about the past and the future, since the present is so cold and so poor. Perhaps the summer will bring a bit of cheer with it; if you come in March as you promise,[3] if I have a job, if fortune smiles upon us, then perhaps we'll be able to live a bit in the present without too much regret, too much longing. But there are so many if's; failing only one of them and all else crumbles.*

*However, don't think I'm completely crushed. Sick I may be, but not yet dead. My mind is still alert and soaring. I even think that suffering is enlarging me. I see and hear things better. I have acquired new senses for judging certain things that I had lacked before. I'm better able it seems to me to depict certain details of life than I was a year ago. In short, my horizon is widening; and, if I should manage to write some day, my touch will be surer, for I will be writing what I have experienced. Hope! [. . .]*

*And what are you up to? How have you arranged your life? Must we bid farewell to our dreams, and will stupidity thwart all our plans?*

ZOLA TO CEZANNE AND BAILLE

*Paris, 18 September 1862*

*My friends,*
    *The sun is shining and I am shut indoors [at Hachette]. [. . .] What are you doing? and why this silence? [. . .] I'm waiting for a letter; are you going to make me wait for long? I am also still waiting for Paul's copy. Yesterday, a bird from the South flew over my head, and I shouted to it: "Bird, little friend, did you happen to see a picture wandering along the road as you came?" "Nothing," it replied, "but the dusty path. So be sad, they've forgotten you." He was lying, wasn't he?*

ZOLA TO CEZANNE

*Paris, 29 September 1862*

*My dear friend,*
    *Faith has returned; I believe and hope. I have really settled down to work;[4] every evening I shut myself up in my room and I write or read until midnight. The best result of this is that I have recovered some of my high spirits . . .*

*Things are going well; I laugh and I'm no longer bored. Pass this good news on to Baille and tell him that your return will be a final cure for the wounds of the past,—for frankly, the past was responsible for a large part of my despair; it nearly obliterated the future; now I'm completely over it.*

*One hope probably helped to banish my low spirits, and that was the hope of being able soon to shake your hand. I know that it's not yet a complete certainty, but you let me hope and that's already a great deal. I heartily agree with your idea of coming to work in Paris and then going back to Provence. I think that is a way to avoid the influence of the academies and to develop whatever originality one may have. So if you do come to Paris, so much the better for you and for us. We will arrange our lives, spending two evenings a week together and working all the rest. The hours we see each other will not be time lost; nothing gives me so much courage as chatting for a while with a friend. So I'm waiting for you.*

[This is the last letter of the youthful correspondence that has been preserved between Zola and his friends Cézanne and Baille. There are extant later letters from Zola to such friends in Aix as Anthony Valabrègue, Marius Roux, Numa Coste and Philippe Solari, in which Cézanne is occasionally mentioned. These letters are contained in Zola's *Oeuvres Complètes*, collected by his son-in-law Maurice Le Blond, in the volume *Correspondance, 1858–1871*, Paris, 1928. The excerpts of letters in the present volume have been drawn from that collection.

Of Zola's later letters to the painter, only one, dated 4 July 1885, is known to exist.]

## [NOTES 1862]

1. Zola in fact began work as an employee with the publishing house Hachette in February 1862. When his novel, *La Confession de Claude*, appeared in late 1865, it attracted the attention of the legal authorities and inquiries were made at Hachette which considerably upset the staff. Although the Attorney-General eventually concluded that the novel was not immoral, Zola decided to leave his job a few weeks later. He then became an editor on the newspaper *L'Événement*.

2. Baille had just been accepted at the Ecole Polytechnique.

3. In fact, Cézanne was not to return to Paris until November.

4. Zola was then working on a series of short stories that appeared in 1865 under the title *Contes à Ninon*, his first book. *La Confession de Claude* appeared shortly thereafter, dedicated to Cézanne and Baille.

# [1863]

5 January 1863, Paris

Dear friend,

Let this letter be for both you and Monsieur Villevieille, simultaneously. And to start off, I should really have written to you some time ago, it's already two months since I left Aix.

Shall I tell you about the fine weather? No. Yet today the sun, hitherto concealed behind clouds, has just peered in through the window and, wishing to end this last day in glory, as it departs casts a few pale rays down upon us.

I trust that this finds you all in good health. Have courage, and let's try to see each other again soon.

As in the past (for it's only fitting that I tell you what I'm up to) I'm going to Suisse in the mornings from 8 to 1 and in the evenings from 7 to 10. I am working calmly away and I eat and sleep in like wise.

I go fairly often to see Monsieur Chautard, who is kind enough to go over my studies for me. The day after Christmas I had supper at their place, where I sampled the apéritif wine you sent him, my good Monsieur Villevieille—and are your youngsters Fanny and Thérèse well, I do hope so, and the rest of you as well? Please give my respects to Madame Villevieille, your father, your sister and yourself. And by the way, the picture I saw you sketching out, is it making progress? I spoke to Monsieur Chautard about it: he praised the idea and says that you may well accomplish something.

O Coste, young Coste, are you still harassing the most reverend elder Coste? Are you still painting, and how are those academic school evenings going, tell me who is the unfortunate creature holding those X-shaped poses or holding their stomach in for you; are the two horrors from last year still around?[2]

Lombard returned to Paris about a month ago. I learned, not without some difficulty, that he was attending Signol's studio. That worthy gentleman provides rather conventional instruction that enables one to do what he does; it's very pretty, but hardly admirable. To think that an intelligent young man should come to Paris only to be led astray. However, the apprentice Lombard has made a great deal of progress.

I'm also fond of Félicien, cohort of Truphemus.[3]

The good fellow only sees things in the manner of his most illustrious comrade and judges solely in his light. Truphème according to him has dethroned Delacroix, he's the only one who knows color, and thanks to a certain letter he is going to attend the Beaux-Arts. Don't think I envy him.

I've just at this moment received a letter from my father announcing his forthcoming arrival on the 13th of this month; tell Monsieur Ville-vieille to entrust him with whatever he likes and, as for Monsieur Lambert (my address for now being Impasse Saint-Dominique d'Enfer [?]) to write to me or have someone write me some details about the object, where it can be purchased, the preferred method of sending it—I'm at his disposal; that being said, I miss

> Ce temps où nous allions sur les prés de la Torse[4]
> Faire un bon déjeuner, et la palette en main,
> Retracer sur la toile un paysage rupin:
> Ces lieux où tu faillis te donner une entorse
> Dans le dos, quand ton pied glissant sur le terrain
> Tu roulais jusqu'au fond de l'humide ravin,
> Et "Black,"[5] t'en souviens-tu! Mais les feuilles jaunies
> Au souffle de l'hiver ont perdu leur fraîcheur.
> Sur le bord du ruisseau les plantes sont flétries
> Et l'arbre, secoué par les vents en fureur,
> Agite dans les airs comme un cadavre immense
> Ses rameaux dépouillés que le mistral balance.

---

The days when we went off to the meadows of the Torse[4] for a good lunch, palettes in hand to trace some fine landscape on canvas: the place where you almost threw your back out once when your foot slipped and you rolled to the bottom of the dank ravine, and do you remember "Black?"[5] But the leaves yellowed by Winter's breath have lost their

freshness. The plants on the banks of the stream have withered and the tree, shaken by the furious winds, waves in the breeze like an immense cadaver, its naked limbs tossed by the mistral.

---

I trust that the foregoing, which I had not altogether finished, finds you both in good health. My respects to your families, greetings to our friends; I clasp your hands, your friend and brother in painting,

Paul Cézanne

See young Penot and tell him hello from me.

### [NOTES 1863]

1. Coste, Numa (1843–1907), historian, journalist and painter; a boyhood friend of Cézanne and Zola, he was to remain in contact with the novelist, but eventually lost touch with the painter.

2. From 1858 to 1862, Cézanne, along with Coste and a few other friends (Chaillan, Huot, Solari, Truphème) had attended the academic *soirées* at the Ecole des Beaux-Arts in Aix.

3. Truphème, August (1836–1898), painter, pensioner of the City of Aix, brother of the sculptor François Truphème. In 1863, he was to sit, unsuccessfully, for the Prix de Rome.

4. A small river between Aix and the village of Le Tholonet.

5. Black was a dog. Cézanne mentions him again in another letter to Numa Coste.

# [1864]

Paris, 27 February 1864

Dear Coste,

You will forgive the paper I'm using to reply to you. I haven't got any other at the moment . . . What can I say about your unhappy fate, it's a terrible calamity and I can understand how upset you must be about it.[1] I gather that Jules too has had bad luck and that he is going to enlist before he's called up.

One possibility (Baille was with me yesterday evening when I got your letter): if perchance you wanted to anticipate your call-up and could come to Paris to join a corps here, he (Baille, that is) could recommend you to the lieutenant of his corps, because he told me he knew a lot of fellows who graduated from the same school as he did, as well as from Saint-Cyr. What I'm trying to say is that you should think of coming back here, where—albeit enlisted, you would still have many more advantages—leaves, lighter duties, so you could still devote yourself to painting. It's up to you to decide and to see if perhaps it may not turn out well after all. And yet I am well aware that it's not a pretty prospect. If you can manage to see them, say hello to Jules, who must not be pleased, and to Penot, who was supposed to send me news about his family and his father.

As for me, old chap, my hair and my beard are more abundant than my talent,[2] but don't be discouraged about the painting, one can do one's little bit, even though a soldier. I see some here who manage to attend the anatomy courses at the *Ecole de bozards* (which, you must know, has been totally screwed up and separated from the Institut).[3] Lombard is drawing, painting and cutting more of a figure than ever, I haven't yet been able to go see his drawings, with which he tells me he is pleased. For two months, I haven't touched my [*word undecipherable*] after Delacroix.[4]

However, I'll work at it a bit more before leaving for Aix, which I don't think will be until July, unless my father summons me. In two months—that is, in May—there will be an exhibition of paintings like the one last year,[5] if you were here we could go through it together. Let's hope for the best. Give my affectionate regards to your parents, and believe me your devoted friend,

<div style="text-align: right">Paul Cézanne</div>

I'll be seeing Villevieille soon, he will have your greetings for me.

## [NOTES 1864]

1. Numa Coste had drawn an unlucky number in the military draft lottery and therefore had to do seven years' service. Cézanne himself, who was passed as fit for duty by the Review Board in Paris (he informed his parents of this news in a letter that is now lost), managed to purchase a replacement. As for Zola, he was exempted from military service as the only son of a widow.

2. Two months later, Zola was to tell Valabrègue: "Cézanne has had his beard chopped off and has laid its remains on the altar of Venus Victorious."

3. A reference to the Imperial Decree of 11 November 1863 which abolished the Institute's control over the Ecole des Beaux-Arts, and, in particular, its right to appoint the latter's professors. This measure deeply offended Ingres; nevertheless, the new professors continued to be chosen—as they had been in the past—from among members of the Institut.

4. Probably a reference to Cézanne's copy of *La Barque de Dante*.

5. A reference to the Salon des Refusés. This famous attempt to hold a public showing simultaneously with the official Salon of works rejected by the jury was in fact repeated during the Salon of 1864, even though the Salon jury had been much more lenient than in 1863. Adjoining rooms were set aside for submissions considered "unworthy of being entered in the competition for prizes."

# [1865]

Paris, 15 March 1865

Dear Mr. Pissarro,

Excuse my not coming to see you, but I am leaving tomorrow for Saint-Germain and I won't be coming back until Saturday with Oller[2] to bring his pictures to the Salon, since, as he has written me, he has painted a Biblical battle scene, I believe, as well as his large picture which you know. The large one is very fine; I've not seen the other one.

I should like to know whether, in spite of the misfortune you have experienced, you have prepared your canvases for the Salon.[3] If you should happen to want to see me, I spend the mornings at the Suisse and the evenings at home, but set a time that suits you and I'll be there to shake your hand on the way back from Oller's. On Saturday, we bring our canvases to the shed on the Champs-Elysées, they will make the Institut blush with fury and despair. I hope you will have created some fine landscape; with a cordial handshake,

Paul Cézanne

TO HEINRICH MORSTATT[4]

[Aix] 23 December 1865

[This is a postscript to a letter from Antoine Fortuné Marion to Heinrich Morstatt, a German musician, inviting him to come from Marseilles to Aix-en-Provence for Christmas.][5]

The undersigned begs you to accede to Fortuné's invitation: you can make our acoustical nerves vibrate to the noble accents of Richard

Wagner. I shall beseech you to do so . . . please accept my sincere compliments and grant our wish by performing. I sign for Fortuné.

Your old friend,

Paul Cézanne

## [NOTES 1865]

1. Cézanne had met Camille Pissarro (1830–1903) through Armand Guillaumin at the Atelier Suisse. Pissarro did little work there, but came there to see his friends: Guillaumin, Cézanne and Oller. In 1866, Pissarro would attend the Thursday evenings on which Zola was at home to his painter and writer friends. Among all the Impressionist painters, Pissarro was certainly the one with whom Cézanne had the closest ties.

2. Francisco Oller y Cestero, a painter born in Puerto Rico in 1833, a student of Courbet and Couture, had met Cézanne at the Atelier Suisse. In 1865–66, he lived in the same house as Cézanne at 22 Rue Beautreillis in Paris. See Cézanne's letters to Oller of July 1895.

3. The two landscapes submitted by Pissarro were admitted by the jury. In the catalogue, he described himself as a "pupil of Corot." One of Oller's canvases was also admitted, whereas Cézanne's submissions were rejected.

4. Morstatt, Heinrich (1844–1925), a German musician, served his business apprenticeship in Marseilles from 1864 to the end of 1866; it was there he met A. F. Marion, who introduced him to Cézanne. Morstatt was later director of a music school in Stuttgart. For the relationship between the three friends, see: Alfred Barr, "Cézanne as seen in the correspondence from Marion to Morstatt," *Gazette des Beaux-Arts*, January 1937.

5. Marion, Antoine Fortuné (1846–1900), a boyhood friend of Cézanne and Zola. Later he became a professor of zoology at the University of Marseilles and director of that city's Musée d'Histoire Naturelle. He was an amateur painter and appears to have been strongly influenced by Cézanne. The latter painted several portraits of him.

# [1866]

TO M. DE NIEUWERKERKE
Superintendant of Beaux-Arts

Paris, 19 April 1866

Dear Sir,

I recently had the honor of writing to you concerning the two canvases that the jury has just rejected.[1]

Since I have not yet received a reply from you, I feel that I must stress the motives that impelled me to write to you. However, since you have surely received my earlier letter, there is no need for me to repeat here the arguments I felt impelled to put before you. I shall therefore confine myself to telling you once again that I am unable to accept the unauthorized judgment of colleagues whom I have not myself appointed to evaluate my work.[2]

I am therefore writing to you in support of my request. I wish to put myself before public opinion and to be shown anyway. I do not consider that my desire is in any way exorbitant, and, if you were to question all the painters who find themselves in my position, they would unanimously reply that they reject the Jury and that they are eager to participate in one way or another in an exhibition that ought, perforce, to be open to any serious practitioner.[3]

The Salon des Refusés should therefore be reestablished. Even were I to find myself alone in it, it is my ardent hope that the public might at least realize that I am no more eager to be associated with the gentlemen on the Jury than they are to be associated with me.[4]

I trust, Sir, that you will not maintain your silence. I feel that any polite letter deserves a reply.

Please accept the assurance of my most distinguished sentiments.

Paul Cézanne
22, rue Beautreillis[5]

[Without waiting for a reply to this letter, Emile Zola, who had for several weeks been literary editor on the newspaper *L'Evénement*, had asked to be assigned to report on the Salon. On the very day that Cézanne wrote his second letter to the Superintendant of the Beaux-Arts, Zola announced in *L'Evénement* that he had "a severe criticism" to address to the Jury. "I shall probably make many people unhappy, determined as I am to state some bald and unpleasant truths, but I shall derive a keen personal pleasure from relieving my heart of such a heavy burden of compounded anger."

From the end of April to the middle of May, Zola published a series of articles in which he attacked the Jury, ridiculed the professors of the Ecole des Beaux-Arts and, above all, praised the works of Manet, which had been rejected. His unconventional opinions gave rise to a flood of protests, to the point that the author was asked to cut short his series of reports (which were to have run to from 16 to 18 articles) and to confine himself to a sixth and final article in which he made his "farewell appearance" as an art critic. Zola, who had signed his articles with the name "Claude," then published them under his own name in a pamphlet entitled *Mon Salon*, to which he added some of the insulting letters—and a few full of praise—that had been received by the editor-in-chief of *L'Evénement*, and which was preceded by a dedicatory letter to Cézanne.]

EMILE ZOLA: TO MY FRIEND PAUL CEZANNE

*Paris, 20 May 1866*

*It gives me a profound pleasure, my friend, to address myself to you directly. You cannot imagine how I have suffered during this dispute which I have just had with the faceless crowd. I felt myself so misunderstood, I sensed such hatred around me, that the pen often fell from my fingers in discouragement. Today, I can allow myself the warm pleasure of one of those good chats we have been holding together for ten years now. I write these few pages for you alone; I know that you will read them with your heart and that tomorrow you will feel even greater affection for me.*

*Imagine that we are alone together in some out-of-the-way place, above the*

*battle, and that we are talking like old friends who know each other so well that we can communicate by a mere glance.*

For ten years, we have been talking together about the arts and literature. We have lived together—do you remember?—and often dawn would find us still arguing, searching the past, questioning the present, trying to discern the truth and to create for ourselves an infallible, complete religion. We have turned over such hopeless heaps of ideas, we have examined and rejected every system, and after such arduous labor, we came to the conclusion that beyond one's own strong and individual life there was nothing but falsehood and folly.

Happy are they who have such memories! In my own life, you appear to me as that pale young man of whom Musset speaks. You are my entire youth; you are a part of all my joys, all my sufferings. In their fraternal closeness, our minds have developed side by side. Today, as we are setting out, we have faith in ourselves because we have come to know our own hearts and our own flesh.

We were living in our own shadow, cut off, not very sociable; we were content with our thoughts. We felt ourselves lost in the midst of a complacent and frivolous crowd. In all things, we sought the man, we tried to discern the personal in every work, be it picture or poem. We stated our conviction that the masters, the geniuses, are those creators who have individually created a world whole and entire, and we reject the disciples, the impotent, those whose trick is to steal here and there a few meager fragments of originality.

Do you realize that we were unwitting revolutionaries? I have just managed to utter aloud what we have been whispering for ten years. The sound of the dispute has reached your ears, has it not? and you have seen the fine reception our cherished thoughts have been given. Ah, the poor boys who lived so wholesomely in Provence, under the generous sun, in whom such madness and such ill will were smoldering!

For—as you may not have been aware—I am apparently a man of ill will. The public has already ordered up several dozen straightjackets in which to carry me off to the madhouse. I praise only my family and friends, I am an idiot and a rotter, I'm a troublemaker.

That is pitiable, my friend, and very sad indeed. Will it always be the same story? Must one thus always speak like the rest or hold one's peace? Do you recall our long conversations? We said that no new truth could appear without arousing anger and boos. And now, my turn has come to be booed and insulted.

You painters are far more irritable than we writers are. I have spoken my frank opinion on mediocre and bad books, and the literary world accepted my

dictums without getting too angry. However, artists have thinner skins. I barely laid a finger on them before they gave vent to shrieks of pain. There was a riot. Some right-thinking folk feel sorry for me and express concern at the hatred I have brought upon myself; I think they are afraid that someone may cut my throat on some street corner.

And yet, I only expressed my opinion, quite naïvely. I felt I had been far less revolutionary than one of my art critic acquaintances who recently informed his 300,000 readers that Monsieur Baudry was the foremost painter of the day. I have never uttered such a monstrosity. For a brief moment, I feared for that art critic, I trembled lest he be murdered in his bed as punishment for such an excess of zeal. I am informed, however, that he is doing extremely well. It seems that there are some services one can render and some truths one dare not speak.

Thus, the campaign is over, and as far as the public is concerned, I have been beaten. There is applause and there is gloating on all sides.

I was loath to deprive the crowd of its amusement, and so I am publishing Mon Salon. In two weeks, the clamor will have died down, the most partisan will be left with only a vague memory of my articles. In people's minds, I will then be remembered as even more ridiculous and dishonest. The articles will no longer be before the eyes of the mockers, the fleeting pages of L'Evénement will have gone with the wind and things I did not say will be imputed to me, arrant stupidities I did not utter will be repeated. I don't want that to happen, and it is for that reason that I am collecting the articles I submitted to L'Evénement under the pen name Claude. I want Mon Salon to remain intact, I want it to be what the public itself expected.

These are the stained and shredded remnants of a project I was unable to complete. I offer them for what they are, fragments of analysis and criticism. It is not a finished work I am offering readers: it consists, in its way, of exhibits in a trial.

The story is a fine one, my friend. I wouldn't destroy these fragments for anything in the world; they are not worth much in themselves, but they were somehow the touchstone against which I tested the public. We now know how unpopular our cherished ideas are.

And then, it gives me pleasure to voice my ideas for a second time. I have faith in them, I know that in a few years the whole world will come to believe that I was right. I have no fear that they will later on be thrown back in my face.

<div align="right">Emile Zola</div>

[Cézanne spent the summer of 1866 at Bennecourt, a village on the right bank of the Seine across from Bonnières and about ten kilometers from Mantes in the direction of Rouen. It is probable that the painter Antoine Guillemet, with whom he had just become friends in Paris, had recommended this vacation spot. Guillemet was a friend of Pissarro and Courbet; he was a pupil of Corot and Daubigny, the latter of whom sometimes came to paint at Bennecourt. (In this connection, see: R. Walter: "Cézanne à Bennecourt," *Gazette des Beaux-Arts*, February 1962.)

On 14 June 1866, Zola announced to Numa Coste in Paris: "I am leaving at once for the country, where I am going to join Paul. Baille is leaving with me [. . .] Paul was rejected, of course, as were Solari and everyone else you know. They have gone back to work, sure that it will be ten years before they are accepted."

On July 26th—some four weeks after the following letter was written—Zola informed the same correspondent: "Three days ago, I was still in Bennecourt with Cézanne and Valabrègue. They both stayed behind and won't be back until the beginning of next month. As I told you, the place is a real [artists'] colony [. . .] Cézanne is working; he is pursuing even more stubbornly the original path along which his nature impels him. I have great hopes for him. In that connection, we count on his being rejected for the next ten years. At the moment, he is trying to bring off some large works, canvases four to five yards in size [. . .]"

In two short stories, *La Rivière* and *Une Farce ou bohème en villégiature*, Zola described the atmosphere of the gatherings at Bennecourt, where lively discussions between writers and poets, partisans of romanticism, and painters who defended realism were common. Zola was then contemplating and had already begun "a book of high criticism": *L'Oeuvre d'art devant la critique*, which he was never to finish and of which nothing has remained. Among the summer visitors, apart from Cézanne, Zola and Gabrielle Meley, his future wife, and Guillemet, there were several other natives of Aix, among them Solari and his mistress, Chaillan, Valabrègue, etc.]

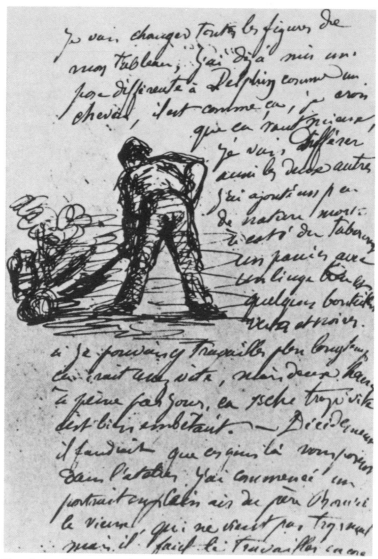

Sketch on a letter to Emile Zola. June, 1866.

TO EMILE ZOLA

[Bennecourt] 30 June 1866

My dear Emile,

I've received the two letters you sent me containing the 60 francs, and much thanks, because I'm even more unhappy when I'm broke. Nothing much amusing must be going on since you don't mention

much in your last letter. Impossible to escape the proprietor.[6] I'm not sure what day I'll be leaving, but it will be either Monday or Tuesday.[7] I haven't worked much, the fair at Gloton was last Sunday,[8] the 24th, and the proprietor's brother-in-law arrived, thus a horde of idiots. Dumont will be leaving with me.

The picture isn't going too badly, but the day seems to crawl by; I must buy myself a box of watercolors to work with when I'm not at my picture. I'm going to change all the figures in my painting; I've already given Delphin a different pose—just a touch different—I think it's better that way.[9]

[Here appears the drawing of a man blowing up the fire in a forge.]

I am also going to alter the two others. I've added some still life next to the stool, a basket with a blue cloth and some green and black bottles.[10] If I could work at it longer, it would go fairly fast, but with barely two hours a day it dries too quickly, which is a nuisance.[11]

These people should really be posing in a studio. I've begun an outdoor portrait of the elder Rouvel,[12] which isn't coming along too badly, but it needs more work, particularly the background and the clothing—on a 40 canvas, a bit larger than a 25.[13]

On Tuesday evening I went fishing with Delphin, and again yesterday evening, by hand, digging in the holes. I caught a minimum of at least twenty yesterday in one single hole. I caught six, one after the other, and once I got three at a time, one in my right hand and two in my left, they were quite large.[14] All of that is easier than painting, but there's little future in it.

Until soon, my dear friend, and my respects to Gabrielle as well as to yourself.[15]

<div align="right">Paul Cézanne</div>

Thank Baille for me, for saving me from financial need.

The food is getting to be too sober and *trychinante*, they'll end up by feeding me with just a big smile.

And greetings to your mother, whom I've neglected, a thousand pardons.

Undated
[Aix, circa 19 October 1866]

My dear Emile,

It's been raining steadily for several days now. Guillemet arrived Saturday evening, he spent several days with me and yesterday—Tuesday—he moved into a small place, nice enough, that costs him 50 francs a month, laundry included. In spite of the heavy rain the landscape is superb and we did some studies. When the weather clears, he's going to get seriously down to work. As for me, I'm overcome by sloth, for four or five days I've done nothing at all. I've just finished a small picture which is, I think, the best I've done; it is of my sister Rose reading to her doll.[16] It's only a three-foot size, if you want it, I'll give it to you; it's the size of Valabrègue's frame.[17] I'm going to submit it to the Salon.[18]

Guillemet's lodgings include a kitchen on the ground floor and a room giving onto the garden that surrounds the countryhouse. He has taken two rooms on the first floor with w.c. He has only the right wing of the house. It's at the beginning of the Route d'Italie, just across from that small house you used to live in and where there's a pine tree you must remember. It's next to Mère Constalin's, the one who had the rustic café.

You know, any picture done indoors, in the studio, never equals things done outdoors. In pictures of outdoor scenes, the contrast of figures to scenery is astonishing, and the landscape is magnificent. I see superb things and I must resolve to paint only out of doors.[19]

I've already mentioned to you a canvas I'm going to try. It's subject will be Marion and Valabrègue (in a landscape of course). The sketch Guillemet liked, the one I did from nature, makes everything else fall by the way and look bad.[20] I truly believe that all the "open air" pictures of the old masters light were done by tricks, for to me none of them have the true and, above all, original look nature alone can give. Old Gibert at the museum, having invited me to visit the Musée Bourguignon,[21] I went with Baille, Marion, Valabrègue. I found everything bad. It's a great consolation. I am fairly bored, only work distracts me a bit, I mope less in company. I see only Valabrègue, Marion and now Guillemet.

Sketch of a future painting on a letter to Emile Zola. Autumn, 1866.

[Here the letter contains a sketch of the portrait of his sister.]

This will give you some small notion of the waffle I'm offering you. My sister Rose is seated in the center holding a small book [that she] is reading, her doll is on a chair, she on an armchair. Black background, head light, blue hairnet, blue child's smock, deep yellow dress, a bit of still life to the left: a bowl and some toys.

You'll give my best to Gabrielle and to Solari and to Baille, who is supposed to be in Paris with his *frater*.[22]

I suppose that now the aftermath of your arguments with Villemessant has blown over,[23] you must be feeling better, and I hope that your work isn't overwhelming you. I learn with pleasure of your entry into the great newspaper.[24] If you see Pissarro, greet him warmly for me.

But, I repeat, I'm somewhat depressed, but for no good reason. As you know, even I can't understand why, it happens every evening when the sun sets and then it rains. That makes me feel very low.

I plan to send you a *saucisson* one of these days, but my mother has to go to buy it, because otherwise, I'd get swindled. That would be very . . . annoying.

If you can imagine, I hardly read anything nowadays. I don't know if you'll agree—and if you didn't it wouldn't make any difference—but I'm beginning to realize that art for art's sake is a bad joke; this, just between ourselves.

Sketch of my forthcoming open air painting.

P.S. I've carried this letter to you in my pocket for four days, and I feel the need to send it to you; farewell, my dear friend,

Paul Cézanne

TO CAMILLE PISSARRO

[Aix, 23 October 1866]

My dear friend,

Here I am in the bosom of my family, the rottenest creatures in the world, the members of it, boring beyond measure. But let's not go into that.[25]

I see Guillemet and his wife daily, they are fairly well installed at 43 Cours Sainte-Anne. Guillemet hasn't yet started any large pictures; he began with a few small canvases that are very good. You're completely right in what you say about gray, it alone prevails in nature, but it's frightfully difficult to capture. The landscape here is very lovely, enormously attractive, and Guillemet did a [study] of it yesterday and today under a gray sky that was very beautiful. His studies seem to me to emerge more than the ones he brought back from Yport last year. I am quite impressed by them. However, you'll be able to judge better when you see them. I've nothing to add, other than that he's going to start on a large canvas very soon now, as soon as the weather improves. In the next letter you get you'll probably receive good news of it.

I've just mailed off a letter to Zola.

I still manage to work a bit, but paints are hard to come by here and very expensive, depression, depression! Let's hope there's a sale. We would sacrifice a golden calf for that. You aren't sending to Marseilles, well, neither am I. I no longer want to submit anything, especially since I don't have any frames, that means additional money that would be better devoted to painting. I say that for myself, and to hell with the Jury.

I think the sun will grant us a few more fine days. I am very upset that Oller, as Guillemet told me, will be unable to return to Paris, for he'll probably be very bored in Puerto Rico and, too, without paints available, it must be difficult to paint. He also told me that he might even join up with a cargo ship that would be coming directly to France. If you happen to write to us again, tell me how to reach him, that is, what address to put on the letter and the proper postage, so that he won't have any useless expenses.

I send you an affectionate handclasp, and after having submitted this letter for Sire Guillemet's perusal, having imparted yours to the aforementioned, I shall do the same with this to the post office. My respects to your family, please, both to Madame Pissarro and your brother. Greetings and farewell.

<div style="text-align:center">Paul Cézanne</div>

*Today, 23 October year of our Lord 1866*

*My dear Pissarro,*[26]

    *I was about to write to you when your letter arrived. I'm not doing too badly at the moment, likewise Alphonsine. I have done a few studies and I'm going to get down to my large spreads, assisted by autumn. Cézanne has done some very beautiful paintings. He's turning to lighter colors and I'm sure you will be pleased with three or four of the canvases he'll be bringing back. I still don't know exactly when I shall be returning, when my pictures are finished probably.*

    *And so you're in Paris, and I imagine your wife likes it there better than Pontoise. I believe the babies are well, and when you get too bored, send us your news. We often speak of you and look forward to seeing you again. All best wishes. My wife and myself send a thousand regards to all.*

    *Until soon.*

*A. Guillemet*[27]

TO EMILE ZOLA

*[Aix] Friday, 2 November [1866]*

*My dear Zola,*[28]

    *For a good month now, I've been here in Aix, this Athens of the South, and I can assure you the time has not seemed long. Good weather, a lovely countryside, friends with whom to discuss painting and construct theories to be demolished the next day—all of that has made my stay in Aix pleasurable. In his two letters, Paul has spoken more about me than about himself, and I shall do the same, i.e., the opposite, and tell you a lot about the master. His appearance has improved, his hair is long, his face glowing with health and his very bearing creates a sensation along the Cours. You can thus rest easy on that score. His morale, while always ebullient, has its calm periods, and painting, abetted by a few firm commissions, promises to recompense him for his efforts; in short, "the sky of the future appears at moments to be less sombre." On his return to Paris, you will see some pictures that will please you a great deal; among others, an* Ouverture de Tannhäuser[29] *that might be dedicated to Robert, since it contains a very successful piano; then there's a portrait of his father in a large*

*armchair looking very genial. The painting is light and very attractive, his father would look like a pope on his throne, were he not reading* Le Siècle.[30] *In short, things are progressing, and we will shortly be seeing very beautiful things, you may be sure.*

*The people in Aix still get on his nerves, they ask to come to see his painting only to disparage it afterwards; he has therefore taken a strong line towards them: "You make me puke," he tells them, and the timid flee in terror. In spite of—or perhaps because of—that, there seems to be a turn in his favor, and I believe that the time is coming when he'll be offered the curatorship of the museum.[31] Which I hope for, since—unless I don't know him very well—I think that we would then see a few quite successful landscapes done with a palette knife and which have only that chance of getting into some museum . . .*

*As for young Marion, whose reputation you know, he cherishes the hope of being appointed to a chair in geology. He is digging determinedly and trying to prove to us that God never existed and that to believe he does is to be taken in. We don't spend much time on that, since it hasn't anything to do with painting . . .*

*We received a letter from Pissarro, who is well . . . We have often been to the dam.[32] We will be returning to Paris around the end of December.*

*I've folded the page because I believe that Paul is going to take this opportunity to write to you; you will have all our greetings in one envelope. I send a hearty handshake. Your devoted friend.*

*A. Guillemet*

My dear Emile,

I am seizing the opportunity of Guillemet's writing to you, and I send you greetings, but I've nothing new to tell you. However, I can inform you that, as you had feared, my large picture of Valab[règue] and Marion has not worked out and that, having attempted a "family evening," that didn't even get started. Nevertheless I shall persevere, and perhaps on another try it will. With Guillemet, we've gone on a third hike, it's very lovely. I clasp your hand, and Gabrielle's.

Paul Cézanne

Greetings to Baille, who sent me his in his letter to Fortuné Marion, geologist and painter.

# [NOTES 1866]

1. This letter appears to be lost.

2. Only artists who had already won prizes at the Salon were permitted to participate in the Jury selection (to which they no longer had to submit their entries). Since he had not yet been accepted by the Salon, Cézanne obviously did not have the right to vote.

3. Cézanne first wrote: "open to everyone . . ."

4. Cézanne was not the only one rejected; the entries of Manet and Renoir had not been accepted, while—among the future impressionists—Degas, Monet, Morisot, Pissarro and Sisley were accepted by the Salon.

5. In the margin of this letter, the sense of the reply to be made is noted: "What he asks is impossible, the complete unsuitability of the Salon des Refusés for the dignity of Art has been made quite evident, and it will not be reestablished."

6. Père Dumont, who, with his wife, née Rouvel (and called Mère Gigoux in Zola's story) ran the small grocery store and the only inn in the region.

7. Cézanne must have put off his departure, for on 26 July Zola informed Coste: "He will be leaving for Aix soon, perhaps in August, perhaps not until the end of September. He will spend at the most two months there." In fact, Cézanne was to remain until the end of the year in Aix, where Guillemet came to join him.

8. A small place only a few hundred yards from Bennecourt. In the years following, Zola was to return to Bennecourt and Gloton.

9. Delphin, then fourteen years of age, was the son of the blacksmith, J.-J. Calvaire-Levasseur, with whom Zola (and perhaps Cézanne) stayed in 1868.

10. It is not possible to identify this picture from this description; it is undoubtedly some destroyed or lost work.

11. Since Delphin helped his father in the smithy, he had little time for posing.

12. Rouvel, then seventy years of age, was the father of Madame Dumont, the innkeeper's wife.

13. The dimensions of a 40 canvas are 100 x 81 cm; those of a 25 canvas, portrait, are 81 x 65 cm. According to the artist's description, this could be the *Tête de vieillard* (Venturi, No. 17), in which the clothing and the background are sketched in. However, that canvas measures only 51 x 48 cm. Perhaps this is a part of the original work.

14. This obviously refers to freshwater crabs that were caught at night in small creeks when, blinded by the light, they could even be taken by hand. They can also be found and caught in this fashion in the region around Aix.

15. Gabrielle-Eléonore-Alexandrine Meley, who was to become Madame Emile Zola in 1870. The novelist had met her around 1863–1864 at Cézanne's, who along with Marius Roux, Philippe Solari and Paul Alexis, was to be a witness at their wedding.

16. Rose Cézanne, born 1854, was the painter's younger sister, Marie Cézanne having been born in 1841. In 1881 she married Maxime Conil, by

whom she had several children. See Cézanne's letter to his nieces Marthe and Paule Conil, his goddaughter. The picture in question appears to be lost.

17. Antonin Valabrègue, poet born in Aix in 1845, was a boyhood friend of Cézanne and Zola. He moved to Paris in 1867 and was later an art critic there. Cézanne painted several portraits of him, one of which measures 116 x 98 cm. and another 60 x 50 cm. He was to publish *Petits Poèmes Parisiens* in 1880; his work on the Frères Le Nain (Paris, 1904) appeared after his death in 1900.

18. According to the Salon's catalogue, this picture was not accepted.

19. These words appear to contradict what Cézanne had written from Bennecourt.

20. Only the sketch for this picture exists (Venturi, No. 96). According to Marion's letters to Morstatt, in this period Cézanne was working on other canvases depicting his friends.

21. This refers to the collection of old masters, generally of the second rank, amassed by J.-B. de Bourguignon (1782–1863) and recently willed to the Aix museum.

22. Philippe Solari (1840–1906), sculptor, boyhood friend of Cézanne and Zola, did two busts of the painter (reproduced in the book by Gerstle Mack) and in particular a handsome bust of the young Zola.

23. Villemessant, editor of *L'Evénement*, in which Zola had published his series of articles on the Salon during the month of May 1866, a series he was forced to abandon owing to vehement public protest. See: E. Zola, *Mes Haines*, and J. Rewald, *Cézanne et Zola*, Paris, Sedrowski, 1936.

24. This must refer to *Le Figaro*, which Zola joined in 1867.

25. The obstacles that Cézanne's father felt impelled to set in the path of his son's artistic career had made the latter feel very strongly against his parents, which explains the foregoing passage. It should be mentioned, however, that later, and especially after the banker's demise, Cézanne was always to speak with a great deal of respect and gratitude about his father, who had assured him of a life free from material concerns.

26. Letter added in Antoine Guillemet's handwriting.

27. Guillemet (1841–1918), during his stay in Aix, tried to get his friend's father to increase Paul's allowance. In future years, Guillemet was to be more closely connected with Zola than with the painter, on whose behalf he nevertheless intervened with the Jury of the Salon, of which he himself was later to be a member.

28. Letter begun by Antoine Guillemet.

29. A later version of this painting is now in Moscow (Venturi, No. 90).

30. In the portrait in question, Cézanne's father is reading *L'Evénement*, not *Le Siècle* (Venturi No. 91). The name of the newspaper, which appears in large letters on the canvas, is obviously a tribute to Zola, who had just published his courageous articles on the Salon in *L'Evénement*.

31. After the proclamation of the Republic on 4 September 1870, Baille, Leydet, Valabrègue and Cézanne's father, then 72 years of age, were appointed to the Aix Municipal Council, while Cézanne himself was appointed a member of the Committee for the Ecole de Dessin and the Museum. However, as

he was hiding out in L'Estaque to escape conscription, he did not attend the meeting of that Committee.

32. This refers to the François–Zola Dam near the Gorges des Infernets, at the foot of Mont Sainte-Victoire, the plans for which had been drawn up by Emile Zola's father, who died shortly before construction work began.

# [1868]

Monsieur
M. Numa Coste
Sergeant, Military Cadet[1]
Place Duplex
In Town
Le Vaguemestre

[Paris] Wednesday, 13 May 1868

My dear Numa,

I've lost the address you gave me. I hope that by sending this note to the Place Duplex (despite the wrong address) I'll be lucky enough to have it reach you. So: I am inviting you to present yourself on Thursday, the 14th, at 5:02 and a half p.m. or thereabouts at the Pont Royal, I believe it is, where it enters the Place de la Concorde, from whence we shall have the pleasure of dining together, since I leave for Aix on Saturday.

If you have any letters or other things to be taken to your family, I will be your faithful Mercury, yours, your friend

Paul Cézanne

If you can't make it tomorrow, try for Friday, same time, if that suits, farewell.

TO HEINRICH MORSTATT

[Aix] 24 May 1868

[Postscripts to a letter from Antoine Fortuné Marion]

My dear Morstatt,

So we shall have the pleasure of seeing you without having to wait until we're in the next world, for according to your last letter you

inform us that you are getting your money. That good fortune makes me very happy for you, for we are all sufficiently exerting every effort for art without material cares having to disturb the work so necessary to the artist. With heartfelt sympathy I shake the hand that need no [longer] be profaned by philistine labours. I had the good fortune to hear the overtures to *Tannhäuser*, *Lohengrin* and *The Flying Dutchman*.

Greetings. All the best.

Paul Cézanne

TO NUMA COSTE

[Aix] Around the first of July [18]68

My dear Coste,

It's been a few days now since I received your news, and I would be hard put to tell you anything new about the homeland of which you are deprived.

Since my arrival, I've been vegetating in the country.[2] I've managed to get away a few times; on two evenings I ventured by your father's, whom I did [not] find in, but one of these days, I expect to find him.

As for Alexis,[3] he was good enough to pay me a visit, having heard from the great Valabr[ègue] of my return from Paris. He even loaned me a little 1840 review by Balzac;[4] he asked me if you were still painting, etc., you know, all the things one chats about. He promised to come again, for a month now I've not seen him. As for me, and particularly since your letter, I've been going off to the Cours in the evenings,[5] which is somewhat contrary to my solitary habits. Impossible to find him. However, impelled by a pressing desire to fulfill my duty, I shall try going by his house. That day, however, I will have first changed my shoes and shirt.

I haven't had any further news from Rochefort, and yet *La Lanterne* has made a stir here.[6]

I did get a glimpse of Aufan, but the others seem to be in hiding and a great void seems to gape around one when one has been away from home for a time. I won't tell you about him. I don't know if I'm living or if I'm merely remembering, but everything makes me pensive. I wandered alone to the dam and out to Saint-Antonin.[7] I spent the night

there, sleeping in a "haystack" with the people at the mill, good wine, good hospitality. I recalled our climbing ventures. Will we ever do that again? An odd part of life, that past time, and one that at the present time would be difficult for the three of us and the dog to go back to, to be where we were such a few short years ago.

I have nothing to distract me save for my family, and a few numbers of *Le Siècle* from which I garner pointless news items. Alone as I am, it's even difficult for me to go to a café. However, underneath it all, I remain hopeful.

Did you know Penot is in Marseilles. I didn't have any luck, and neither did he. I was in Saint-Antonin when he came to see me in Aix. I'm going to try to go down to Marseilles one of these days, and we shall gossip about absent friends and drink to their health. In a letter he said to me "And the bottles of bock will scatter."

P.S. I had left this letter unfinished when on the stroke of noon Dethès and Alexis descended upon me. You can imagine how we talked about literature and the cool refreshments we took, it being a very hot day.

Alexis was good enough to read me a poem that I found really very good, then he recited to me from memory a few verses from another, entitled *Symphonie en la mineur* [Symphony in a-minor]. I found those few lines more special, more original, and I complimented him on them. I also told him of your letter, and according to what he told me he will be writing to you. In the meantime, I send you his greetings, as well as those of my family, to whom I communicated your letter, for which I give you great thanks; it fell like dew under a burning sun. I've also seen Combes, who came out to the country. I send you a hearty handshake, yours with affection.

Paul Cézanne

TO NUMA COSTE

Aix, around the end of November [1868]
It's Monday evening

My dear Numa,

I can't tell you exactly when I shall be returning. But it will most probably be early in December, around the 15th. I'll not forget to see

your parents before my departure and I'll bring back whatever you want.

Since a trunk of clothing is to be sent to me by ordinary post, I can load up with a lot of stuff.

I saw your father some time ago now, and we went to see Ville-vieille. Telling you about it makes me remember to go to see him and above all not to forget it before I leave. But I am going to make a list of everything I have to do and the people I must see, and I'll erase items as I do them, so that I won't forget anything. You gave me great pleasure by writing to me, since it shakes one out of the customary somnolence. The great expedition we were supposed to make to Saint Victoire fell through this summer because of the oppressive heat, and in October because of the rainy weather; from which you can gather how our resolve begins to dissolve. However, what can one do, that's how it is, it seems that we aren't always going to be full of life, as the Latin goes *semper virens*, always vigorous or, rather, eager.

I won't give you any news from here, since save for the initiation of *Le Galoubet* in Marseilles, I know of nothing new. And yet, Gibert *Pater*,[8] a bad painter, refused to allow Lambert to photograph a few canvases in the Musée Bourguignon and thereby cut into his work. A refusal to allow Victor Combes to copy, etc. Noré is a dunce. He is supposed to be doing a picture for the Salon.

They're a bunch of goiters. For 58 months Papa Livé has been sculpting a bas-relief one yard long, he's still on the eye of saint XXX.

It appears that Sire Agay, the young *Fashionable* you know, went to the Musée Bourguignon one day. And Mother Combes says to him: "Give me your cane, Papa Gibert doesn't allow that."

"I don't give a damn," replies the other. He holds on to his stick. Gibert *pater* arrives, he tries to make a scene. "Piss off," Agay shouts. Authentic.

Monsieur Paul Alexis, a fellow of another and better sort altogether and not at all proud, lives on poems *et alia*. I saw him a few times when the weather was good. I saw him again just recently and I gave him your news. He's dying to be off to Paris, without parental consent; he's trying to borrow some money by mortgaging his father's skull and take off to other climes, where the great Valab . . . is beckoning—the latter barely gives any sign of life. Alexis therefore thanks you for your

thoughts and returns same. I told him I thought him a bit lazy, and he told me that if you knew the amount of things he had on his mind (a poet must always be pregnant with some personal Iliad, or rather, Odyssey) you would forgive him. So even if you don't give him a prize for diligence, I feel you must forgive him, for he read me some bits of verse that evidenced a not mediocre talent. He already has an abundance of the feel of poetry.

I give you a somewhat distant handshake until I can do so more closeby, yours, your friend

<div align="right">Paul Cézanne</div>

The word "employee" seems outlandish to me, and yet how am I supposed to refer to you in the exercise of your new occupation?

I can't mail this letter until tomorrow afternoon.

I'm still doing a lot of work on a landscape of the banks of the Arc, it's still for the next Salon, will that be 1869?

## [NOTES 1868]

1. Coste had in fact taken the advice Baille had given him through Cézanne in his letter of 27 February 1864 and had enlisted in Paris.

2. Cézanne was at the Jas de Bouffan, a large property four kilometers from Aix where he painted a large number of landscapes, portraits, etc.

3. Paul Alexis (1847–1901), novelist, was to meet Emile Zola in Paris and to become one of his closest friends. Cézanne mentioned him frequently in his letters.

4. His important study on *Le Chartreuse de Parme* had appeared in *La Revue de Paris*, edited by Balzac, in 1840 and must have been of particular interest to Zola and his friends.

5. The Cours Mirabeau, the principal thoroughfare of Aix-en-Provence.

6. The political journalist Henri de Rochefort was at the time a well-known opponent of the Empire, and his weekly *La Lanterne* was read by all who opposed Napoleon III (including Cézanne's father).

7. A village at the foot of Mont Sainte-Victoire, some ten kilometers from Aix and beyond Le Tholonet.

8. Gibert, Joseph (1808–1884), professor at the Ecole de Dessin d'Aix, was at the same time the curator of the Musée, which had the Collection Bourguignon de Fabregoules. His son Honoré (1832–1891) succeeded him in that position.

# [1870]

[Paris] 7 June 1870

My dear Gabet,

It's already been a long time since I received your letter, and I've been neglectful in not answering you, but now I am redressing my sins against you. In any event, dear friend, you must have received news of me through Emperaire about a month ago,[2] and more recently from my uncle, who promised me he would see you and give you a copy of Stock's caricature.[3] So I have been rejected as in the past, but I'm bearing up not worse than before. Needless to say, I'm still painting and that for the moment, I am well.

I can report that there are many very pretty things in the exhibition, as well as some ugly ones. There is Monsieur Honoré's picture that makes a very fine effect and is well hung. Solari has also done a very pretty statue.

I beg you to offer my respects to Madame Gabet, to kiss little Titin for me. Also give my greetings to your father and father-in-law. Don't forget our friend Gautier, the extinguisher of streetlamps, and Antoine Roche.

My dear friend, I embrace you with all my heart and good courage, yours, your old friend,

P.C.

Is he walking straight ahead, or still to one side, and the great Saint Y . . . ?

## [NOTES 1870]

1. Justin Gabet, cabinetmaker in Aix, was a boyhood friend of Cézanne. He remained in touch with the painter throughout their lives. His studio was located right near the Rue Boulegon, where Cézanne was later to live.

2. Achille Emperaire (1829–1898), a boyhood friend of Cézanne's and himself a painter; physically deformed, he posed for Cézanne on several occasions. See the letters addressed to him by Cézanne in later years.

3. The caricature of Cézanne that appeared in the spring of 1870 in a Parisian weekly published by Stock showed the painter with two of his pictures, a reclining nude and a portrait of Emperaire that had just been rejected by the Jury of the Salon. The accompanying text read as follows: "The artists and critics who were at the Palais de l'Industrie last March 20th, the closing day for the submission of pictures, will recall the ovation given two paintings of a novel genre. . . ." Later, Cézanne was quoted: "Yes, my dear Monsieur Stock, I paint as I see, as I feel—and I have very strong feelings—the others [Courbet, Manet, Monet] feel and see as I do, but they don't dare . . . they create salon paintings . . . I, Monsieur Stock, I do dare . . . I have the courage of my opinions . . . and he who laughs last, laughs best."

*From the Impressionist Period to
the Break with Zola
[1872–1890]*

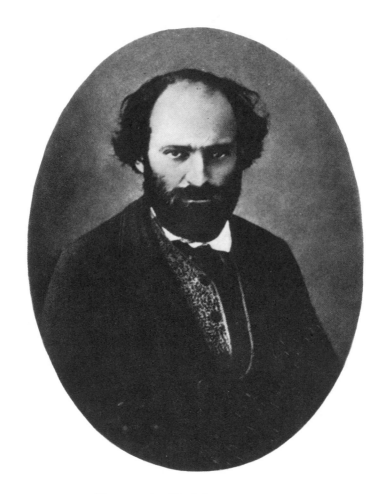

Photograph of Paul Cézanne, ca. 1871.

# From the Impressionist Period to
## the Break with Zola
## [1872–1890]

THE FEW LETTERS that passed between Cézanne and Zola during the 1870 Franco-Prussian war have been lost. Throughout that entire period, Cézanne was staying in L'Estaque, near Aix, on the shores of the Mediterranean, accompanied by Hortense Fiquet, whom he was later to marry after repeated conflicts with his father, from whom he did his best to conceal both his liaison and the child that was to be born in Paris early in 1872.

The two friends were reunited in Paris after the fall of the Commune. A few months after the birth of his son, Cézanne moved to Pontoise, near Camille Pissarro, with the child and its mother. Then, in the autumn of 1872, he moved to the neighboring village of Auvers-sur-Oise, where he remained until 1874.

From this period on, Cézanne's visits to Aix were complicated by the fact that he could not go there with Hortense and the child, or, at least, had to hide them while he was with his parents.

# [1872]

[Paris, January 1872]

My dear Achille,

I must ask you to be a go-between for this letter to my mother.[1] You will forgive me for bothering you so often.

If you were to write to me, it would give me great pleasure. Address your letter to me to 45 Rue de Jussieu—Monsieur Paul Cézanne—or care of Monsieur Zola, 14 Rue de La Condamine. I am including herein a 25-centime postage stamp so that you won't have to run around town for one. You need only toss whatever you are sending me into the post box.

    Yours,

Paul Cézanne

If you need a few tubes, I can send them to you.

### TO ACHILLE EMPERAIRE

[Paris] 26 January 1872

My dear Achille,

I've just seen Zola, who came to 45 Rue de Jussieu. He would like to have four or five more days in order to be able to give you a definite answer. He is trying to obtain a pass, but he hasn't yet managed to get one.[2] A few more days of patience and you will have your reply. Needless to say, I'd be very happy to see you. You won't be very comfortable at my place, but I willingly offer to share my retreat with you.

When you leave Marseilles, be good enough to send me a note by

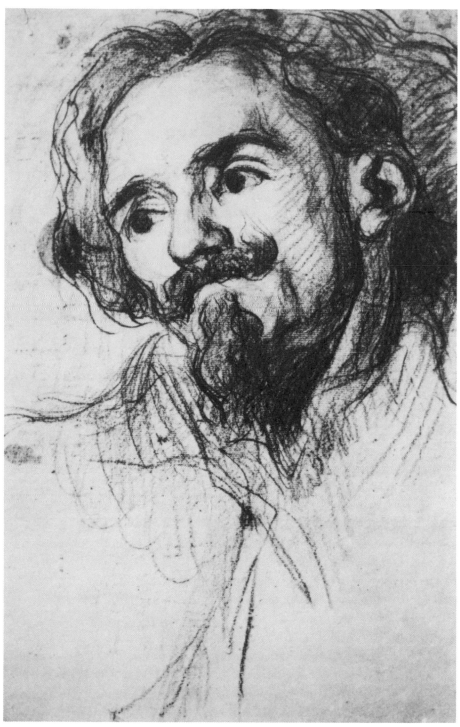

Portrait of Achille Emperaire. Paul Cézanne. Charcoal, 1867–70.

mail telling me the time of your departure and the most likely time of your arrival. I shall be there to meet you with a cart and will carry your luggage to the house. It's in the former Rue Saint-Victor, now called Rue de Jussieu, where I am across from the wine depot, and I'm on the second floor.

In any event, I'll write to you as soon as there is any news.

Yours,

Paul Cézanne

If, as I expect, you have a lot of heavy luggage, bring what you need most with you and send the rest by package mail. I must warn you to bring your own bedding, since I've none to offer you.

TO ACHILLE EMPERAIRE

Paris, 5 February 1872

My dear Achille,

I have received nothing from Batignolles, nor elsewhere. If I have delayed so long in writing to you it's because up until the last moment I had some glimmers of hope. But Zola has just recently informed me that he was unable to procure what I had asked.

If you can undertake to make the trip at your own expense, do so. You will find a welcome at my place.

Believe me, I tried at once and wherever I had any hope. However, I had to face the disappointment of failure.

If, despite this setback, you still intend to come, please send me a note for the reasons I told you in my earlier letter. And I'll be there to meet you at the station.

Believe me, in spite of all these problems, your devoted friend, who only wishes he was somewhere other than in the stew he finds himself so that he might be of assistance to you.

Paul Cézanne

I had a few messy bothers I'll tell you about.

[In fact, Emperaire did go to Paris. In several letters addressed to his friends in Aix, he wrote of Cézanne as follows:

(19 February 1872) "Paul was at the station—I stopped by his place to rest a bit, and then to one of his sculptor friends' for the night."

(17 March 1872) "Paul is rather badly lodged. In addition, there is a racket that would wake the dead—in short, I was able [to stay] here, I accepted, but afterwards when there is some money I won't remain."

(27 March 1872) "I've just left Cézanne's. It was necessary. In that regard, I would have been unable to avoid the fate of others. I found him forsaken by everyone. He hasn't a single intelligent or affectionate friend left. Zola, Solari, etc., et al.—all gone. It's the most astonishing scene imaginable."

A year later, Emperaire would speak of Cézanne in an even more unpleasant manner, and in June, 1873, before returning to Aix, he would write: "But among other worries, I am angrier than ever at the loss of my large packing case. I wasn't at the Rue Jussieu when my baggage arrived, and my noble Amphitryon took it into his head to destroy it. Thanks to this good luck, I now have further expenses."

In the spring of 1872, Cézanne joined Pissarro at Pontoise and then moved Hortense and their child to the nearby village of Auvers-sur-Oise. There, one Dr. Gachet, a friend of many painters and a habitué of the Café Guerbois, also bought a house. He and Cézanne met frequently, and the doctor would acquire a number of paintings from the artist.]

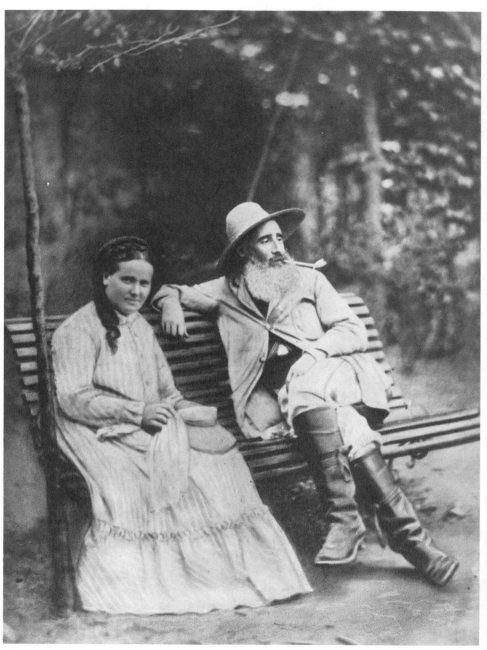

Photograph of Camille and Julie Pissarro, ca. 1877.

TO CAMILLE PISSARRO

[Pontoise, 11 December 1872]

Dear M. Pissarro,

I am borrowing Lucien's pen at a time when the railroad should be carrying me to my hearth. This is to inform you obliquely that I missed the train. Needless to add that I will be your guest until tomorrow, Wednesday.

Now, Madame Pissarro invites me to bring some milk powder from Paris for young Georges.[3] And Lucien's shirts from his aunt Félicie's.

I wish you good evening,

Paul Cézanne

11 December 1872
In the town of Pontoise[4]

[NOTES 1872]

1. Cézanne's mother was aware that her son had a mistress, Hortense Fiquet, but this fact had to be concealed from his father. The painter was therefore unable to correspond directly with his mother to tell her about his private life, since the banker opened the letters addressed to all the members of his family. For that reason Cézanne was frequently forced to importune his friend with messages intended for his mother. It is probable that the secret letter in question contained the news that Hortense Fiquet had just given birth, on 4 January 1872, Rue de Jussieu, to a son whom the artist recognized and who was named Paul Cézanne.

2. Living in total poverty, Emperaire wanted to come to Paris to earn his living by making copies in the Louvre. Apparently, he had hoped to obtain, with Zola's assistance, a free railway ticket.

3. This refers to Nestlé's milk powder, recommended by Dr. Gachet, a friend of the chemist Nestlé. Little Georges Pissarro was just a few weeks older than Cézanne's son.

4. To this letter, Lucien Pissarro, the painter's elder son, added the following lines:

"My dear Papa,

Maman wants you to know that the door is broken and that you must come quickly because thieves can get in. Please if you would be so kind bring me a coloring box. Minette asks if you will bring her a bathing dress. I haven't written this well because I wasn't in the mood.

Lucien Pissarro 1872"

# [1873]

LOUIS-AUGUSTE CEZANNE TO DR. GACHET[1]

Aix, 10 August 1873

Dear Dr. Gachet,

I have received your painful letter of July 19th last in which I learned of the unfortunate demise of your brother's son at the age of 19; I was extremely sorry to hear it and I beg you to believe that I share in your sorrow. You tell me as well that your wife, Madame Gachet, has just borne a child after a very serious months illness but that today she is somewhat improved.[2] I hope that this letter will find her continuing in said improvement and on the way to a complete recovery. Monsieur Paul, from whom I received a letter today to which I am replying, has been behaving well towards you, you tell me, whereby he is merely doing his duty.

Please act as my voice for your honorable family in tendering them their respect as well as that of your most humble servant.

Cézanne

## [NOTES 1873]

1. It would appear that Dr. Gachet had met the banker Cézanne during an internship in Aix. He was to exert his influence with him in an attempt to obtain a more generous allowance for the painter. Indeed, since he was unable to confess the circumstances of his private life to his father, Cézanne was forced to live with his little family on a bachelor's budget.

2. This is the son of Dr. Gachet, also named Paul; the doctor also had an older daughter.

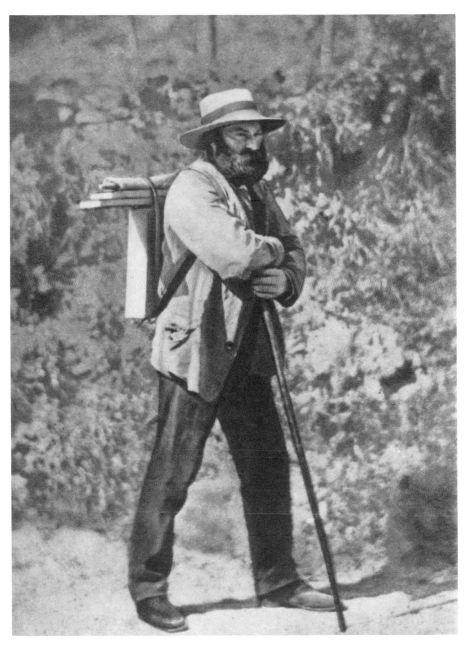

Photograph of Paul Cézanne near Auvers-sur-Oise, 1873.

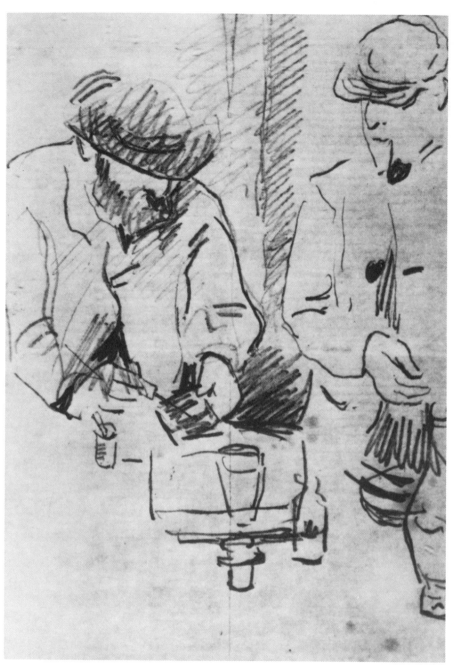

Dr. Gachet and Cézanne. Paul Cézanne. Drawing.

# [1874]

Undated
[Auvers-sur-Oise, beginning of 1874]

I am leaving Auvers in a few days to settle in Paris. As a result, I am taking the liberty of writing to you.

If you would like me to sign the canvas you mentioned, please send it to me in care of Monsieur Pissarro, whereupon I shall affix my signature.

Very sincerely yours

TO THE ARTIST'S PARENTS

Undated
[Probably Paris, circa 1874][2]

In your last letter, you ask me why I haven't yet returned to Aix. In that regard, I told you that I find it pleasant to be with you, even more than you can imagine, but once in Aix I'm no longer free [and] when I want to return to Paris again I always have to put up a struggle; and although your opposition to my returning is not categorical, I'm always very affected by the resistance I feel on your part. I am most eager that my freedom of action be in no way impeded, and if such were the case, it would serve to increase my pleasure and hasten my return.

I am asking papa to give me 200 francs a month, which will enable me to make a real visit to Aix, and it would make me extremely happy to work in the Midi where the scenery offers so many opportunities for my painting. I am really begging papa to be kind enough to grant my request and, I believe, I shall be able to succeed with the studies I want to do in the Midi.

Here are the last two receipts.

Portrait of the artist's father. Paul Cézanne. Crayon, 1879–81.

[Aix] 24 June 1874

My dear Pissarro,

Thank you for having thought of me when I was so far away and for not holding against me my breaking my promise to come out to see you in Pontoise before I left. I've been painting ever since my arrival here, which was a Saturday evening at the end of May. And I sympathize with all the troubles you must be going through. It's really bad luck—the house always filled with illness—yet I hope that by the time my letter reaches you little Georges will be better.

But what do you think of the climate of the country you live in?

Don't you think that it has an influence on your children's health? I regret that new circumstances are distracting you from your studies, for I know how a painter feels when he is unable to paint. Now that I've taken another good look at this part of the country, I think it would totally satisfy you, because it reminds me amazingly of your sunlit study of the railroad crossing.[3]

For a few weeks I was without news of my child and I was quite concerned, but Valabrègue just arrived here from Paris, and yesterday, Tuesday, he brought me a letter from Hortense which contained news that he was fine.

I read in the newspapers about Guillemet's great success, and the happy event for Groseillez, whose picture was bought by the admini- str[ation] after having been awarded a medal. Which goes to prove that by following the path of Virtue, one is always rewarded by mankind, if not by painting. I would be happy if you could give me some news of Madame Pissarro following her delivery and if you could tell me if there are any new members in the Co-op.[4] However, not if it should distract you from your tasks.

I'll let you know about my return when the time is ripe, and about what I've managed to wrest from my father, but he is going to allow me to return to Paris. Which is already a lot. I recently saw the director of the Musée d'Aix, who, impelled by a curiosity nourished by the Parisian newspapers that have mentioned the cooperative, wanted to see for himself the extent to which Painting was being threatened. However, when I assured him that my progress would hardly give him a correct idea of the progress of the disease and that he should see the pictures of the major Parisian offenders, he said: "I'll be able to get a good enough idea of the dangers threatening Painting by looking at your attacks upon it." Whereupon he arrived, and when I told him for example that you were replacing a model with studies in tonalities and that I was trying to make him understand by reference to nature, he closed his eyes and turned away. However, he said he understood, and we parted happy enough with one another. But he's a fine fellow, who made me promise to persevere, patience being the mother of genius, et cetera.

I almost forgot to tell you that Mama and Papa have told me to pass on their most affectionate greetings.

A word for Lucien and Georges, with a kiss. My respects and thanks

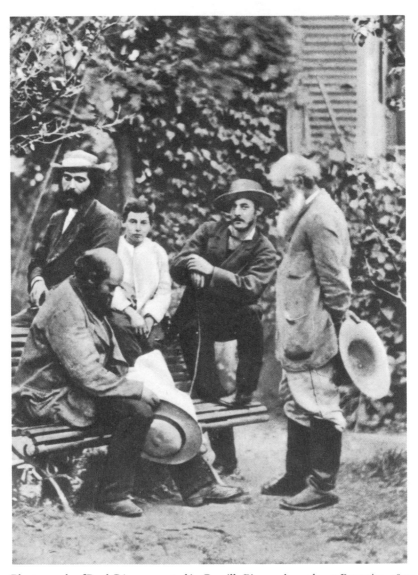

Photograph of Paul Cézanne seated in Camille Pissarro's garden at Pontoise, 1877. Pissarro is standing at the right.

to Madame Pissarro for all the kindnesses you have shown to me during our stay in Auvers. And a hearty handshake for yourself, and if wishes could make things go well, you may be sure that I would make them.

    Yours,

<div style="text-align: right">Paul Cézanne</div>

Portrait of the artist's mother. Paul Cézanne. Pencil, ca. 1885.

## TO THE ARTIST'S MOTHER

[Paris] 26 September 1874

Dear Mother,

First, let me thank you for having thought of me. The weather has been awful for several days now and very cold. But it doesn't bother me and I'm keeping warm.

I look forward with pleasure to receiving the promised trunk. You can send it to 120 Rue de Vaugirard. I should be here until January.

Pissarro has not been in Paris for about a month and a half; he's in Brittany,[5] but I know that he thinks well of me, given my own good opinion of myself. I'm beginning to feel stronger than those around me, and you know that I have reasons for the good opinion I have of myself. I must work continuously, not to attain some end, which gives rise to the admiration of idiots. This thing that is so appreciated by the vulgar is no more than mere craftsmanship, which makes any work it produces inartistic and commonplace. I must seek for completeness solely for the pleasure of working more truly and wisely. And believe me, a time always comes when one is recognized and gains admirers

who are much more fervent and convinced than those who are only taken in by some vain surface appearance.[6]

The times are bad for sales, all the bourgeois are loath to relinquish a cent, but that will change.

*        *        *

My dear mother, give my sisters my greetings.
And greetings to Monsieur and Madame Girard, and my thanks.
Yours, your son,

Paul Cézanne

[On 17 December 1874, a plenary meeting of the Société anonyme coopérative des artists, etc., was held in Renoir's studio, 35 Rue Saint-Georges in Paris, which neither Cézanne nor Pissarro (who was in Montfoucault at the time) attended. The treasurer's report revealed that—all outside debts having been settled—the Société's liabilities stood at 3,713 francs (money advanced by the membership), whereas its assets amounted to only 277.00 francs; each member was therefore liable for a sum of 184.50 francs towards settling internal debts. It was unanimously decided at that point to liquidate the Société.

Since Cézanne had paid only 61 francs for his shares in the Société, he still owed 25 centimes.

Because of the very slim budget on which he was living, it is likely that Cézanne had been forced to apply to his father in order to pay his debts to the *Société anonyme*. This would furnish clarification of the letter he was to write to his parents on 10 September 1876.]

# [NOTES 1874]

1. The draft of a letter on a sketch of the farm at Jas de Bouffan, with a landscape of Auvers on the back. This letter was probably addressed to Monsieur Rondès, a grocer in the Rue de la Roche in Pontoise, who had accepted some of Cézanne's paintings in payment of his debts, on Pissarro's recommendation.

2. Only the draft of this letter exists, on the back of which appears a sketch of two peasants. It is impossible to fix the date on which it was written, but in

all probability it was during the painter's stay in Paris, Pontoise, or Auvers, where Cézanne stayed for three consecutive years without returning to the Midi, as he had done in most previous years. The request for money, a condition for his return, can be explained by the fact that Cézanne wanted to ensure funds for Hortense Fiquet and his child during his absence. There is every reason to believe that he wrote this letter to his parents before visiting them in the summer of 1874. In a letter to Zola dated 28 March 1878, Cézanne was later to report that his father had earlier promised him a monthly allowance of 200 francs.

3. This refers to a landscape of Pontoise, 1873–1874; see L. R. Pissarro and L. Venturi, *Camille Pissarro, son art, son oeuvre*, Paris, 1939, No. 266.

4. This "coopérative" was the *Société anonyme des artistes, peintres, sculpteurs et graveurs*, whose first exhibition (15 April – 15 May 1874) had just closed in Paris, Boulevard des Capucines. Cézanne had shown several canvases. His picture *La Maison du pendu*, painted at Auvers, had been purchased by the Comte Doria.

5. Terribly short of money, Pissarro had been forced temporarily to abandon his house in Pontoise and "take refuge" with his wife and their three children (a fourth child had just died in April 1874, aged 9 years) at the home of his friend Piette, who owned a large farm at Montfoucault.

6. This parenthetical portion appears to refer to the impressionist exhibition at which Cézanne had shown his works to the public for the first time. The smashing failure of that show had apparently not discouraged him.

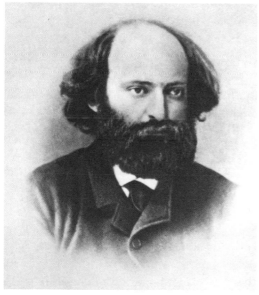

Photograph of Paul Cézanne, ca. 1875.

# [1876]

[Aix] April 1876

My dear Pissarro,

Two days ago, I received a packet of catalogues and newspapers about your exhibition at Durand-Ruel.[1] You must have read them. Among other things, I saw a long, savage attack by Sire Wolf.[2] Monsieur Choquet was the person who gave me the pleasure of such news.[3] I also learned from him that Monet's *La Japonaise* had been sold for two thousand francs. According to the papers, it appears that the Salon's rejection of Manet caused quite a stir and that he exhibited at home.

Before leaving Paris, I met a certain Authier [?] whom I once mentioned to you. He is the young man who signs the articles on painting with the name Jean-Lubin. I told him what you had shown me about yourself, Monet, etc., but (as you have probably found out since) he had not intended to write the word "Imitator," but "Initiator," which completely alters the meaning of the article. As for the rest, he told me that he felt obliged, or at least that it was fitting, that he not say too much against the other painters at Durand's. You will understand why.

The article in *Le Rappel* by Blémont seems to reveal a better view of things,[4] in spite of an undue reticence and a long preamble in which he gets somewhat lost. It seems to me that you're accused of Blue because of your mist effects.

It's been very aquatic here for the last two weeks. I very much fear that the same weather has prevailed everywhere else. Down our way, there was such a heavy frost that the fruit and vine harvests were ruined. But that is the advantage of art, painting endures.

I almost forgot to tell you that I was sent a certain rejection letter.[5] It's nothing new or surprising. I wish you fine weather and, if possible, a good sale.

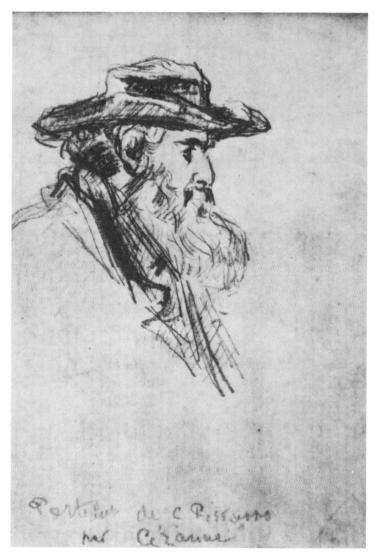

Portrait of Camille Pissarro. Paul Cézanne. Pencil, 1873.

Please give my respects to Madame Pissarro, as well as greetings to Lucien and your family.

With a cordial handshake,

Paul Cézanne

Don't forget Guillaumin when you see him, or Monsieur and Madame Estriel.[6]

TO CAMILLE PISSARRO

L'Estaque, 2 July 1876

My dear Pissarro,

I am forced to reply to the elegance of your magic pencil with an iron tip (that is, a metal pen). If I dared, I'd say that your letter was full of sadness. Pictorial affairs go badly, I'm afraid that you must be under a gray influence where morale is concerned, but I'm sure that it's only temporary.

I would like not to touch upon impossible things, and yet I'm always engaged on the very projects that are the most unlikely to be realized. I believe that the landscape here would suit you marvelously. There are some formidable drawbacks, but I believe they're purely accidental. This year, it's been raining two days out of seven every week. It's terrible in the Midi. No one has ever seen anything like it.

I have to tell you that your letter caught up with me in L'Estaque, on the coast, I haven't been in Aix for a month now. I've begun two small subjects showing the sea for Monsieur Chocquet, who had spoken to me about it. It's like a playing card. Red roofs against the blue sea. If the weather improves, I might be able to finish them. In the event, I've done nothing yet. But one could settle on subjects that would require three or four months of work, since the vegetation here doesn't evolve. Olive trees and pines retain their leaves. The sun here is so vivid that it seems to me that objects are always outlined, not only white or black, but blue, red, brown, violet. I may be wrong, but it seems to me that it is the limit of modeling. How happy our gentle landscape painters from Auvers would be here, and that great (fill in three-letter word here) Guillemet. As soon as I can, I am going to spend at least a month here, because it begs for paintings of at least two meters, like the one you sold to Faure.[7]

I hope that the Exhibition by our cooperative is a flop, if we have to show alongside Monet. You may quite possibly think me a swine, but first things first. Meyer, who doesn't seem to have a very successful hand with cooperatives, seems to me to be becoming a cruddy leader, and by trying to push the impressionist exhibition, to be destroying it. He can tire public opinion out and lead to confusion.[8] First, too many

exhibitions one after the other seems bad to me, and on the other hand people who might think they were going to see impressionists see nothing but cooperatives. A chill will set in. However, Meyer must be very determined to damage Monet. Has he made any money out of it? Another question—now that Monet is making money, why, since that exhibition was a success, would he fall into the trap of another? From the moment he succeeds, he's right. I say Monet but I mean: the impressionists.

In the meantime, I'm rather fond of Monsieur Guérin's gentility as he waddles about in the process of mingling with the riffraff of rejected cooperatives. I proffer these few notions a bit crudely, perhaps, but I haven't much subtlety. Don't hold it against me and when we can chat about it upon my return to Paris we'll have the best of both worlds. And if the contrast with the impressionists can help me, I'll show the best things I have with them and something neutral with the others.

My dear friend, I shall end by saying like you that since there is a common tendency among a few of us, let's hope that necessity will lead us to act together, and that interest and success will strengthen the bond that goodwill has often not been sufficient to consolidate. Finally, I'm very happy that Monsieur Piette is on our side.[9] Give him my greetings, my respects to Madame Piette, to Madame Pissarro, and my friendship to the entire family, a hearty handshake for yourself, and fine weather.

If you can imagine, I'm reading the *Lanterne de Marseille* and I'm going to delve into *La Religion laïque*. Don't laugh!

I'm waiting for Dufaure to be laid low, but from now to the partial turnover in the Senate, how long it will be and what pitfalls.

Yours,

Paul Cézanne

If the looks of the people around here could kill, I'd have been dead a long time ago. They don't like my appearance.

P.C.

I may be returning to Paris at the end of this month, if you want to answer me beforehand, write to: Paul Cézanne, Maison Girard (dit Belle), Place de l'Eglise à l'Estaque, Banlieu de Marseille.

TO THE ARTIST'S PARENTS

[Paris] Saturday, 10 September 1876

My dear parents,

I'm writing to give you my news and to receive yours in return. I am well and hope to hear the same thing from your end.

I went to Ussy [les Moulineaux] to see my friend Guillaumin. I ran him down and had dinner with him last Wednesday. I learned from him that the exhibition organized by the painters on our side went very well last April. The rent of the place where the exhibition was given, Rue Le Peletier and Rue Laffitte (you enter on the Rue Le Peletier and exit onto the Rue Laffitte) came to 3,000 francs. Fifteen hundred francs were put down and the renter was supposed to get the additional 1500 from the price of entry.[10] Not only were the 3,000 francs made up, but the 1500 francs the artists had advanced in equal shares were also re-imbursed,[11] plus a 3 franc dividend, which doesn't mean a lot, of course . . . but it was a good beginning. And already, the artists from the official exhibition have come to rent the space, having learned of this small success, but it had already been reserved for next year by the people who showed there this year.[12]

According to what Guillaumin told me, I am one of the three new members who is supposed to take part, and I was very hotly defended by Monet at a dinner meeting that was held following the exhibition when someone named Lepic spoke out against my being included.[13]

I haven't yet managed to see Pissarro nor any of the other people I know, since I got down to painting the very day after I arrived . . .[14]

TO DR. GACHET

Thursday a.m., 5 October [1876]

My dear Doctor,

I am suffering at the moment from a fairly intense headache which makes it impossible for me to accept your invitation.

Please excuse me. Guillaumin, whom you will see this evening and

with whom I spent yesterday, Wednesday, in Issy, will be able to tell you about my attack.

I would be poor company at that fine reunion which, were it not for this damned mishap, I would have been so happy to attend.

Please be assured of my great regrets,

Yours,

Paul Cézanne

## [NOTES 1876]

1. This refers to the second impressionist exhibition in which Cézanne did not participate and which was held at the gallery of the dealer Durand-Ruel.

2. Albert Wolf, art critic for *Le Figaro*, was staunchly hostile to the impressionist movement and called the young artists "madmen." His article, along with others that appeared on the exhibition at Durand-Ruel, is reproduced in Chapter XIV of Gustave Geffroy's book *Claude Monet*, Paris, Cres, 1924.

3. For Victor Chocquet, see the note to the letter to Choquet of 28 January 1879.

4. In an article published 9 April 1876 in *Le Rappel*, Emile Blémont had spoken of the impressionists with some sympathy, stating, among other things: "They do not imitate; they translate, they interpret, they strive to bring out the overall effect of the many lines and colors that the eye perceives all at once when viewing."

5. As in the past, Cézanne was to continue to submit his canvases to the official Salon, by which his submissions were, however, always rejected.

6. Armand Guillaumin (1841–1927) was, it would appear, the first painter with whom Cézanne was friendly in Paris.

7. This refers to a landscape, 1.50 x 2 meters, entitled *Les Coteaux de l'Hermitage à Pontoise*, painted circa 1867; see L. R. Pissarro and L. Venturi, *Camille Pissarro, son art, son oeuvre*, Paris, 1939, No. 58. This painting is today in the Solomon R. Guggenheim Museum in New York (J. K. Thannhauser Foundation).

8. After the liquidation of the *Société anonyme coopérative des artistes*, etc., in December 1874, the *Union* was established on 18 August 1875, as a company with changing personnel and capital whose treasurer and moving spirit was the painter Alfred Meyer. Among its members were Pissarro, Béliard and Cézanne, who had shown with the impressionist group. Pissarro was actually a member of the Board of Directors.

This new *Société* was to have opened its doors prior to the exhibitions of Monet and his friends. However, on 24 February 1877, Guillaumin announced to Dr. Gachet: "You know that the exhibition of the *Union* has opened at the Grand Hôtel. We were supposed to be in it, Pissarro, Cézanne and me; at the last minute, we resigned . . ."

9. Ludovic Piette (1826–1877), a landscape painter to whom Cézanne had been introduced by Pissarro. In 1877, Piette showed with the impressionists who—at the time of their fourth group exhibition in 1879—were to organize a small retrospective showing of his works.

10. The renter was Paul Durand-Ruel, with whom Cézanne—almost alone among Monet's friends—never had any direct dealings.

11. Since there were twenty members, this represents 75 francs each. If one can believe a report according to which Albert Wolf had the arrogance to demand the reimbursement of his entry fee of 50 centimes, the 3,060 francs taken in represented 6,120 paying visitors, whereas the first exhibition had attracted only 3,500 (the entry fee 1 franc). However, the 1876 total may also include the profit from the sale of the catalogue.

12. Cézanne (or Guillaumin) is in error. On 27 January 1877, Caillebotte wrote to Pissarro: "We have a lot of trouble with our exhibition. The Durand-Ruel space is entirely rented for a year." The third impressionist group exhibition was held in the spring of 1877 in an apartment at 6 Rue Le Peletier, and Cézanne took part in it.

13. The painter and engraver Ludovic Napoleon Lepic (1839–1889), a pupil of Gleyre, was closely linked with Degas. From 1876 on, he refused to show with the impressionists.

14. The letter breaks off here, and the final portion is missing. It is probable that Cézanne dwelt on the financial success of the show as he did in order to obtain from his father the sum he needed for his membership fee to show with his friends again in 1877.

# [1877]

[In April of 1877, Cézanne participated in the third impressionist group exhibition. He showed sixteen works, principally landscapes and still-lifes, but including a portrait of his friend, Victor Chocquet.]

[Paris] 24 August 1877

My dear Zola,[1]

My heartfelt thanks for your kindness towards me. Please let my mother know that I am in need of nothing, since I am planning to spend the winter in Marseilles. If by December she is willing to undertake to find me a very small apartment—two rooms—in Marseilles, not too expensive but in a neighborhood where there aren't too many murders, she would be doing me a great favor. She might send down a bed and bedding, two chairs that she could take from her place in L'Estaque, in order not to have to spend too much. Here, I must tell you, the weather—the temperature is very often cooled by benevolent breezes (Style Gaut of Aix).

Every day I go out to the park in Issy where I do a few sketches. And I'm not too discontented, but it seems that profound depression reigns elsewhere in the impressionist camp. The golden stream isn't flowing into their pockets, and their studies are at a standstill. We are living in troubled times, and I don't know when poor painting will recover a bit of its former luster.

Was Marguery less unhappy during the last excursion to Le Tholonet? And have you seen Houchard, Aurélien? Aside from two or three painters, I've seen absolutely no one.

Are you going to the Cigale's *agape*?[2] For a month and a half, Daudet's new novel has been appearing in *Le Temps*, yellow posters—even

in Issy—have informed me of this event, and I am also aware that Alexis will be on the bill at the Gymnase.

Is the sea bathing proving healthy for Madame Zola, and as for you, are you cutting through the bitter waves? I send all my respects and a cordial handshake. Farewell then, until your return from the sun-drenched shores.

For all your kindnesses, I am, the grateful painter,

Paul Cézanne

TO EMILE ZOLA

[Paris] 28 August 1877

My dear Emile,

Once again I am having recourse to you to tell my mother not to worry. I have changed my plans. As a matter of fact, execution of the whole thing seems to be fraught with problems. I've given it up.

Nevertheless, I am still planning to come to Aix during December or, rather, towards the beginning of January.

My sincerest thanks. To which I join my family's greetings. Yesterday evening, on the way to my paint dealer's in the Rue Clauzel,[3] I ran into good old Emperaire.

# [NOTES 1877]

1. Zola was with his entire family in L'Estaque at this time, and by entrusting him with passing on his errands to his mother, Cézanne avoided revealing his plans to his father.

2. A reference to the annual banquet held by *La Cigale*, a club founded in 1876 for writers and painters from the South of France.

3. "Père" Tanguy, a dealer in paints and pictures, was one of the first to show an interest in the work of the impressionists and he traded paints for their canvases, which were more or less unsaleable. For many years, his small shop in the Rue Clauzel was the only place Cézanne's pictures could be seen. Vincent Van Gogh mentions him frequently in his letters and was to paint two portraits of the old dealer.

# [1878]

Paris, 4 March 1878

The undersigned, Paul Cézanne, *artiste peintre*, residing in Paris at 67 Rue de l'Ouest, am indebted to Monsieur and Madame Tanguy for the sum of two thousand one hundred and seventy-four francs, twenty-four centimes, for painting supplies received.[1]

Paul Cézanne

TO EMILE ZOLA

[L'Estaque] 23 March 1878

My dear Emile,

I am on the verge of having to provide entirely for myself, if indeed I am capable of it. The situation between my father and myself is becoming extremely tense, and I risk losing my entire allowance. A letter Monsieur Chocquet wrote to me in which he mentioned "Madame Cézanne and baby Paul" completely revealed my situation to my father, who was for that matter already on the alert and full of suspicions and who had nothing better to do than to unseal and read the letter addressed to me before I was able to, even though it was sent expressly to Monsieur Paul Cézanne, *artiste peintre*.

So I am begging you to demonstrate your benevolence towards me and to see if among your acquaintances and through your influence you can put me up somewhere if you think that might be possible. The break between me and my father is not total yet, but I don't think it will be two weeks till my fate will be completely settled.

Write to me (addressing to Monsieur Paul Cézanne, general delivery), whatever you decide you can do about my request.

My sincere greetings to Madame Zola, and a cordial handshake for yourself.

Paul Cézanne

I am writing from L'Estaque, but I'm returning to Aix this evening.

TO EMILE ZOLA

[Aix] 28 March [1878]

My dear Emile,

I agree with you that I ought not turn down the parental allowance too forcefully. However, by the traps set for me, and from which I have thus far managed to escape, I can see that the great question will be that of money and the use I should put it to. It's more than probable that I shall only get 100 francs from my father, even though he promised me 200 when I was in Paris. So I will have to rely on your kindness, especially since the child has been ill for two weeks with a mucous infection. I'm doing everything I can to keep my father from obtaining definite proof.

You will pardon my making the following remark—but the paper you use for writing and for your envelopes must be very thick: I had to pay 25 centimes at the post office because there weren't enough stamps on it . . . and all your letter contained was a double sheet. When you write to me, would you please use only one sheet folded in half?

If in the end my father doesn't give me enough, I will have recourse to you again during the first week of next month, and I'll send you Hortense's address, to whom you can kindly send it.

Greetings to Madame Zola; I shake your hand,

Paul Cézanne

There will probably be an impressionist show; so would you please send in the still life you have in your dining room.[2] In that connection, I received a convocation letter for the 25th of this month, Rue Laffitte. Naturally, I wasn't there.

Has *Une page d'amour* come out in book form?

TO EMILE ZOLA

[Aix] Wednesday evening, 1878

My dear Emile,

My warmest thanks for having sent me your latest book,[3] and for the dedication. I've not yet got far into it. My mother is extremely ill and has been in bed for ten days now, her condition is very serious. I stopped reading at the description of the sun setting over Paris and the onset of Hélène and Henri's reciprocal passion.

I am not the one to praise your book, for you might answer, as did Courbet, that the conscientious artist evaluates himself more justly than anyone else can. Anything I say to you about it is therefore only to communicate what I have been able to perceive in the work. It seems to me that it's a picture painted more softly than in the earlier one,[4] but that the temperament or creative force is still the same. And then, if it isn't heresy to say so, the development of the heroes' passion is built up very carefully. Another observation I've made that also seems right to me is that the settings, by their description, become imbued with the same passion that moves the characters, and thus make a unified whole. They seem to become animate and a part of the sufferings of the living creatures. According to what the papers say, it will be at least a literary success.

I shake your hand and beg you to present my respects to Madame Zola.

Paul Cézanne

You have probably noticed that my letters do not precisely correspond to yours, but that is because I often write before I've read yours, being unable to get to the post office regularly.

P.C.

A last-minute thought: in creating your characters, you follow Horace's precept: *Qualis ab incepte processerit, et sibi constet.*

But probably you don't give a damn, and that's another revenge of Time.

TO EMILE ZOLA

[Aix] 4 April 1878

My dear Emile,

Please send 60 francs to Hortense at the following address:
Madame Cézanne, 183 Rue de Rome, Marseilles.

Despite our arrangement, I've only been able to get 100 francs from my father, and I was afraid he'd give me nothing at all. He's heard from various people that I have a child, and he tries to catch me out every which way. He wants to rid me of it, he says. I say no more. It would take too long to explain the gentleman to you, but you have my word that with him appearances are deceiving. When you can, if you could write to me it would give me pleasure. I am going to try to go to Marseilles, I slipped away Tuesday, a week ago, to go [to see] the child. He's better and I had to return to Aix on foot, since the train marked on my schedule was an error and I had to show up in time for dinner—I was an hour late.[5]

My respects to Madame Zola, and a handshake for you,

Paul Cézanne

TO EMILE ZOLA

[Aix] 14 April 1878

My dear Emile,

I'm just back from Marseilles, which will explain my long delay in replying to you. I could only get your letter last Thursday. Thank you for both dispatches. I'm writing under the paternal eye.

When I went to Marseilles, I was accompanied by Gibert. People like that see all right, but with professors' eyes. As the railway passed near Alexis' field, an absolutely stunning view appears towards the East: Sainte-Victoire and the cliffs overlooking Beaureceuil. I remarked: "What a fine subject!" and he replied, "The outlines are too regular." On the subject of *L'Assommoir*, about which by the way he was the first person to speak to me, he said some very sensible and laudatory things, but always from the technical point of view! Then, after a long pause:

"He really must have studied hard," he went on, "to graduate from the Ecole Normale." I spoke to him about Richepin, he replied: "he has no future." So beside the point: that's the kind of things he says. And yet he's undoubtedly the person most concerned with art in a city of 20,000.

"I have to be careful since I can't be clever."

I wish you good health and my respects to Madame Zola, and thank you,

Paul Cézanne

Villevieille's students insult me as I go by. I'll get my hair cut, perhaps it's too long. I'm working: little result and too far from the norm.

TO EMILE ZOLA

[Aix] May 1878

My dear Emile,

Since you have offered to come to my assistance once again, I ask that you send 60 francs to Hortense, to the same address, 183 Rue de Rome.

I thank you in advance, I understand that right now you must be completely preoccupied with your new book, but later, when you can, if you were to write me about the artistic and literary scene you would give me great pleasure. That would make me feel even closer to Paris and farther away from the provinces.

With my thanks, I ask that you give my respects to Madame Zola.

Paul Cézanne

TO EMILE ZOLA

[Aix] 8 May 1878

My dear Emile,

Thank you for your latest dispatch. Rest assured that it has been of immense service to me and has eased my worries.

My mother is now out of danger, she has been getting up for the past two days, which is a comfort to her, and enables her to sleep better at

night. She was very exhausted for a week. However, I hope that the good weather and good care will put her back on her feet.

I didn't collect your letter until yesterday evening, Wednesday, which explains the long delay between your sending it and my reply.

Thank you for the news of my small canvas.[6] I can easily understand that it couldn't be accepted because of my point of departure, which is too far removed from the end in view, that is, the representation of nature.

I've just finished *Une page d'amour*. You were quite right to tell me that it couldn't be read in installments. I hadn't perceived the connections, it seemed broken up, whereas on the contrary the development of the plot is handled with great skill. It has a great deal of dramatic feeling. Nor had I caught the fact that the action takes place within a confined, condensed framework. It's really regrettable that artistic things aren't more appreciated and that one needs to attract the public with some sensational event that doesn't really belong [?] without, it's true, making a bad effect on the whole.

I read your letter to my mother, and she joins me in wishing you happiness.

My respects to all your family,

<div align="right">Paul Cézanne</div>

TO EMILE ZOLA

<div align="right">[Aix] 1 June 1878</div>

My dear Emile,

Here is my monthly solicitation again. I hope it doesn't bother you too much and that it doesn't seem too importunate. But your offer relieves me of such problems that I'm again having recourse to it. My good family—an excellent one given that I'm a poor painter who has never been able to turn his hand to anything—may be a bit miserly, that's a minor flaw and doubtless quite understandable in the provinces.

Here, then, is the inevitable result of such an introductory paragraph: I'm asking you to be so kind as to send 60 francs to Hortense, who is in other respects well enough.

I am buying the illustrated *L'Assommoir* at Lambert's, the democratic bookseller. *L'Egalité* of Marseilles is putting it out in installments.

I'm still working a bit. Politicians have an awesome power. And how is Alexis?

A handshake for yourself and my respects to Madame Zola,

Paul Cézanne

TO EMILE ZOLA

[Aix] Tuesday, July 1878

My dear Emile,

Please send, if you're still amenable, 60 francs to Hortense. She has moved, her address is now 12 Vieux Chemin de Rome.

I'm planning to go to L'Estaque in ten days.

Girard, known as Belle,[7] has been released from the sanitorium where he'd been stuck because of his temporary mental disorder.

It appears that things didn't turn out too badly in Marseilles. A certain Coste Junior, a municipal councillor, distinguished himself by cracking a few clerical pates.

It's beginning to be oppressively hot. Are you working now? Was there a presentation of decorations on May 30th?[8] The newspapers here say nothing about it, but today I expect to get Monday's *Le Bien Public*.

A handshake, and my greetings to Madame Zola,

Paul Cézanne.

TO EMILE ZOLA

[L'Estaque] 16 July 1878

My dear Emile,

I've been in L'Estaque for a week or so. I was harpooned by Sire Girard, he informed me that you might receive a visit from his father-in-law, who is going to Paris on Friday of this week. We've had to leave the house in L'Estaque; at the moment I'm right next door to Girard, at Isnard's. If you feel like writing, drop me a word about the

decoration, which I didn't see announced in *Le Petit Marseillais*. How-
ever, I hope that it's actually happened.

The hot weather has set in.

Thank you for the latest money you were so kind as to send to
Hortense.

In the meantime, I learned of the end of *Le Bien Public*. Is there a new
paper in which you can fight on behalf of your plays? It's a pity the
paper wasn't able to achieve its goal.

My respects to Madame Zola and greetings to you.

I saw Guillaumin the gardener, back from Cannes where his boss is
going to set up a nursery.

                                                        Paul Cézanne

TO EMILE ZOLA

                                                 [L'Estaque] 29 July 1878

My dear Emile,

Before leaving Paris, I left the key to my apartment with a certain
Guillaume, a shoemaker. What must have happened is this: this fellow
must have had visitors from the provinces because of the Exhibition
and put them up at my place. My landlord, very put out because no one
had told him about it beforehand, sent me, along with the receipt for
my last rent a chilly formal letter informing me that my apartment was
occupied by strangers.[9] My father read aforesaid letter and came to the
conclusion that I was keeping women in Paris. It's all beginning to
seem like some Clairville comedy. Otherwise, everything was going
well, I was looking for a place to live for the winter in Marseilles, work
there and then return to Paris next spring, perhaps in March. That's
when the weather turns bad and I thought I'd be less able to use my
time out of doors. On the other hand, I would be in Paris during the
painting Exhibition.

I congratulate you on your acquisition,[10] and I shall take advantage
of it, with your permission, to get better acquainted with that region;
and if life there weren't impossible for me, I would try to spend a year
or two around there, perhaps at La Roche [Guyon] or at Bennecourt or
somewhere in the vicinity, as I did in Auvers.

I must ask you as in the past to send 60 francs to Hortense, although I am seriously thinking of relieving you of this monthly tax. If I can make a trip to Paris for a month in September or October, I will.

I passed your kind wishes on to my mother, which gave her a great deal of pleasure, I am with her here.

A handshake for you and greetings to Madame and to your mother, who is probably with you. Wishing you fine outings on the water.

Paul Cézanne

Hortense is still at: 12 Vieux Chemin de Rome, Marseilles.

TO EMILE ZOLA

[L'Estaque] 27 August 1878

My dear Emile,

I must have recourse to your kindness again this month, if you can still manage to send 60 francs to Hortense—at 12 Vieux Chemin de Rome until the 10th of September.

I haven't been able to find lodgings in Marseilles as yet because I don't want anything expensive. I plan to spend the entire winter there if my father agrees to give me the money. Then I could continue with some of the studies I've been doing in L'Estaque, from which I shall depart as late as possible.

Thank you in advance, and accept, along with your entire family, my sincere greetings.

Paul Cézanne

TO EMILE ZOLA

*Undated*
[L'Estaque, Summer of 1878]

My dear Emile,

Hortense, having gone to Aix, saw Achille Emperaire. His family is in the most painful of states, three children, winter, no money, etc. . . . you can picture it. As a result, I beg you: 1) Achille's brother being out

of favor with his ex-superiors at the tobacco board, have the files relating to his request withdrawn if there is nothing quickly obtainable for him; 2) see if you can find for him or facilitate his entry into some kind of job, in the docks, for example; 3) Achille is also looking to you for help in finding employment, no matter how small.

So if you *can* do something for him, please try; you know how much he deserves it, fine fellow that he is, and how he suffers oppression and abandonment by those more fortunate than he. There you have it.

In addition, I wanted to write to you apart from that, for it seems to me that I've had no news from you for a long time. I understand that there is probably nothing new. But give me the pleasure of writing me a bit, that will provide some distraction in this long sameness of days. My situation remains as before.

My respects to your son, and your mother, please.

Yours ever,

Write to me care of Monsieur A. Fiquet, etc.

Paul Cézanne

TO EMILE ZOLA

[L'Estaque] 14 September 1878

My dear Emile,

I am able to write to you at present with a calmer mind, and if I've been able to survive various minor mishaps without undue pain, it's thanks to the good, solid plank you have reached out to me. Here is the latest blow to land on me.

Hortense's father wrote to his daughter to the Rue de l'Ouest [Paris] addressing his letter to Madame Cézanne. My landlord immediately forwarded the letter to the Jas de Bouffan. My father opened it and read it . . . you can picture the result. I made violent denials, and since, very fortunately, Hortense's name didn't occur in the letter, I swore it was addressed to some other woman.

I received your book of plays,[11] I've only read five acts so far, three of the *Héritiers Rabourdin* and two of *Le Bouton de Rose*; it's extremely interesting, especially, I think, *Le Bouton de Rose*. *Les Héritiers Rabourdin*

has a certain family resemblance to Molière, which I was rereading last winter. I've no doubt you will make a total success of the theatre. Never having read anything of yours in that form, I had no idea it would be so vividly and well put into dialogue.

I met Huot the architect, [12] who praised your *Rougon-Macquart* to me highly and told me that it was much esteemed by informed people.

He asked me if I ever saw you. I told him: from time to time . . . if you wrote to me, to which I replied: very recently. He was much surprised and I rose in his esteem. He gave me his card with an invitation to visit him. So you see that having friends serves its purpose, and no one will say of me what the oak said of the reed: "If only you grew beneath a canopy of leaves, etc. . . ."

My mother thanks you and is very touched by your thoughts of her. Pelouze has come back from Paris: nothing is good.

Remember me to Alexis and tell him that business firms and artistic reputations are both based on work. [13]

My respects to Madame Zola, and my heartfelt thanks to you.

<div align="right">Paul Cézanne</div>

*Nota bene*: Papa gave me 300 francs this month. Unheard of! I think he's been flirting with a charming young maid we have in Aix. [14] Mama and I are still in L'Estaque.

How things seem to turn out!

<div align="center">TO EMILE ZOLA</div>

<div align="right">L'Estaque, 24 September 1878</div>

My dear Emile,

I got your letter just as I was making a soup of pasta and olive oil, the kind Lantier liked so much. [15] I will be in L'Estaque through the winter, I'm working here. Mama left a week ago for grape picking, jam-making and moving house in Aix; they are going to live in town—behind Marguery or thereabouts. I'm alone here in L'Estaque, I go to Marseilles in the evening to sleep and come back the next morning.

Marseilles is the olive oil capital of France, just as Paris is the butter

capital: you have no idea of the arrogance of this ferocious population, they have only one passion and that's for money; they're said to earn a lot, but they're very ugly—the new facilities of transportation are smoothing over the differences between people, at least on the surface. In a few hundred years, living will be completely useless, everything will have been made the same. However, the little bit that remains is still pleasant to the soul and sight.

I saw Monsieur Marion from a distance on the steps of the Faculté des Sciences. (Should I go to see him, it would take a long time to resolve.) He can't be sincere about art, perhaps unwittingly. [16]

When I said that your comedy, *Les Héritiers Rabourdin*, reminded me of Molière, I hadn't read the preface. For that matter, maybe it was Regnard it reminded me of more, at least as I remember it. If I can get hold of Dancourt, I shall read it. I've almost finished reading *Thérèse Raquin*. [17] Probably the day that you get hold of a very personal and characteristic subject you will achieve success, as with *L'Assommoir*. Indeed, people are not really fair towards you, because if they don't like the plays as plays, they might at least recognize their power and the interaction between characters and the unfolding of the plot.

I send you a handshake and much thanks. My respects to Madame Zola and Alexis.

<div align="right">Paul Cézanne</div>

I think of the Darnagas and of the rabbit's tail.

### TO EMILE ZOLA

<div align="right">[L'Estaque] Monday, 4 November 1878</div>

My dear Emile,

I'm sending this letter to Paris, in the belief that you have gone back to town. The reason for my letter is as follows: Hortense is in Paris on urgent business; I beg you to send her 100 francs, if you can advance me that much. I'm in a real mess but I expect to get out of it. Let me know if you can render me this further service. If it's a problem, I'll try to manage. One way or another, I thank you, and if you write me, write me something about art. I am still hoping to return to Paris for a few months next year, around February or March.

I've just seen in *Le Petit Journal* that they're going to perform *L'Assommoir*. Who did the adaptation, because I don't think it could be you?

Here is where you should send the money, if you can: Mr. Antoine Guillaume, 105 Rue de Vaugirard; he'll pass it on to Hortense.

My greetings to you as well as to Madame Zola and Alexis.

<div align="right">Paul Cézanne</div>

<div align="center">TO GUSTAVE CAILLEBOTTE[18]</div>

<div align="right">L'Estaque, 13 November 1878</div>

My dear Colleague,

When you realize I am a long way from Paris, you will excuse me for having been neglectful of the obligation incumbent upon me at this period of additional sorrow for you. I left Paris around nine months ago, and your letter reached me at the far end of France after lengthy detours and a long time.

Please accept at this time of sorrow for you the assurances of my gratitude to you for the assistance you have given to our cause, and be assured that I share your sadness. Although I did not know your mother, I know well the painful emptiness created by the disappearance of those we love. My dear Caillebotte, I send you an affectionate handshake and beg you to bring your time and concern to bear upon painting, for it is the surest way we can dispel our sorrow.

Please remember me to your father and take heart, if you can.

<div align="right">Paul Cézanne</div>

<div align="center">TO EMILE ZOLA</div>

<div align="right">L'Estaque, 20 November [1878]</div>

My dear Emile,

I received some time ago the news from Paris telling me you had been kind enough to advance me the 100 francs I'd asked you for. A week has passed since then and I have had no further news from Paris. I

have the child here with me in L'Estaque, but the weather has been dreadful for the past few days.

You are, I am sure, terribly busy. I am waiting until the weather clears to continue with my painting experiments.

I bought a very strange book, a tissue of observations of a subtlety that often escapes me, I feel, but what anecdotes and true stories! And proper folk speak of the author as being paradoxical. It is a book by Stendhal: *Histoire de la peinture en Italie*. You've probably read it, but if you haven't allow me to bring it to your attention. I had read it in 1869, but not thoroughly, and I'm rereading it now for the third time. I've just finished buying the illustrated *L'Assommoir*. However, the publisher would probably not have been better served by better illustrations. When I can talk to you about it face to face, I shall ask you if your opinion on painting as a means of expressing feelings isn't the same as mine. I beg you to think of me, I'm still in L'Estaque.

Don't neglect to give my best to Madame Zola, and a handshake for you and Alexis.

<div align="right">Paul Cézanne</div>

<div align="center">TO EMILE ZOLA</div>

<div align="right">[L'Estaque] 19 December 1878</div>

My dear Emile,

I probably indeed forgot to tell you that in September I had moved from the Rue du Vieux Chemin de Rome. At the moment I'm living—Hortense is, at least—at 32 Rue Ferrari. As for me, I'm still in L'Estaque, where your last letter reached me.

Hortense got back from Paris four days ago, which has eased my mind somewhat since I had the child here with me and my father could have caught us out. It seems almost as if there were some kind of conspiracy afoot to reveal my situation to my father, my jackass of a landlord is mixed up in it as well. So Hortense got the money I asked you to send her a month ago, and I thank you, she really needed it. She had a small misadventure in Paris. I shan't put it in writing; I'll tell you about it when I return; it's nothing much in the end. I plan to stay a few

more months here, and leave for Paris around the beginning of March. Here, I had hoped to enjoy utter tranquillity, and, on the contrary, a misunderstanding between myself and the parental authority has made me even more upset. The author of my being is obsessed with the thought of getting me off his hands. There's only one good way of doing that, and that would be to let me have two or three thousand francs more each year instead of waiting till my decease to make me his heir, because I will expire before he does, for sure.

As you say, there are some very beautiful views here. The thing is to capture them, not likely for me, having begun to look at nature a bit late; which, however, doesn't keep it from holding my full interest.

I wish you all a very pleasant Christmas season.

I'll be going to Aix for a few days next Tuesday.

You say nothing about your hunting exploits. Is it because your enthusiasm as well as that of your weapon was not sufficiently long-ranged? A handshake for you.

<div align="right">Paul Cézanne</div>

When you feel like writing to me, still to L'Estaque, please.

TO MARIUS ROUX[19]

<div align="right">Undated draft<br>[circa 1878]</div>

My dear compatriot,

Even though our friendship has not been very actively pursued, in the sense that I haven't often knocked at your hospitable door, I do not hesitate to write to you today. I hope that you will manage to separate my minor standing as an impressionist painter from my person and think only of the comrade. I am not calling upon the author of *L'Ombre et la Proie*, but the Acquasixtain nourished beneath the same sun that shone upon my own birth, and am taking the liberty of sending my friend, the eminent musician, Cabaner, to you.[20] I beg you to look with favor upon his request, and at the same time I also recommend

Sketch on a letter. 1878.

myself to you should it become necessary some day when the sun of the Salon may shine down upon me.

Please accept—with the hope that my request will be well received —the expression of my thanks and my confraternal feelings,

Paul Cézanne

*Pictor semper virus.*

Although I do not have [the honor of knowing her] may I also add my respectful homage to Madame Roux?

## [NOTES 1878]

1. Seven years later, Tanguy was to remind Cézanne of this debt; see his letter dated 31 August 1885.

2. In the end, this exhibition was not held. Later, Cézanne did not participate in the impressionist exhibitions organized between 1879 and 1886. The still life that the painter wished to borrow from his friend was probably the one with a shell and a black clock (Venturi, *op. cit.*, No. 69). It is interesting that the artist should have chosen an early work rather than a more recent canvas.

3. This refers to the novel *Une page d'amour* from the Rougon-Macquart series.

4. The preceding novel in the Rougon-Macquart series was *L'Assommoir*.

5. Aix is approximately 30 kilometers from Marseilles.

6. Cézanne's submission to the Salon had just been rejected yet again.

7. The owner of the house in which Cézanne always stayed in L'Estaque.

8. The decoration Zola was to have received in 1878 was not awarded to him, and he was not named to the Légion d'Honneur until 1888.

9. The landlord of the building at 67 Rue de L'Ouest, where Cézanne had retained a modest apartment while he was working in the Midi, had a wine shop with a billiard table, which enabled him to keep an eye on the comings and goings in the house. Since the artist paid a rent of only 230 francs, rather than the 270 price set, the owner was probably on the lookout for any violation of the lease.

10. Following the great success of *L'Assommoir*, Zola had bought a property in Médan, where he was thenceforth regularly to spend a part of the year, and where Cézanne visited him and worked on many occasions.

11. Zola had written several plays based on his novels, and was at the time attempting to bring naturalism to the stage. In this regard, see the allusions in the letter from Cézanne dated 16 July 1878. At the same time, Zola was

serving as drama critic for *Le Bien Public* and later *Le Voltaire*. In 1881, he collected his articles in a volume entitled *Le Naturalisme au théâtre*. It was this that led Cézanne to mention Molière, Regnard and Dancourt in his letter dated 24 September 1878.

12. This is the same Huot to whom the painter wrote on 4 June 1861.

13. Zola had obviously complained about Alexis, who was fond of going out to dances and did not devote himself to his work with as much regularity as did Zola.

14. The painter's father was 84 years old at the time.

15. A reference to a sentence in Zola's *L'Assommoir*: ". . . his great treat was a kind of pasta soup cooked in water, very thick, into which he poured half a bottle of oil." (Chapter VIII)

16. As with Huot, Cézanne appears to have completely lost touch with this other boyhood friend, Antoine-Fortuné Marion, with whom he had in the past been very close. However, both of them still lived either in Aix or Marseilles.

17. Zola had written a play based on this youthful novel.

18. Gustave Caillebotte (1848–1894), a painter who showed with the impressionists and was a friend of most of them. His wealth enabled him to assist them by purchasing their paintings, especially those considered "unsaleable." He was to leave his entire collection to the State, specifying that it must be accepted as a whole. In spite of that formal proviso, only a part of the Caillebotte collection was accepted—after lengthy negotiations and violent polemics.

19. Marius Roux (1838–1905), a journalist and novelist, boyhood friend of Emile Zola, was a witness at Zola's wedding in 1870, along with Cézanne, Alexis and Solari. Around the same period, he wrote a play with Zola, *Les Mystères de Marseille*. The novel to which Cézanne refers here was entitled *La Proie et l'Ombre*; it appeared in 1878. Since Roux also wrote as an art critic, Cézanne is most particularly asking his favor. At the time of the Dreyfus Affair (1898), Roux broke with his old friend Zola.

20. Cabaner, a musician and philosopher, friend of Renoir, Cézanne, Jean Richepin and Manet. The latter painted his portrait, which now hangs in the Louvre. Cabaner owned an important *Baigneurs* by Cézanne, given him by the artist.

# [1879]

L'Estaque, 28 [January] 1879

My dear Mr. Chocquet,

I am taking advantage of your kindness in asking you to obtain some information for me. Here is the problem. Of course, this is only if you can obtain the aforesaid information without undue trouble and difficulty, otherwise I shall write to Tanguy, which I would have done had I not thought, I believe correctly, that I would be better satisfied and receive more ample clarification from you. Thus, to the point. I should like to know how one must go about getting a picture to the Beaux-Arts administration in order to have it submitted to the jury for evalua-

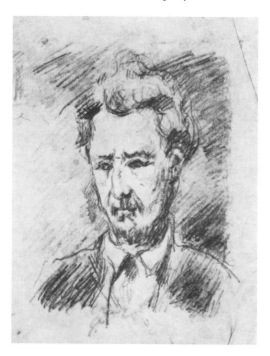

Portrait of Victor Chocquet. Paul Cézanne. Pencil, 1875–77.

tion and then, as I fear will be the case, if the picture is rejected, whether
the kind administration undertakes to return the aforesaid work of art
to its author, should the author happen to be in the provinces? Needless
to add that the artist is not unaware that the sending and return of his
work must be at his expense.[2]

I am taking the liberty of writing to you on behalf of one of my
compatriots. It's not on my behalf, since I shall be coming to Paris with
my little caravan around the beginning of March of this year.

The weather this year has been very aquatic, but in our region very
mild for the past two weeks.

Monsieur Chocquet, please accept my excuses and please share my
respects with Madame Chocquet; my wife and child send greetings.

Your servant,

Paul Cézanne

TO VICTOR CHOCQUET

L'Estaque, 7 February 1879

Monsieur Chocquet,

Thank you, albeit somewhat belatedly, for your kindness in sending
me the information I requested in my last letter.

I think that my friend will be highly gratified at the peremptory and
printed manner in which the higher administration acts towards its
subordinates.

I am happy to learn of Renoir's fine success and let us hope that some
special situation—not too unfortunate for him—is what has kept him
apart from you of late.[3]

My wife who, being charged with providing our daily bread, knows
the difficulty and cares that that entails, shares Madame Chocquet's
torments and sends to her, as does your servant, her most respectful
greetings. As for the child, he is a terror in every way and promises
worse to come.

I close wishing you good health and I am, gratefully, your devoted,

Paul Cézanne

TO EMILE ZOLA

L'Estaque, February 1879

My dear Emile,

I should have written to you some time ago, for I learned from *Le Figaro* and *Le Petit Journal* of the great success of *L'Assommoir* as a play and I wanted to congratulate you on it. I think I will spend only a fortnight more in L'Estaque, after which I will go to Aix, and from there to Paris. If you need anything from the region, I am at your service, or for any errand at all.

Mama joins me in sending her greetings, as well as to Madame Zola and your mother.

A handshake,

Paul Cézanne

TO CAMILLE PISSARRO

[Paris] 1 April 1879

My dear Pissarro,

I think that in the midst of the problems created by my submission to the Salon, it would be better for me not to participate in the impressionists' Exhibition.[1]

On the other hand, I will thereby avoid the problems caused by the difficulties of transporting my few canvases. And I'm leaving Paris in a few days.

I send greetings, until the time comes when I can come to greet you personally,

Paul Cézanne

TO EMILE ZOLA

Melun, 3 June 1879

My dear Emile,

It's June already, and should I come to see you, as you more or less invited me to do recently? I am going to Paris on the 8th of this month,

and if you write me before then, I will take advantage of the occasion to seek you out in your Médan countryside. If you, on the other hand, feel I should put off this little excursion, let me know anyhow.

On May 10th I went by your place, Rue de Boulogne, but I was told that you had left for the country a few days before.

Perhaps you knew that I paid a short hinting visit to friend Guillemet, who, I was told, was sitting on the jury.[5] Alas, without any effect on those hard–hearted judges.

I take this opportunity to thank you for having sent me your pamphlet on *La République et l'Art*. As it happens, Cabaner told me similar things about the situation, but from a darker point of view. Finally, I'm sending the pamphlet to Guillaumin from here, Melun, since he wanted to read it.

Will we have some fine days? The weather doesn't seem very promising. I've tested the water, and yet it didn't seem too cold to me.

My greetings to Madame Zola, as well as to yourself. I got the news about what you are doing and have done from *Le Petit Journal* and *La Lanterne*.

A handshake,

Paul Cézanne

TO EMILE ZOLA

[Melun] Thursday, 5 June 1879

My dear Emile,

So it's set for Tuesday, between 4 and 4:30.

I shall go to Paris during the day Monday and will come to meet you at the Rue de Boulogne the next day.

A handshake,

Paul Cézanne

TO EMILE ZOLA

Melun, 23 June 1879

My dear Emile,

I arrived undampened at the Triel station, and waved wildly out the window of the train when I went past your chateau, which should have revealed my presence to you in the train, which I managed not to miss.[6] Since then, I've received, on Friday I believe it was, the letter that had been sent to me care of you and I thank you; it was a letter from Hortense. During my absence, your book, *Les Haines* arrived here,[7] and today I just bought the issue of *Le Voltaire* in order to read your article on Vallès.

I've just read it and find it magnificent. The book by Jacques Vingtras made me feel very warmly towards the author. I hope that he'll be happy.

Please extend my respects to Madame Zola your mother, and to your wife as well my sincere thanks.

A handshake,

And good health.

Paul Cézanne

If Alexis is with you—greetings—When the opportunity arises, let me know how deep the water in the well turned out to be.

TO EMILE ZOLA

[Melun] 24 September 1879

My dear Emile,

Here is my reason for writing to you—for nothing has happened since I left you last June that could have inspired me to write a letter, even though you were kind enough to say in your last one that I should send you news. Today and tomorrow are so like yesterday that I didn't know what to tell you. But here is what I want: I'd like to see *L'Assommoir*. Can I ask you for three seats? That, however, isn't all; there's a

further problem, and that is the precise time I am asking you for them, namely, for the 6th of October. Would you please see if what I'm asking you doesn't raise too many huge problems? Because first of all, you're not in Paris. I'm not going there either, and I'm afraid that it won't be easy to synchronize the time I will be going to Paris with the obtaining of the tickets. So, if there's a problem, let me know, and don't be afraid of refusing me, for I understand perfectly that you must have already been flooded with similar requests. I learned from *Le Petit Journal* that Alexis had been done successfully.

I'm still trying to contrive some way to find my way, pictorially. Nature presents the greatest problems for me. However, I'm not getting on too badly, following an attack of bronchitis, the same as in '77, from which I suffered for a month. I hope that you are far removed from any similar bother. I trust that this letter finds both you and yours in good health. My father lost his partner a while ago, but he and my mother are doing well, fortunately.

I send you a handshake and beg you to give my sincere greetings to Madame Zola your wife and your mother.

Your devoted,

Paul Cézanne

TO EMILE ZOLA

[Melun] 27 September 1879

My dear Emile,

Thank you very very much. Send the tickets to me in Melun. I am not going to Paris until the morning of the 6th.

I accept willingly your invitation for Médan. Above all for that time of year, when the countryside is really astonishing. It seems that there is more silence. But those are feelings I am unable to express; they're better felt.

Greetings to all of yours and my thanks. A handshake.

Your devoted,

Paul Cézanne

TO EMILE ZOLA

Melun, 9 October 1879

My dear Emile,

I've seen *L'Assommoir*, which pleased me very much. I couldn't have had better seats, and I didn't doze at all, even though as a rule I go to bed shortly after eight o'clock. The interest doesn't let down ever, but, after having seen this play, I dare say that, so appealing did the actors seem to me, they must be able to make a success of lots of plays that are plays in name only. Literary form can hardly be necessary to them. The end of the Copeau is truly extraordinary, and the actress who played Gervaise was totally captivating. However, they all act very well. What's marvelous is the need to make a melodramatic traitress out of the great Virginia, an obligatory concession that must have appeased Bouchardic's spirit, which would otherwise never have known what was going on.

I saw an announcement for the forthcoming appearance of *Nana* for the 15th, on a huge canvas that filled the entire curtain.

Thank you very very much, and when my colleagues with the wide brushes have finished, write to me.

Please give my respects to Madame Zola, your mother and yourself.

A handshake,

Paul Cézanne

TO EMILE ZOLA

Melun, 18 December 1879

My dear Emile,

I've received your last two letters, the one telling me about the snowdrifts and the other about the total lack of thaw. I can easily believe it. Where cold is concerned, we are in the same boat.

On Wednesday it was almost 25 degrees here. Even less amusing is that I can't get hold of any fuel.

Probably I will run out of coal on Saturday and be forced to seek

refuge in Paris. It's quite a winter. I find it difficult to go back to July in my mind, the cold makes the present too vivid.

So it's set for January, if that doesn't put you out. If I go to Paris, I'll give you my address.

A handshake for you, and please give my respects to Madame Zola and to your mother.

<div align="right">Paul Cézanne</div>

Photograph of Mme Cézanne, date unknown.

# [NOTES 1879]

1. Victor Chocquet (1821–1891), customs official and avid collector, began by collecting Delacroix's works and later took up Auguste Renoir. It was through Renoir, who painted portraits of both Chocquet and his wife, that Cézanne, about 1876, met the collector, of whom he too was to paint several portraits and with whom he became friends. Chocquet was one of Cézanne's most fervent admirers and gathered together a very important collection of his works.

2. This request appears odd, but Cézanne, who had always personally delivered his pictures to their destinations, was perhaps unaware how to go about doing so from a distance; unless, he was asking for information on behalf of a friend, Achille Emperaire, for example.

3. Renoir was beginning to receive commissions for portraits, particularly since a large portrait of Madame Charpentier—the wife of Zola's publisher—and her two children, painted in 1878, had been shown with great success in the 1879 Salon.

4. In 1879, Cézanne—and Monet, Renoir and Sisley as well—decided to submit their works yet one more time to the Salon Jury and not to show with the impressionist group. Furious, Degas insisted that henceforth no one be allowed to participate in both exhibitions simultaneously. Since Cézanne was never to give up his hopes of being accepted into the Salon, he was therefore automatically excluded from the exhibitions of his friends. Neither he nor Sisley were accepted by the Jury in 1879.

5. Antoine Guillemet, who—on Corot's advice—had not joined the impressionist group, was now serving on the jury for the Salon, but he was never able to obtain acceptance for any work by Cézanne. In 1882, he finally had recourse to a "favor" granted to jury members, that of being allowed to grant entry to the work of one of their students. Thus, Cézanne was hung in the 1882 Salon as a "pupil of A. Guillemet."

6. The railway crossed Zola's property in Médan.

7. This volume of Zola's early literary and artistic criticism included his *Salon*, with its dedicatory letter to Cézanne, and had just been republished for the first time since 1866.

# [1880]

Undated
[Melun, February 1880]

My dear Emile,

I'm a bit late in thanking you for the last volume you sent me. But drawn by its novelty, I fell upon it, and yesterday I finished reading *Nana*. It's a magnificent book, but I'm afraid that through some cabal the newspapers haven't mentioned it at all. In fact, I haven't seen a single article or announcement in any of the three small newspapers I take. That discovery bothered me somewhat, as it seems to indicate a blatant disinterest in artistic matters or the prudish and deliberate avoidance of going into certain subjects.

Perhaps the uproar *Nana*'s publication must have created hasn't reached my ears, in which case it is the fault of our filthy rags of newspapers, which fact would console me somewhat.[1]

My respects to Madame Zola and my thanks to you. I'll come to see you in March.

Paul Cézanne

Melun, 25 February 1880

My dear Emile,

This morning I received the book that Alexis has just brought out. I want to thank him, and since I don't have his address I'm asking you to be good enough to let him know that I am very touched by his friendly gesture towards me. This book augments the library with which you've furnished me, and it will serve to distract me for some time and

fill my winter evenings. I hope to see Alexis when I return to Paris and be able to thank him personally as well.

Our friend Antony Valabrègue has brought out a charming volume of *Petits poèmes parisiens*, published by Lemerre. You must have a copy of it. My newspaper says nice things about it.

However, it seems that Mademoiselle de Reismes from Pontoise or thereabouts has treated you very roughly.[2] Pons, Sainte-Beuve's Pons, would say that she'd be better off knitting stockings.

I send you an affectionate handshake and hope that Madame Zola will accept my respectful greetings.

Your devoted friend,

Paul Cézanne

TO EMILE ZOLA

[Paris] 1 April 1880

My dear Emile,

After having received your letter this morning, April 1st, enclosing Guillemet's, I arrive in Paris to find at Guillaumin's that the "impressionists" are under a cloud.[3] I rush over. Alexis falls into my arms, Dr. Gachet invites us to dinner, I prevent Alexis from paying his respects to you. Dare I invite us to dinner on Saturday evening? If it's impossible, be good enough to let me know. I'm staying at 32 Rue de l'Ouest, in Plaisance.

I am your grateful former school chum of 1854.

Please give my respects to Madame Zola.

Paul Cézanne

TO EMILE ZOLA

[Paris] 10 May 1880

My dear Emile,

I'm enclosing a letter that Renoir and Monet are going to send to the Minister of Fine Arts to protest against the way their pictures are

displayed and to demand an exhibition next year for the pure impressionists. Here is what I am being asked to beg you to do:

That is: to get this letter printed in *Le Voltaire*, with a brief foreword or afterword on the group's earlier shows. Those few words should be designed to show the importance of the impressionists and the wave of real curiosity they have provoked.[4]

I needn't add that whatever decision you decide to take with regard to this request should in no way be influenced by the kind feelings you have towards me, or on the friendship you have so kindly allowed to exist between us. For I have on more than one occasion made requests of you that could have been a bother. Now I'm only acting as a go-between, nothing more.

I learned yesterday the very unhappy news of Flaubert's death. I fear that this letter may arrive in the midst of a lot of other worries.

I ask Madame Zola and your mother [to accept] my sincere respects. I send you a cordial handshake.

Paul Cézanne

*Dear Minister,*

*Two artists labeled as impressionists are herewith addressing themselves to you with the expectation that they will be granted a showing next year in the Palais des Champs-Elysées in suitable circumstances.*

*Please accept, Monsieur le Ministre, our respectful regard.*

ZOLA TO CEZANNE

*Médan, 13 May 1880*

*My dear Paul,*

*I've been so busy, so many worries, that I'm late in answering you. If I were in Paris, I would ask you to come and talk with me about the business of Monet and Renoir. You know that their letter will have no effect. They are wrong to address the administration, which will do nothing. The only way for them is to produce their works and send them in: they will end up by carving their niche on their own, if it is at all possible to do so. Outside of their work, they will only waste time with useless petitions.*

*If it's an article they want from me, tell them I'm doing a Salon for Russia, to*

*appear in* Le Voltaire *next month. I will devote a whole chapter to Impression-ism.*

*As for their letter, it will provoke a smile, that's all. But if they really want it in* Le Voltaire, *I'll send it in.*

*A hearty handshake, old friend, while awaiting your visit.*

Emile Zola

TO EMILE ZOLA

[Paris] Saturday, 19 June 1880

My dear Emile,

I should have thanked you for the next-to-last letter you wrote me with regard to what I had asked you to do for Monet and Renoir. First, out of negligence, and because June was coming, I didn't reply. And lastly, your last letter didn't reach me until today. That was because the address wasn't right. It's 32 Rue de l'Ouest, not 12. I thank you very much. I was able to find the issue dated the 19th.[5] I will go by *Le Voltaire* to get hold of the issue for the 18th of this month.

Monet now has a splendid showing at Charpentier's gallery, *La Vie Moderne*.[6]

I'm not sure if it is going to get really hot, but whenever I won't be a bother, write to me and I'll come to Médan with pleasure. And if you think you can put up with the amount of time I'm likely to take, I shall presume to bring a small canvas with me and paint something, all this of course if it's convenient for you.

Many thanks to Madame Zola for the huge bundle of rags she gave me and which I'm using. I go out to paint a bit every day in the country.

I saw Solari, a fine fellow. Tomorrow I'm going to see him; he's been by three times and I was always out. Tomorrow, Sunday, I shall go round to shake his hand. Nothing is going well for him. He cannot get chance on his side. How many lucky devils succeed with less effort. However, we have the man himself, and for my part, I thank God for having an eternal father.

Please give my greetings to Madame Zola as well as to your mother.

I shake your hand,

Paul Cézanne

TO EMILE ZOLA

[Paris, 4 July 1880]

My dear Emile,

On June 19th I replied to the letter you wrote me on the 16th of that month. In it, I asked you if I could come to you to do some painting. But of course I didn't want to be a source of bother. Since then, I've had no word from you, and since it's been almost two weeks, I take the liberty of asking you to send me a word about the situation. If you want me to come say hello, I'll do so, or if you say no, I won't come right now.[7] I've read the articles you've been publishing in *Le Voltaire* beginning with the second number. And I thank you on my behalf and that of my colleagues. Monet, according to what I've heard, has sold some of the canvases that were shown at Monsieur Charpentier's, and Renoir is said to have got a few good portrait commissions.

I wish you good health—and please give my sincere respects to Madame Zola and to your mother.

I am, with gratitude, your devoted

Paul Cézanne

My address is: 32 Rue de l'Ouest, not 12, as you mistakenly put it.

TO EMILE ZOLA

Saturday, 1880

My dear Emile,

I've just received the copy you sent me. It will be my treat during the quiet evening hours.[8] Please pass on the artistic fellow-feeling that unites all sensitive creatures—in spite of the different means by which they are expressed—to your colleagues, and thank them for having joined you to give me this volume that I can sense is full of substantial and nourishing substance.

To you, great heart, a Provençal in whom maturity has not taken precedence over age. I mustn't forget to proffer my respects to your wife, and to ask her to look upon me as her very humble servant.

Paul Cézanne

TO EMILE ZOLA

[Paris] 28 October 1880

My dear Emile,

This morning, Solari brought me the letter you sent me. I read in *Le Journal* that you had lost your mother, and that you were going to Aix.[9] That is why I didn't come to Médan. I was going to write to ask you whether you were planning to come to Paris next month, but since you tell me you will be coming sometime later, I will wait until then, unless you would like me to come to see you, I'm at your service for anything at all I can do.

I fully understand all your sadness, and I hope that nonetheless your health has been affected as little as possible, as well as your wife's.

Please accept my sincere greetings and my cordial handshake.

Paul Cézanne

32 Rue de l'Ouest.

# [NOTES 1880]

1. In spite of the hostile silence of the press, *Nana* was to enjoy an even greater popular success than *L'Assommoir*.

2. Marie Deraismes (1828–1894) was one of the first women in France to fight for women's rights.

3. Neither Monet nor Renoir took part in the fifth impressionist group show, preferring to submit their works to the Salon Jury. They hoped to be taken more seriously there, since the press continued to poke fun at the impressionist exhibitions. Cézanne did likewise, but without managing to get accepted.

4. Zola acceded to this request by publishing a series of articles entitled "La Naturalisme au Salon" in *Le Voltaire* from 18 to 22 June, the tenor of which, however, corresponded only vaguely with the desired statement. Rather than mentioning the case of Monet and Renoir, Zola gave the history of the movement they and their friends had created. However, since his own works had found a public, the novelist's attitude toward the painters had changed. "The most unfortunate thing," he wrote, "is that not one artist among this group has achieved a powerful and definitive realization of the new formula they have all proclaimed, hinted at throughout their works."

5. The article, which appeared in the June 19th issue, contained a brief reference to Cézanne, "the temperament of a great painter who is still caught up in experiments in technique—[and] remains closer to Courbet and Delacroix." The artist never gave an opinion on this comment, but since he was in fact experimenting with a new method at the time and since, furthermore, he was beginning to distance himself from his impressionist friends, it is quite possible that Zola's statement was a reflection of something he had heard the painter say.

6. In fact, it was Madame Charpentier who had participated in the launching of the new review *La Vie Moderne*, whose editor was Edmond Renoir, the painter's brother. At the time, private showings were held in one of the editorial rooms (often starring the epigones of impressionism).

7. Cézanne must have gone to Médan, from where Zola was to write to Guillemet on 22 August: "Paul is still here with me. He is working a great deal and he is still counting on you for your support [entry to the Salon]." It was during this extended visit that Cézanne must have met certain of Zola's friends, such as Huysmans, Céard, Rod and probably Duret.

8. This was the volume entitled *Les Soirées de Médan*, containing short stories by Zola, Maupassant, Alexis, Huysmans, etc.

9. Zola's mother was buried next to her husband in Aix-en-Provence.

# [1881]

[Unpublished letter in the Bibliothèque de l'Arsenal, MS Lambert 46, fol. 21.   (Courtesy Theodore Reff)]

### TO JORIS KARL HUYSMANS

Wednesday, April 1881

M. Huysmans,

I received day before yesterday the book you were kind enough to send me. My hearty thanks for this pleasant gesture.

Along with your gift, I found one from M. Céard—Since I carelessly failed to note his address, I must ask you to give him my thanks for the token of his esteem for my qualities of mind.

I am, with gratitude, your devoted

Paul Cézanne

### TO EMILE ZOLA

12 April 1881

My dear Emile,

Cabaner's sale is supposed to take place in a few days. Here is what I would like to ask: it's whether you would be so kind as to undertake to do a short announcement, as you did for Duranty's sale.[1] For there is no question that the mere appearance of your name would be a great attraction for the public, to bring in art lovers and promote the sale.

Here is a list of some of the artists who have submitted their works:

Manet—Degas, Frank Lamy—Pissarro—Bérand—Gervex—Guillemet—Pils—Cordey—etc., and your servant.

As one of your oldest acquaintances, I was the one entrusted with making this request.

I send you a cordial handshake and ask that you give my respects to Madame Zola.

Yours ever,

Paul Cézanne

TO THEODORE DURET [?]²

*Undated*
[April 1881]

Here is the very benevolent letter that Zola has been kind enough to write me.

Will you for your part send him the necessary notes, if you please.

I am, respectfully, your honored servant,

Paul Cézanne

[The above appears on the back of a letter from Zola to Cézanne, dated from Médan 16 April 1881, the text of which follows:]

*My dear Paul,*

*I will be happy to write the short announcement you asked for; but I absolutely must have a few details.*

*I have to mention Cabaner; but in what terms? Should I say that he is ill and in the Midi and that the sale is being held to assist him? In short, should I mention his straits? I don't know him at all well, and I wouldn't want to hurt him. Reply quickly what you think and if we can arouse public pity for his fate, while still mentioning his artistic struggles and his talent. I think that would strike the right note. However, I'd like the organizers of the sale to give me their authorization to say it.*

*I await your letter before writing the announcement.*

*Yours,*

*Emile Zola.*³

TO EMILE ZOLA

Pontoise, 7 May 1881

My dear Emile,

I've been in Pontoise for two days. Since you were kind enough to write to tell me that you would undertake to write the Cabaner notice, I haven't seen Frank Lamy, who I believe is one of the organizers of the sale on behalf of the hapless musician.

Now, I want you to let me know if you've received the notes you needed to work from and if you have made up a short announcement, which I was entrusted with asking you to do. I've received from both Huysmans and Céard, as well as from yourself, your latest volumes as soon as they have appeared, and I've been enchanted with them. I think that Céard will have a great deal of popularity, because it seems to me very amusing, not to mention the superlative viewpoints and observations his book contains.

Thank you very much for having enabled me to meet such very remarkable men, and please give my respects to Madame Zola and accept them yourself.

Very hearty greetings,

Paul Cézanne

I'm presently staying at      Quai du Pothuis, 31,
                            Pontoise (Seine-et-Oise)
At the last moment, I've just heard that Madame Béliard is very ill; it's always painful to learn that fate is oppressing admirable people.

TO VICTOR CHOCQUET

Pontoise, 16 May [18]81

Monsieur Chocquet,

Having learned that the 40-size canvas Monsieur Tanguy was to deliver to you was lacking a frame, I would be very obliged, if you would be so kind, if you would have the border of said painting

brought to you. I thank you in advance and beg you to accept my excuses for the further inconvenience I have just caused you.

Monsieur Chocquet, we are all in good form and since our arrival we are reveling in all the atmospheric changes the sky has been kind enough to accord us. Monsieur Pissarro,[4] who we saw yesterday, gave us your news and we are happy to hear you are in good health.

My wife and Paul junior have instructed me to give you their most affectionate caresses; allow me to beg you to accept the homage of my sincere greetings and to share them with Madame Chocquet, without overlooking, on my family's behalf, Mademoiselle Lisbeth.[5]

I greet you and send you an affectionate handshake.

Paul Cézanne

TO EMILE ZOLA

Pontoise, 20 May 1881

My dear Emile,

Since you were kind enough to write to me, the sale on Cabaner's behalf has taken place. As you tell me, I did indeed think that Frank Lamy must have gotten in touch with you, and I thank you for the preface you wrote about this metaphysician who should have written some conspicuous work, for he has some truly bizarre and paradoxical theoretical notions that are not without a certain spice.

There's one small cloud on the horizon. My sister and brother-in-law are coming to Paris, accompanied, I believe, by their sister Marie Conil.[6] You can see me piloting them around the Louvre and other pictorial locales.

Of course, as you say, my stay in Pontoise will not stop me from coming to see you, on the contrary, I'm determined to come to Médan by shank's mare.[7] I do not feel that that task is beneath me.

I see Pissarro fairly frequently, I lent him Huysman's book, which he is gobbling up.

I've begun several studies, in both cloudy and sunny weather. I hope that you soon get back to normal with your work, which is, in my opinion and in spite of all the alternatives, the sole refuge where one can experience true inner contentment.

I ask you to give my respects to Madame Zola and I send you a cordial handshake.

Yours ever,

Paul Cézanne

Don't forget to mention me to my compatriot Alexis, whom I've not seen for a long time and whom you will of necessity be seeing sooner than I shall.

TO EMILE ZOLA

[Pontoise] Tuesday, June 1881

My dear Emile,

I wanted to thank you for sending me your latest volume, but I've continually put off doing so and could have done for a long time had I not found myself awake before four o'clock this morning. I began reading it, but I haven't finished it quite, although I've read a great deal, skipping about, because of the Sections, from one essay to another. I think the one of Stendhal is very fine.

Having gone to Paris, I found at my lodging the book Rod was kind enough to send to me, which is easy reading.[8] I've skimmed right through it. I didn't know his address and was unable to thank him for the copy he sent me. If it should happen that you want to write me a note, you might enclose his address so that I can do my duty to him.

My sister and my brother-in-law came to spend a few days in Paris. Sunday morning, since my sister was unwell, I was obliged to send them off back to Aix. The first Sunday of the month, I went with them to Versailles, city of the great king, to see the fountain display.

I send wishes for your good health, that being the most precious gift, especially when one is in comfortable circumstances as well.

I take the liberty of sending my respects to Madame Zola and a handshake for yourself,

Paul Cézanne

I'm working a bit, but easing off somewhat.

[Pontoise] Monday [July] 1881

My dear Emile,

On the way to Auvers I heard that Alexis had been injured in an accident in which, as ever, the righteous have been made to suffer. If it wouldn't be too much trouble, you would be kind to send me news of my brave compatriot.

I can't come to Paris before early August, when I will inquire into his health.

By happenstance, I later heard about the discussion raised by Wolff concerning the article you wrote about Maupassant and Alexis.

I would ask that you pass on my greetings to Madame Zola and, in the midst of all the sound and fury I hope you will keep in good health; and if Alexis should happen to be with you, since I am still hoping that his injury is not a serious one, pass on to him my confraternal feelings.

I am your old comrade,

Paul Cézanne

TO EMILE ZOLA

[Pontoise] 5 August 1881

My dear Emile,

While I was with Alexis on Tuesday morning, your letter reached me in Pontoise. So I heard from both sides that the *affaire Alexis* had been settled in a manner not too unhappy for him. I found my compatriot completely restored to health, and he showed me the articles that had preceded and followed his encounter.

At my Paris residence I found a letter from Caserta and signed by someone called Etorre-Lacquanitin or something along that line, asking me to assist him in obtaining a lot of critical articles with regard to your work, recent and prior to the *Rougon-Macquart* series. Probably you know this writer, who intends to do a critical study of your work.

Alexis, to whom I showed this letter, told me he had received a similar one and that he would answer for both of us.

Several minor setbacks are not making my visit to Médan any easier, but I will come for sure the end of October. At that time, I will have to leave Pontoise, and perhaps I shall go to spend some time in Aix. Before making that trip, I will come, when you write me, to spend a few days with you.

I send you an affectionate handshake and proffer my respects to Madame Zola and wishes for good swims.

Yours ever,

Paul Cézanne

TO EMILE ZOLA

Pontoise, 15 October 1881

My dear Emile,

The time is drawing near when I must leave for Aix. Before taking off, I wanted to come to say hello to you. Since the bad weather has set in, I'm writing you in Médan, guessing that you must be back from Grandcamp.[9] So if it isn't inconvenient for you, I'll come to see you around the 24th or 25th of this month. If you would write me a line in this regard, I would be happy.

Please give my greetings to Madame Zola, hoping that you have returned in good health, and I send you a cordial handshake,

Your devoted,

Paul Cézanne

## [ NOTES 1881 ]

1. Edmund Duranty (1833–1880), novelist and art critic, a friend of Degas and close to the impressionist group, was the author of a pamphlet on the new painting, *La Nouvelle Peinture*. Zola had written the preface to the catalogue of the sale held to benefit his widow.

2. It is not certain that this letter was addressed to Thèodore Duret (1838–1927); it was found among the papers of the famous historian of the impressionists, with whom Zola had been linked prior to 1868, both as a collaborator

on the anti-imperialist newspaper, *La Tribune*, and as a fervent admirer of Edouard Manet.

3. The "documentation" the novelist requests was provided by Frank Lamy, a friend of Renoir, and Zola's notice appeared in the catalogue of the sale, which enjoyed only a modest success. A few months later, on 3 August 1881, Cabaner died of tuberculosis.

4. It was during this visit that Cézanne, through Pissarro, met Paul Gauguin, who was still working in a bank but who spent all his free time with Pissarro, devoting himself to painting at his side.

5. A child taken in by the Chocquets, whose only child, a daughter born in 1861, had died before the age of 5.

6. The painter's youngest sister, Rose, had just married Maxime Conil in Aix. Their elder sister, Marie, never married.

7. The distance from Pontoise to Médan is approximately 15 kilometers.

8. Rod, Edouard (1857–1910), a Swiss novelist and a member of the Médan circle.

9. A small port on the Channel where Seurat was to work in 1885. After Zola's return from Grandcamp, Cézanne did spend a week with him in Médan before going to the Midi.

# [1882]

L'Estaque, 15 February 1882

My dear Paul,

I am surely terribly late in thanking you for the receipt of your biographical work,[1] since here I am in Estaque, the land of [sea] Urchins. The copy you were kind enough to send me ended up in Aix in the sullied hands of my relatives. They took care not to inform me of it. They tore it out of its wrappings, cut the pages, skimmed through it in both directions, while I sat here under the harmonious pines. However, finally I learned of it. I demanded it, and now I have possession of it and I'm reading it.

So I thank you very very much for the good feelings you have aroused in me by bringing back the past. What more can I say? I won't be telling you anything new if I say what marvelous stuff there is in the lovely lines of the man who is still willing to be our friend.[2] But you know that I mean it. Don't tell him, he'll say that I'm being soppy. This is just between us, quietly.

In the event, my dear Alexis, please allow me to express my compatriotic and friendly feelings to you,

*Vale*
Paul Cézanne

TO EMILE ZOLA

L'Estaque, 28 February 1882

My dear Emile,

The day before yesterday I received the book of literary criticism you were kind enough to send me. So I'm writing to thank you and at the

same time to tell you that, after having spent four months in the Midi, I will be returning to Paris in about a week. And since I suppose you're in Médan, I shall come out to your retreat to say hello. However, first I'll go by the Rue de Boulogne to find out whether you might not be there.

My greetings to Madame Zola, a cordial handshake for yourself.

Gratefully yours,

Paul Cézanne

TO EMILE ZOLA

[Paris] 2 September 1882

My dear Emile,

Since you mentioned it to me last April, I suppose you to be at the country house. So I am sending this note there. I shall only be in Paris for a month more, may I come to visit you in Médan? If, as you did two years ago, you are coming to Paris around the 10th or 12th, please let me know and I'll come to see you there. And I will find out when I see you if I can start off to your home in the fields.[3]

There, I hope my letter finds you in good health.

I close by sending my respects to Madame Zola and please accept my sincere greetings.

Paul Cézanne

TO EMILE ZOLA

[Aix] Jas de Bouffan,
Tuesday, 14 November 1882

My dear Emile,

Yesterday I received the book you sent me and this is to thank you for it. Since my arrival here, I haven't left the country and I've seen no one but Gibert, the director of the museum, which I must go to see.

I also met the fat Dauphin we were in school with and little Baille—both lawyers—the latter looks like a nice little legalistic toad. But here, nothing's new, not the least little suicide.[4]

If you need anything from here, write to tell me. I would be happy to be of service. I keep on working a bit, even though I do nothing else at all.

Please give my respects to Madame Zola, and my mother asks to be remembered to you. Many greetings and a hearty handshake,

Paul Cézanne

I didn't get to see the good Alexis; since you can more easily get hold of him, please pass on my greetings to him.

TO EMILE ZOLA

[Aix] Jas de Bouffan, 27 November [1882]

My dear Emile,

I've decided to draw up my will, since it appears I can do it now because the income from the properties that have been handed over to me is in my name.[5] So I'm writing to ask your advice. Could you tell me the formula for drawing up such a document? I want, in case I should die, to leave half of my income to my mother and the other half to the child. If you know anything about this, you'd oblige me by filling me in on it. For should I die in the near future my sisters would inherit from me, and I fear my mother would be left out and the child (since he was recognized when I filed the statement at the town hall) would, I believe, still have a right to half of whatever I leave, but perhaps not without having to go to court.

In the event that I can draw up a handwritten will myself, I would ask you, if you wouldn't find it too much trouble, to take care of a duplicate of same. Only if that doesn't cause you any problems, because someone could get their hands on the said document here.

That's what I wanted to put before you. My greetings and I wish you the best and at the same time to give my respects to Madame Zola.

Yours ever,

Paul Cézanne

# [NOTES 1882]

1. Alexis had just published *Emile Zola, Notes d'un Ami*, which contained a lengthy evocation of the painter's and the novelist's shared boyhood.

2. Alexis published as an appendix to his biography many of Zola's youthful verses. Among them is a poem from 1859 dedicated to Cézanne.

3. Cézanne did eventually spend several weeks in Médan.

4. Probably a reference to the death of the boyhood friend, the lawyer Marguery, who committed suicide in August of 1881 by throwing himself from the first-floor gallery of the Palais de Justice in Aix down onto the floor of the building's main ceremonial hallway.

5. It is possible that at the time he provided the dowry for his daughter Rose, who was married in June 1881, Cézanne's father also decided to settle their shares on his other two children. Long retired from his bank, the old man therefore dispersed at least part of his fortune; not only his bonds, but also the real estate (see Cézanne's letter to Chocquet dated 11 May 1886). Finding himself possessed of some income, the painter was concerned to divide it between his son (without setting aside a portion for Hortense Fiquet) and—which may seem surprising—his aged mother. Perhaps he was afraid that his brother-in-law, of whom he did not have a very high opinion, might one day attempt to get his hands on her income.

This will must have been changed following the death of Cézanne's father and again after the painter's marriage in 1886, and yet again following the death of his mother in 1897.

# [1883]

[Aix] 6 January 1883

My dear Coste,

I believe it's to you that I owe the receipt of the newspaper *L'Art Libre*.[1] I've read it with the liveliest interest and for good reason. So I would like to thank you and tell you how greatly I appreciate the generous energy with which you leap to the defense of a cause to which I am far from being a stranger.

Gratefully, I remain your compatriot and, if I may say so, colleague.

Paul Cézanne

[Aix] Saturday, 10 March 1883

My dear Emile,

I am late in thanking you for having sent your latest novel. However, here is the attenuating circumstance behind my delay. I got to L'Estaque, where I was going to spend a few days. Renoir was supposed to have a show following Monet's, which is on at the moment,[2] and he asked me to send him two landscapes he had left at my place last year.[3] I sent them off to him on Wednesday, and so here I am in Aix, where the snow fell all day yesterday, Friday. This morning the countryside had a lovely snowy effect. However, it's melting.

We are still in the country. My sister Rose and her husband have been in Aix since October, where she gave birth to a daughter. All this is not very amusing. I believe that my protestations will result in their [not] coming to the country this summer. You can imagine my mother's happiness at that. I won't be able to get to Paris for some time, I think I

shall spend another five or six months here. So I offer myself to your thoughts and ask that you greet Alexis for me.

Please give my respectful greetings to Madame Zola, as well as my mother's.

Thank you very very much, and I am yours ever,

Paul Cézanne

TO EMILE ZOLA

L'Estaque, 19 May 1883

My dear Emile,

In December 1882, I think it was, I asked you if I might send you *testamentum meum*. You answered yes. Now I should like to ask you if you are in Médan, as is likely, in which case I shall send it to you by registered letter. I believe that's the proper thing to do. After a fair amount of dithering, this is what has happened. My mother and I went to see a notary in Marseilles who advised a Holographic Will and, if I wished, my mother as residuary legatee. This I did. When I get back to Paris, if you can accompany me to a notary's, I shall have another consultation and remake my will, at which time I shall tell you face to face my motives for doing so.

Now that I have set down the serious matters I had to tell you, I shall conclude my letter by asking you to present my respects to Madame Zola and I shake your hand, and if good wishes were of any effect, I would hope you are feeling well, for sometimes things go otherwise. These words are inspired by Manet's catastrophe;[4] other than that I am well. So I've finished and I thank you for this further service.

Paul Cézanne

Here is my address I almost forgot:

Cézanne, Quartier du Château, above the station at L'Estaque (Marseilles).

### ZOLA TO CEZANNE

*Médan, 20 May 1883*

*My dear Paul,*

*Just this morning I was thinking of you and promising myself to write and ask for your news, when I received your letter.*

*Yes, I've been at Médan for a month, and you can send me your will here. As soon as you can get back, we'll go to the best notary for the consultation you want, and do everything necessary to reassure you. But you must be present, to explain your situation. You haven't told me about your return. In your letter you said you would stay down there all summer. I hope to see you in September; you could spend a few days here, and we could talk at leisure.*

*Are you working? Are you happy? For myself, I've started a new novel. That's my life. Nothing else new; we are well settled and in good health.*

*In your next letter, give me an idea about your return. Be of good cheer, my warm friendship to your mother and all your family.*

*Affectionately,*
*Emile Zola*

*The idea of making you mother sole legatee seems good, as long as you have confidence in her.*

### TO EMILE ZOLA

[L'Estaque] 24 May 1883

My dear Emile,

Now that I am sure you are in Médan, I'm sending you the document in question, of which my mother has a copy. However, I'm afraid that the whole thing doesn't mean much, since these wills are very easily attacked and overturned. A proper will formally drawn up in the presence of some civil authority would be worth more were questions to arise.

I shan't be returning to Paris before next year; I've rented a small house with garden in L'Estaque just above the station, and at the foot of the hill, with the pine-clad rocks just behind me.

I'm still busy with painting. Here there are fine views, but that doesn't necessarily make subjects. Nevertheless, when the sun sets and you're on high ground there's a beautiful distant panorama of Marseilles and the islands, the whole enveloped in the evening light with a very decorative effect.

I don't speak of yourself since I am totally ignorant about everything, save that sometimes when I buy *Le Figaro* I come upon a few facts about men I know, for example: lately I read a heavy article on good old Desboutins.[5] I did learn that Gaut highly esteems your last novel (but you doubtless know that). As for me, it gave me a great deal of pleasure, although my appreciation is scarcely a literary one. I thank you very much and don't forget to remember me to Madame Zola as well as to Alexis and anyone else who is still alive. I send a sincere handshake.

Yours ever,

Paul Cézanne

This only appears to be predated because the postal letter form was purchased last year.

TO PHILIPPE SOLARI

L'Estaque, 10 July 1883

My dear Solari,

I received the letter you wrote to me on the occasion of your daughter's marriage to Monsieur Mourain. I would beg you on my behalf to express my warmest regards to the young couple and to express to them our wishes for their future happiness and prosperity.

I congratulate you as well as Madame Solari and send greetings to Baby Emile, who must be pleased.[6]

A cordial handshake, your old travelling companion,

Paul Cézanne

P.S. My wife joins me in the above, as well as my brat.

### TO EMILE ZOLA

L'Estaque, 26 November 1883

My dear Emile,

I received the book you were so kind as to send me. But the new circumstance that has caused such a delay in my thanking you is that since the beginning of November I've been back in L'Estaque, where I plan to stay until January. Mama has been here for several days now, and last week Rose, who is married to Maxime Conil, lost a child she had in September or October, I think. Actually, the poor thing didn't last long. Otherwise, everything is as usual. If good old Alexis is nearby, remember me to him. On the other hand, I send many greetings to you and salutations to Madame Zola.

Allow me to felicitate you and to repeat my thanks for your kind remembrance of me.

Yours ever,

Paul Cézanne

## [NOTES 1883]

1. Numa Coste had continued to devote his leisure time to painting and even showed fairly regularly at the Salon. He had just begun the review *L'Art Libre* with Zola, Alexis and several other friends.

2. Unable to arrive at an agreement with the various impressionists for a group show in 1883, Durand-Ruel had decided to organize a series of individual exhibitions, although some of the painters were not in favor of this idea.

3. Returning from a trip to Italy, Renoir had stopped in L'Estaque in the spring of 1882 to pay Cézanne a visit. There, he caught pneumonia. On 2 March 1882, he wrote from L'Estaque to Chocquet: "I've just been ill and am convalescing. I cannot tell you how kind Cézanne has been to me. He tried to give me everything he had. We are having a formal farewell dinner with his mother, since he is returning to Paris and I am forced to remain somewhere in the Midi: strict doctor's orders . . . Madame Cézanne served me a *brandade de morue* for lunch. I believe it must be the lost ambrosia of the Gods. Once you've tasted it, there's nothing left but to die. . . ."

4. Manet had just died a few days after having had one of his legs amputated.

5. Marcellin Desboutins (1823–1902), painter, engraver and playwright,

was a close friend of Edouard Manet. He frequented the Café Guerbois and the Nouvelle Athènes in Batignolles, where the impressionists often gathered in the evenings. Cézanne had probably met him there.

6. Emile, the son of the sculptor Philippe Solari, was a writer and Emile Zola's godson. See Cézanne's later letters to him.

# [1884]

Aix, 23 February 1884

My dear Emile,

I received the latest book you were kind enough to send me, *La Joie de Vivre*, which appeared in *Gil Blas*, because I saw a few bits of it in said newspaper. Thus hearty thanks for sending it, and for not forgetting me in the isolation in which I exist. I'd have nothing at all to tell you were it not that lately, finding myself in L'Estaque, I received a hand-written letter from good Valabrègue, Antony, telling me he was in Aix, whence I hied myself at once, yesterday, and where I had the pleasure of seeing him this morning, Saturday. We took a stroll through town together—recalling some of those we had known—but how different our feelings now are! My head was full of notions about the area, which seems truly extraordinary to me. On the other hand, I saw Monet and Renoir, who went off vacationing in Genoa in Italy around the end of December.

Don't forget to remember me to my compatriot Alexis, even though I haven't heard anything of him for an age.

All my thanks to you and my respects to Madame Zola, with my wishes for your good health.

Sincere greetings,

Paul Cézanne

*[On 29 March 1884, Antoine Guillemet wrote to Zola: "I've received a note from Cézanne referring to a head he submitted to the Salon. Alas, the head was rejected."]*

TO EMILE ZOLA

[Aix] 27 November 1884

My dear Emile,

I've just received two more books you have been kind enough to send me. Thank you, and let me tell you that I've nothing much to say about the fine town where I first saw the light of day. Only (but probably this won't affect you very much) art as an exterior effect transforms itself terribly and overly dresses up any minor and paltry object, at the same time that the careless lack of harmony is increasingly revealed by the discord between colorations themselves, even more unfortunate, because of dissonance of tonalities.

After having bemoaned one's lot, let's hail the sun which sheds such lovely light upon us.

I can only repeat I am yours ever, without neglecting to present my respects to Madame Zola.

                                        Paul Cézanne

# [1885]

[L'Estaque] 11 March 1885

My dear Emile,

I got the book you were so kind as to send me a week or so ago. I've neglected thanking you because of fierce neuralgic pain, which leaves me only sporadically lucid. However, my headaches are easing up and I go walking on the hills where I see some lovely views. I wish you good health, since you have everything else you need.

A cordial handshake,

Paul Cézanne

TO A LADY [1]

*Undated draft*
[Spring, 1885]

I saw you, and you allowed me to kiss you; from that moment, I've been agitated by a profound unrest. You will forgive the liberty of writing you taken by a friend tormented by anxiety. I don't know how to excuse this liberty, which you may consider an enormous one, but could I remain in this depression? Isn't it better to show a feeling than to hide it?

Why, said I to myself, keep silent as to the source of your torment? Isn't it a solace of suffering to allow it to find expression? And since physical pain seems to find some relief in the cries of the victim, is it not natural, Madame, that mental griefs seek some assuagement in confession to an adored being?

I know that this letter, whose foolhardy and premature posting may seem indiscreet, has nothing to recommend me to you save the goodness of . . .

TO EMILE ZOLA

[Aix] Jas de Bouffan, 14 May 1885

My dear Emile,

I'm writing in hopes that you will be kind enough to reply. I would like you to do a few favors for me, minimal I think for you, immense for me. It would consist in receiving a few letters for me and to forward them on to me to an address I shall be sending you later. Either I'm crazy or inspired. *Trahit sua quemque voluptas!*[2] I'm relying [on you] and I beg absolution: how happy are the wise!

Don't refuse this favor, I don't know where else to turn. My dear friend, I send you a heartfelt handshake.

Yours ever.

Paul Cézanne

I'm a nonentity and unable to do you any service, but since I'll be going before you, I shall put in a word with the All Highest on your behalf for a good place.

TO EMILE ZOLA

La Roche [Guyon] 15 June 1885

My dear Emile,

I arrived in La Roche this morning. Would you please, therefore, should a letter arrive for me, forward it to:

General Delivery, La Roche-Guyon,[3] via Bonnières
(Seine-et-Oise)

Yesterday evening, I overindulged myself at table, and I beg you to accept my thanks and my greetings.

Paul Cézanne

Madame Zola as well, and a quick recovery.

TO EMILE ZOLA

La Roche-Guyon, 27 June 1885

My dear Emile,

It's almost the end of June. When it comes time for you to leave for Médan and you are moved in, would you let me know? I really feel the need for a change.

Happy they whose hearts are faithful!

My respects to Madame, and thank you in advance for your services with regard to my letters from Aix.

I am, with the usual closing,

Paul Cézanne

TO EMILE ZOLA

La Roche-Guyon, 3 July 1885

My dear Emile,

Owing to unforeseen circumstances, my life here is becoming rather difficult. Could you let me know if I could come to visit you?

In case you aren't yet moved to Médan, please send me a note to let me know.

A hearty handshake and lively thanks,

Paul Cézanne

EMILE ZOLA TO PAUL CEZANNE

*Médan, 4 July [18]85*

*My dear Paul,*

*Your letter has upset me considerably. What's going on? Can't you wait a few days? In any event, keep me informed and let me know if you have to leave La Roche, since I want to know where to write to you when my house is finally available. Be philosophical, nothing goes as one would like, I too am very much upset at the moment.*

*So until soon? As soon as I can, I'll write to you.*

*Affectionately,*
*Emile Zola*

TO EMILE ZOLA

La Roche [Guyon] 6 July 1885

My dear Emile,

I must beg you to excuse me—I'm a real idiot. If you can imagine, I forgot to collect your letters from general delivery. That explains my second, insistent one. A thousand thanks.

Please give my respects to Madame Zola.

As soon as you can, drop me a note. Grande Rue, Cézanne, care of Renoir, La Roche.

Yours ever,

Paul Cézanne

However, if a letter should come from Aix, be so kind as to send it to general delivery and let me know in a note to the house by making a cross in a corner of the letter.

TO EMILE ZOLA

11 July 1885

My dear Emile,

I'm leaving today for Villennes.[4] I'm going to the inn. I will come to see you for a moment as soon as I arrive; I'd like to ask you if you could lend me *Nana* to paint,[5] I'll return it to its berth after using it.

Doing nothing makes me very bored.

Yours ever,

Paul Cézanne

Don't read anything unpleasant in my decision. I'm just compelled to move. And, when you're free, I'll have only a short way to go to be at your place.

### TO EMILE ZOLA

[Vernon] 13 July 1885

My dear friend,

Impossible this holiday week to find a place to stay in Villennes. Not at the Sophora, not at the Berceau, not at the Hôtel du Nord. I send a handshake. I'm in Vernon at the Hôtel de Paris. If my canvases for painting happen to be sent to you, please accept delivery for me and keep them at your place.

Thank you in advance,

Paul Cézanne
Hôtel de Paris
Vernon (Eure)

### TO EMILE ZOLA

Vernon, 15 July 1885

My dear Emile,

As I told you in a note dated the 13th last, I'm in Vernon. Things aren't going right for me. I've decided to leave for Aix as soon as possible. I'll pass by Médan to shake your hand. I left in your obliging custody some papers that I would like to have, if they're in Paris; one day when your servant is going to the Rue de Boulogne could you get him to bring them back?[6]

Farewell and thanks in advance. Once more, excuse me for having to have recourse to you in the present circumstances, but seven or eight days' waiting seems very long to me.

Allow me to send you a cordial handshake,

Paul Cézanne

TO EMILE ZOLA

[Vernon] 19 July 1885

My dear Emile,

As you say, I shall go to Médan on Wednesday. I will try to get off in the morning. I would have liked to be able to do some more painting, but I was very torn; since I have to return to the Midi, I thought the earlier the better. On the other hand, it might be better if I wait a bit longer. I can't decide. Maybe things will work out.

A cordial greeting,

Paul Cézanne

TO EMILE ZOLA

[Aix] Jas de Bouffan, 20 August 1885

My dear Emile,

I received the news you sent from your address last Saturday. I should have answered at once, but the pebbles under my feet, which seem like mountains to me, distracted me.

Please excuse me. I am in Aix, and I go out to Gardanne every day.[7]

Please give my respects to Madame Zola and continue to think kindly of me.

Yours ever,

Paul Cézanne

TO EMILE ZOLA

[Aix] Jas de Bouffan, 25 August 1885

My dear Emile,

The comedy begins. I wrote to Roche-Guyon the same day that I sent you a note to thank you for having thought of me. Since then I've had no news at all, I seem to be totally cut off. The bordello in town or

some such, but nothing more. I pay, it's a dirty word, but I need re-
laxation and even at this price I must have it.

I therefore ask you not to reply; my letter must have got there in due
time.

I thank you, and beg you to excuse me.

I'm beginning to paint, but because I'm more or less without cares. I
go to Gardanne every day and I come back to the country in Aix.

If only I had a family that minded its own business, everything might
have been for the better.

I send you a cordial handshake,

Paul Cézanne

JULIEN TANGUY TO PAUL CEZANNE

*Paris, 31 August 1885*

*Dear Monsieur Sézanne,*

*I begin by wishing you good day and at the same time to inform you of my
straits; imagine, my dolt of a landlord has just sent me a notice of eviction for the
six months advance rent I owe him according to our lease, but since I find myself
unable to pay him I am writing to you, my dear Monsieur Sézanne and am
begging you to exert every effort to send me a payment on your bill: in this
connection I am enclosing your bill as you asked, which amounts to 4,015,40
francs after subtracting your payments of 1,442.50, as detailed below.*

*I have an I.O.U. from you for two thousand one hundred and seventy-four
francs 80 centimes (2,174.80) which you signed on 4 March 1878. Thus you
should pay me 1,840.90 on the 4,014.40 you owe me. If you prefer that the
total be on one bill, please do so as soon as you receive your I.O.U. I will send
you the one you wrote for me in 1878.*

*I would be most grateful, dear Sir, if you could assist me at this critical
moment.*

*In the hope that you will be kind enough to accede to my request, please accept
in advance my thanks and believe me, dear Sir, your devoted servant.*[8]

*Julien Tanguy*

[NOTES 1885]

1. This draft is on the back of one of Cézanne's drawings in the Albertina Museum in Vienna; it stops short at the bottom of the page. The woman's identity is unknown. It seems that Cézanne may have had an affair with a young housemaid at the Jas de Bouffan, but this letter does not sound as though it had been written to a servant, nor does it seem likely that a maid would have written to him, as we gather from the following letters to Zola. Besides, the maid in question had had to leave Aix in 1884, summoned home by her parents during the cholera epidemic that swept Marseilles from June to October.

2. Each is prey to his own passion (Virgil, *Eclogues*).

3. La Roche-Guyon, where Pissarro had worked twenty years earlier and where Guillemet and, probably, Cézanne, had joined him, is a picturesque town near Bonnières, directly across from Bennecourt where Cézanne and Zola had stayed in 1866, on the opposite bank of the Seine. Cézanne had arrived there after a short visit to Zola; he had doubtless been invited by Renoir, who had spent the summer of 1885 in La Roche-Guyon and perhaps wanted to repay the hospitality he had received in L'Estaque in 1882.

4. A village near Médan.

5. *Nana* was the name of Zola's canoe, which Cezanne used to reach the island across from the novelist's house and from which he painted a view that included the Château de Médan.

6. This is probably a reference to Cézanne's will, a copy of which had been given to Zola.

7. Gardanne, a small town some ten kilometers from Aix, a picturesque region boasting a hill topped by a church with a tall spire. Cézanne often painted the view of the town and the surrounding landscape. Today, as a result of industrialization, the region has become unrecognizable.

8. This letter appears to have been written by the daughter of Père Tanguy, who himself was more or less illiterate.

# [1886]

Gardanne, 4 April 1886

My dear Emile,

I have just received the copy of *L'Oeuvre* you were kind enough to send me. I thank the author of the *Rougon-Macquart* for this fine memorial and ask his permission to allow me to shake his hand, remembering years gone by.

Ever yours for old time's sake,

Paul Cézanne[1]

In Gardanne, arrondissement of Aix

## TO THE PREFECT OF THE SEINE

The undersigned has the honor to request you to be good enough to legalize the signature of the Mayor of the Fourth Arrondissement which appears on the birth certificate attached to the present request.

Please accept the respectful greetings of the undersigned.

Paul Cézanne[2]

## TO VICTOR CHOCQUET

Gardanne, 11 May 1886

Monsieur Chocquet,

Touched by your last letter, I wanted to answer it at once, but even though I've little to do, both because of declining health and stretches of bad weather, things do seem to get put off till tomorrow!

So I was loathe to burden you, from the point of view of morale, I mean, but since Delacroix has been the intermediary between yourself and me, I will just say this: how I would have liked to possess the intellectual balance so notable in you and that enables you to attain the goals you set. Your fine letter, with that of Madame Chocquet, is evidence of a fine equilibrium in your way of life. And since I was struck by that serenity, I'm mentioning it to you. Fate did not provide me with similar fare, it's my only regret where earthly matters are concerned. As for the rest, I can't complain. The sky and the infinite elements of nature still attract me and provide me with the opportunity to take pleasure in looking.

As for the fulfillment of one's desires for the simplest of things, those that one would expect to find within oneself, for example, a twisted fate would seem to be bent on making them all come to naught, for I had a few vines, but unexpected frosts have snipped that thread of hope. And I would really have liked to have seen a fine harvest, which is why I hope that you will witness the success of your plantings and a burgeoning of your crop; green being one of the gayest of colors and most pleasing to the eye. Lastly, I can tell you that I am still busying myself with painting and that this region offers treasures to be gleaned and has not yet found an interpreter worthy of the riches it offers.

Monsieur Chocquet, I want this letter to please you and not bore you; therefore I shall take the liberty of offering you the humble homage of our greetings and ask you to share them with Madame Chocquet, as well as of expressing my wish that you remain always in good health.

As in the past, I am your grateful

Paul Cézanne

The child is at school and his mother is well.

[This letter was probably written to thank Chocquet for the congratulations he had sent Cézanne on the latter's marriage. On 28 April 1886, the painter wed Hortense Fiquet in Aix-en-Provence with his parents in attendance. A few months later, on 23 October 1886, the artist's father died at the age of 88.

Of the period from June 1886 to June 1889, no letter of Cézanne's has been preserved.]

## [NOTES 1886]

1. This letter is not only the latest dated found among Emile Zola's papers, but would also seem to have been the last that Cézanne wrote to him. Its tone is markedly different from his other letters to the novelist. We must surmise that the reason for this break was precisely the publication of *L'Oeuvre*, the only novel in the *Rougon-Macquart* series that is at all autobiographical in nature. In it, Zola's boyhood friends—Baille, Valabrègue, Alexis, Solari— and Zola himself—are depicted, and, in addition, many of Cézanne's traits are to be found in the principal character, the painter Claude Lantier. The obvious resemblance of this character, an artist of genius but incomplete, confused, impotent and unbalanced—in short, a failure—must have revealed to Cézanne how little Zola had understood his efforts. The publication of the book dis- illusioned him deeply and caused him great pain. After more than thirty years of the most affectionate friendship, he preferred to break with Zola rather than to make the compromises he felt to be unworthy of the friendship they had shared. (See J. Rewald, *Cézanne, sa vie, son oeuvre, son amitié pour Zola*, Paris, 1939)

2. Draft of a letter written in the margin of a watercolor; this request probably has to do with the formalities involved in the artist's marriage to Hortense Fiquet, which was to take place in Aix in April 1886.

# [1889]

TO ARMAND, COUNT DORIA

Paris, 30 June 1889

Dear Count,

You have been good enough to give Monsieur Chocquet permission to show *La Maison du Pendu*,[1] which is the name given to a landscape I painted in Auvers. I have just learned that Monsieur Antonin Proust[2] has agreed to hang it in the exhibition, and I am therefore requesting that you send this small picture to the Palais des Beaux-Arts for the Exposition Universelle.[3]

Please accept, my dear Count, along with my thanks, my greetings and respect,

Paul Cézanne

TO ROGER MARX[4]

Paris, 7 July 1889

Dear Sir,

I am writing to thank you for having troubled yourself on my behalf. I regret that you did not receive the letter. Allow me to repeat very sincerely my thanks and to request that you express my gratitude to Monsieur Antonin Proust on my behalf.

Yours devotedly,

Paul Cézanne

TO OCTAVE MAUS (Brussels)[5]

Paris, 27 November 1889

Dear Sir,

Having read your flattering letter, allow me first to thank you, and I shall with pleasure accept your kind invitation.

However, will you allow me to refute the accusation of contempt you have made against me because of my refusal to participate in the painting exhibitions?

In this connection, I would say that since the numerous efforts I have undertaken have yielded only negative results, and fearing some all-too-justified criticism, I had made up my mind to work in silence until the time when I would feel able to back up theoretically the fruits of my labors.

Faced with the pleasure of finding myself in such good company, I do not hesitate to alter my resolve and I would ask you, Sir, to accept my thanks and my confraternal greetings,

Paul Cézanne

## TO VICTOR CHOCQUET

Paris, 18 December 1889

Monsieur Chocquet,

I am asking you for your kind assistance, should the notion I have appear acceptable to you. Having received a formal invitation from the *Association des Vingt* in Brussels to participate in its exhibition, and finding myself taken unawares by said request, I am taking the liberty of asking you to allow *La Maison du Pendu* to be sent to them. I am attaching to this note the first letter I received from Brussels, which will fill you in on my situation *vis-à-vis* this Association, adding that I have acceded to their kind request.

Please accept my sincerest greetings, and impart my respectful homage to Madame Chocquet.

Mother and child join me in the above.

Your grateful,

Paul Cézanne

## TO OCTAVE MAUS

Paris, 21 December 1889

Dear Sir,

I got in touch with Tanguy to find out which of my studies he had sold to Monsieur de Bonnières. He was unable to tell me exactly.

Therefore, I would ask that you enter that canvas in the catalogue as *Etude de paysage*. On the other hand, since your request took me unawares, I have got in touch with Monsieur Chocquet, who is not in Paris at present,[6] and who immediately made available to me *Une chaumière à Auvers-sur-Oise*. However, this canvas is unframed, since the frame ordered by Monsieur Chocquet (carved wood) is not yet ready. If you should have some old frame to put on it, you would ease my mind. It's a regular size 15. Lastly, I am sending you a canvas, *Esquisse de Baigneuses*, whose frame I shall have delivered to Monsieur Petit.

Please accept my cordial greetings,

P. Cézanne

## [NOTES 1889]

1. Count Doria had purchased this picture at the first impressionist group exhibition in 1874. It was probably the first canvas the artist sold.

2. A friend of Manet, for whom he obtained a decoration, Antonin Proust was the Commissioner in Chief of the Centenary Exhibition of French Art (1789–1889) that was held in the Exposition Universelle in 1889. The exhibition had already opened on 16 May.

3. At the last minute, Chocquet made a trade with his friend Doria, obtaining *La Maison du Pendu* for a snowy landscape. It was Chocquet, therefore, who was listed as the lender in the Exhibition catalogue. At the Doria sale in 1899, the snowy landscape was purchased by Monet, while a few weeks later, at the Chocquet sale, the Count Camondo became the owner of *La Maison du Pendu*, which he later left to the Louvre.

4. Roger Marx (1859–1913), a writer and art critic, was one of Cézanne's earliest supporters and wrote numerous articles about him. At the Exhibition of 1900, he gave the painter's works a place of honor, scandalizing the public and the "official" artists. See Cézanne's letter of 23 January 1905.

5. Octave Maus, the leader of the "Vingt," a group of avant-garde artists in Brussels. Cézanne was to send three pictures to the group's exhibition in 1890, which were hung alongside works by Renoir, Sisley, Signac, Toulouse-Lautrec, Van Gogh, Redon, etc.

6. Upon the death of her mother in March 1882, in Yvetot, Madame Chocquet had inherited a considerable fortune that included large landholdings in that region. The collector and his wife were henceforth to spend the greater part of the year in Normandy, where Cézanne visited them, for example in 1882 in Hattenville; he was to return there several times.

# [1890]

Paris, 15 February 1890

Dear Sir,

Thank you for having sent the catalogue for the Exhibition of the XX, especially because I had been intending to ask you to be good enough to send a copy.

Allow me to express to you my congratulations on the picturesque and highly successful appearance you have given this charming pamphlet.

Please accept my sincere thanks and most cordial greetings,

Paul Cézanne

## HORTENSE CEZANNE TO MADAME VICTOR CHOCQUET

*Emagny, 1 August 1890*

*Dear Madame, dear friend,*

*You must be back in Paris, so I shall address this letter there. We are leaving on Thursday or Friday for Switzerland, where we plan to remain for the rest of the season. The weather is very fine and we are hoping it will remain so.*

*Paul[1] and I have already spent ten days in Switzerland and we found the country so lovely that we returned wanting to go back. We saw Vevey, where Courbet painted the pretty picture you have.*

*I hope that you, as well as Monsieur Chocquet and little Marie, are in good health.*

*You must be very busy with your mansion, for it's no small undertaking to remodel and furnish four floors.[2] I hope that it will be completed on schedule and that you will be able to move in very soon. You will then I am sure be very comfortable and will not mind the trouble it has caused you.*

*We are well. I am better than I was when I left, and I hope that my trip to Switzerland will put me back on my feet completely. We plan to look for a house and spend the summer months there. My husband has been working quite hard; unfortunately, he has been put out by the bad weather that has prevailed until the 10th of July. However, he has persisted in working at his landscapes with a tenacity that merits a better fate.*

*Monsieur Chocquet must be very busy with all his pictures, furniture and pretty bibelots. We hope that next year we shall have the pleasure of seeing you in Switzerland. You will be over the disturbances of this year and I can assure you that you will find the country superb; I've never before seen anything so lovely and it is so cool in the woods and on the lakes, and of course it will give us such great pleasure to have you.*

*My husband and Paul join me in sending their best wishes and ask to be remembered with friendship to Monsieur Chocquet. Please also give little Marie a kiss; we are certain she is very good and that she can read very well.*

*As for yourself, dear friend, I send you a heartfelt kiss and am your affectionate,*

*Hortense Cézanne*

*P.S. My mother-in-law and sister-in-law Marie are reconciled, I am overjoyed. As soon as we have found a place in Switzerland I shall send you our address.*

## [NOTES 1890]

1. This refers to his son, who was then 18.
2. In March of 1890, Chocquet had purchased a private house at 7 Rue Monsigny (between the Opéra and the Bourse) for 150,000 francs. He planned to install his collection, which he had not moved to Yvetot.

[From 1890 to 1894, there is a large gap in Cézanne's correspondence. After spending the summer of 1890 in Switzerland with his wife and son, he was in Aix at the beginning of 1891, where he often saw Paul Alexis and Numa Coste. It was in Aix that he received the news that his friend Chocquet had died on 7 April 1891 at 70 years of age.

Somewhat later, Cézanne moved into a new apartment in Paris at 2 Rue des Lions-Saint-Paul in the Marais. At this period, he often painted in the Forest of Fontainebleau, to which he returned in following years. In 1892 as well as 1893 and 1894, he spent a part of the year in Paris and the remainder in Aix.

In 1894, Gustave Caillebotte died; his collection, which included two landscapes by Cézanne, was transferred to the Musée de Luxembourg. Père Tanguy died in the same year; when his inventory was sold at public auction, Cézanne's works were sold at prices ranging from 45 to 215 francs, whereas Monet was already obtaining several thousand francs for his paintings.

During this period, Cézanne began to suffer from diabetes, which often made him extremely irritable.

Zola appears to have asked mutual friends for news of Cézanne. There are two letters extant, one from Alexis and the other from Coste, that give detailed information on the painter's life. In February 1891, Alexis wrote to Zola from Aix:

"This town is full, desolating and paralyzing. Coste, the only person I see at all, is not always good company [. . .] Fortunately, Cézanne, whom I am now seeing again, brings a breath of air and life into my socializing. He, at least, is vibrant, expansive and alive.

"He is furious with the Globe [Hortense] who, after a year's stay in Paris, punished him with five months in Switzerland and hotel food last summer . . . the only bit of friendship he found was with a Prussian. After Switzerland, the Globe, escorted by her bourgeois son, made her way back to Paris. However, by cutting off her allowance, he forced her to retreat back to Aix.

"Yesterday evening, Thursday, at 7, Paul left us to go to meet them at the station, her [and the] repulsive son; and the furniture from Paris, which cost 400 francs to transport, is arriving as well. Paul is planning to move everything into a rented apartment in the Rue de la Monnaie, where he will keep them (he even told his offspring: 'No matter what idiocies you commit, I shall never forget that I'm your father!').

"Notwithstanding, he himself does not intend to leave his mother and elder sister with whom he is living outside of town where he feels comfortable and which he far prefers to being with his wife in town. Now if, as he hopes, the Globe and the brat take roots here, there's

nothing to prevent him from going to Paris for six months from time to time. 'Long live sunshine and freedom,' he shouts.

"During the day, he paints at the Jas de Bouffan, where a laborer poses for him, and where I'll be going one of these days to see what he's up to.

"Finally, to complete the picture, he's been converted and is practicing. 'It's fear . . . I feel I've only got four days left, and after that? I believe that I will live on afterwards and I don't want to run the risk of roasting *in aeternum*.'

"On the other hand, there's no lack of money. Thanks to his pater, whom he now venerates—and who told him such things as: 'Each time you go out, be sure you know where you're going,' and 'Don't get too excited about anything . . . take time and take care of yourself!'—he now has enough to live on. And he has parcelled his income into twelve monthly installments, each of which is split three ways: one for the Globe! one for the little Globe! and one for himself! Only the Globe, who seems rather unfeeling, has a perpetual tendency to impinge on his personal share. Nowadays, buttressed by his mother and sister—who loathe the lady in question—he feels himself able to stand firm."

For his part, Coste wrote to Zola on 5 March 1891:

"How do you explain the fact that a greedy and hard banker could have given birth to a creature like our poor friend Cézanne, whom I saw lately. He is in good health and physically he seems to be holding his own. However, he has grown shy and primitive and younger than ever.

"He is living out at Jas de Bouffan with his mother who, for her part, is on the outs with the Globe, who doesn't get on with her sisters-in-law, who in turn don't get along with each other! So that as a result Paul lives on one side, and his wife on the other. And it's one of the most touching things I've ever seen, the sight of this fine fellow still preserving his childish naïveties, forgetting the disappointments of his struggle and, resigned and suffering, doggedy continuing to pursue a work he cannot manage to bring into being."

Five years later, Coste again wrote to Zola:

"Recently and now fairly frequently I've been seeing Cézanne and Solari, who have been here for a while [. . .] Cézanne is depressed and often prey to somber thoughts.

"However, he has some self-satisfaction, and in the sales his works are having a success to which he has not been accustomed. His wife must have made him do some stupid things. He is obliged to go to Paris and return according to the orders she issues. In order to have peace, he has been forced to part with his inheritance and, according to the confidences he has let escape, he seems to have been left with an allowance of some 100 francs a month. He rents a cabin in the quarries near the dam and spends the greater part of his time there."]

*Letters to Young Friends*
*Letters About Painting*
[1894–1906]

# Letters to Young Friends
## Letters About Painting
## [1894–1906]

[BECAUSE he had scarcely shown his works in Paris at all for over fifteen years, Cézanne was totally unknown there. Only a few enlightened persons had ventured into Père Tanguy's tiny shop to admire the canvases of the hermit of Aix. Slowly this circle broadened and such critics as Roger Marx and Gustave Geffroy began to take an interest in Cézanne's work. In 1895, Ambroise Vollard gave in to the insistent urgings of Camille Pissarro and his friends and gave the first large exhibition of Cézanne's pictures in his gallery in the Rue Laffitte. This was soon to be followed by other showings, all of which gave rise to extremely vehement argument and discussion. Along with determined opposition, the exposure created for Cézanne sincere and ardent admirers among the new generation of artists, who soon began to seek out in Aix the Master's friendship and advice. To these young painters and writers, Cézanne was to write letters expressing his artistic ideas and theories.]

# [1894]

TO GUSTAVE GEFFROY [1]

Alfort, 26 March 1894

Dear Sir,

Yesterday, I read the long article you devoted to shedding light on the experiments I have been making in painting. I wanted to express to you my gratitude for the sympathy I have found in you.

Paul Cézanne

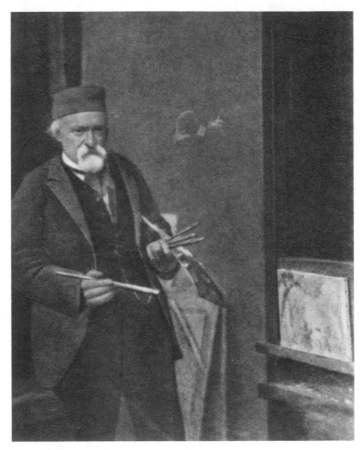

Photograph of Paul Cézanne in his atelier in Paris, 1894.

TO A DEALER IN ART SUPPLIES IN MELUN

[Fragment]²
21 September 1894

Yesterday, the 20th inst., I purchased from you four canvases, three
20's and one 25, the first three at 2 francs 50, and the 25 at 2 francs 80.
The total should have been 10.30, and not 11.50, as I mistakenly paid.

I hope that you will credit me with the difference upon my next visit
to Melun.

[When Cézanne was spending a few weeks in Giverny in the fall of
1894, Claude Monet, on 23 November, wrote to his friend Geffroy:

". . . It's set for Wednesday. I hope that Cézanne will still be here and that he will join us, but he is so odd, so timid at seeing new faces, that I fear he may not turn up, despite his desire to meet you. How unfortunate it is that this man has not had more support in his life! He is a true artist but a victim of too much self-doubt. He needs to be encouraged; he was therefore much moved by your article."

Geffroy was in fact to meet Cézanne shortly afterwards at Monet's, who had also invited Rodin, Clemenceau and Mirbeau. The American painter, Mary Cassatt, who was at the time staying in the only inn in Giverny, in which Cézanne was also living, sketched out in a letter a portrait of the painter that gives a clear perception of why he seemed so disconcerting to those who met him: "He resembles the description of a southerner by Daudet. When I saw him for the first time, he struck me as a kind of brigand, with large, red bulging eyes, which gave him a ferocious air, further augmented by a pointed beard, almost gray, and a manner of speaking so violent he literally made the dishes rattle. I later discovered that I had let myself be deceived by appearances, for far from being ferocious, he has the sweetest possible temperament, like a child [. . .]

"At first glimpse, his manners shocked me. He scrapes his soup plate and then tilts it and drains the last drops into his spoon; he picks up his cutlet in his fingers, tearing the meat from the bone. He eats with his knife, and with that instrument, which he firmly grasps at the beginning of the meal and doesn't relinquish until he rises from the table, he accompanies every gesture and movement of his hand. Yet, despite his total contempt for good manners, he displays towards us a politeness that none of the other men here could possibly equal. He never allows Louise to serve him before us, in the order in which we are seated at the table; he even treats that stupid maid with deference, and he takes off his cap, which he wears to protect his bald head, as soon as he enters the room [. . .]

"Conversation at lunch and dinner is mainly about art and cooking. Cézanne is one of the most liberal artists I have ever seen. He begins each sentence with 'For me, it's this way,' but he acknowledges that others can be equally honest and truthful with regard to nature, according to their convictions. He does not think that everyone must see in the same way."]

TO OCTAVE MIRBEAU[3]

[*Fragment, end of December, 1894*][4]

Show—I beg you to set me up with a dealer. Show . . . if you are intelligent—you will see. Make the reader see what you see. Write for the average intelligence. I don't believe that you are a Huysmans.[5] Never feel that you are his reader.

I was waiting for the new year to recall myself to your kind remembrance, but with this recent mark of favor you have shown me in *Le Journal*, I cannot put off thanking you.

I trust I shall have the honor of seeing you again and of being able to show you in a less ephemeral way than by mere words the gratitude that [word indecipherable] and called for.

Please tender my respectful homage to Madame Mirbeau and believe me, most cordially yours,

Paul Cézanne

# [NOTES 1894]

1. Gustave Geffroy (1855–1926), writer and art critic, had just written an article on the sale of the Thèodore Duret collection, in which three works by Cézanne had been sold at prices ranging from 600 to 800 francs (*Le Journal*, 25 March 1894). See his recollections of Cézanne in his book on Claude Monet.

2. Draft of a letter found in one of Cézanne's sketchbooks.

3. The writer Octave Mirbeau (1848–1917), who published articles on art that were imbued with a real passion for the subject, had just met Cézanne at Monet's in Giverny. In February 1894, he had written an obituary of Père Tanguy, whom he had known well, and on 25 December 1894 an article by him appeared in *Le Journal* on "The Caillebotte Donation and the State," in which he ridiculed the shilly-shallying of those in power with regard to Caillebotte's legacy (of the five pictures by Cézanne included in the legacy, three were finally to be rejected).

4. Draft found in a sketchbook. The first lines of this draft have been crossed out. In deciphering them, A. Chappuis has suggested that the sentence "I beg you to set me up with a dealer" was written because of the death of Tanguy, which had deprived Cézanne of all commercial support in Paris.

5. J.-K. Huysmans (1848–1907) had at times reservations about Cézanne's art and at other times praised him in his writings.

# [1895]

Paris, 31 January 1895

Dear Sir,

I am continuing my perusal of the studies in your book *Le Coeur et l'Esprit*, in which you have been kind enough to write such a sympathetic passage about me. And the further I read, the more I become aware of the honor you have done me.[1] I trust that in the future you will maintain that sympathy, which is precious to me.

Paul Cézanne

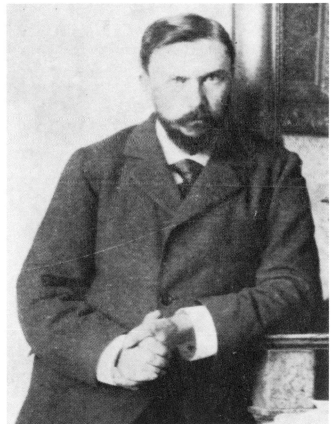

Photograph of Gustave Geoffroy.

TO GUSTAVE GEFFROY

Paris, 4 April 1895

Dear Monsieur Geffroy,

The days grow longer, the weather has become more clement, I am idle every morning until the hour when civilized men sit down to table. I am planning to come up to Belleville to shake your hand and lay before you a project that I have in turn considered and then abandoned on several occasions, and that I return to from time to time . . .[2] Cordially yours,

Paul Cézanne, painter by inclination

TO GUSTAVE GEFFROY

Paris, 12 June 1895

Dear Monsieur Geffroy,

[I conclude][3] Since I am on the point of leaving and find myself unable to finish successfully a task that is beyond my powers and that I was wrong to undertake—I would beg you to excuse me and to hand over to the messenger I am sending the objects I left in your library.

Please accept my regrets and my best regards,

P. Cézanne[4]

TO FRANCISCO OLLER[5]

[Aix] Jas de Bouffan, 5 July 1895

Dear Sir,

The highhanded tone you have taken towards me for some time now[6] and the rather too cavalier attitude you have been so bold as to adopt towards me at the moment of your departure have not been such as to please me.[7]

I have decided not to receive you in my father's house.

The lessons you have taken it upon yourself to give me have thus borne full fruit. Therefore goodbye.

P. Cézanne

## TO CLAUDE MONET

Aix, 6 July 1895

My dear Monet . . .

I was obliged to leave Paris, since the date set for my trip to Aix had arrived. I am at my mother's, who is of an advanced age, and I find her unwell and alone.

I was forced to abandon for the nonce the study I had been doing at Geffroy's, who generously made himself available to me, and I am somewhat distraught at the meager results I obtained, particularly after so many sittings and such alternating enthusiasm and disappointment. So I have ended up back in the Midi, which I should perhaps never have left, to hurl myself into the chimerical pursuit of art.

In concluding, let me tell me how happy your moral support has made me, and which serves me as a stimulus for painting. So until my return to Paris, where I must go to continue with my task, since I promised Geffroy I would.

With my regrets at having gone off without seeing you again, I am very cordially yours,

Paul Cézanne

## TO FRANCISCO OLLER

[Aix] Jas de Bouffan, 17 July 1895

Dear Sir,

Your mildly amusing letter came as no surprise to me. But first, the necessity of settling certain accounts with you . . . you should have remembered certain accounts I had to settle with Monsieur Tanguy. I shall not mention the unsuccessful attempt *vis-à-vis* Madame Ch.[8] Lastly, I find it hard to understand how I can be responsible for the monetary loss you say you suffered during your stay in Lyons.

You can pick up your canvas at the studio in the Rue Bonaparte any time between now and next January 15th.

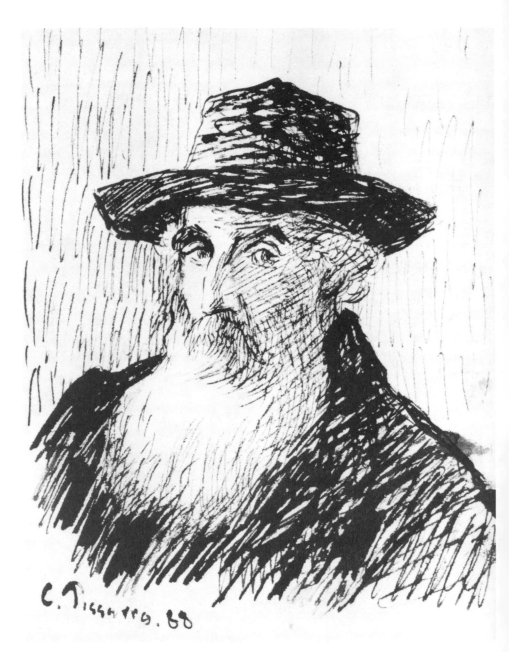

Self-portrait of Camille Pissarro, 1888.

Forget about the rest of the money I advanced you and the rest of it.

I hope that thanks to your change of attitude you will be able to extend your visit with Dr. Aguiar.⁹

Farewell.

<div align="right">P. Cézanne</div>

TO OCTAVE MIRBEAU¹⁰

<div align="right">Aix, 22 Nov. [1895?]</div>

. . . I have recently received news of Monet. Might I appear too indiscreet! Please accept my liveliest gratitude for the good remembrance you have kept of our meeting at the home of the Master of Giverny . . .

## [NOTES 1895]

1. This sentence may refer to a passage in the book in which the author puts into the mouth of an elderly man statements that must have expressed ideas similar to those Cézanne had voiced at Giverny and that are similarly set forth in his own letters. The painter must have appreciated the manner in which Geffroy had transcribed his thoughts through the words of his character:

"Nature furnished me, here on earth, with the extraordinary privilege of man's estate. Nature opens our eyes, as it does to all beings, to the spectacle around us and it gives us senses to appreciate it. It provides us, as it does all beings, with a brain that forms the focal point of our sensations. However, we can see that only man's power of cerebration can link facts together and, from chance happenings, deduce provisional hypotheses and general laws. It is through this dominance of ideas, which is our fate, that we become stronger than our destiny and that we can survive ourselves [. . .]

"I have wondered if the all-too brief span allotted us for making contact with things is really best employed in trying to understand the totality or whether we should work to assimilate the things immediately surrounding us. The brain that thinks overmuch is too heavy for the body [. . .] In my case, youth regrets the declining years, it controls what strength I have left, it wants to enjoy the last rays of sun, everything that one must leave behind—greenery, water, wind, mornings and evenings—it wants to go on seeing, to go on loving, before it disappears."

2. This project was the painting of a portrait of Geffroy seated at his desk (Venturi, No. 692).

3. Words crossed out.

4. Upon Geffroy's urging, Cézanne continued to work for another week and then left for Aix, intending to take up the work again upon his return to Paris (see his letter to Claude Monet of 6 July 1895). However, he was not to return before the following year, being kept in Aix by his work and by the state of his mother's health; she was then 80 years of age. On 3 April 1896, he finally sent a messenger to Geffroy's to collect his things, but not the portrait. Cézanne himself was not to return to Paris until the fall of that year. He and Geffroy never saw each other again.

5. The painter Francisco Oller y Cestero (1833–1917), a Puerto Rican, was a boyhood friend of Camille Pissarro, who had been born on the neighboring island of Saint Thomas. Having come to study in France, like Pissarro he had been a pupil of Courbet and Couture. In 1861, he and Pissarro noticed Cézanne at the Atelier Suisse. Returning to Paris after a twenty-year absence to submit a 4 meter picture to the Salon, he had got in touch with his former comrades.

6. Cézanne had first written "over the past ten days."

7. A letter from Camille Pissarro to his son Lucien recounts what had occurred between the two old friends: "Oller has been telling me extraordinary things that have happened to him with Cézanne, things that clearly reveal that the latter is a bit cracked. [. . .] After great evidences of affection in that expansive southern manner, Oller trustingly decided to follow friend Cézanne to Aix-en-Provence. They made an appointment to meet at the station at the P.L.M. train beside the third-class carriages, in friend Cézanne's words. So the next day, Oller is on the platform on the lookout, peering in all directions, no sign of Cézanne. Trains pass by, no one!!! Finally, Oller says to himself: he's left . . . makes up his mind and leaves too. Arriving in Lyons, he is robbed at the Hôtel of 500 francs he had in his wallet. Not knowing what else to do, he sends off a telegram to Cézanne, on the off chance; the latter had already reached Aix, having travelled first class!! . . . Oller received back a letter you'd have to read to believe it. He sent him packing, asking if he took him for an idiot, et cetera, a letter that was, in short, dreadful. It's a variation on what happened with Renoir. It seems he is furious with all of us . . ." The few details we have of this odd episode indicate that, from Lyons, Oller did not write to Cézanne, but rather telegraphed to the latter's son in Paris, who informed him that his father was already in Aix. Having reached Aix himself, Oller is supposed to have informed Cézanne of his presence there and to have received the following reply: "If that's how it is, come out right away. I'm waiting for you. P. Cézanne."

8. Madame Victor Chocquet?

9. This Cuban medical man and amateur painter was a friend of Pissarro, Guillaumin and Dr. Gachet, as well as of Oller and Cézanne. According to a letter from Pissarro to his son, "Aguiard witnessed similar scenes. As a doctor, he told Oller that Cézanne was ill, and that no attention should be paid to him, that he wasn't responsible." Cézanne also fell into rages against all his

former friends, even, as Pissarro was to tell his wife "with Monet, who, after all, has been very nice to him." Oller had passed on to him such outbursts of Cézanne's as: "Pissarro is an old animal, Monet's a sly dog, they've got no guts [. . .] I'm the only one of them with any temperament, I'm the only one among them who knows how to create a real red . . . !" And Pissarro concluded: "Isn't it sad and pitiful that a man with such a fine temperament should be so unbalanced?"

10. Unpublished letter; cf. Sale, Autographes et documents divers, Hôtel Drouot, 19 June 1970, no. 92 (from Theodore Reff).

# [1896]

Aix, 15 April 1896

Dear Sir,

I am leaving for Paris tomorrow.[2] Please accept the expression of my regard and my most sincere greetings.

P. Cézanne

TO JOACHIM GASQUET

Aix, 30 April 1896

Dear Monsieur Gasquet,

I met you in the courtyard this evening, you were with Madame Gasquet. If I'm not mistaken, you seemed to be extremely angry with me.

If you could see inside me, the man inside me, you wouldn't be. You cannot see the sad state to which I am reduced. Not my own master, the man who does not exist, and you, a would-be philosopher, you now want to destroy me? But I curse the Geffroys and the other bunch of fools who have drawn the attention of the public to me for the sake of a fifty-franc article.[3] All my life I've worked in order to be able to earn my living, but I thought one could paint good paintings without drawing attention to one's private life. Of course, an artist attempts to elevate himself intellectually as much as he can, but the man must stay in the background. The pleasure must stay in the work. If it had been left up to me, I would have stayed hidden away in my corner with those few friends with whom we used to down a bottle. I still have one friend from those days; well, he's never made it, although he's a hell of a lot better painter than all these beribboned low lifes, it's enough to make

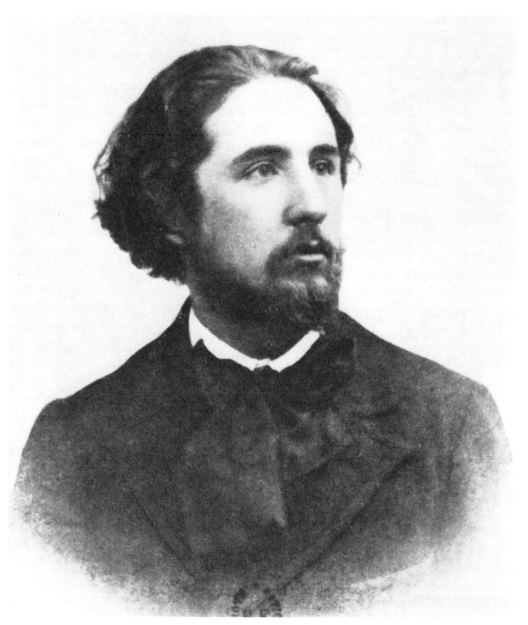

Photograph of Joachim Gasquet.

you puke.[4] Do you expect me, at my age, to believe in anything? I might as well be dead, for that matter. You are young, and I can understand that you want to get ahead. As for me, however, the only thing I can do in my situation is to fade away, and were it not that I have an enormous affection for the contours of my countryside, I wouldn't be here.

However, I've bored you enough with this, and after this explanation of my state, I hope that you will not continue to look upon me as if I had committed some attack on your security.

Please, my dear sir, in consideration of my vast age, accept my best regards and all the good wishes I hold for you.

<div style="text-align: right">Paul Cézanne[5]</div>

TO JOACHIM GASQUET

<div style="text-align: right">Aix, 21 May 1896</div>

Dear Monsieur Gasquet,

Being obliged to return to town early this evening, I cannot be at the Jas de Bouffan. Please excuse this confusion.[6]

At five o'clock yesterday evening, I had not yet received either Geffroy's *Le Coeur et l'Esprit* or the *Figaro* article. I sent a telegram to Paris in this connection.[7]

So until tomorrow, Friday, if you can, at the usual time.[8]

Cordially yours,

<div style="text-align: right">P. Cézanne</div>

TO JOACHIM GASQUET

<div style="text-align: right">Vichy, 13 June 1896</div>

My dear Gasquet,

You would like to start up a review.[9] Let's forget about me. Summon to your assistance those who have severally written letters to Monsieur d'Arbaud in reply to your proposal.[10] Their support, I

would even say their established positions, are necessary—they are even the basis of your review. They have lived; that in itself has given them experience. No one is a lesser person for recognizing things as they are. You are young, you have vitality, you will bring to your publication an impetus that only you and your friends who have the future before them can give it. It seems to me that that's a fine enough role to play, one to be proud of and in which you can involve yourselves. Take advantage of all the initiatives that have proven themselves. It's not possible that a man who has experienced life and who has attained, whether he knows it or not, the heights of existence, should hamper the progress of those who are just starting out in life. The path they have traversed is a sign to the right road and not a barrier in your way.

My son read your review with greatest interest. He is young and he cannot but share your hopes.

I have been here in Vichy for a week. The weather, rainy and cheerless upon our arrival, has cleared up. The sun is shining and the heart is full of hope. I shall soon be back at work.

If you see my friend Solari, please give him my greetings. Have courage, as I am sure you will. Believe me, with all my heart, on your side and accept my best wishes.

<div style="text-align:right">Paul Cézanne</div>

Vichy, Hôtel Molière (Allier).

TO JOACHIM GASQUET

<div style="text-align:right">Talloires, 21 July 1896</div>

My dear Gasquet,

I have left our Provence for a while. After considerable shilly-shallying, my family, in whose hands I find myself at the moment, has persuaded me to settle temporarily where I now find myself. It's a temperate climate. The surrounding hills are high enough. The lake, which is narrowed here by two channels, seems made for the linear exercises of young misses. It's the same old nature, of course, but more as we have been taught to see it in the sketchbooks of young lady tourists.

Valiant as you are, with your magnificent brain power you must be working away and without undue fatigue. I am too far away from you, both on the score of age and the knowledge that you are advancing each day; nevertheless, I recommend myself to you and your good thoughts so that the links that keep me attached to our old native soil, so vibrant, so harsh and so reverberant with light that your eyelids squint and your vessels of sensation are enchanted, will never break and set me loose as it were from the land where I felt, even without realizing it, so much. It will thus be a true act of compassion and a comfort to me if you continue to send me your review, which will remind me both of the distant country and of your benevolent youthfulness I have been allowed to brush elbows with. On my last visit to Aix, I was sorry not to be able to see you. But I learned with pleasure that Madame Gasquet and yourself were presiding over the regional and meridional festivals.[11]

And how I must thank you and express my gratitude to you for the good wishes you were so kind as to express in your letter on my wife's behalf. And I must also thank you for having sent me the second number of the review, so fruitful and so well filled.[12] I cherish the hope of being able to read more from you and your ardent collaborators.

In closing, please be kind enough to give my respects to the Queen of Provence, to remember me to your father and the other members of your family, and allow me to sign myself most cordially yours,

Paul Cézanne

Address: Hôtel de l'Abbaye, Talloires par Annecy (Haute Savoie).

One would need Chateau[briand's] descriptive pen to give you any notion of the old monastery where I am staying.

TO PHILIPPE SOLARI

Talloires, 23 July 1896

My dear Solari,

When I was in Aix, I had the feeling I would be better off somewhere else, now that I'm here, I miss Aix. For me, life has begun to be deathly monotonous. I was in Aix three weeks ago, I saw the elder Gasquet, his son being in Nîmes. In June, I spent a month in Vichy, where one eats

well. Nor does one do badly here. I'm staying at the Hôtel de l'Abbaye. What a superb survival from former days: a flight of steps up to the entrance that is some five meters broad, a marvelous doorway, an inner courtyard with columns that form a gallery around it; you ascend a huge staircase, the rooms give onto a broad corridor, the whole thing is very monastic. Your son will probably be in Aix soon. Please remember me to him and remind him of our strolls to Peirières and [Mont] Sainte-Victoire, and if you see Gasquet, who must be basking in the joy of further parenthood, give him my best.

Please also remember me to your father and give him my respects.

To overcome my boredom, I am painting, it's not greatly amusing, but the lake, with the high hills around it is very fine,[13] they tell me they're two thousand meters high, it's not our countryside, but all right as far as it goes. However, when you've been born there that's it—nothing else can compare. You have to have a strong stomach and down a stiff glass of grog, "the vine being the mother of the wine," as Pierre used to say, do you remember? And to think that I will be returning to Paris at the end of August. When will I see you again? If your son should be passing through Annecy on his way home, let me know.

A hearty handshake.

Your old friend,

<div align="right">Paul Cézanne</div>

Jo sent me the second number of the review around the end of June, when I was still in Vichy.[14] What a pleasure to get news from home.

My address here is: Hôtel de l'Abbaye, Talloires, near Annecy (Haute-Savoie).

Gasquet tells me that you have done some things that turned out very well—good for you.

<div align="center">TO JOACHIM GASQUET</div>

<div align="right">Paris, 29 September 1896</div>

My dear Gasquet,

As you can see, I'm very late in replying to your kindness in sending me the last two numbers of *Les Mois Dorés*. But upon returning to Paris

after Talloires, I've spent a good deal of time finding a studio for the winter. I'm very much afraid that circumstances will keep me for a time in Montmartre, where my factory has been set up. I'm a stone's throw from Sacré Coeur, with its campaniles and belfries thrusting towards the sky.[15]

I am at present rereading Flaubert, interrupted by reading the review. I often remark to myself how redolent of Provence it is. Reading your words, I can see you with an easier mind, and I recall the brotherly feelings you have always demonstrated for me. I won't go so far as to say that I envy your youth, that would be impossible, but your drive, your inexhaustible vitality.

So I thank you most heartily for not having forgotten me now that I'm far away.

Please remember me to your father, my old co-disciple, and give my respects to the Queen who presides with such magnificence over the artistic renewal that is taking place in Provence.

And to you, my best wishes and the hope that I will be witnessing your continued success. Yours ever,

Paul Cézanne

P.S. I must sadly inform you of Vollard's lack of success in selling Monsieur Heiriès's drawings.[16] He claims to have made several attempts, all fruitless, because of the difficulty of finding a market, book illustrations being in very little demand. I'll get the drawings back and, with great regret, return them to you.

P. Cézanne

TO EMILE SOLARI[17]

Paris, 30 November 1896

My dear Solari,

I am so very sorry I was not at Rue des Dames when you came by. There's only one way to make up for that, and that is to give me a rendezvous for tomorrow, for example. A fixed place, a precise time, which I leave up to you. I am free from four in the afternoon on. So please send me a note and believe I am yours cordially,

Paul Cézanne

TO A YOUNG ARTIST FRIEND OF JOACHIM GASQUET'S
(GUSTAVE HEIRIES?)

*Incomplete* [*Date unknown*]

[. . .] Perhaps I came too soon. I was a painter of your generation more than my own [. . .] You are young, you have vitality, you will imbue your art with a force that only those with true feelings can manage. As for me, I'm old. I won't have the time to express myself. [. . .] We must work [. . .]

[. . .] The reading of a model and its realization are sometimes very slow in coming.

## [NOTES 1896]

1. The Aix poet Joachim Gasquet (1873–1921), the son of one of Cézanne's school fellows, had just met the painter, to whom he devoted a book that was published in 1921. Gasquet met Cézanne a few months after his first show at Vollard's in November–December 1895 (on which occasion Geffroy devoted a favorable article to his work). The enthusiasm of his young fellow-country-man appears to have greatly touched the artist, who gave him a landscape of Mont Sainte-Victoire (Venturi, No. 454). During the course of their many walks and lengthy conversations, the voluble poet probably did most of the talking.

2. Cézanne had had no intention of abandoning Aix (as is evident from the following letter, written two weeks later). However, since he was probably at a loss as to how to cool the young man's somewhat overwhelming friendship, he hit upon his fairly feeble excuse in order to enable himself to withdraw once again into his habitual isolation.

3. This somewhat surprising remark is a further proof that Cézanne had begun to run his friends down, one after the other. True, Geffroy was what one might call a "Leftist," and his book about the life of the socialist and revolutionary L. A. Blanqui, published in 1897, created a sensation. As a practicing Catholic, Cézanne was unable to share the political views of the author; as for Gasquet, he was a royalist. It is even possible that the painter dropped Geffroy's portrait because he had come to feel a certain antipathy for his model during the course of the sittings. In this connection, see: J. Rewald, *Cézanne, Geffroy et Gasquet*, Paris, 1959.

4. This artist was perhaps Achille Emperaire, with whom Cézanne seems to have been reconciled around this time.

5. In his book on Cézanne, Gasquet relates how, upon receiving his letter, he dashed out to the Jas de Bouffan and was greeted by the painter with open arms. "Let's not talk about it," he said, "I'm an old fool. Sit down. I'm going to paint your portrait."

6. It would appear from these words that Cézanne had cancelled a sitting for Gasquet's portrait.

7. This is the work for which Cézanne had thanked Geffroy in his letter dated 31 January 1895. As for the *Figaro* article, it was a report on the Salon written by Zola and published on 2 May 1896. In it, the novelist appears to be abandoning his former opinions when he states, among other things: "Thirty years have passed, and I have rather lost interest in painting. I grew up almost in the same cradle as my friend, my brother, Paul Cézanne, that great failed painter in whose work people are only now beginning to discern elements of genius." Understandably, Cézanne was eager to read this article, but it is less clear why he had sent a telegram to Paris for a copy of Geffroy's book, which he apparently wanted to show to Gasquet.

8. "The usual time" probably refers to the sittings for Gasquet's portrait. These sittings were broken off the following month when Cézanne went to Vichy for the cure.

9. The title of this review, *Les Mois Dorés*, is an allusion to Pythagoras' *Golden Verses*. Gasquet had earlier published *La Syrinx*, which did not last long.

10. In order to get Cézanne's participation, Gasquet must have mentioned the names of other persons whose support he had already been promised. Among Gasquet's friends were José d'Arbaud, Joseph and Charles Maurras, Xavier de Magallon, Louis Bertrand, Georges Dumesnil, Emmanual Signoret, Paul Souchon, Edmond Jaloux and Jean Royère; the painter met some of them at the poet's home.

11. The Félibrige was a society of poets and prose writers founded in 1854 and devoted to preserving the Provençal dialect. There were many meetings of the society in 1896, particularly on 23 January at the wedding of Gasquet and Marie Girard, the Queen of the Society. On 26 July, a large festive celebration was held by the Félibrige at Saintes-Maries-de-la-Mer.

12. These somewhat vague lines are probably to thank Gasquet for an article published in *Les Mois Dorés* in July, in which the poet referred to the painter as follows: "Beneath the foliage of the Jas de Bouffan, by the fountains, he works away at the most painstaking studies, and it is wonderful to see the entire soul of a landscape suddenly being transformed into lines of color and become a permanent part of the calm workings of our minds [. . .] Later, as is fitting, I shall give an account of the life of the noble Master of Aix and the profound significance of the thousand canvases that are stacked away in his light-filled studio [. . .]"

13. Cézanne painted a view of the lake at Annecy (Venturi, No. 762).

14. This refers to Joachim Gasquet.

15. Cézanne was at this time living in the Rue des Dames in Montmartre. The Basilica of the Sacré-Coeur, which was begun in 1875, was not finished until 1914.

16. The draughtsman Gustave Heiriès was a member of Gasquet's circle of friends in Aix.

17. Emile Solari, the son of the sculptor who was Cézanne's boyhood friend, was Zola's godson. He was planning to take up a literary career.

# [1897]

Paris, 13 January 1897

My dear Guillemet,

Having been confined to my room for two weeks by a stubborn cold, I only yesterday received your letter fixing an appointment and the card confirming your kind visit. I must therefore express to you all my regrets at having been unable to be at my studio when you came by to see me there, and to tell you how upset I am by this unfortunate occurrence, which prevented me from telling you my condition, and from getting to the studio.

Please accept my excuses and believe me yours, cordially,

P. Cézanne

Letter to Antoine Guillemet. June 13, 1897.

TO PHILIPPE SOLARI

Paris, 30 January 1897

My dear Solari,

I've just received your kind letter. Needless to say, I didn't receive the one you say you wrote in late December. I've not seen Emile since the end of last month, but for good reason. Since the 31st last, I have been confined at home by the flu. Paul took care of my move from Montmartre. And I'm not out of it yet, although I'm getting better. As soon as I can, I shall write a note to Emile to fix an appointment.

As for Gasquet, his request has touched me deeply, and please pass on to him my wish that he present the two canvases in question to Monsieur Dumesnil.[1] To this end, please get in touch with Gasquet and go to my sister's, 8 Rue de la Monnaie, and ask her to go with you to the Jas where the above-mentioned canvases are. I am writing to my sister about it.

Save for the stagnant state inherent in the situation, things aren't going badly, although had I been able to organize my life in order to live down there I would have been better off. However, families entail a great many concessions.

I embrace you affectionately and ask that you give my greetings to your entire circle of friends.

Cordially yours,

Paul Cézanne

TO JOACHIM GASQUET

Paris, 30 January 1897

My dear Gasquet,

Solari has just told me about your plan. May I ask you to employ all the circumlocutions necessary in the circumstances in presenting the two canvases in question to Monsieur Dumesnil? It would make me very happy were the philosophy professor of the Aix faculty to deign to accept my homage. In extenuation, I would suggest the fact that in my region I am more a friend of art than a producer of paintings, that on the other hand it would be an honor for me to know that two of my

studies were being hung in suitable surroundings, etc., etc. This you can fill out with a few flourishes of your own, since I know you do that sort of thing extremely well.[2]

So that's settled. And thank you for the honor I have been given through your mediation.

Please give my respects to Madame Gasquet—I refer to the Queen— and my best wishes to your father, and I am yours, gratefully.

Paul Cézanne

Thank you for the last big issue of the review.
Long live Provence!

TO EMILE SOLARI

Mennecy, 24 May 1897

My dear Solari,

I should be leaving for Aix soon. In all probability, my departure will take place during the night of Monday 31 May–1 June, God willing. On Saturday, the 29th inst., I will be going to Paris; if you are free and would like us to get together before my departure, please be at 73 Rue Saint Lazare, at the time agreed upon.

Cordially yours,

Paul Cézanne

Hôtel de la Belle Etoile, Mennecy near Corbeil (Seine-et-Oise).

TO JOACHIM GASQUET

Tholonet, 18 July 1897

My dear Gasquet,

Owing to my immense fatigue, I am overcome with such weariness that I cannot accept your kind invitation. I feel that I am at the end of my strength, and I would beg you to excuse me and to make my

excuses to your family. I must be more reasonable and understand that at my age illusions are no longer possible and will always disappoint.

Please give my respects and my regrets to Madame Gasquet and to Madame and Monsieur Girard, and believe me, yours cordially,

Paul Cézanne

TO PHILIPPE SOLARI

*Undated*
[*Tholonet, late August 1897*]

My dear Solari,

On Sunday, if you're free and would like to, come have lunch in Tholonet at the Berne restaurant. If you come in the morning, you will find me around 8 o'clock near the quarry where you did a sketch when you came out the time before last.[3]

Cordially yours,

Paul Cézanne

TO EMILE SOLARI

Tholonet, 2 September 1897

My dear Solari,

I received your letter of 28 August. I didn't reply at once. In it, you told me you were sending me a review that would allow me to savor some of your poems. I waited for several days, but no review.

I have just reread your letter and I realize that I didn't really take it in and that what you were promising to send was a report of the celebrations in Orange.

You refer to the review in which your writings appear as the *unknown* review. Is that really what it's called, and is that the title I should ask for at the post office, since I haven't received it?

But you are really very kind in the midst of your Parisian occupations and preoccupations to think of the few all-too-brief hours you spent in Provence; true, that great magician—I refer to the Sun—was a

member of the party. But your youth, your hopes, played a consider-
able part in making you see our region in a favorable light. Last Sun-
day, your father came to spend the day with me—the poor man, I
drowned him with theories about painting. He must be good-natured
to have stood it. However, I see that I'm being somewhat longwinded
and I send you a cordial handshake in wishing you good luck and *au
revoir*.

<div style="text-align:right">Paul Cézanne</div>

<div style="text-align:center">TO EMILE SOLARI</div>

<div style="text-align:right">Tholonet, 8 September 1897</div>

My dear Solari,

I've just received the copy of *L'Avenir Artistique et Littéraire* that you
were kind enough to send me. Thank you.

Your father is coming to eat a duck with me next Sunday. With
olives (the duck, of course). If only you could be with us! Please re-
member me kindly in future years and allow me to express myself
yours cordially,

<div style="text-align:right">P. Cézanne</div>

<div style="text-align:center">TO JOACHIM GASQUET</div>

<div style="text-align:right">Tholonet, 26 September 1897</div>

My dear Gasquet,

I greatly regret that I will be unable to accept your tempting invita-
tion. However, having left Aix this morning at 5 a.m., I cannot get
back before late in the day. I'm having supper at my mother's and the
weary state in which I find myself at the end of the day doesn't allow
me to present myself in a suitable state to company. Please, therefore,
excuse me.

Art is a harmony parallel to nature—what can those imbeciles be
thinking who keep saying that the artist always falls short of nature?

Very cordially yours, and I promise to come to visit you soon.

<div style="text-align:right">P. Cézanne</div>

TO EMILE SOLARI

[Aix] Jas de Bouffan, 2 November 1897

My dear Solari,

I received your letter telling me of your impending marriage. I have no doubt that in your future companion you will find that indispensable fulcrum every man requires who has a long and often arduous career ahead of him. My best wishes for the realization of your well-founded hopes.

You also tell me of the problems you are having in breaching the walls to get your productions onto the stage. Thinking of that impels me to tell you that I am well aware of the problems you are facing. What can I add, other than that I sympathize with your difficulties, and my exhortation to much courage, you'll need it to arrive.

By the time you receive these words you will have heard of my poor mother's death.[4]

Repeating my exhortations to courage and work, I am very cordially yours,

                                                                                        Paul Cézanne

I had the pleasure of seeing your father a few days ago, he promised me to come out to the Jas.

# [NOTES 1897]

1. Georges Dumesnil had been Gasquet's professor at the Université d'Aix.
2. This refers to landscapes of Peyrières and L'Estaque.
3. The Bibémus Quarry, above the village of Tholonet near the François-Zola Dam, with its picturesque masses of yellow rock cut in cubes and its trees growing out of the crevices, provided Cézanne with many subjects.
4. She died on 25 October 1897 at the age of 82. Maxime Conil, the painter's brother-in-law, had thereupon insisted that the inheritance be parceled out to the heirs. The Jas de Bouffan was to be sold in 1899.

# [1898]

Montgeroult, Monday evening [1898]

Dear Sir,

I just woke up and remember that in circumstances similar to those recently brought to my attention I did indeed have such an encounter. I am very upset by the false position I have got myself into.[2] Although I have not had the honor of being acquainted with you for very long, I would ask you to assist me in redressing my blunder. Tell me what I ought to do. I would be most grateful.

Please accept my best wishes,

P. Cézanne

TO LOUIS LE BAIL

Marines [1898]

Dear Sir,

The rather informal manner in which you have allowed yourself to appear at my home has not been pleasing to me. You will be so good as to have yourself announced in the future.[3]

Please return the glass and the canvas that are still in your studio to the person who will come to get them.

Sincerely,

Paul Cézanne

TO JOACHIM GASQUET

Paris, 22 June 1898

My dear Gasquet,

After having read your superb lines exalting the race of Provence I

cannot remain silent as I would were I faced with the vexing presence of some mere Geffroy.[4]

One thing needs to be said, and that is that the task accomplished is not worthy of the praise you heap upon it. However, you're aware of that, and you see things through such a prism that any words thanking you must pale.

Please be so good as to tell Paul [the painter's son] when I may see you again?

In sending you my most heartfelt thanks, I would ask you to give my respects to Madame Gasquet.

Paul Cézanne

TO HENRI GASQUET[5]

Paris, 23 December 1898

My dear Henri,

I have just received the remembrance you were so kind as to send me. I can only send you my hearty thanks. For me, it is an evocation of forty years ago. May I say that it was providence that introduced me to you? Were I younger, I would say that it is a source of security and comfort for me. A person who is stable in his opinions and his principles is remarkable. Please thank your son as well, whose acquaintance was heavensent and whose friendship is very precious to me.

I hope I shall see him soon, either when I come down to the Midi or when his studies and literary interests bring him back here. He, Madame Gasquet and their friends have all their futures before them. With all my heart, I support the artistic movement that they are initiating and upon which they will make their mark. You have no idea how uplifting it is to find oneself surrounded by young people who are not ready to bury you on the spot, and thus I can only express my sincerest wishes for their triumph.

I shan't dwell on this now; it's better to talk face to face—one explains oneself and makes oneself better understood that way.

In closing, please remember me to your mother, who, in your house, is indeed the matriarch of wisdom. I know that she cherishes the

memory of the Rue Suffren where we grew up. It is impossible not to be deeply affected when we recall those lovely bygone days and that atmosphere we unquestioningly enjoyed, the basis of our spiritual lives till today.

My dear Henri, please express my friendliest feelings to your family and allow me to embrace you with all my heart.

Your old comrade,

Paul Cézanne

## [NOTES 1898]

1. Louis Le Bail, a young painter living in Marines at the time, had learned from Camille Pissarro that Cézanne was working not far away. He had already paid him several visits, and Cézanne struck up a friendship with his young colleague.

2. Baron Denys Cochin, an art collector, had while out riding come upon Cézanne painting in Montgeroult. The painter, unaware that the gentleman was an admirer of his talent, had been fairly curt with him. Louis Le Bail later informed him of the identity of his visitor, who owned several of Cézanne's works.

3. What had happened was this: Cézanne had asked Louis Le Bail to awaken him every day after his nap, around three in the afternoon. The latter, faithful to his task and finding Cézanne asleep, had, after having knocked at length on the door, entered his bedroom to awaken him.

4. Under the title *Le Sang Provençal*, Gasquet had just published in the March-April 1898 issue of *Les Mois Dorés* a review of a book on Provençal society in the late Middle Ages by the Aix historian Charles de Ribbe. He had again mentioned Cézanne, particularly in his conclusion: "The rustic and noble painting of Paul Cézanne offers to our imaginations the same information Monsieur de Ribbe imparts to our minds. These two men complement each other perfectly. They tell us what they know, the one with passion, the other with simplicity. Both, constantly emulating others of their race, have experimentally, via factual data, almost achieved the realization—each in his own field—of something as magnificent and as sincere as was achieved in epic, lyric and drama by the author of *Le Rhône* and *Calendal*" [Frédéric Mistral].

With his regional chauvinism, Gasquet regarded Cézanne as above all a Provençal artist whose achievement was "almost" as great as that of Frédéric Mistral's. However, it is difficult to understand why the painter, in accepting this homage, should have taken pains to make further disobliging remarks about Geffroy.

5. The poet's father and former schoolmate of Cézanne, a prosperous bourgeois, owned a bakery in Aix that he had inherited from his family.

# [1899]

Paris, 25 February [1899?]

My dear Emile,

Two sittings per day with a model are more than enough to wear me out. And such has been the case for over two weeks. Tomorrow, Sunday, rest.

Would you like to come by the studio in the afternoon? I'll be there from two to four.

Cordially yours,

Paul Cézanne

## TO MADEMOISELLE MARTHE CONIL, THE ARTIST'S NIECE

Paris, 16 May 1899

My dear niece,

Yesterday, I received your letter inviting us to your First Communion. Aunt Hortense, your cousin Paul and myself are very touched by your nice invitation. However, to our great regret, the great distance between here and Marseilles prevents us from being at your side at that lovely rite.

At present, I [find myself] detained in Paris by a fairly lengthy piece of work,[1] but I hope to come down to the Midi sometime next month.

So I shall soon have the pleasure of giving you a kiss. Remember me in your prayers, for once we have begun to grow old, we can find no greater support and consolation than in religion.

With thanks for your good wishes, I send you greetings from Aunt Hortense, cousin Paul and a kindly caress from your old uncle,

Paul Cézanne

Please say hello too to your sisters Paulette and Cécile.

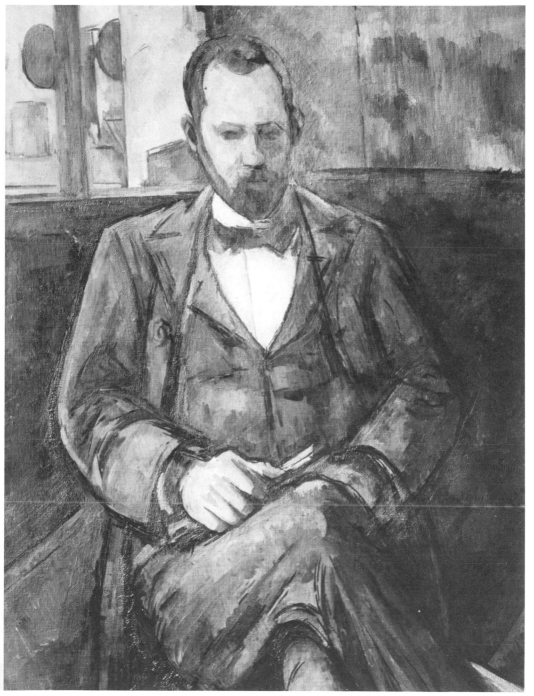

Portrait of Ambroise Vollard. Paul Cézanne, 1899.

TO EGISTO PAOLO FABBRI[2]

Paris, 31 May 1899

Dear Sir,

The number of my studies which you have housed assures me of the great artistic sympathy you have shown on my behalf.

I don't know how to deny your highly flattering desire to make my acquaintance. The fear of disappointing expectations is doubtless the excuse for keeping to one's self.

Please accept my respects.

Paul Cézanne
15 Rue Hégésippe Moreau,
Villa des Arts

TO HENRI GASQUET

Paris, 3 June 1899

My dear Henri,

Last month, I received an issue of *Le Mémorial d'Aix* that contained as its leading article a splendid one by Joachim on our region's claim to worldly fame.[3] I was touched by his remembrance and I would ask that you pass on to him the feelings he awakened in me, his former co-pupil at the St. Joseph school, for the vibrations of those feelings set in motion by the lovely Provençal sun have not completely died out for us, [of] our memories of our past youth, the horizons, landscapes and unforgettable outlines that have left so many deep impressions upon us.

When I return to Aix, I shall come to give you an affectionate greeting. For the nonce, I am still seeking a way to express those confused feelings that we bring with us into the world. If I die it will all be over, but that doesn't matter. Whether I come to the Midi first or you should happen to come to Paris beforehand, please think of me; let me know in advance and we'll get together.

Please give my respects and remember me to Madame Gasquet,

your mother, and my best regards to your son and his wife, and for yourself, in the hope of seeing you soon, the fond remembrance of your old companion,

Paul Cézanne

## [NOTES 1899]

1. This probably refers to the portrait of Ambroise Vollard (Venturi, No. 696), which was painted in 1899 and required more than 100 sittings. Vollard devoted a chapter of his biography, *Paul Cézanne* (Paris, 1914), to this portrait.

2. Egisto Paolo Fabbri, an Italo-American collector and painter (1866–1933), had, prior to 1899, assembled an important collection of Cézanne's works. This letter from the painter is a reply to one from Fabbri, but unfortunately we do not know whether or not Cézanne gratified his admirer's wish to make his acquaintance. Fabbri's letter to Cézanne was as follows:

*Paris, 28 May 1899*

*Dear Sir,*

*I have the good fortune to own sixteen of your works. I know their aristocratic and austere beauty—for me, they represent what is the most noble in modern art. And often, as I gaze at them, I have wanted to tell you face to face of the feelings to which they give rise.*

*However, I am aware that you are burdened with many claims on your time, and that it may be indiscreet of me to ask you if I might be allowed to visit you. Nevertheless, I would hope that one day I might have the pleasure and the honor of making your acquaintance; in any event, my dear Sir, please accept this expression of my deep admiration.*

*Egisto Fabri*

3. Gasquet had just published in *Le Mémorial d'Aix* of 7 May 1899 an article of "random observations" in which he had written: "The great argument brought against our town is as follows: Aix is asleep. Aix is dying. No one wants to work. And yet, nothing has changed here since the days of Peiresc, Du Vair, Malherbe, Vauvenargues, Mirabeau, Mignet, Thiers, Victor de Laprade, Frédéric Mistral . . ." To those former glories, however, Gasquet did not add the name of any living person. He did not mention Cézanne, probably because the article was intended not for a small, esoteric review but rather for a weekly newspaper that was widely read in Aix, where Cézanne was generally considered to be an eccentric without any talent. Because of his political opinions, Gasquet also took care not to allude to Zola either, particularly because the Dreyfus Affair was then at its height.

# [1900]

Aix, 10 July 1900

Dear Sir,

Herewith the information you were kind enough to request:

Born in Aix-en-Provence in 1839.

Yours sincerely,

Paul Cézanne[1]

Aix, Sunday, August 1900

My dear Gasquet,

I enclose the article you lent me and which I read with great pleasure. It admirably sets off the verses you employed to paint the rustic picture you presented in your lovely lines. And now that you have become a *master* of the *expression* of your feelings, I too think that you will succeed, through work of this quality, in receiving public recognition of your talent.

Please accept my best regards and my best wishes for your success.

P. Cézanne

Aix, 11 August 1900

My dear Gasquet,

I am sick and cannot come to thank you as I wanted to. I shall come to shake your hand as soon as I can.

Very cordially yours,

P. Cézanne

[In the autumn of 1900, Cezanne would appear to have seen Gasquet more frequently, and to have met at his house such persons as the young poet Léo Larguier, who was beginning his military service in Aix at the time, and Louis Aurenche, another budding writer, who had just arrived in Aix from Lyons for a tour of duty in a registry office. Through Larguier, he was to meet Pierre Léris, a law student at the Aix Faculté, as well as another young soldier, the painter Charles Camoin, born in Marseilles. The artist became friendly with these young men and often invited them to dinner at his home in the Rue Boulegon. Gasquet, however, does not seem to have been asked to join them.

Further details are to be found in Léo Larguier's memoirs *Dimanche avec Paul Cézanne*, Paris, 1925, and those of Louis Aurenche, published in J. Rewald, *Cézanne, Geffroy et Gasquet*, Paris, 1959.]

## [NOTES 1900]

1. Thanks to Roger Marx, three of Cézanne's works were included in the Centennial Exhibition. The information requested was evidently for the catalogue.

# [1901]

Aix, 4 January 1901

My dear Gasquet,

Thank you for the nice letter you wrote to me. It proves to me that you haven't dropped me. If isolation tempers the strong, it is a stumbling-block for the hesitant. I must admit that it is always sad to turn one's back on life, as long as we are here on earth. With the feeling that we are together morally, I shall hold out till the end.

P. Cézanne

TO MAURICE DENIS[1]

Aix, 5 June 1901

Dear Sir,

In the newspapers I have learned of the demonstration of your artistic sympathy towards me that has been shown at the Salon of the Société Nationale des Beaux-Arts.

Please accept this expression of my deep gratitude and relay it to the artists that have joined you on this occasion.

Paul Cézanne

MAURICE DENIS TO PAUL CEZANNE

[Paris] 13 June 1901

*Dear Sir,*

*I am deeply touched by the letter you have been so kind as to write to me. Nothing could give me greater pleasure than to know that in the depths of your solitude you have been made aware of the sensation that has been created by the* Hommage à Cézanne. *Perhaps this will give you some idea of the position*

*you hold in the painting of our time, of the admiration you enjoy and of the
enlightened enthusiasm of many young people, myself among them, who may
rightfully call themselves your pupils because whatever they have understood
about painting they owe to you; and that is a debt we can never sufficiently
acknowledge.* [2]

*Please accept, dear Sir, etc.*

*Maurice Denis*

TO JOACHIM GASQUET

Aix, 17 June 1901

My dear Gasquet,

I have received *L'Ombre et les Vents* which you sent to me. How kind
of you to have thought of the recipient. I shall savor it slowly, but
already, having skimmed through it, exquisite and heady aromas have
been emitted.

I have no doubt that you will achieve the fine success you deserve.

Yesterday, Sunday, I saw your father and mother, who ask that you
not forget them.

Please give my respects to Madame Gasquet, and I hope that your
present success will be followed by many more.

Very cordially yours,

Paul Cézanne

TO MONSIEUR VOLLARD

Aix, 22 July 1901

Dear Monsieur Vollard,

I have sent you today the canvasses and the pastel. You or Paul put
me on the track of the maker, who is no other than Guillaumin (Paul
has just written me).

Cordially and with warm thanks,

Paul Cézanne

So it is only a false attribution.

TO LOUIS AURENCHE[3]

*Undated*
*[Aix, probably October 1901]*
*On the letterhead of the Café Clément, Aix*

Dear Monsieur Aurenche,

Were I not under strong pressure from the poet Larguier, I would let go some well-turned phrases. However, I'm only a poor painter, and the brush is most likely the only means of expression heaven intended me to wield. Thus, having ideas and setting them forth is not my province. I shall be brief—I hope that you will soon find yourself at the end of your trials and that your freedom will permit us a warm and friendly handshake.

He who entered the career of life before you and wishes you the best of luck,

Paul Cézanne

TO LOUIS AURENCHE

Aix, 20 November 1901

Dear Monsieur Aurenche,

My pen is clogged up—please forgive the handwriting, which will still, I hope, enable you to perceive the pleasure I got from reading your letter.

Yesterday evening, the 19th inst., Léo Larguier and the undersigned dined together. We talked about all sorts of things: as you can imagine, you were not left out of our conversation, quite the contrary. Since we are well aware of your deeply human feelings, we could not but sympathize with you. *Homo sum: nihil humani a me*, etc.[4]

I have had the pleasure of making the acquaintance of Monsieur Léris, who has all the appeal of his years and the exquisite qualities with which a benevolent nature has endowed him.

You refer in your letter to Monsieur de Taxis.[5] I believe he is a fine man whose acquaintance should be cultivated; reason, that clarity that

enables us to see into matters with which we are faced, is I feel his guide in life and in his social practice. As you say, we will not be far apart and neither you nor we will forget each other.

Yesterday I had news from my rascal of a son, who is gliding through life while waiting to become a sober citizen.[6] He is leaving [Paris] a week from Friday, the 29th, and will turn up in Aix on the 30th of this month. If you can drop me a note telling me what day you are arriving, we will try to arrange to dine together at my house here in Aix.

I hope that this letter finds you in good spirits; have courage and we shall try to spend some more pleasant evenings philosophizing at length. The Jo's[7] seem (*nescio cur*)[8] to have somewhat toned down their arrogance not all that threatening for that matter.

Very cordially yours. From one who preceded you in life and who—willy-nilly—will surely precede you out, your old

<div style="text-align: right">Paul Cézanne</div>

## [NOTES 1901]

1. The painter Maurice Denis (1870–1943) had just exhibited a large canvas entitled *Hommage à Cézanne* (now in the Musée National d'Art Moderne, Paris), in which he had grouped the following around one of the Master's still lifes: Odilon Redon, Vuillard, K. X. Roussel, Ambroise Vollard, Maurice Denis, Sérusier, Mellerio, Ranson, Bonnard and Madame Maurice Denis. When he painted this canvas, Maurice Denis had not yet met Cézanne. The picture was bought by André Gide and now belongs to the National Museums.

2. In January 1906, Maurice Denis, accompanied by K. X. Roussel, was to pay a visit to Cézanne in Aix.

3. Having arrived in Aix in November of 1900, Louis Aurenche left the city a year later upon being appointed district land assessor in Pierrelatte (Drôme).

4. I am a man, nothing human is foreign to me.

5. A gentleman in Aix.

6. The painter's son was nearly thirty years of age.

7. This refers to Joachim and Marie Gasquet.

8. I know not why.

# [1902]

TO AMBROISE VOLLARD

Aix, 20 January 1902

My dear Monsieur Vollard,

Yesterday evening we received your delightful gift. We tasted it immediately and under its benificient influence declared unanimously that you were *indeed a fine man*. So I send you the warmest thanks of the whole family for the pleasure of tasting your precious liquid. I fear that it will not acquire much age.

The bouquet is still progressing, and it seems to me better than when you saw it two weeks ago, when it was still transitional. I haven't seen the landscape again, but it is supposed to be going quite well.

I am digging through the paternal packages right now. I hope to find some watercolors in finished state to add to those you plan to exhibit at my return to Paris.

My parents send you cordial greetings, and I, dear Mr Vollard, my best wishes,

Paul Cézanne f.

TO AMBROISE VOLLARD [1]

Aix, 23 January 1902

Dear Monsieur Vollard,

We received the case of wine you were kind enough to send us a few days ago. Since then, your last letter has arrived. I am still working on the bouquet of flowers, which will probably take me up to around the fifteenth or twentieth of February.[2] I will have it carefully packed and send it off to you, Rue Laffitte. When it arrives, please be so good as to have it framed and to submit it officially.[3]

The weather is very changeable; sometimes good sun, followed un-

expectedly by heavy, slate-gray clouds, which makes landscape work difficult.

Paul and my wife join me in thanking you, and I very much on my behalf, for the magnificent gift of the great Master's work you have given me.[4]

Best regards,

<div style="text-align: right">Paul Cézanne</div>

TO CHARLES CAMOIN[5]

<div style="text-align: right">Aix, 28 January 1902</div>

Dear Monsieur Camoin,

Many days have passed since I have had the pleasure of a letter from you. I have little to tell you: more, indeed, can be said about painting, and perhaps, more pertinently, by stressing the subject than by devising purely speculative theories—in which one often gets lost. In my long hours of solitude I have thought of you more than once. Monsieur Aurenche has been appointed assessor in Pierrelatte in the Dauphiné. Monsieur Larguier, whom I see fairly often, usually on Sundays, gave me your letter. He yearns for his discharge, which will occur in six or seven months. My son who is here has met him and they go out and often spend the evening together; they chat about literature and the future of art. When his army service is over, Monsieur Larguier will probably return to Paris to continue his studies (moral and political science) in the Rue Saint-Guillaume, where Monsieur Hanoteaux, among others, holds forth, but without abandoning poetry, of course. My son is also going back, so he will have the pleasure of making your acquaintance when you return to the Capital.

Vollard came through Aix some two weeks ago. I've had news of Monet and a card from Louis Leydet, the son of the senator from the Aix district. The latter is a painter, he is in Paris at the moment and shares our notions. So you see, a new artistic era is beginning, as you foretold; continue to study unstintingly, God will see to the rest. I close wishing you courage, good studies and success will not fail to crown your efforts.

Believe me sincerely yours, and long live the homeland, our common mother and land of hope, and accept my heartfelt thanks for your good wishes.

Your devoted,

<div align="right">Paul Cézanne</div>

<div align="center">TO CHARLES CAMOIN</div>

<div align="right">Aix, 3 February 1902</div>

Dear Monsieur

Today, the 3rd, I find your letter of February 2nd in my letterbox, from Paris. Larguier was ill last week and in hospital, which explains the delay in the forwarding of your letter.

Since you're in Paris and the masters in the Louvre attract you, you should if you feel so inclined make studies of the great decorative masters, Veronese and Rubens, but as though you were working from nature—which I myself never quite succeeded in managing. However, you should study nature above all. From what I've seen of you, you should make rapid progress. I'm glad to hear that you appreciate Vollard, who is both sincere and serious. I am sincerely glad that you are with your mother, who in moments of sorrow and depression will be the surest moral support and the most generous source of renewed courage for you in the pursuit of your art, which one must try to manage to engage in—not without a firm basis and half-heartedly—but rather in a calm and constant way that will not fail to lead to clear-sightedness, something very useful in guiding you firmly through life. Thank you for the brotherly way in which you regard the efforts I have attempted to make to express myself lucidly through painting.[6]

In the hope that I will have the pleasure of seeing you again one day, I send you a cordial and affectionate handshake.

Your old colleague,

<div align="right">Paul Cézanne</div>

TO LOUIS AURENCHE

Aix, 3 February 1902

Dear Monsieur Aurenche,

I received your kind letter a few days ago and it made me very happy. All the good memories you evoke come back to me. I was extremely sorry to see you leave, but life is but a continual voyage. And being with you perked me up; it was good for my self-esteem to discover new friends in the wilderness of good old Aix. I haven't been able to feel close to anyone here.[7] Today, the sky being hung with gray clouds, I see things in an even darker light.

I see Léris very rarely; my son, who goes out often, meets him frequently. Larguier, who has a finely balanced nature, gives me the pleasure of dining here at the house on Sunday evenings with my wife and Paul. We miss you.

Larguier has been promoted to corporal. I received a long letter from Camoin and answered him in a fatherly vein, as befits my age.[8]

The painting proceeds willy-nilly. Sometimes I am quite carried away, and more often I am sadly disappointed. Such is life.

I am very pleased by the news you give me of Madier de Montjau's presence in Pierrelatte.[9] I am sure he is a thoroughgoing artist, not only as regards talent, but in his heart as well. In my younger days (we were then in the sixth-year class of Père Brémonde, nicknamed Pupille), there was also Edgard de Julienne d'Arc, who was killed at Gravelotte. He was already a virtuoso. Please pass on to him my gratitude for having remembered our days at the Collège Bourbon.

Paul, my son, who was sorry to see you leave, and my wife join me in sending you greetings. I would be very happy if you were to come to Aix next April. Léo [Larguier] will still be here and, if you are free, I would invite you to stay with me, 23 Rue Boulegon.

My best wishes and a firm handshake. When you are sad, think of your old friends and don't abandon art altogether; it's the most intimate manifestation of ourselves.

Thank you for your kind thoughts and very cordially yours,

Paul Cézanne

TO LOUIS AURENCHE

Aix, 10 March 1902

Dear Monsieur Aurenche,

I am very late in replying to your last letter. To blame are the *cerebral difficulties* by which *I am affected* and that only allow me to manage when I am painting from the model.

Here is what I would like to suggest. Can you put off your coming to Aix until May, for otherwise I won't be able to offer my hospitality at home since my son will be using his bedroom until then. In May, he's returning to Paris with his mother, who is not very well.

Larguier has been in the hospital for two weeks with an eye ailment called conjunctivitis. The Gasquets of either sex have not shown themselves. They have acquired a chateau in Eguilles, a hamlet some ten kilometers from Aix. It will be real country-house living; Abbé Tardif is going to purchase a luxury automobile to go visit them. He is said to be an outstanding preacher.

As for me, I am painfully pursuing my painting studies. Were I young, this might produce some cash. But old age is the great enemy of man.

While strolling along the road to Marseilles I had the honor of encountering Madame de Taxis. I had the honor of saluting her and performing all the customary courtesies.

Very cordially yours,

Paul Cézanne

Who is forced to admit that he is not one of the most unfortunate men on earth. A little confidence in yourself, and work. Never neglect your art, *sic itur ad astra.*[10]

TO CHARLES CAMOIN

Aix, 11 March 1902

Dear Monsieur Camoin,

For the first question, I must inform you that I know Monsieur Louis Leydet, the senator's son, only as a painter. He is a charming fellow and I believe you may approach him by mentioning my name. I am sorry

that he has not come to Aix at all, I think we would have been able to tighten the bonds of artistic comradeship already established between us. He lives at the home of his father the senator at 85 Boulevard Saint-Michel.

For the second question, I would reply: I believe absolutely in Vollard as an honest man. Since your departure, the Bernheims[11] and another dealer have been to see me. My son had some dealings with them. However, I remain faithful to Vollard, and I deeply regret that because of my son he got the impression that I might take my canvases somewhere else.

I am having a studio built on a piece of land I acquired for the purpose, and Vollard, I am quite sure, will continue to act as my agent with the public.[12] He is a man with immense flair, bearing, and manners.

Please believe me yours cordially,

P. Cézanne

TO MAURICE DENIS

Aix, 17 March 1902

Dear Sir and Colleague,

This is to inform you that upon receipt of your letter of the 15th, which touched me very much, I immediately wrote to Vollard instructing him to place at your disposal any canvases you find suitable for showing at the Independants.

Please believe me yours very cordially,

P. Cézanne

TO AMBROISE VOLLARD

Aix, 17 March 1902

Dear Monsieur Vollard,

I have received a letter from Maurice Denis saying that he considers my abstaining from participation in the Independants' exhibition as tantamount to desertion.

I am replying to Maurice Denis to tell him that I am asking you to place at his disposal whatever canvases you can lend him and to choose the ones that will create the least fuss.

Please believe me yours very cordially,

P. Cézanne

It appears that I have trouble keeping away from young people, who have shown such sympathy towards me, and I do not think that showing will compromise the course of my studies in any way.

P. Cézanne

If this doesn't suit you for some reason, please let me know.

TO LOUIS AURENCHE

[Aix] March 1902

Dear Monsieur Aurenche,

I have a great deal of work to do; such is the case with any serious person. Thus I am unable to allow myself to be distracted this year. I would strongly urge you to work intellectually; that is the only true recourse we have here on earth from all the troubles that dog our steps.

Very cordially yours,

Paul Cézanne

TO AMBROISE VOLLARD

Aix, 2 April 1902

Dear Monsieur Vollard,

I find myself obliged to put off sending the canvas of your *Roses* to a later date. Although I would have very much liked to have submitted something to the 1902 Salon, I am putting off that plan again this year. I am not happy with the final result. On the other hand, I am not going to give up pursuing my study, which involves efforts that will not, I like to think, be fruitless. I have had a studio built on a small plot of land

I purchased for that purpose. Thus I am continuing my experiments and I will inform you of the final result as soon as my study has yielded me some satisfaction.

Please believe me yours very cordially,

Paul Cézanne

### TO AMBROISE VOLLARD[13]

Aix, 10 May 1902

Dear Monsieur Vollard,

De Montigny, a distinguished member of the Société des Amis des Arts d'Aix, chevalier of the Légion d'Honneur, has just invited me to show something with them.

I am therefore asking that you pick out something fairly innocuous, to frame it, at my expense of course, and to send it posthaste to the Société des Amis des Arts d'Aix-en-Provence, Bouches-du-Rhône, 2 Avenue Victor-Hugo.

### TO JOACHIM GASQUET

Aix, 12 May 1902

My dear Gasquet,

Having been invited by Monsieur de Montigny to show at the Société des Amis des Arts, I find myself without anything ready. The aforementioned distinguished colleague has just been to see me *iterum* and asks if you would be so good as to lend them the head of the old woman, the former maid of [Jean] Marie Demolins, the esteemed collaborator on the review you direct.[14]

With the expression of my deep feelings of co-citizenship,

P. Cézanne

23 Rue Boulegon, Aix-en-Provence

In case it should not have a frame, let me know, please, and I will see to it.

TO JOACHIM GASQUET

Aix, 17 May 1902

My dear Gasquet,

Thank you for the timely advice you were kind enough to give me. I shall take it into account.

I believe that you did a wise thing in isolating yourself in the country. You must be able to work there marvelously well.[15]

As soon as I have recovered from these latest upheavals, I will come out to see you.

Thank you, very cordially yours,

P. Cézanne

TO JOACHIM GASQUET

Aix, 8 July 1902

My dear Gasquet,

Solari came to the house yesterday. I was away. According to the tale told me by my housemaid, I gather that you are unable to understand my silence with regard to my plan to stay at "Font Laure."

I am pursuing success through labor. I despise all living painters, save for Monet and Renoir, and I will succeed through work.

As soon as an opportune moment arrives, I shall come to shake your hand.

One has to have something in the gut, and after that there's nothing but work.

Very cordially yours,

Paul Cézanne

I had a study that I began two years ago; I had hoped to pursue it. The weather has finally turned good.

TO LOUIS AURENCHE

Aix, 16 July 1902

Dear Monsieur Aurenche,

I have just received your good news. I shall of course be in Aix the 24th, 25th and 26th of July. I will thus have the pleasure of seeing you again and, hoping that the Tutelary Gods of Labor and Intelligence will smile upon you,

Please accept my best regards.

Please also give my respectful greetings to Madame Aurenche.

Paul Cézanne

TO MADEMOISELLE PAULE CONIL,
THE ARTIST'S NIECE

Aix, 1 September 1902

My dear godchild,

I received your nice letter on Thursday, August 28th. Thank you very much for thinking of your old uncle; your remembering touches me and reminds me at the same time that I am still in the world; it could so easily have been otherwise.

I remember Establon and the once so picturesque shores of L'Estaque very well. Unfortunately, what we call progress is nothing other than the invasion of bipeds, who won't stop until they have transformed the whole thing into odious quays with gas lamp standards and—even worse—electric light. What kind of times are we living in!

The sky has been stormy and that has cooled things off a bit, and I'm afraid that the water, not being so warm anymore won't make swimming much fun, if indeed you can do it at all.

Thursday, I went to Aunt Marie[16] where I stayed for dinner in the evening. I saw Thérèse Valentin there, to whom I read your letter, as well as to my sister.

Everything is fine here. Marie has cleaned up my studio, which is

finished and into which I'm moving little by little. I enjoy thinking that you will be coming to honor it with a visit when you return.

Give your sisters my greetings, and to young Louis, and I send you a very cordial kiss,

Your uncle,

Paul Cézanne

[In the autumn of 1902, Cézanne visited Larguier and his family in the Cévennes. On 23 September, Zola died in Paris. Upon learning of the death of his old friend, Cézanne burst into tears and shut himself away in his studio for the rest of the day.

It was in 1902 that Octave Mirbeau took steps to obtain the Cross of the Légion d'Honneur for Cézanne. This initiative failed in the face of the opposition of Roujon, the director of the Beaux-Arts.]

# [NOTES 1902]

1. Ambroise Vollard (1865–1939), the art dealer, was the first to express interest in Cézanne after Tanguy's death and organized a one-man show of his works in 1895. He became the artist's exclusive agent and published his recollections of him in a biography, *Paul Cézanne*.

2. This still life was evidently painted from artificial flowers.

3. The painter had planned to submit this canvas to the Salon, but it was not ready in April 1902 (see the letter to Vollard of 2 April 1902) and was abandoned a year later (see letter to Vollard of 9 January 1903). This was the *Bouquet de Fleurs* (Venturi, No. 757).

4. This refers to a large watercolor by Delacroix, *Bouquet de Fleurs*, which Vollard had purchased at the sale of the Victor Chocquet collection and which Cézanne had admired at his friend's house. Vollard always maintained that there was no question of a gift, but rather of a trade; indeed, had Vollard intended to offer this work to the painter as a gift, he would have done so immediately after the Chocquet sale on 1 July 1899. Cézanne was to make a copy of this watercolor (Venturi, No. 754). Delacroix's *Bouquet* is now in the Louvre.

5. The painter Charles Camoin (1879–1965) had been sent to Cézanne by Vollard. He became friendly with Léo Larguier in Aix, where they were both doing their military service.

Unfortunately, the most important letter from Cézanne to Camoin no longer exists. The impecunious young artist had sent it to a wealthy aunt who lived in Venice, in the hope that the Master's favorable opinions with regard

to his younger colleague expressed in it might persuade the aunt to subsidize her nephew. That lady, however, never having heard of Cézanne, threw the letter away after reading it.

Like Aurenche, Camoin was to maintain a correspondence with Cézanne after leaving Aix.

6. Camoin had just written to Cézanne that Baudelaire's poem, *Les Phares*, in which the poet hymns the praises of the works of Rubens, Leonardo da Vinci, Rembrandt, Michelangelo, Puget, Watteau, Goya and Delacroix, now required another verse. This passage in Cézanne's letter is in reply to that remark.

7. This sentence would appear to indicate that Cézanne no longer felt close to the Gasquets.

8. See the preceding letter, written the same day.

9. Former conductor at the Opéra, son of the well-known 1848 tribune.

10. "Thereby one reaches the stars." (Virgil)

11. The brothers Josse and Gaston Bernheim-Jeune (the latter also an amateur painter) were then at the beginning of their brilliant career as art dealers. Since the majority of the impressionists had long been associated with Durand-Ruel, and since Vollard, who took over from Tanguy in 1894–1895, had become Cézanne's representative as well as of Gauguin and Redon, before taking on Picasso, Derain, Rouault, Maillol, etc.) the Bernheim-Jeune brothers were to find many of the very new painters already associated with dealers. Nevertheless, they paid a visit to Cézanne, whose son, charged with his father's "business" affairs, sold them a few watercolors, an act that seems to have embarrassed the painter.

The Bernheim-Jeunes thereupon devoted themselves principally to such younger painters as Matisse, Signac or Bonnard, although they also played an active role with regard to works of Van Gogh and Seurat, as well as Cézanne and Renoir. In the autumn of 1904, Gaston Bernheim-Jeune paid a second visit to Cézanne in Aix (see the painter's letter of 11 October 1904, in which he states that he must proceed solely "in order to have his theories disseminated.")

Following the artist's death, the Bernheim-Jeune brothers were to purchase from Gasquet and Geffroy the works Cézanne had given them and were to share, mostly with Vollard, in the group of over 100 watercolors sold by the Master's son.

12. Because Cézanne had only a relatively small studio at the Rue Boulegon, in November 1901 he had purchased a property on the flanks of the Lauves above Aix. In the studio he had built for himself there he was to work principally on his large compositions of bathers. This studio is now open to the public.

13. Draft.

14. This refers to the picture *La Vieille au chaplet* (Venturi, No. 702) which the artist had given to Gasquet. However, the poet might have had good reasons for refusing this request. He may have feared that this work would not be understood by the inhabitants of the town or that—since the model was known—unfavorable comments might be made as to the likeness, or—in line

with his view of Cézanne as a "Provençal painter"—he may have suggested that he show a landscape instead. In any event, the portrait did not appear in the show, in which Cézanne was finally represented by two canvases (probably sent by Vollard) that were listed in the catalogue as No. 16, *Le Pré, au Jas de Bouffan (environs d'Aix)* and No. 16*bis, Nature morte.*

Cézanne seems not to have taken offense at Gasquet's refusal; see the following letter.

15. Gasquet had just purchased the property, "Font Laure," in the village of Eguilles near Aix.

16. Cézanne's elder sister, who never married.

# [1903]

Aix, 9 January 1903

Dear Monsieur Vollard,

I am stubbornly working away, I can glimpse the Promised Land. Will I be like the great leader of the Hebrews, or will I be able to enter it?

If I am ready by the end of February, I'll send you my canvas for framing and embarcation to some hospitable harbor.

I had to abandon your flowers, with which I am not at all pleased. I have a large studio in the country. I work there, I'm more comfortable there than in town.

I've made some progress. Why so late and so painfully? Is Art in fact a priesthood which demands the pure who belong to it wholly? I regret the distance separating us, for more than once I would have had recourse to you for a bit of moral support. I live alone, the . . . and the . . .[1] are indescribable, they're the intellectual clique, Good God, the whole lot of them! If I live long enough, we shall talk again about all that. Thank you for thinking of me.

Paul Cézanne

Aix, 22 February 1903

Dear Monsieur Camoin,

Tired as I am, 64 years of age, I beg you to excuse me for my lengthy delay in answering you. It will be brief.

My son, who is in Paris at the moment, is a great philosopher. In saying that, I don't mean he is either the equal or the follower of Diderot, Voltaire or Rousseau. Would you like to honor him with a

visit, 31 Rue Ballu, near the Place Clichy, where the statue of General Moncey is? When I write to him, I'll mention you; he's somewhat moody, an idle sort, but a decent fellow. His intercession will ease the difficulty I have in dealing with everyday things.

Thank you very much for your last letter. But I must work. Everything, above all in art, is a question of theory developed and applied to contact with nature.

We will discuss all that when I again have the pleasure of seeing you.

This is the best letter I have written you so far.

*Credo.*

Very cordially yours,

Paul Cézanne

When I see you, I will talk to you more aptly than anyone else about painting. I have nothing to hide when it comes to art.

The initial force, *id est*, temperament, is the only thing that can carry one forward to the goal one must reach.

P. Cézanne

TO HIS SON

[*Aix, March 1903*]

*Fragment*

. . . No use sending it to me,[2] I find copies daily under the door, not to mention copies of *L'Intransigeant* sent to me through the post.

TO JOACHIM GASQUET

Aix, 25 June 1903

My dear Gasquet,

I didn't have your address,[3] which explains my delay in thanking you for what you so very kindly sent me. Your father took the trouble of getting it to me. So far, I've not yet managed to do more than glance through your poem.

You have acquired the status of young master: by young, I mean in years and prepared for the good fight that is about to be joined.

The artistic movement Louis Bertrand has described so well in his fine preface to *Les Chants Séculaires* is under way. March on, and you will continue to clear a new pathway for Art leading to the Capitol.

Your very devoted compatriot and admirer,

P. Cézanne

TO JOACHIM GASQUET

Aix, 5 September 1903

My dear Gasquet,

I've just heard that you did me the honor of calling on me at the Rue Boulegon. Here's how things are with me: I have six months' more work to do on the canvas I've begun; it will go to meet its fate at the Salon des Artistes Français.[4] In the meanwhile, I'll find a day to come to see you. If there is some delay, it is because of this impasse I long to get out of. I need either 10,000 or nothing, or else—like Bourdelet [?] and the idiots he works with, I'll have to turn to patrolling the streets, checking on which unhappy woman has got pregnant out of wedlock and you know that charming intellectual level.[5]

My respects to Madame Gasquet and a very cordial handshake for you.

P. Cézanne
The Pest of Roujon

TO CHARLES CAMOIN

Aix, 13 September 1903

Dear Monsieur Camoin,

I was glad to hear from you and I congratulate you on being free to devote yourself entirely to work.

I think I told you that Monet lived in Giverny; it is my hope that the

artistic influence the master cannot help but exercise on those in more or less direct contact with him will be duly and justly felt, as it should be by any young artist willing to work. Couture used to tell his students: *Keep good company*, meaning: *Go to the Louvre*. But after seeing the great masters who rest there, one must hasten to leave and to revivify oneself through contact with nature, with the instincts and with the artistic sensations within us. I regret not being able to be with you. Age wouldn't matter if other things didn't prevent me from leaving Aix. Nevertheless, I hope I shall have the pleasure of seeing you again one day. Larguier is in Paris. My son is in Fontainbleau with his mother.

What can I wish for you: studying well in Nature's presence, that's the best thing there is.

If you meet the master we both admire,[6] please remember me to him.

I don't believe he takes very kindly to being disturbed, but sincerity may perhaps soften him up a bit.

Believe me very cordially yours.

<div align="right">Paul Cézanne</div>

<div align="center">TO LOUIS AURENCHE</div>

<div align="right">Aix, 25 September 1903</div>

Dear Monsieur Aurenche,

I am very happy to hear of the birth of your son, you will come to understand how happily he will change your life.

Paul, who is in Fontainebleau, will give you my regards in person when he returns. I can't say when that will be; however, I am working away stubbornly, and if the Austerlitz sun of painting shines for me we will come together to shake your hand.

Please give Madame Aurenche my congratulations and my most respectful greetings.

<div align="right">P. Cézanne</div>

# [NOTES 1903]

1. It is not impossible that Cézanne made reference here to the Gasquets, but because persons still alive were involved, Vollard discreetly omitted their names.

2. On the occasion of the posthumous sale of Zola's collection, Henri de Rochefort had published an article in *L'Intransigeant* of 9 March 1903 entitled "The Love of Ugliness," in which he wrote as follows with regard to the painter's early works: "Had M. Cézanne been a suckling when he perpetuated these daubs, we would refrain from comment; but what can we think of the leader of the group, the self-styled squire of Médan who propagated such pictorial ravings? . . . Had the unhappy creature never seen a Rembrandt, a Velasquez, a Rubens or a Goya? For if Cézanne is right, all those great masters of the brush are wrong [. . .] We have often said that Dreyfusards existed long before there was a Dreyfus case. All those sick minds, those perverted souls, those cross-eyed and crippled creatures, were ripe for the advent of the Messiah of Treason. When someone sees nature as did Zola and his painters-in-waiting, it is only natural that they should also discern patriotism and honor in the figure of an officer handing over his country's defense plans to the enemy. The love of physical and moral ugliness can be a passion like any other."

In spite of this article, Cézanne's works were sold for sums higher than expected, attaining from 600 to 4,200 francs.

3. The friendship between Cézanne and Gasquet had evidently declined. However, the poet continued to send the painter his books, like *Les Chants Séculaires*, published in 1903.

4. Cézanne's entry was again to meet with rejection.

5. The meaning of these comments, designed to explain why Cézanne had not yet come to "Font Laure," is obscure.

6. Referring to Claude Monet.

# [1904]

Aix, 25 January 1904

My dear Monsieur Aurenche,

Thank you so very much for the New Year's wishes sent me by you and yours.

Please accept mine, in turn, and extend them to your family.

In your letter you speak of my artistic accomplishment. I feel I am getting closer every day, albeit somewhat painfully. For if a strong feeling for nature—and mine is certainly intense—is the necessary basis for any artistic concept, and upon which rest the grandeur and beauty of future work, a knowledge of the means of expressing our emotion is no less essential, and can only be gained through long experience.

The approbation of others is a stimulus, but sometimes one to beware. The feeling of its strength leads to modesty.

I'm pleased by the success of our friend Larguier. I haven't seen Gasquet, who lives in the country, for a long time now.

Dear Monsieur Aurenche, please believe me very truly yours,

Paul Cézanne

Aix, 29 January 1904

Dear Monsieur Aurenche,

I am greatly touched by your concern. At the moment, I'm feeling well enough. The reason I did not reply sooner to your first letter is a very simple one. After a long day spent grappling with the difficulties of expressing nature, when evening comes I feel the need to rest a bit, and so I don't have the freedom of mind one needs to write.

I don't know when I will have an opportunity to get to Paris. If that happens, I shan't forget that friends await me in Pierrelatte.

If you come to Marseilles, I'll be more certain of having the pleasure of seeing you.

With very best wishes, my dear Monsieur Aurenche, I am yours,

P. Cézanne

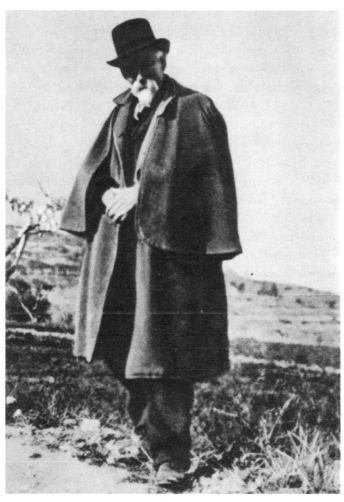

Photograph of Paul Cézanne in Aix, 1905, by Emile Bernard.

TO EMILE BERNARD[1]

Aix–en–Provence, 15 April 1904

Dear Monsieur Bernard,

By the time you receive this you will probably have also received a letter from Belgium, I believe, that was addressed to you at the Rue Boulegon. The expression of artistic sympathy you gave me in your letter made me happy.

Allow me to reiterate what I said to you here: deal with nature as cylinders, spheres, cones, all placed in perspective so that each aspect of an object or a plane goes toward a central point. Lines parallel to the horizon give a feeling of expanse, either of a section of nature or, if you prefer, of the spectacle the *Pater Omnipotens Aeterne Deus* offers to our eyes. Lines perpendicular to that horizon give depth. Now, for us men, nature consists more of depth than of surface, whence the need to introduce into our vibrations of light, represented by reds and yellows, a sufficient amount of shades of blue to make the air felt.

I should tell you that I've had another look at the study you made of the ground-floor of the studio.[2] It's good. I believe you have only to continue along that path. You know what must be done and you will soon be able to turn your back on Gauguin and [Van] Gogh.

Please thank Madame Bernard for her kind remembrance of the undersigned, a hearty Père Goriot kiss for the children, and my respects to your fine family.

TO EMILE BERNARD

Aix, 12 May 1904

My dear Bernard,

My devotion to work and advanced age will explain my delay in replying to you.

Furthermore, in your last letter you spoke of so many different matters, all of them however connected with art, that I cannot quite follow the whole of your argument.

As I have told you, I like Redon's talent a great deal,[3] and I share his feeling and admiration for Delacroix. I don't know whether my precarious health will ever enable me to realize my dream of creating his apotheosis.[4]

I am proceeding very slowly, nature appears to me very complex; and the road is never ending. One must see the model clearly and feel it right; and then express oneself with distinction and force. Taste is the best judge. It is a rare thing. Art speaks to a very small group.

The artist must disdain all opinion that is not based upon intelligent observation of character. He must be wary of the literary mind, which so often leads the painter out of his true path—the concrete study of nature—and to waste time in abstract speculations.

The Louvre is a fine place to study, but it must be only a means. The real, the great study is the endless variety of the natural scene.

Thank you very much for sending your book,[5] I am waiting to read it when I can relax.

If you consider it good, you can send Vollard what he asked for.[6]

Please give my respectful greetings to Madame Bernard, and to Antoine and Irène a kiss from Père Goriot.

Cordially yours,

P. Cézanne

TO EMILE BERNARD

Aix, 26 May 1904

My dear Bernard,

I can for the most part approve the ideas you are going to embody in your forthcoming article for *L'Occident*.[7] However, I always come back to this: the painter must devote himself entirely to the study of nature and strive to produce pictures that will instruct. Talk about art is almost worthless. Work that yields progress in one's own metier is sufficient recompense for not being understood by idiots.

The writer expresses himself through abstractions whereas the painter is concrete through line and color, his feelings, his perceptions.

He is neither over scrupulous nor too sincere nor unduly subservient to nature; but he is more or less the master of his model and, above all, of his means of expression. Penetrating what is before one and persevering in expressing oneself as logically as possible.

Please give my respectful greetings to Madame Bernard, a hearty handshake for yourself and remember me to the children.

*Pictor*   P. Cézanne

TO EMILE BERNARD

Aix, 27 June 1904

My dear Bernard,

I received your favor of the . . . which I left in the country. My delay in replying is due to the fact that I've been having cerebral problems that prevent me from maneuvering freely. I am still possessed by sensations and, despite my age, clamped tight to painting.

The weather is fine and I'm taking advantage of it to work. I must do ten good studies and sell them dear, since collectors are speculating in my work.

Yesterday, a letter arrived addressed to my son which Madame Brémond guessed was from you;[8] I had her forward it to 16 Rue Duperré, Paris IX$^e$.

It seems that Vollard gave a *soirée dansante* a few days ago at which everyone stuffed themselves. The whole younger set seems to have been there. Maurice Denis, Vuillard, etc. Paul ran into Joachim Gasquet there. I believe the best thing is to work hard. You're young, work and sell.

Do you remember that lovely pastel of Chardin wearing spectacles with a kind of raised visor attached? What a wily old fox that painter was. Have you ever noticed how by overlapping a slight transverse plane on the bridge of the nose he has made the values more vivid? Check on it and tell me if I'm mistaken.

Very cordially yours, and please give my respects to Madame Bernard and remember me to Antoine and Irène.

P. Cézanne

It seems to me that Paul wrote me they had rented something in Fontainebleau to spend a couple of months.[9]

I must inform you that because of the intense heat I have lunch brought to me in the country.

TO EMILE BERNARD

Aix, 25 July 1904

My dear Bernard,

I've received *La Revue Occidentale*.[10] I can only thank you for what you have written about me.

I regret we cannot be side by side, because I don't want to win out theoretically, but by nature. Despite his *estyle* (as it is pronounced in Aix), and his admirers, Ingres is really only a very minor painter. You know better than I who the great ones are: the Venetians and the Spaniards.

In any future progress to be made nothing counts but nature and an eye educated through contact with it. The more one looks and works, the more concentric it becomes. I mean, in an orange, an apple, a sphere, a head, there is a culminating point, and that point is always— despite the terrible effect: light and shade, sensations of color—the one closest to our eyes;[11] the edges of objects flow towards a central point situated on our horizon. With a bit of temperament, one can be a fine painter. One can achieve fine things without being either a harmonizer or a colorist. All you need is a sense of art. And that sense is the one the bourgeois find horrid. So you have institutes, pensions, honors that are set up only for cretins, clowns or fools. Don't be an art critic, paint. There is where salvation lies.

A cordial handshake, your old comrade,

P. Cézanne

All my respects to Madame Bernard, and remember me to the children.

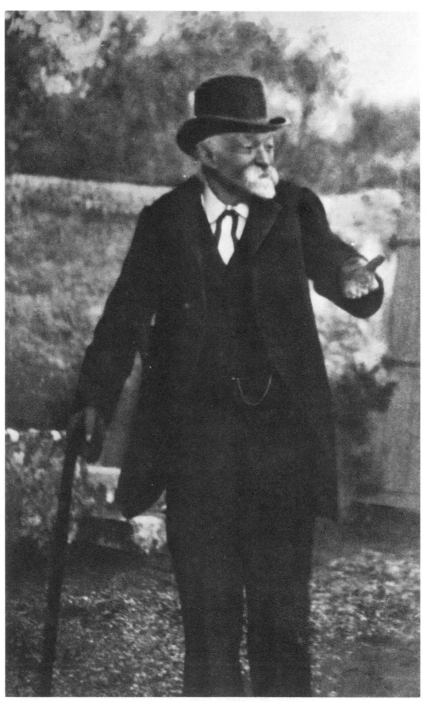

Photograph of Paul Cézanne at Aix, 1904. M. J. Bernheim, Jr.

TO JOACHIM GASQUET

Aix, 27 July 1904

My dear Gasquet,

I can't tell you how touched I was by your excellent remembrance. Shaking off my torpor, I emerge from my shell and will make every effort to respond to your invitation.

I went to the [Cercle?] Musical to inquire of my friend your father about the projected journey. Please tell him to give me some details about the train departures and the place we might settle on to meet.

Very cordially yours and all my respects to your family.

P. Cézanne

I read the article in *La Provence Nouvelle* devoted to your fine work. [12]

TO PHILIPPE SOLARI

[Aix] Friday, 24 September 1904

My dear Solari,

I'd like to have a sitting on Sunday morning. [13] Could you manage to come to lunch at Madame Berne's around 11 o'clock? From there we can go up to your place—see if this plan suits you, otherwise I'll try to get to your place by asking directions; yours ever,

P. Cézanne

TO GASTON BERNHEIM-JEUNE[14]

Aix, 11 October 1904

Dear Sir,

I am late in replying, the precarious state of my health will be sufficient excuse.

I am touched by the evidences of esteem and the terms of praise your letter contains.

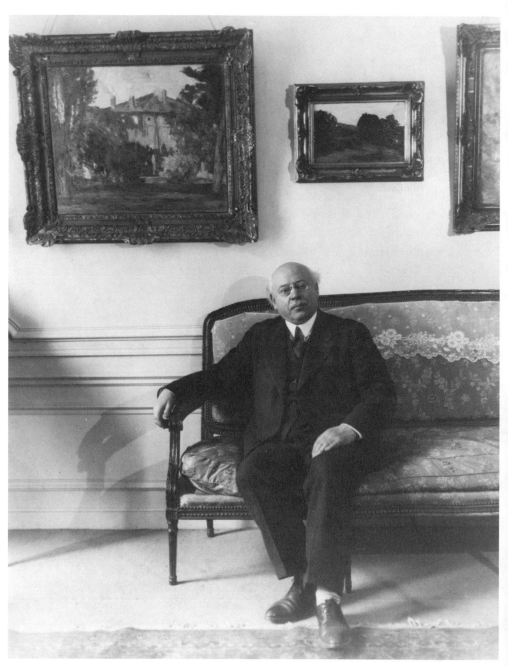
Photograph of Paul Cézanne, Jr., in his home in Paris.

I would be very pleased to reply favorably to your wish if it were limited to my explaining my theories and the fixed goal towards which I have been striving all my life.

With the expression of my artistic sympathy,

P. Cézanne

*Aix, 11 November 1904*

*Dear Mr. Vollard,*

*I acknowledge a bit tardily the receipt of your transfer of two thousand francs; and I enclose herewith two signatures. My father is delighted with the successful results of the Salon d'Automne and he thanks you much for the care you have taken of his exhibition. He will be happy to see all four sides of the room which has been graciously devoted to him. I am awaiting the first lot of photographs that you are sending. I will do my best to catalogue them with the date, place and subject, as you request. My return to Paris will be early in December, when I will bring you the finished project.*

*My father is keen as ever for his art, as you can imagine. The Bathers canvas is making progress. The portrait of the old poacher who models for him is going well. He has started three or four landscapes which he plans to continue next year. He is also doing some watercolors. The weather helps, it's very fine*

*My father and mother send you their best regards.*

*Please accept, dear Mr. Vollard, my cordial greetings.*

*Paul Cézanne f.*

TO CHARLES CAMOIN

Aix, 9 December 1904

My dear Camoin,

I received your kind letter sent from Martigues. Come whenever you like, you'll always find me at work; if you like, we can go out painting together. Let me know what day you're coming, because if

you come to the studio up to the Lauves I'll have lunch brought for two. I eat at eleven and then I go out to where I'm painting unless it rains. There's a luggage depot just twenty minutes from my place.

Sometimes for an artist the reading of the subject and its realization is very slow in coming. Whichever master you prefer, he must be only an orientation for you. Otherwise, you will only be an imitator. With a feeling for nature, in whatever guise, and a modicum of natural gifts— which you have—you should manage to succeed; someone else's advice or method must not lead you to change your way of feeling. Even if you give way momentarily to the influence of someone older than you, as soon as you become aware of it, your own emotion will always come to the fore and earn you your place in the sun—so grab hold of it and have confidence—you must equip yourself with a good method of construction. Drawing is no more than the configuration of what you see.

Michelangelo is a builder, and Raphael, great as he is, is an artist who was always restricted by the model. Whenever he tries to become reflective, he falls below the level of his great rival.

Very cordially yours,

P. Cézanne

TO EMILE BERNARD

[Aix] 23 December 1904

My dear Bernard,

I received your kind letter sent from Naples. With you, I won't dwell on aesthetic considerations. Yes, I approve of your admiration for the most daring of the Venetians; let us honor Tintoretto. Your need to find some moral, intellectual support in works that will certainly never be surpassed keeps you on perpetual alert, always searching for some sure means to lead you to an inner realization of your expressive abilities; and the day when you find them, you may be sure that you will find, effortlessly and from within, the means the four or five great Venetians employed.

This—and I am categorical on this point—cannot be contested: an optical sensation occurs in our visual organ which allows us to classify —by light, halftone or quarter tone—the areas represented by the sensations of color. For the painter, therefore, light does not exist. Obviously, as long as you go from black to white, the first of these abstractions being a fulcrum for the eye as well as for the brain, we flounder and can't manage to gain our mastery, to realize ourselves. During this period of time (I'm repeating myself for emphasis) we turn to the admirable works handed down to us from the past, in which we find comfort, support, like a plank stretched out towards a swimmer.

Everything you tell me in your letter is quite true.

I am happy to hear that Madame Bernard, yourself and the children are well. My wife and son are in Paris at the moment. I hope we will soon be together again.

I've tried to respond as much as possible to the main points in your letter, and I would ask you please to remember me respectfully to Madame Bernard, to give a hearty kiss to Antoine and to Irène, and to you, my dear colleague, with my best wishes for the new year, a cordial handshake.

P. Cézanne

TO JEAN ROYERE[15]

[Aix, 1904]

[Cézanne is thanking the poet for having sent him his *Poèmes Eurythmiques*.]

[. . .] I wanted to penetrate that sharp vision that makes them stand out so clearly. Unfortunately, the advanced age at which I have arrived makes it difficult for me to assimilate new artistic formulas . . . In the beginning, therefore, I was not prepared to relish all the savor of your colored rhythms. That, in short, explains my delay in answering . . .

TO GUSTAVE GEFFROY

[1904]

[A letter in reply to a subscription fund set up for Rodin's *Le Penseur*. Cézanne often remarked that he had subscribed because Geffroy and Rodin had publicly complained that the only persons who had subscribed were Dreyfusards.]

## [NOTES 1904]

1. The young painter Emile Bernard (1868–1941), a long-time friend of Gauguin and Van Gogh, was a fervent admirer of Cézanne, about whom he had written an article in 1892, twelve years before making his acquaintance. On his way home after a stay of many years in Italy and Egypt, Bernard had just stopped in Aix with his wife and two children in order to meet Cézanne. He was to remain there with him for a month. Constantly preoccupied with artistic, philosophical and religious questions, Bernard had long, speculative conversations with the elderly painter, conversations he was afterwards to attempt to pursue in his letters. Although Cézanne had little taste for such speculations, Bernard's many questions led him to formulate some of his views in writing.

Less than a year after Cézanne's death, Bernard was to publish his recollections of the painter along with the letters he had received from the old man. He was unaware of how severely Cézanne judged the painting of his young colleague and how wearisome he had often found his eternal questions (see in this connection, *inter alia*, Cézanne's letter to his son dated 13 September 1906). Also noteworthy is the fact that in 1907, the poet Rilke, upon reading the letters to Bernard, should have sensed how little at ease Cézanne had been in his correspondence with him (see Preface).

2. In a room on the floor below his studio, Chemin des Lauves, Cézanne had set out a still life for Bernard. Bernard also appears to have painted a landscape while Cézanne worked on the floor above and went down into the garden from time to time when things were not progressing to his satisfaction.

3. Bernard had a veneration for Odilon Redon (1840–1916), whom he had known since around 1889 and with whom he corresponded. In 1891, when asked by a journalist which painters he most admired, Bernard replied: "Among contemporary painters, I admire only Cézanne and Redon." Denis had placed Redon in the center of his *Hommage à Cézanne*, but Redon himself had certain reservations about Cézanne's art.

4. Only sketches exist for this *Apothéose de Delacroix*, which Cézanne wanted to paint and in which he had planned to give Victor Chocquet a prominent

place. On the back of a watercolor inspired by Delacroix, Bernard discovered the following lines of verse by Cézanne:

> Voici la jeune femme aux fesses rebondies.
> Comme elle étale bien au milieu des prairies
> Son corps souple, splendide épanouissement;
> La couleuvre n'a pas de souplesse plus grande,
> Et le soleil qui luit darde complaisamment
> Quelques rayons dorés sur cette belle viande.

---

Behold the girl with rounded buttocks. How she stretches out in the field her supple and splendidly blooming body; the grass snake is not more supple, and the glittering sun sheds its golden beams down upon this lovely flesh.

---

5. This probably refers to a collection of Bernard's articles entitled *La Décadence du Beau*, published in 1902.

6. Bernard had photographed Cézanne in his studio seated before one of his large compositions of bathers.

7. Bernard was writing an article on Cézanne. In writing, "I approve for the most part the ideas you are going to embody in your forthcoming article," Cézanne was not necessarily identifying himself with Bernard's views, nor that the young painter's ideas came from Cézanne (as has sometimes been maintained), but was only agreeing in principle with what Bernard was planning to write. Instead of simply writing that he approved such ideas, Cézanne preferred writing "I approve *for the most part* . . ." And he took care to add his total disapproval of "talk about art."

8. Madame Brémond was Cézanne's housekeeper.

9. Cézanne's son was later to buy a house in Marlotte.

10. This refers to the July issue of *Occident*, in which Bernard's article on Paul Cézanne had just been published.

11. The words between the dashes were added later in the margin.

12. This is the last letter from Cézanne to Gasquet. It is not inconceivable that during the course of the visit the painter finally made to "Font Laure," two years prior to his death, some misunderstanding arose between the two men. We only know that at some unspecified date their friendship came to an end: Cézanne's letters to Aurenche had already indicated certain reservations concerning the poet. In the book Gasquet was to write on the painter some fifteen years later, there is no mention of the coldness between them, nor of this visit to Equilles.

13. Solari was modeling a lifesize bust of Cézanne for which the latter was posing.

14. For Gaston Bernheim-Jeune (de Villers) (1870–1953) see note to the letter to Camoin of 11 March 1902. On the present occasion, the dealer had written to Cézanne as an artist, and the painter was prepared to receive him so long as there was no question of the former's being "unfaithful" to Vollard.

15. Cézanne had met the young poet among Joachim Gasquet's friends.

# [1905]

Aix, 5 January 1905

My dear Camoin,

In answer to your last letter I can tell you that after having made inquiries Madame Brémond says there are rooms to let at the Crémerie d'Orléans, 16 Rue Matheron. They are on the second, third and fourth floors; the food is also quite good.

Very cordially yours,

P. Cézanne

Aix, 10 January 1905

I'm sorry I won't have the pleasure of seeing you again this year. But I too send you my good wishes.

I'm still working, and without worrying about criticism and critics, as a true artist should. The work must prove me right.

I have no news of Gasquet who is in Paris at the moment, I believe.

My best regards to you and my respects to Madame Aurenche.

Paul Cézanne

[Aix] 17 January 1905

Dear Colleague,

I have received your remembrance and thank you. If I can get up to Paris in the spring, I will come shake your hand.

My wishes for you are that you can manage to give form to the sensations we experience through contact with the beauty of nature—man, woman, still life—and that conditions will be favorable for you, with all my fellow feelings as an artist.

Your old

Paul Cézanne

TO ROGER MARX

[Aix] 23 January 1905

Dear Editor,

I read with interest the lines you were so kind as to devote to me in the two articles in the *Gazette des Beaux-Arts*.[2] Thank you for the favorable opinions you express in them about me.

My age and my health will never allow me to realize the artistic dream I have pursued throughout my entire life. However, I shall always be grateful to the group of intelligent art lovers who have—in spite of my halting attempts—sensed what I was trying to do to renew my art. In my opinion, one does not replace the past, one only adds a further link to it.[3] Along with a painter's temperament and an artistic ideal, in other words his concept of nature, there should be sufficient means of expression to make oneself intelligible to the public and to occupy a suitable rank in the history of art.

Please accept this expression of my keen artistic fellow feeling.

P. Cézanne

TO AN ART-SUPPLY DEALER

Aix, 23 March 1905

[Cézanne writes that he is somewhat unwell and cannot deal with returning some cinnabar green that he had been sent. He also requests the sending of five tubes of Prussian blue and a bottle of Harlem siccative, which he needs urgently.]

TO AN ART–SUPPLY DEALER

Fontainebleau, 6 July 1905[4]

I was pleased to receive yesterday delivery of the canvases and paints
I had ordered from you, but I am still eagerly awaiting my box that I
had asked you to fix for me by adding a palette with a hole large enough
to accommodate my thumb . . .

[Cézanne goes on to request delivery of some burnt lacquer, cobalt and
chrome paints.]

PAUL CÉZANNE FILS TO AMBROISE VOLLARD

*Aix, 20 April 1905*

*Dear Mr. Vollard,*
  *The case with the five albums of photographs arrived three days ago in good
shape. I haven't told you sooner because of a bit of rheumatism in my right
shoulder.*
  *I have just heard from my friend Guillaume that you have picked up the
watercolors and drawings from the framer that you are planning to use in the
forthcoming exhibition. I have been asked to send you the enclosed list of a
collection of good pictures, more or less authentic, for sale, very reasonable!!*
  *I must ask you to hold on to the still lifes you have on consignment, my father
being not at all sure he wants to part with them just yet.*
  *My father and mother say hello, and a cordial handshake from me.*
                                        *Paul Cézanne f.*

TO EMILE BERNARD

[Aix, 1905] Friday

My dear Bernard,
  A succinct reply to some of the paragraphs in your last letter. As you
have written, I do indeed believe I have made some further very slow
progress in the latest studies you saw when you were here.[5] But it is

painful to realize that the growth of one's understanding of nature, ⌐
painting-wise, and of one's powers of expression must entail old age
and debility.

If the official Salons remain so inferior it is because they display only
more or less commonplace things and methods. It would be better to
provide more personal feeling, more observation and more character.

The Louvre is the book from which we learn to read. Yet we ought
not be content with the fine formulas of our illustrious forebears. We
must go out to study beautiful nature, we must try to free our minds,
we must seek to express ourselves according to our personal tempera-
ments. Thus time and reflection gradually modify vision, and finally
we reach understanding.

In this rainy weather it is impossible to put these theories, correct as
they are, into practice outdoors. However, perseverance enables us to
understand interiors as we do the rest. It's only old heel-taps that clog
our intelligence, which needs constant stirring.

<div style="text-align: right">P. Cézanne</div>

You'll understand me better when we meet again; study so modifies
our vision that the humble and colossal Pissarro seems justified in his
anarchist theories.

Draw, but remember: the play of light defines the object, light con-
tains all.

<div style="text-align: right">P.C.</div>

TO EMILE BERNARD

<div style="text-align: right">Aix, 23 October 1905</div>

My dear Bernard,

I cherish your letters on two counts, the first being purely selfish
since their arrival relieves the monotony created by the ceaseless pur-
suit of the one and only goal, which in moments of physical fatigue
brings on a kind of intellectual exhaustion, and the second enabling me
to reiterate, perhaps unduly, the stubborn way I am striving to realize

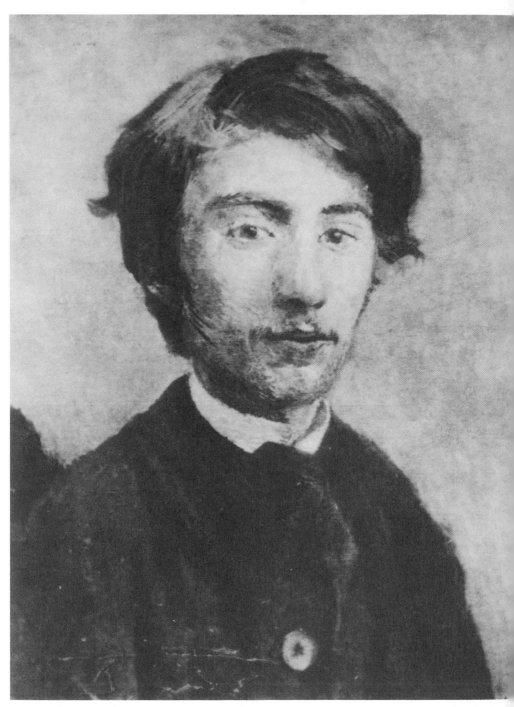

Portrait of Emile Bernard by Toulouse Lautrec.

that part of nature that, falling under our eyes, yields up the picture to us. Now, the thesis to be expounded—whatever our temperament or our strength in the face of nature—is to render the image of what we see, in forgetting everything that appeared before us. This, I believe, should enable the artist to devote his whole being, great or small.

Now, old as I am, nearly seventy, I find that the sensations of color that light gives create abstractions that don't let me cover my canvas or follow the outlines of objects when the points of contact are tenuous, delicate; thus my image or picture is incomplete. On the other hand, planes get superimposed, from which comes the neo-impressionism that circumscribes outlines with black, an error that must be strongly combatted.[6] Consulting nature provides us with the means for achieving our goal.

I did remember that you were in Tonnerre, but the problems of moving have made me totally dependent on my family, who take advantage of it to make themselves more comfortable while rather ignoring me.[7] Such is life; at my age, I should have more experience and use it better for the general welfare. In painting, I owe you the truth and I shall tell it to you.

Please give all my respects to Madame Bernard; I must send love to the children, Saint Vincent de Paul being the one to whom I should most commend myself.

Your old

Paul Cézanne

A hearty handshake and courage.
Optics, which we develop through study, teaches us to see.

## [NOTES 1905]

1. Louis Leydet was already mentioned in two 1902 letters to Camoin. The young painter was the son of Senator Victor Leydet, a boyhood friend of Cézanne and Zola who had attempted, in vain, to obtain a decoration for Cézanne in 1897.

2. Marx's article on the Salon d'Automne had appeared in the December issue of the *Gazette des Beaux-Arts*.

3. This is *à propos* a comment by Marx who, in his article (which even included the reproduction of a Cézanne landscape) had stated: "The reminiscence goes beyond Puvis de Chavannes with Chasseriau, beyond Cézanne with Courbet, beyond Odilon Redon with Rodolphe Bresdin, beyond Lautrec with Daumier and Degas. Despite these examples, unquestionably, more than one link in the chain is missing, and we would be wrong to ignore the ascendancy over recent generations exercised by a Gauguin, a Van Gogh or a Seurat. On the other hand, the influences become juxtaposed, intertwined, combined: thus, one group of painters can simultaneously lay claim to both Gustave Moreau and Cézanne; some join Fantin-Latour and Seurat in a common direction; Maurice Denis [. . .] goes hand in hand with Puvis de Chavannes and Gauguin. No matter: thanks to repeated enlightenments, art movements hitherto considered to be irrational have today ceased to have anything disconcerting about them . . ."

4. This was Cézanne's last visit to Paris and environs. Although he was represented in the Salon d'Automne by ten works, it does not appear that Cézanne himself ever attended it. Gustave Geffroy was to publish another article full of praise for the painter on this occasion.

5. At the end of March, Bernard had paid a second visit to Cézanne in Aix.

6. In fact, the practice of outlining areas of the same color in black had nothing to do with Seurat's neo-impressionism, but had been practiced first by Bernard himself when, with Anquetin, he developed "cloisonnism," which had an influence on Gauguin.

7. Cézanne first wrote: "but problems of moving have forced me to become . . ."

# [1906]

*Aix 7 March 1906*

*Dear Monsieur Vollard,*

*Once again I take the liberty of calling on your kind assistance. Some Provençal artists are organizing an exhibition of modern art. They insisted on my father's participation, and I have finally conceded. But, having nothing available, I must turn to you in order to keep my promise.*

*You will soon receive a letter from the agent of the exhibition, Mr José Silbert, whom I authorized to write and tell you what he wants. The group will undertake full guaranties for any works you give them.*

*Please excuse this new bother, and accept, dear Mr. Vollard, my best regards,*

*Paul Cézanne f.*

PAUL CEZANNE FILS TO AMBROISE VOLLARD

*Aix, 16 March 1906*

*Dear Monsieur Vollard,*

*Your letter arrived this morning, but I got the notice from the Crédit Lyonnais yesterday afternoon. I went there today to collect the six thousand francs which you sent me for the two still lifes of my father that you have had since March 2, 1905, and for which we had set a price of three thousand francs each.*

*Thank you for your offer of assistance for the exhibition I wrote to you about. But since the agent hasn't written you, I hope he will have the good sense to leave us alone.*

*My father's health isn't bad at present. But he lost a good month of work because of snow and winds, and then a bout of the grippe. He's back to work now. My return to Paris will probably not happen before the end of May. I hope to bring my father with me.*

*My parents send you friendly greeting, and I my best regards*

*Paul Cézanne f.*

TO HIS SON

[Aix] Friday [20] July 1906

My dear Paul,

This morning, my head being fairly clear, I am replying to your two letters, which as usual gave me great pleasure. At four-thirty in the morning—by eight, the temperature will be unbearable—I get on with my work. It would be nice to be young and do a lot. The atmosphere is rather hazy and the tonality lamentable. It's only fine at moments.

Thank you for the news you sent me. I go along my good old path.

Greetings to Maman and all those who still remember me. Greetings to Madame Pissarro—how far away it all seems already, yet how near.[1]

Your father embraces you both,

Paul Cézanne

I haven't yet seen your aunt, I sent her your first letter. Do you know where the little sketch of the Bathers is?

TO HIS SON

Aix, 24 July 1906

Yesterday, the ghastly Abbé Gustave [?] Roux got a car and came by to take me out again to the Jourdan's; he's a leech.[2] I promised to go see him at the Catholic College. I won't go. You have time to write and give me your advice.

I send you and Mama both a kiss. It's very hot.

Your old father,

Paul Cézanne

TO HIS SON

Aix, 25 July 1906

My dear Paul,

I received your good letter with your news yesterday. I can only deplore the state your mother is in, care for her as much as you can; try to provide comfort, cool and appropriate diversions. Yesterday, Thursday, I was supposed to visit the soutaned Roux. I didn't go and that will remain the best policy in the future. He's an awful bore. As for Marthe, I went to see your Aunt Marie. There's another sore point; at my age it's better to live alone and paint.

Valler[3] gives me massages, my back is a bit better. Madame Brémond says that the foot is better.[4] I am following Boissy's treatment, it's awful. It's very hot. By eight o'clock, the weather is unbearable. The two canvases of which you sent me photographs are not mine.

I embrace you both with all my heart.

Your old father,

Paul Cézanne

Give my greetings to Monsieur and Madame Legoupil, I am touched by their remembering me and they are so kind to your poor mother.

P. Céz.

TO HIS SON

Aix, 3 August 1906

My dear Paul,

I've received your nice letters dated quite close together. If I didn't reply at once its because of the overwhelming heat we're having. It's very hard on the brain and keeps me from thinking. I get up early and I can lead my normal life between five and eight o'clock. Then, the heat gets so stifling and creates such cerebral depression that I can't think of painting. I have had to call in Doctor Guillaumont; having caught bronchitis, I've abandoned homeopathy for some syrup concocted in

the old-fashioned way. I coughed a good deal, old lady Brémond made a compress of iodized cotton and that made me feel better. These exacerbations make me all the more resent my age.

I'm happy that you see Monsieur and Madame Goupil who are good solid folk and should bring some palpable calm to your life. I'm happy to hear of the good relationship you have with the artistic intermediaries to the public, and I hope they persist in such good intentions with regard to myself.

It's unfortunate that I'm unable to create a great many specimens of my ideas and feelings, long live the Goncourts, Pissarro, and all those who love color, the representative of light and air. I know that with the awful heat prevailing you and Maman must be tired; so it's a good thing that you were able to get back to Paris in time to enjoy a less torrid atmosphere. As for my foot, it's not too bad at the moment. I was touched by the kind remembrance of Forain and Léon Dierx, whom I have known for a considerable time. Where Forain is concerned, the Louvre in 1875, and as for Léon Dierx, at Nina de Villard's, Rue des Moines, in 1877.[5]

I must have told you that when I used to have dinner at the Rue des Moines, the guests would be Paul Alexis, Frank Lami, Marast, Ernest d'Hervilly, L'Isle Adam and [among] many other hearty trenchermen, the late lamented Cabaner. Alas, such memories, all sunk in the abyss of years! I think I've answered almost everything you asked me. Now I would ask you to please remember the slippers, the ones I have are almost falling off me.

I embrace you and Maman with all my heart.

Your old father,

Paul Cézanne

TO HIS SON

Aix, 12 August 1906

My dear Paul,

It has been hatefully hot for days; today, it was fine from five o'clock, the time I got up, until around eight. I am racked with pain to the point that I can't control it, and it makes me keep away from

people, which is the best thing for me. In Saint Sauveur,[6] Poncet, the former chapel master, has been succeeded by an idiot of an abbé who plays the organ badly. So that I can't even go to mass, his music-making makes me hurt.

I think that in order to be a Catholic, one has to be devoid of any feeling of soundness, but have one's eyes open for advantage.

Two days ago, Sire Rolland came to see me; he engaged me in conversation about the painting. He offered to pose for me as a bather on the banks of the Arc[7]—that idea rather appealed to me, but I'm afraid that the gentleman only wants to get his hands on my study; I'm almost tempted to try something with him, however. I demolished Gasquet and his Mardrus for him; he told me he was reading the *Thousand Nights and One Night* in Galland's translation.[8] He appears to understand that one's acquaintances can help us to get ahead, but that in the long run the public becomes aware what one is up to. I hope that the heat will end soon and above all that you and your mother aren't suffering overmuch. You should have received your Aunt Marie's letter.

When you get a chance, greet our friends there. I've had no news from Emile Bernard, I'm afraid that he's not overwhelmed with commissions. A bohemian gentleman from Lyons came to borrow a few sous from me, he seemed to me to be in an awful fix.[9]

I embrace you both with all my heart,
your old father,

<div align="right">Paul Cézanne</div>

The heat is getting stultifying again.
I remind you of the slippers.

<div align="center">TO HIS SON</div>

<div align="right">Aix, 14 August 1906</div>

My dear Paul,

It's two in the afternoon, I'm in my room; it's turned hot again, it's dreadful. I'm waiting until four o'clock when the car will pick me up and take me to the river at the Trois Sautets bridge.[10] It's a bit cooler

there; yesterday it was quite comfortable there and I began a watercolor like those I did in Fontainebleau, it seems more harmonious to me, the whole thing is to put in as much consonance as possible. In the evening I went by to congratulate your Aunt Marie on her saint's day, Marthe was there; you know better than I what I think of that situation, but it's up to you to manage our business. My right foot is getting better. But how hot it is, the air has a nauseating smell.

I received the slippers, I put them on, they fit me very well, they're a success.

At the river a poor child, very lively, dressed in rags, came up to me an asked me if I was rich, and another one, older, told him that one didn't ask such questions. When I got back into the car to return to town, he followed me, when we got to the bridge I threw him two sous. If you could have seen how he thanked me.

My dear Paul, the only thing I have left is painting. I embrace you with all my heart, you and Mama, your old father,

                                                                    Paul Cézanne

TO HIS SON

                                            Aix, Sunday [26] August 1906

My dear Paul,

When I forget to write to you it's because I'm beginning to lose track of time. It's terribly [hot] and in addition my nervous system must be very debilitated. I live almost in a vacuum. Painting is the best thing for me. I'm very much upset by my compatriots' gall in trying to approach me as a painter and in trying to get close to my work. You should see the messes they make. I go to the river in the car every day. It's nice enough there, but my weakened condition tells on me. Yesterday, I met the soutaned Roux, he makes me sick.

I'm going up to the studio, I got up late, after five o'clock. I'm still working with pleasure, and yet sometimes the light is so awful that nature seems ugly to me. So one has to choose. My pen barely moves. I

embrace you both with all my heart and remember me to all the friends who still think of me across time and space. I embrace you and Mama. Greetings to Monsieur and Madame Legoupil, your old father,

<div align="right">Paul Cézanne</div>

### TO HIS SON

<div align="right">Aix, 2 September [1906]</div>

My dear Paul,

It's four o'clock, there's no air. The weather remains stifling. I'm waiting for the car to take me to the river. I spend a few pleasant hours there. There are tall trees and they form a vault over the water. I go to the place known as the Gour de Martelly, it's on the little Milles road that goes to Montbriant.[11] In the evening, cows pass along it on their way to pasture. There's plenty to study and to turn into masses of pictures. Sheep also come there to drink, but they disperse a bit too quickly. Some house painters came up to me and told me that they would like to do the same kind of painting, but at art school they aren't taught it; I said that Pontier was an old skunk,[12] they seemed to agree with me. As you can see, there's nothing new. It's still hot, no rain, and none likely for a long time. I don't know what else to tell you, other than four or five days ago I met Demolins,[13] and he seemed to me quite meretricious. Our evaluations must be greatly influenced by our moods.

I embrace you and Mama with all my heart, your father,

<div align="right">Paul Cézanne</div>

### TO HIS SON

<div align="right">Aix, 8 September 1906</div>

My dear Paul,

Today (it's nearly eleven o'clock) a new heat wave. The air is over-heated, not a hint of a breeze. The only thing such a temperature is

good for is to expand metals, make it easier to sell drinks, make beer merchants happier, an industry that appears to be attaining respectable proportions in Aix, and swell the heads of the intellectuals of my country, a bunch of ignoramuses, idiots and fools.

There are probably exceptions, but well hidden. Modesty hides its own light. Anyhow, I must tell you that as a painter I am becoming more lucid with regard to nature, but in my own mind the realization of my feelings is still very difficult. I can't manage to achieve the intensity my senses feel, I don't have that magnificent richness of color that livens nature. Here, on the river bank, there are so many motifs, the same subject seen from another angle offers a subject of the most compelling interest, and so varied that I believe I could work away for months without changing position but just by leaning a little to the right and then a little to the left.

My dear Paul, in closing let me tell you that I have the greatest confidence in your feelings, which give your mind the direction it needs in seeing to our interests; in other words I have utter confidence in the way you are seeing to our affairs.

I learn with patriotic satisfaction that the venerable statesman who presides over the political fate of France has set a date to honor our region with a visit, something that will set our meridional population aquiver with eagerness.[14] Jo, where will you be? On this earth in this life, is it the superficial and the commonplace that most surely succeed, or do our efforts succeed only through a series of happy coincidences?

Your father, who embraces you and Mama,

Paul Cézanne

TO HIS SON

Aix, 13 September 1906

My dear Paul,

I'm forwarding to you a letter I've just got from Emilio Bernardinos, a very distinguished art lover I'm sorry not to have before me in order to suggest to him the sane, comforting and the only correct idea, that art must be developed in contact with Nature. I can barely read his

letter, but I think nevertheless it is just, however the fellow completely turns his back on the things he sets forth in his writings. In drawing, he only turns out old rubbish that reproduce the dreams of art he has gained not from his feeling for nature, but rather from what he has seen in museums and even more so from the philosophical mind he has developed because of his too-exhaustive knowledge of the masters he admires. You'll tell me if I'm wrong. On the other hand, I can't help but be sorry for the unpleasant accident that has befallen him. You know that I can't come to Paris this year. I wrote you that I was going to the riverbank daily in a car.

Because of fatigue and constipation, I've had to give up going upstairs to the studio. This morning, I took a little walk, I returned around ten or eleven o'clock, I had lunch, and at three-thirty I set out as I told you earlier for the banks of the Arc.

My experiments interest me a great deal. Perhaps I could have made Bernard into a true believer. Obviously, one must arrive at one's own feeling and express oneself accordingly. However, I'm always digging away at the same thing, but the way I've arranged my life enables me to isolate myself from the local low life.

I embrace you and your mother with all my heart, your old father,

Paul Cézanne

One strong man is Baudelaire, his *Art Romantique* is marvelous, and he is never mistaken about the artists he appreciates.

If you want to reply to his letter, write one and send it to me and I'll copy it. Don't lose the above-mentioned letter. [15]

TO EMILE BERNARD

Aix, 21 September 1906

My dear Bernard,

I am in such a state of cerebral unrest, so greatly disturbed, that for a moment I was afraid that my frail mind would give way under it. After the terrible heat we have been subjected to, the temperature has become more clement and has calmed our minds somewhat, and none

too soon. It seems to me now that I can see more clearly and am thinking more correctly in forming my studies. Will I ever achieve the goal I have sought so fervently and pursued so long? I hope so, but as long as I haven't reached it, I have this vague unrest that will not disappear until I have reached port, or until I have achieved something better developed than in the past, and thereby proving theories, which for that matter are always easy; it's only giving proof of what one thinks that presents serious obstacles. So I'm pursuing my studies.

I have just reread your letter, however, and I see that I never really reply to you. I know you will excuse me—as I say, it's caused by this constant preoccupation with the goal to be reached.

I'm still painting from nature, and it seems to me I'm making some slow progress. I'd have liked to have you here with me, for solitude is always somewhat hard to bear. But I'm old, ill, and I've taken an oath to die painting rather than give way to that hideous senility that threatens old people who let themselves be ruled by passions debilitating their senses.

Should I have the pleasure of being with you again one day, we will better be able to explain ourselves face to face. You'll forgive my always coming back to the same point; but I believe in the logical unfolding of what we see and feel by studying nature, never mind bothering about the ensuing processes, those being only mere means for us to manage to make the public feel what we ourselves feel and to accept us. The great men we admire must have done no differently.

Kind remembrances from the stubborn Macrobite who sends you a cordial handshake.

<div style="text-align: right">Paul Cézanne</div>

<div style="text-align: center">TO HIS SON</div>

<div style="text-align: right">Aix, 22 September 1906</div>

My dear Paul,

I've sent in reply to Emile Bernard a long letter, a letter filled with my concerns, as I told him, but since I see things a bit better than he, and since my way of imparting my thoughts to him cannot upset him

in any way, even though I don't share either his temperament or his manner of feeling, well, I have come to the conclusion that we can do nothing for others. True, with Bernard it's possible to go on theorizing indefinitely, since he has a logician's temperament.

Every day I go out to the landscape, the subjects are beautiful and so I spend my days more pleasantly than elsewhere.

I embrace you and Mama with all my heart, your devoted father,

Paul Cézanne

My dear Paul, I've already told you that I'm suffering from cerebral problems, my letter reflects that, well, I look on the dark side of things, so I feel increasingly forced to rely on you and to look to you for my bearings.

TO HIS SON

Aix, 26 September 1906

My dear Paul,

I've had a flyer from the Salon d'Automne signed Lapigie, probably one of the main organizers and . . . of the exhibition. I learn that I will have eight canvases in it. [16] Yesterday, I saw that good fellow from Marseilles, Carlos Camoin, who came to show me a bundle of canvases and ask my opinion; what he does is good, he'll soon make progress. He is coming to spend a few days in Aix and will be working on the little Tholonet path. [17] He showed me a photograph of a picture by poor Emile Bernard, we agreed that he is an intellectual whose mind is blocked by his museum memories, but who doesn't look at nature enough, and that is the great point, getting away from any and all schools. Pissarro wasn't mistaken, therefore, although he went a bit far, when he said that one should burn all artistic necropolises. You could make up a very strange menagerie with all those art professionals and their cohorts. The first person is the artist himself. In that case, in light of his situation, he should be the equal—in the Salon d'Automne, I mean—of any member of the Institut. But there you have that building that rises so proudly, not to say victoriously, across from the edifice

on the Quai Conti, whose library was founded by that person Sainte-Beuve referred to as an "Italian trickster."[18] I still paint out of doors, on the banks of the Arc, leaving my gear with a man named Bossy who offered to keep it for me. I embrace you and Mama, with all my heart, your father,

Paul Cézanne

TO HIS SON

Aix, 28 September 1906

My dear Paul,

I must ask you to send me some restorative lozenges, No. 4. I only have two or three left in the last box I have. I told you that I had to send back to Vignol three out of five tubes of fine lacquer, the two others I mislaid either while I was moving them out of the Rue Boulegon studio or while painting outdoors. I don't think the good man is still capable of running his business. The weather is wonderful, the landscape superb. Carlos Camoin is here, he comes to see me once in a while. I'm reading Baudelaire and the appreciative things he wrote about Delacroix's work. As for me, I should remain alone, the double-dealing of mankind is such that I can't get over it, it's all thieving, self-satisfaction, infatuation, rape, grabbing hold of your output, and yet nature is so beautiful. I still see Vallier, but I am so slow at carrying things out that it makes me very sad. You are the only one who can console me in my unhappy state. So I commend myself to your care. I embrace you, and Mama, with all my heart.

Your old father,

Paul Cézanne

TO HIS SON

Aix, 8 October 1906

My dear Paul,

I've sent the card you asked for.[19] I'm terribly sorry for the nervous

state I'm in and which prevents me from writing to you at greater length; the weather is fine and I go out to paint in the afternoons. Emery raised the price of the car from three francs round trip to five francs when I go out to Château Noir.[20] I've abandoned him. I met Monsieur Roublard, who married money in the person of a Mademoiselle Fabry. When you meet her you will see what he's up against. He's a young man, well situated in the town; he organizes concerts, both religious and artistic.

I won't go on any longer today. Yesterday evening I was with Capdeville, Niolon,[21] Fernand Bouteille and so on before dinner from four to seven, at the Café des Deux Garçons.

Your father, who tenderly embraces you and Mama,

Paul Cézanne

TO HIS SON

Aix, 13 October 1906

My dear Paul,

Today, after a rainstorm during the night, and this morning too, since it was still raining, I've stayed in the house. Indeed, as you reminded me, I forgot to mention the wine to you. Madame Brémond tells me that we have to get some in. If, on the same occasion, when you see Bergot you could order some white for yourself and your mother. It rained a great deal and I think that finally the heat is over. The banks of the river have grown a bit chilly, I've abandoned them and am going higher up around Beauregard where the path is quite steep, very picturesque but wide open to the Mistral. At the moment, I'm going on foot with just a bag of watercolors, putting off painting in oil until I've found somewhere to leave my gear. In the old days, you could do that for thirty francs a year. One is exploited on all sides. I'm waiting for you before deciding on anything. The weather is stormy and very changeable. With my nerves so weakened, only oil painting keeps me going. And I must continue. Thus, I have to work from nature. Any sketches or canvases I would do would have to be con-

structions [from nature] based on the means, feelings and approaches suggested by the model. But I'm always saying the same thing. Could you get me a small amount of almond loaf?

I embrace you and Mama with all my heart.
Your father,

Paul Cézanne

My dear Paul, I've found Emile Bernard's letter.[22]
I hope he gets ahead, but I fear the contrary.
Best to you and your mother.

Paul Cézanne

TO HIS SON

Aix, 15 October 1906

My dear Paul,

It poured rain Saturday and Sunday, the weather has cooled off a great deal. It's no longer hot at all. You are right when you say that this is the real country. I'm still working, with difficulty but at last something is coming. It's important, I think. Feelings being at the bottom of what I'm doing, I believe I'm impenetrable. So let the unhappy creature, you know who I mean, go on copying me as much as he likes, there's little danger in that.

When you have a chance, give my greetings to Monsieur and Madame Legoupil, who are so kind as to think of me. And don't forget Louis and his family, and old Guillaume.[23] Everything happens so terribly quickly, I'm not doing too badly. I take care of myself and eat well.

Please order me two dozen *émeloncile* brushes, like those we ordered last year.

My dear Paul, in order to give you as pleasant news as you would like, I'd have to be twenty years younger. I repeat, I eat well, and a bit of moral satisfaction—but only work can provide that—would be good for me. All my compatriots are asses compared to me. I should have told you that I received the cacao.

I embrace you and Mama, you old father,

Paul Cézanne

I think the young painters far more intelligent than the others, the elders see in me only a dangerous rival.

<div align="right">Best to you, your father,<br>P. Cézanne</div>

I'll say it again: Emile Bernard I think is worthy of great compassion, because he is in charge of souls.

## TO AN ART-SUPPLY DEALER

<div align="right">Aix, 17 October 1906</div>

Dear Sir,

A week ago, I ordered from you ten tubes of burnt lacquer No. 7, and I have received no reply. What is going on?

Please reply at once.

Sincerely,

<div align="right">Paul Cézanne</div>

## MARIE CEZANNE TO HER NEPHEW, PAUL CEZANNE, JR.

<div align="right">*Aix [Saturday] 20 October 1906*</div>

*My dear Paul,*

*Your father has been ill since Monday; Dr. Guillaumont doesn't think he's in danger, but Madame Brémond is not up to taking care of him alone. You must come as soon as you can. At times he's so weak that a woman can't lift him by herself; with your help that would be possible. The doctor told us to get a male nurse; your father wouldn't hear of it. I think that your presence is required so that he can be as well cared for as possible.*

*He was out in the rain for several hours on Monday; they brought him back on a laundry cart, and two men had to carry him up to his bed. The next day, as soon as it was light enough, he went out to the garden [of the Lauves studio] to work on a portrait of Vallier under the linden tree; he came back nearly dead. You know your father; what can one say [. . .] I repeat, I think your presence is needed.*

*Madame Brémond has expressly asked me to tell you that your father has set*

*up his studio in your mother's bathroom and that he doesn't plan to move out; she wants your mother to be informed of this fact. And since you aren't supposed to be back for a month, your mother might be able to prolong her stay in Paris a bit longer than that; by then your father may have moved his studio.*

*So, my dear child, there is what I felt it my duty to tell you, the decision is up to you. Until soon, I hope. An affectionate kiss.*

*Your devoted aunt,*

*M. Cézanne*

MADAME BREMOND TO PAUL CEZANNE, JR.

*Telegram: Cézanne R. Duperré 16 Paris*
*P. Aixenpce 291 13 22 date 10.20*

*BOTH COME AT ONCE   FATHER VERY ILL*
*BREMOND*

Cézanne died in Aix on Tuesday, 23 October 1906, before the arrival of his wife and son.

## [NOTES 1906]

1. Camille Pissarro had died on 12 November 1903. His death appears to have affected Cézanne very deeply, since following that date the name of his old friend frequently occurred in his conversations as well as his letters.

2. The last landscape of Cézanne is entitled *Le Cabanon de Jourdan* (Venturi, No. 805).

3. Cézanne's gardner, who also posed for a series of portraits.

4. Swollen, painful feet are one of the symptoms of diabetes.

5. Nina de Callias or de Villard, a musician and artist, was devoted to anything involved with art, literature and music. Her parties were famous and attended by, among others, Verlaine, Mallarmé, Manet and Edmond de Goncourt. Cézanne had probably been introduced to her by either Cabaner or by Paul Alexis, both of whom were members of her circle. According to a contemporary, "from dinner time until late at night, a group of young, revolutionary intellectuals would be there—egged on by alcohol—indulging

in every kind of mental debauchery and verbal clowning, under the aegis of a pretty woman, a slightly deranged muse." (Probably Cézanne's son had met Forain and Dierx in Vollard's famous "cellar.")

In a chapter of his novel *Madame Meuriot* (Paris, 1890), Alexis described a party at Nina Villard's home, in which Cabaner, Manet (Edouard Thékel) and Cézanne (Poldex) are briefly described. With regard to Cézanne, he wrote: ". . . thinking of the problems of his art, of everything that could never be rendered, of the miseries of his craft, he beat his fist against the wall: 'God damn it! . . . God damn it!' "

6. The cathedral in Aix, which was on the route Cézanne followed on the way from his studio in the Rue Boulegon to the studio at Lauves.

7. Cézanne had always dreamed of being able to paint nudes from live models on the banks of the Arc.

8. The new translation of the *Thousand Nights and One Night* by Dr. Mardrus, which had been published in 1900, had been given considerable attention. The older version by Galland dated from 1704. Renoir also preferred the 18th-century version.

9. This may refer to the vagabond-poet Germain Nouveau (*Humilis*), who often begged in the doorway of the Aix cathedral and to whom Cézanne is supposed to have given generously.

10. A small bridge over the Arc near Palette, where Cézanne worked during the final months of his life.

11. Montbriant was the estate owned by Maxime Conil, Cézanne's brother-in-law. The painter often worked there, as well as in the neighborhood, where he could gaze upon the Arc valley with Mont Sainte-Victoire and the railway viaduct.

12. Auguste-Henri Pontier, a sculptor, was the curator of the Aix museum from 1892 until his death in 1925. He swore that no work by Cézanne would enter the museum so long as he was alive, and he kept his word.

13. The "old woman with rosary" had been a maid in the home of the lawyer Jean-Marie Demolins, a contributor to Gasquet's review (see letter to Gasquet dated 12 May 1902).

14. This refers to President Armand Fallières, who had just been elected.

15. Judging by Cézanne's letter to his son dated 13 October 1906, the artist forgot to enclose Bernard's letter. In any event, his reply to the latter a week later, 21 September, had clearly been written by the painter and not copied from a draft sent to him by his son.

16. In actuality, there were ten pictures by Cézanne, along with works by Bonnard, Brancusi, Delaunay, Dedrain, Duchamp-Villon, Dufy, Jawlensky, Kandinsky, Kupka, Marquet, Matisse, Redon, Renoir, Rodin, Rouault, the Douanier Rousseau, Van Dongen, Villon, Vlaminck, Vuillard, etc., as well as retrospectives of Carrière and Gauguin.

17. Cézanne had worked there himself some years earlier. This refers to the path leading to Château Noir where he had painted many landscapes.

18. A reference to Cardinal Mazarin.

19. This probably refers to a card allowing for free entry to the Salon d'Automne that had been given Cézanne as a participant.

20. A large wooded property four kilometers from Aix, halfway between that town and the village of Tholonet. Cézanne did a great deal of work there, particularly between 1899, the date when the Jas de Bouffan was sold, and 1902, when he had his studio in Lauves built.

21. Niolon, an Aix painter, sometimes went with Cézanne and Madame Louise Germain to paint in Château Noir or in the vicinity. Cézanne usually took them in the car he rented; he also painted in the company of another Aix painter, Ravaisou.

22. See Cézanne's letter to his son of 13 September 1906.

23. Louis Guillaume was a boyhood friend of Cézanne's son; the two young boys posed for the picture *Mardi Gras* (Venturi, No. 552), among others. The painter himself was close to the father of Louis, a shoemaker, who had formerly been a neighbor and to whom he had given the key to his apartment in 1878 (see Cézanne's letter to Zola dated 29 July 1878).

# Index